# William Kentridge

Carolyn Christov-Bakargiev

Société des Expositions du Palais des Beaux-Arts de Bruxelles
Vereniging voor Tentoonstellingen van het Paleis voor Schone Kunsten Brussel

This book was published by the Société des Expositions du Palais des Beaux-Arts de Bruxelles / Vereniging voor Tentoonstellingen van het Paleis voor Schone Kunsten Brussel in association with Kunstverein München and Neue Galerie Graz on the occasion of the exhibition 'William Kentridge':

15 May - 23 August 1998
*Palais des Beaux-Arts / Paleis voor Schone Kunsten Brussels*
(on the occasion of the KunstenFESTIVALdesArts)
rue Royale 10, B-1000 Brussels
t. +32 (02) 507 84 66
f. +32 (02) 511 05 89
e-mail: expopba@netpoint.be
Organisation: Piet Coessens, Marie-Thérèse Champesme, Catherine Robberechts
Administration: Ann Flas, Axelle Ancion
Technical realisation: Pierre De Clerck, Robert Demeersman, Bruno Roelants, Henri Van den Thoren, Roger Van der Meulen
Supported by the Vlaamse Gemeenschapscommissie van het Brussels Hoofdstedelijk Gewest and by the Exchange Programme Flemish Community-South Africa

28 August - 11 October 1998
*Kunstverein München*
Galeriestraße 4, D-80539 München
t. +49 (089) 22 11 52
f. +49 (089) 22 93 52
Organisation: Dirk Snauwaert, Heike Ander
Administration: Renate Kern
Technical realisation: Dietmar Stegemann

15 November 1998 - 15 January 1999
*Neue Galerie Graz am Landesmuseum Joanneum*
Sackstraße 16, A-8010 Graz
t. +43 (316) 82 91 55
f. +43 (316) 81 54 01
e-mail: neue-galerie-graz@sime.com
http://www.sime.com/neue_galerie
Organisation: Günther Holler-Schuster, Peter Weibel, Christa Steinle
Technical realisation: Walter Rossacher and the technical team of the Neue Galerie (Alois Hochegger, Klaus Tattermus, Nikolaus Vodopivec, Alois Weitzer, Kasimir Werschitz)

LENDERS
Collection Jonathan Beare
Billiton SA Ltd
Coll. Jan des Bouvrie
Leszek Dobrovolsky
Stephen Friedman Gallery
Coll. Linda Givon
Collection Pierre Lombart
Collection Susan and Lewis Manilow, Chicago
Dr. and Mrs. G.J. van Rooyen
Other private collections

PUBLICATION
Concept: Carolyn Christov-Bakargiev, Piet Coessens, William Kentridge
Author: Carolyn Christov-Bakargiev
Coordination and production: Catherine Robberechts
Editor: Melissa Larner
Design: Gracia Lebbink
Coordination assistant: Ann Flas
Research assistants: Anne McIlleron, Raffaella Ridolfi
Typesetting: Holger Schoorl
Printer: Die Keure, Brugge

AUTHOR'S ACKNOWLEDGMENTS
I would like to thank Piet Coessens for allowing this catalogue to be made, Raffaella Ridolfi and Anne McIlleron for their help as research assistants, Anne Stanwix, Samuel Kentridge, Isabella Kentridge and Alice Kentridge for their insights, Jane Taylor for her help and friendship, Linda Givon and the Goodman Gallery, Ruth Sack, Steven Sack, Deborah Bell, Robert Hodgins, Basil Jones and Adrian Kohler of Handspring Puppet Company, Mannie Manim, David Krut, Okwui Enwezor, Ken Lum, Giancarlo Norese, Civitella Ranieri Center, Stefania Miscetti, Stephen Friedman, Barbara Gladstone gallery, Francesco Bonami, Jen Budney, Roberto Pinto, Gianni Baiocci, Melissa Larner for her patient editing, Catherine Robberechts for her useful comments and editorial care, as well as all the authors of the anthologised texts. I would also like to thank Cesare Pietroiusti for his patience and, in particular, William Kentridge, whose constant dedication to this project, support and guidance through what was for me the uncharted landscape of his work has made this publication possible.

ACKNOWLEDGMENTS
Suzanne Anderson, Elizabeth Armstrong, Francesco Bonami, Hugh M. Davies, Claire Diez, Linda Givon, Barbara Gladstone Gallery, Frances Goodman, The Handspring Puppet Company, Cécile Jacobs, Llilian Llanes, Frie Leysen, Seonaid McArthur, Anne McIlleron, Celesta Rottiers, Anne Stanwix, Sophie Van Stratum, Jane Taylor, Hortensia Völckers, the anthologised authors.

NUGI 921, 922, 925
ISBN 90-74816-09-6
D/1998/2256/1

# William Kentridge

# PREFACE

It is only over the last couple of years that William Kentridge's visual art work has come to the fore in Europe, with several recent exhibitions focusing on this aspect of his output. As a theatre-maker, however, he has been touring the world for many years. Indeed it was when Kentridge and the Handspring Puppet Company were in Brussels presenting a short run of their multi-media performance *Faustus in Africa!* (1995) at the 'KunstenFESTIVALdesArts' in 1996 that a proposal was made to consider a simultaneous show of his films.

However, we did not want to mount a quick exhibition, or to invite Kentridge to make a single new piece. We decided to organise the first major survey of his work, from the earliest of the films in the series *Drawings for Projection – Johannesburg, 2nd Greatest City after Paris* (1989) to the most recent – *WEIGHING... and WANTING* (1998), combined with a new, site-specific installation that would change with each venue to which the show toured. Almost simultaneously, the 'KunstenFESTIVALdesArts' commissioned Kentridge and the Handspring Puppet Company to produce a new theatre work. It would become their first opera production, based on Monteverdi's *Il ritorno d'Ullisse in patria,* to be performed in May 1998. It was agreed that the exhibition in the Palais des Beaux-Arts would open at the same time.

Kentridge's recent presence in important international exhibitions like the Sydney, Istanbul, Havana, and Johannesburg Biennales, Inklusion/Exklusion (Graz, 1996, curated by Peter Weibel) and documenta X (Kassel, 1997) demonstrate his ever-increasing worldwide reputation. However, these shows presented individual pieces in the framework of a group exhibition and were not always able to reflect Kentridge's unique process of developing ideas and statements through the act of drawing and its various applications in film, theatre and multi-media works. Wishing to focus particularly on this aspect, we have tried to develop a model in which these applications are 'tested': mural drawings as part of a site-specific installation, large, unframed autonomous drawings displayed on the wall, a 'patchwork' presentation of the Project drawings for theatre, combined with the drawings for the films, and a complete presentation of the animations themselves, transmitted on laserdisc, some screened on monitors, others projected on the wall. An additional determining element is imposed by the architectural conditions of the exhibition spaces, always interacting with these drawn images.

Right from the start, we recognised that Kentridge's writings were an essential part of his work. Not only do they clarify the interrelationship between all the different strands that make up his practice, they also provide a personal comment on South Africa's recent artistic, social and political history. The only way one could give more than a superficial idea of Kentridge's diverse activities would be to make a broad presentation of his visual art supported by a book in which his output as a whole is framed within his personal and national background. To achieve that goal we began a collaboration with Carolyn Christov-Bakargiev, one of the very few European art critics who was familiar with Kentridge's work before he received international acclaim.

Not only has she contributed an in-depth essay, in which she analyses his techniques, themes and approach in the context of his personal history and that of his country, she has also produced the first complete chronology and bibliography of the artist. Each of the key works are described in extended captions, accompanied by personal comments from the artist himself. An important aspect of the book is its multi-layered structure, in which written and visual material is interwoven, and Kentridge's own words alternate with those of Christov-Bakargiev and the anthologised writings of other critics and colleagues. This approach, which echoes the way in which Kentridge expresses himself through images (fixed or moving) and through words (spoken, written or sung), enables the reader to gain access to the complexity of his activity.

Taken together, the book and the exhibition document the entire spectrum of Kentridge's rich output, and above all, show that each of his activities can be brought back to the act of drawing, an act developed by William Kentridge as a highly vivid tool for the interpretation of our present world.

We would particularly like to thank William Kentridge himself, before acknowledging those whose contributions were vital for this project:
all the lenders
Carolyn Christov-Bakargiev
Frie Leysen and the KunstenFESTIVALdesArts
Linda Givon & Goodman Gallery,
Johannesburg
Stephen Friedman Gallery, London

*Piet Coessens*
Palais des Beaux-Arts Brussels
*Dirk Snauwaert*
Kunstverein München
*Peter Weibel*
Neue Galerie Graz

# CONTENTS

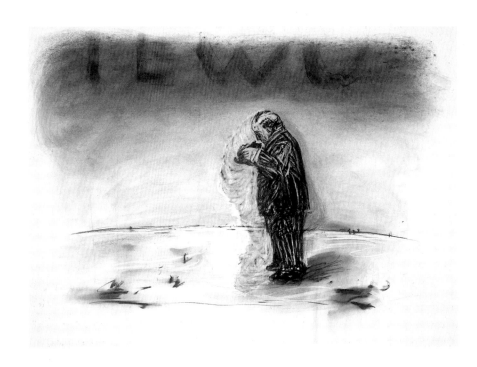

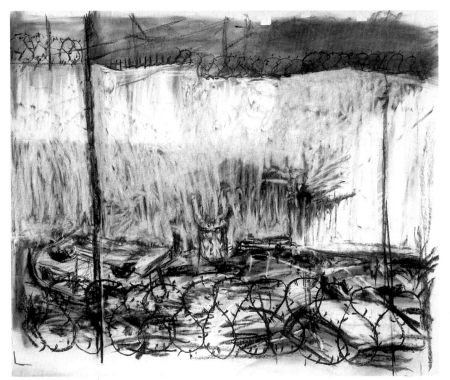

Drawing from *Sobriety,*
*Obesity & Growing Old* 1991
charcoal on paper, 120 x 150 cm

Drawing from *Johannesburg*
*2nd Greatest City after Paris* 1989
charcoal on paper, 86 x 107 cm

# William Kentridge

Carolyn Christov-Bakargiev

## I INTRODUCTION

William Kentridge was born in 1955 in Johannesburg, South Africa, where he still lives and works. His art is an expressive and personal attempt to address the nature of human emotions and memory, the relationship between desire, ethics and responsibility. He investigates the shaping of subjective identity through our shifting notions of history and geography, looking at how we construct histories and what we do with them. An elegiac art that explores the possibilities of poetry in contemporary society, it also provides a vicious, satirical commentary on that society. It posits a way of seeing life as process rather than as fact, and constantly questions the meaning of artistic practice in today's world.

Kentridge has always been socially and politically engaged. While acknowledging that art is historically and ideologically constructed however, he does not use the tools of deconstructive critique (an approach to art based on the linguistic paradigm, whereby the artist takes apart and reveals through rational analysis the mechanisms of underlying structures of power). Rather, his animated films appear at first glance to suggest simple narratives, adopting an apparently traditional, figurative style that recalls the world of cartoons and illustrated books. Kentridge's work is 'political' without being prescriptive or polemical. He probes the diseased body politic without suggesting solutions. At most, one might say that it is a therapeutic art, not an ideological one.

Writing about Kentridge from a distant cultural perspective is problematic. The issues he raises in his works are informed by the histories of the African context from which his art emerges, but to a South African reader, the contextualisation of his art within the landscape of that country's cultural production or in relation to apartheid would seem both to over-simplify it and to state the obvious. And discussing his work from a European point of view is particularly complex because of Europe's historical responsibility in the emergence of apartheid and the exploitation of Africa. Added to this is the fact that Kentridge draws upon a European legacy of oppositional art from Goya to Hogarth to Beckmann, but at the same time – despite the spread of sophisticated communications systems and an increasingly global art world – his work is oddly out of sync with current trends in Europe. Though he uses the prevailing technology of video projection, for example, the drawings that form the basis of his animated films retain a more old-fashioned appearance.

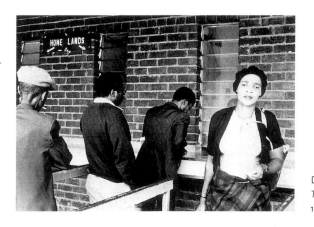

David Goldblatt, from the series
*The Transported of Kwa-Ndebele*
1987, black and white photograph

* All quotations are from William Kentridge's recent correspondence and conversations with Carolyn Christov-Bakargiev, unless otherwise stated.

« The question of naiveté has a colonial/political origin I think:

a) From the essentially domestic nature of the peripheral art scenes – art made for domestic use.

b) An anxiety not to copy styles or interests of the metropole – while acknowledging the attraction of the glossy magazines and shining galleries.

c) A need therefore to have a solid ground for the work even if this means reinventing the wheel.

d) A perceived need for the work to justify itself instrumentally – i.e. it has to be legible, understandable. »*

Yet, to someone like myself, living in Rome, far from New York, London and Paris, in an ancient centre of western culture that has been slumbering on the cultural periphery throughout this century, linguistically isolated from the global language (English) of art, business and the Internet, the nature of Kentridge's ethical and artistic endeavour has its own particular relevance. It explores a border zone where identity is hybrid, multiple and shifting, between remembering and forgetting, between belonging to a tradition of fine art and being relegated to its margins.

In the aftermath of the Cold War, since the decline of ideological confrontation and stalemate between East and West, European identity has been shattered into myriad local, provisional selves, and new waves of immigration are adding yet more diasporic dimensions to this changing situation. Economic crisis and competition for resources within Europe, as well as the weakening of universalist ideals of modernity and of the labour movement, have ushered in a renewed xenophobia, a fear of immigrants. Kentridge's constantly changing drawings, which create merging, overlapping or dividing personae, provide commentary on analogous yet different issues of identity as they emerge on another continent. While in Europe fresh divisions appear, the irony of South Africa today is that it is striving to forge a new, post-apartheid 'rainbow nation' in a post-national age in which the globalisation of world economies is having devastating effects on communities and their shifting identities.

To those living far away from South Africa, Kentridge's work offers a point of entry, an empathetic way in to understanding the reality and complexity of life there, in contrast to the rhetorical, stereotypical and simplified view that media reports grant us of great events in that country. He presents intimate, personal narratives of daily existence suggesting the complexity of identity. By combining drawing, movement and music, his stories are suggested with fluidity. He encourages a longer time for reflection on the human condition in a fast-moving world that tends to see this approach as out of date.

Kentridge's drawings, animated films and videos, theatre and opera productions deal with abuse and suffering, guilt and confession, subjugation and emancipation in the post-colonial,

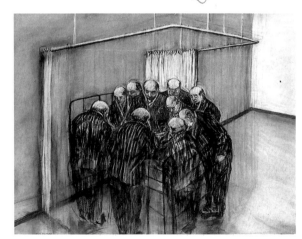

late 20th century. While evoking issues that characterise the human condition in general, his is an art particularly rooted in its place of origin, a nation wrought by racial division and the apartheid laws that prevailed until the 1994 general elections brought the ANC (African National Congress) into power. These cathartic works do not 'illustrate' apartheid, however, they communicate through metaphor. The analogy of medical pathology is often used to indicate a sickness both within the individual and in society. A sense of yearning for healing is expressed as a longing to flood the burnt, barren, urban wasteland around Johannesburg with blue water, slippery fish, and love. The 'medicine' Kentridge suggests as a cure for this pathology is to understand the complicated ways in which we construct ourselves.

Though Kentridge's work may appear archaic, it is in fact highly contemporary. A sense of belonging to a cultural 'periphery' of Europe, and therefore of *geographic* distance from a 'centre', is translated into the visual imagery of objects that represent a *historical* distance from today's accoutrements. The clothes, telephones, typewriters and other items in his animated drawings recall an early 20th-century colonial world as perceived by a child in the 1950s and 60s looking at illustrated books from the 1940s. The simultaneous presence in the work of CAT scan machines and other examples of modern equipment, however, indicates the way in which experience is layered: the computer exists side-by-side with the old-fashioned telephone.

Similarly, Kentridge's portrayal of anti-apartheid demonstrations in the 1980s and early 1990s recalls photographs showing crowds of striking miners in Johannesburg in the previous part of the century, such as the famous strike of March 1922. The drawing style adopted by Kentridge is also reminiscent of early 20th-century oppositional vanguard art like Berlin Dada and German Expressionism. These drawings are combined with the contemporary techniques of video-projection and installation on the one hand, and music and captions recalling the distant age of silent movies on the other. Furthermore, many of them make reference to specific works by Goya, Hogarth and other artists of the past. This procedure owes nothing to the critique of authenticity that has developed over the past two decades into postmodernist appropriation and simulation of art. For Kentridge, these memories and traces of art-historical sources provide yet another level on which to explore the mechanisms of forgetting and remembering.

Kentridge's simple, immediate drawings are a rebellion against the anonymity and homogeneity of 'contemporary' languages of representation, as well as the non-representational visual art developed during the Modern Age. His use of the traditional techniques of printmaking and computer animation go beyond the modernist tactic of reduction. Yet his refusal to engage in illusion, his need to acknowledge the medium, method and process by which the representation is achieved owes something to a modernist notion of authenticity.

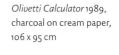

*Olivetti Calculator* 1989,
charcoal on cream paper,
106 x 95 cm

Drawing used in the animation
for *Faustus in Africa!* 1995
charcoal on paper, 52 x 63 cm

Drawing from *History of the
Main Complaint* 1996
charcoal and pastel on paper,
120 x 160 cm

White miners' strike,
Johannesburg, 1922

Drawing from *Sobriety, Obesity
& Growing Old* 1991
charcoal and pastel on paper,
70 x 100 cm

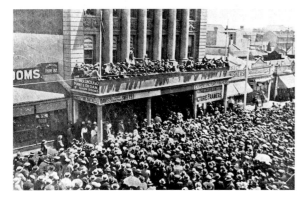

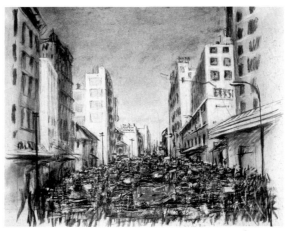

1.
Everlyn Nicodemus and
Kristian Romare, 'Africa,
Art Criticism and the Big
Commentary', *Third Text*,
London, Winter 1997-98,
no. 31 pp.63-65

The animated films are achieved by creating a series of drawings in charcoal and pastel on paper; each is successively altered through erasure and re-drawing and photographed at the many stages of its evolution. Thus, rather than being constructed from thousands of drawings, as in traditional cel animation, Kentridge's films are made up of hundreds of moments in the ongoing progress of a small number of drawings, each corresponding to a scene. The process of facture remains visible, establishing a jerky effect (tempered by music) that causes the viewer to perceive the spatial and temporal disjunctures of the drawing, rather than creating an illusion of fluid movement. And, because erasure is necessarily imperfect, traces of the preceding stages of each drawing can still be seen. Like the echoes of past art that pervade the drawings, these smudges and shadows reflect the way in which events are layered in life, how the past lingers in the mind and affects the present through memory.

Just as Kentridge has questioned the racist stereotypes of 'white' art produced during apartheid, particularly idyllic landscape painting, he has also carefully avoided speaking on behalf of the 'native'. Though he has never engaged in the paternalistic portrayal of the colonised African body, he has depicted various black Africans as characters. Present in *Monument* (1990), in *Woyzeck on the Highveld* (1992) and in many early drawings, for example, is a figure sometimes referred to as 'Harry' in Kentridge's writings and lectures, representing a leader of the dispossessed and based on a homeless person who lived in the streets near the artist's home. In *Felix in Exile* (1994), the black, female character, 'Nandi' acts as a surveyor of the land, explorer of the stars and witness of events. Other white South African artists have sometimes attempted the conceptual and critical denouncement of the stereotypical or racist representation of the black African body through its ironic presentation, parody and reversal. Perhaps aware of the contradictions that such practice might engender, Kentridge has never taken this approach. Instead, he acutely expresses a cultural dilemma, to which the only alternative would be artistic silence.

« I disagree that all portrayals – the fact of portrayal – entails paternalism. It implies that all representations are equal – that one does not have to look at them. I think Nandi is interesting in this regard. I struggled for a long time to find, not a form, but a persona for her. Victim yes. But she had to be more, too. When she gained her theodolite and started drawing the landscape herself, she found her place in the film. Perhaps she could be a displaced self portrait – is this imperialism to the nth degree? Maybe, but it ceased to be a problem that interested me. I was then intrigued by my personal displacement towards her – the eyes looking at each other. »

Everlyn Nicodemus and Kristian Romare have recently summed up the current position in the South African art world: 'The post-apartheid art situation is stamped by the drastic inequality of the white and the black art scene, the latter, where it exists, being out of step to a degree that cannot be conjured away by liberal discourses or by simply leaving out the colour label (…) What Steve Biko wrote twenty-seven years ago on the games of white liberals, might prove to be applicable to the split art field today.'[1] Kentridge's dilemma is that he cannot make modernist paintings – that is, he cannot pursue the fiction of making South Africa look 'white' – yet he cannot speak for the 'black', nor provide a platform or voice for the 'other'. He can only explore a zone of uncertainty and shifting meanings, through the portrayal of his own personal situation, a 'double-bind' where guilt and expiation express the condition of the privileged.

Emancipation is therefore both a theme in Kentridge's art and a principle underlying its form, media, technique, scale and experience.

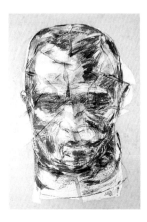

Preliminary drawing for *Industry and Idleness* and *Woyzeck* 1987, 103 x 82 cm

*Untitled* 1991, gouache and charcoal collage, 160 x 120 cm

Since the late 1970s, Kentridge has worked with a wide array of media and techniques, from charcoal drawing on paper to etching, from film to animation, from acting and set-designing to directing numerous theatrical productions. He has created video installations, and projected images onto buildings. He has made large-scale drawings on the landscape, and an outdoor work using fire. Often, Kentridge engages in collaborative projects with other artists. Currently, he is presenting his first opera production with Handspring Puppet Company, *Il Ritorno d'Ulisse* (1998), based on Claudio Monteverdi's *Il ritorno d'Ulisse in patria* (1641). But however different and varied the languages he uses, they all have the simplicity and immediacy of a drawing, balancing design and control with improvisation and chance.

Kentridge is of Lithuanian and German-Jewish descent. His maternal great-grandfather emigrated to South Africa just before the Boer war in the late 1800s, driven out of Eastern Europe by the Pogroms, and becoming a Hebrew teacher in Cape Town. His paternal great-grandfather, Woolf Kantorowitz, who was a 'chazan' (a chanter) and a 'shochot' (a ritual slaughterer), also travelled to South Africa at the turn of the century, changing his name to Kentridge. His maternal grandmother, Irene Newmark, who became Irene Geffen by marriage, was the first woman barrister in South Africa. Kentridge's father, Sydney, is among the most renowned lawyers in the country, particularly engaged in defending victims of abuse during apartheid and involved in key political cases of the 1960s, 70s and 80s, including the inquest into Steve Biko's death in 1977, the Treason trials and the Mandela trials. Kentridge's mother, also an advocate, has been influential in the birth of the Legal Resources Centre. This organisation, which survives on grants and donations, provides legal assistance for people with no money to pay for it.

« My grandfather, Morris Kentridge, became a lawyer and a parliamentarian for the Labour Party. He was imprisoned as a socialist in the 1920s. He stayed a parliamentarian for Troyville, a suburb of Johannesburg, until the 1950s when he died. His wife, May Shaffner, my father's mother, was the daughter of a locksmith. Morris is interesting because in some ways he becomes a model for Soho Eckstein. There is an early linocut, which I made in the 1970s, based on a family photograph on the beach, where Morris Kentridge is sitting in a deck chair in his pin-striped suit. And of course, that only makes Soho a displaced self portrait: there is a strong male family resemblance down the generations. There is even one moment in *Johannesburg, 2nd Greatest City after Paris* where he looks like my maternal grandfather.

My father was involved in a number of key political cases of the 1960s, 70s and 80s. I had a different childhood from the average white South African one. I went through school knowing that outrageous things were happening in an abnormal society. For many of my colleagues in school, there was no apparent sense of their being in anything other than a natural world. I was more aware, and in certain ways, more knowledgeable. So, in many senses, law was the obvious field for me to have gone into, and is what I would have been best at. Public speaking, thinking on my feet, were natural and easy skills. Being an artist was a very unnatural and hard thing for me to do. »

2.
Statement in *William Kentridge: Drawings for Projection. Four Animated Films*, Goodman Gallery, Johannesburg, 1992 and in French in *Revue Noire*, no.11, Paris, December 1993 - January 1994, p.23

3.
From interview published in: G. Davis, A. Fuchs, *Theatre and Change in South Africa*, Harwood Academic Publishers, Amsterdam, 1996

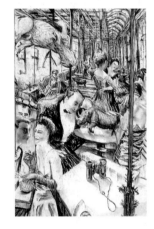

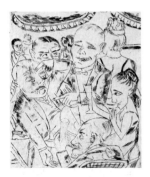

*The Conservationists' Ball II (Game Watching)* 1985, charcoal, pastel and gouache on paper, (second panel triptych), 120 x 200 cm

Max Beckmann, *Caffé* 1921, drypoint etching, 337 x 256 mm

A student of Politics and African Studies in the 1970s, Kentridge took part early on in drama workshops and art classes, which he had begun even as a teenager at the Johannesburg Art Foundation under Bill Ainslie. Established in 1972, during apartheid, the JAF was founded on non-racial principles, offering art training and opportunities to different groups, with bursary funding for students unable to support their studies.

« I have never been able to escape Johannesburg. The four houses I have lived in, my school, studio, have all been within three kilometres of each other. And in the end, all my work is rooted in this rather desperate provincial city. I have never tried to make illustrations of apartheid, but the drawings and the films are certainly spawned by, and feed off, the brutalised society left in its wake. I am interested in a political art, that is to say an art of ambiguity, contradiction, uncompleted gestures and uncertain endings. An art (and a politics) in which optimism is kept in check and nihilism at bay... »[2]

For several years, Kentridge taught etching at JAF, and although he made a number of early paintings, it was on the 'poorer' medium of drawing and printmaking that he soon focused his attention. His first exhibition in 1979 included a number of monoprints and some drawings. These dark grey, claustrophobic works show figures in pits being watched from above by faceless individuals, a vision of people living in a closed society from which there is no escape. By association, one thinks of the walled gardens and barbed-wire-fenced homes of Johannesburg's residential areas. These works prefigure later images of enclosure, such as the curtains around the hospital bed in *History of the Main Complaint* (1996) or the anatomy theatre setting of the recent *Il Ritorno d'Ulisse* (1998).

« When I started art school, I used to do oil paintings, and I still make 'Sunday paintings'. But oil painting is always, in some sense, trying to get an effect, something that looks like a nice picture. Drawing is a very different process. The speed of putting the marks down, the fact that they are dry yet changeable, and that you can alter them as quickly as you can think (you don't have to wait for the paint to dry and then scrape it off), gives the work a kind of immediacy. Also, I'm insecure about colour: I don't trust my taste. Charcoal has a range of grey scales, and there are moments of colour that can come through, but the work is not constructed around colour; it is constructed around line and tone. The drawings don't start with 'a beautiful mark'. It has to be a mark of something out there in the world. It doesn't have to be an accurate drawing, but it has to stand for an observation, not something that is abstract like an emotion. I never say, 'I have to make a sad drawing'. »

Experiencing feelings of inadequacy as a visual artist, however, Kentridge stopped making static works and developed his interest in film and theatre – with which he had already been actively involved since the mid-1970s as a member of the Junction Avenue Theatre Company, Johannesburg. In 1981-82, he went to Paris with his wife Anne Stanwix, an Australian medical doctor, where he studied mime and theatre at the Ecole Jacques Lecoq.

« After I had come back from theatre school in Paris, and had decided I wasn't going to be an actor, and I wasn't going to work as a painter, and I had to restrict myself to one craft, I thought I would be a film-maker. So I spent several years as an art-director of other people's films, learning the craft. One of the things that I learnt was the way the space in which people moved – film space – was so completely arbitrary and changeable. One's normal, Renaissance sense of perspective – how rooms are created – was completely interchangeable once you started working with flats for walls, which you could shift or change. So the drawings that emerged from the film work had to do with the freedom that came from being able to play with space. »[3]

It was not until 1984 that Kentridge returned to drawing, having learnt that the artificiality of space and lighting used in film could be applied to drawing. He engaged in a series of very large works on paper, sometimes narratively grouped in triptychs, which would later develop into the well-known animated films that he calls *Drawings for Projection*. These sketchy drawings present charged, haunted settings, rarely the open, barren landscapes of his later works. By entirely filling the space of the paper with different scenes, Kentridge presents multiple points of view, close to the Expressionist and post-Cubist structure of Max Beckmann's satires. Multi-layered and dynamic, they combine deep, abysmal spaces with compressed perspectives. They are inhabited by women in pearls and men in evening dress – recalling a decadent Weimar-style bourgeoisie and a carefree café society. Surrealist, allegorical images of animals and objects combine with the detritus of a recklessly urbanised wilderness. A sense of irony lies within the layers of these dramatic drawings. Works like the silkscreen triptych *Art in a State of Grace, Art in a State of Hope, Art in a State of Siege* (1988) frequently make reference to early, utopian vanguards such as Russian Futurism and Constructivism. By alluding to these socially engaged art movements in works that evoke to a far off, distant past, Kentridge presents a paradoxical approach to modernism, implying a nostalgia for these utopias, while suggesting that they are gone for good, that they have failed.

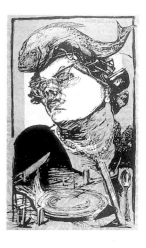

*Art in a State of Grace* 1988, silkscreen, 160 x 100 cm

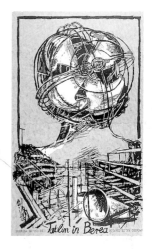

*Art in a State of Hope* 1988, silkscreen, 160 x 100 cm

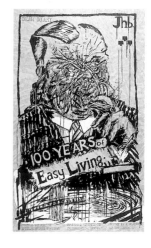

*Art in a State of Siege* 1988, silkscreen, 160 x 100 cm

4.
Interview with Amanda
Jephson and Nicholas
Vergunst, *ADA*, no.4,
Cape Town, December
1987 - January 1988, pp.6-7

WK: The artists working in Weimar were working in a state of siege. In other words, the subject matter was about the possibility of failure, of attempts to transform the world, and the project is similar to mine. Iconographically, there are many images in my work that refer to men in dinner suits. In most cases, they have been either copies from photographs, or derive from people I saw one evening at the State Opera House in Pretoria. But there is also, obviously, a danger of being lost in a wonderful nostalgia for that era. What can one say about it? It was the last (with the exception of the Mexican muralist painters), great flowering of political art.
*What about ideology? How does that interact with culture and politics? You speak a lot about culture and you speak about politics…*
WK:… But not about ideology. I think this is so, because 'ideology' is a word that is used to make a broad summary of the cultural activities and productions of a period. I was specifically interested, not in the simplification of that, but in expanding, elucidating its contradictions and complexities…
*How do you feel about being part of South African society?*
WK: It's a mixture between feeling absolutely directly involved and com-

mitted, and the next minute feeling that it's all too hard and I must leave; and then thinking, you know, this is 'home'; and the next moment thinking of a villa in Italy. I would like to make those sort of quick internal changes coherent in my work. I do believe they are fundamental structures of the way everybody operates and works. In other words, it's not a question of free-association or stream-of-consciousness but, as an image of incoherence, it represents coherent life activity.[4]

The triptych, *Dreams of Europe* (1984-5), is closely linked to the recent *Il Ritorno d'Ulisse* (1998) and stems from Hogarth's *The Rewards of Cruelty*. It represents a naked body lying on a round table, being martyred by men in evening coats, smoking cigars. Indifferent to the humanity of their victim, they are intent on their quest for modern knowledge through anatomical study of the body, which becomes a pornographic spectacle.

« I only recently learnt that triptychs were originally a religious form, used as altarpieces. Beckmann, and particularly, Bacon were the first artists whom I noticed employing the form. There are two different ways in which my triptychs refer to panoramic, patchwork photography. Firstly, you have a series of images of the same place, but each is different because that space is occupied by a different centrepiece each time. Time has passed between each image, objects have been rearranged and even the viewpoint has changed slightly. Secondly, and far more importantly, is the dislocation of space. Again, the impulse derives from successive images of the same place on a roll of film. The viewpoint is slightly changed and the perspective altered. Making a patchwork out of several photographs, the overlaps and dislocations

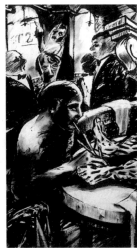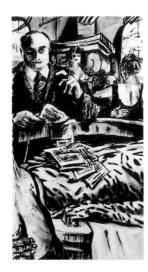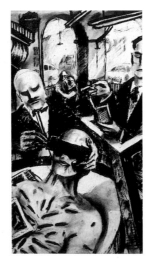

are the exciting moments. You set up continuity between images and then refuse to let it happen.

Working with drawings in series also has to do with storytelling and with cooking and eating. The panels are the separate courses. If all the elements were together it would be too rich and not necessarily delicious either: asparagus and chocolate mousse in a porridge, rather than two very distinct moments in a meal (…) There is no necessary continuity between the images. There is no allegorical, one-to-one meaning in the symbols that enables them to read like a book. But neither is it arbitrary or 'anything goes'. The story of the panels has to be told, finally, by the viewer. But not all are equal: there are good storytellers and bad, and like the topological transformations, there is, as likely as not, no solution. It is about the impossibility of factuality. Facts are not enough. The dancers in the *Conservationist's Ball* are not on their own: whenever they dance there are always the police hyenas on roller skates outside and the flagellation in the inner chamber. Facts are not simple. They bring a whole train of mud and slime with them, or like a comet, a train of frozen ice ahead of them. Facts are not fixed. The single viewpoint of the head-on image is on shaky epistemological ground – the deceitfulness of the view camera is a whole new area to investigate. The contradictions and dislocations are the interesting things, rather than the consistencies. It is not the strength of passion but its briefness that interests me. »[5]

In an attempt to create drawings that would 'breathe', and after a number of earlier experiments in film and animation, in 1989 Kentridge began to create his series of short animated films, *Drawings for Projection: Johannesburg, 2nd Greatest City after Paris* (1989), *Monument* (1990), *Mine* (1991), *Sobriety, Obesity & Growing Old* (1991), *Felix in Exile* (1994), *History of the Main Complaint* (1996) and *WEIGHING… and WANTING* (1998). Chronicling the rise and fall of Soho Eckstein and his alter ego Felix Teitlebaum, these films present the ills of avidity and power and the struggle for emancipation. Narrative emerges through a sequence of related scenes and recurring 'personae' reflecting different perspectives on the world and various parts of the artist's own self. The magnate Soho Eckstein in his pin-striped suit buys land, builds mines and develops his 'empire', which finally crumbles. The sensual dreamer Felix Teitlebaum, always naked, falls in love with Eckstein's wife and enters into a battle between good and evil with Eckstein against the background of the pain and suffering of exploited miners and land. The most recent films, *History of the Main Complaint* (1996) and *WEIGHING…and WANTING* (1998), portray more intimate, psychological and personal scenarios about consciousness and how to deal with memory and guilt in a post-apartheid era.

Kentridge's sketchy drawing in many of the films, his chalk-line marks on black in *Ubu Tells the Truth* (1997), along with his 'poor man's' animation technique, in which the film progresses jerkily through stop-shoot techniques, recall utopian animation films of the 1960s. These anti-Disney experiments were a return to rudimentary techniques, made in an age in which animation was no longer a popular film form among adults, as it had been from the 1920s through to the 1950s. In the hands of these avant-garde artists, addressing adults and resisting the commodification of animation, this was a radical approach. When these techniques were appropriated by ads and music videos in the following decades, however, this potential was lost. But far from the 'centre', not hampered by the presence of these commercialised forms,

5.
'Triptychs', unpublished note, 1985

*Dreams of Europe I, II, III*
1984-1985, charcoal on paper, 100 x 73 cm each

Kentridge was able to reinvest these techniques with new possibilities. While most animation is made as a succession of static images, drawn on transparent celluloid and placed on a fixed background, Kentridge's characters and backgrounds are integrated on the same sheet of paper. His bodies are not superimposed onto a setting, they are part of the landscape itself.

The fantastical world of animated film allows a sort of suspension of disbelief in viewing the work. It is a form that can easily shorten or extend time by the acceleration or slowing down of actions, and Kentridge uses this in different ways. A procession of workers, for example, fills the landscape in an impossibly short time, whilst the blinking of a character's eyes may endure for several moments. Animation allows Kentridge to explore the transformation of things: a phone turning into a cat, water filling a room, buildings crumbling. On the other hand, because it is harder to move around an object than in live-action film, Kentridge usually presents scenes frontally. More often than not, the camera is fixed to a certain spot, and only occasionally will he move it nearer to the drawing to get a close-up view, or to follow the movement of a detail like the mine shaft in *Mine*. Paradoxically, when Kentridge emulates the conventions of film he does so in the drawings themselves rather than in the way in which he films them (he will draw a 'close-up' or a 'long-shot' of a scene in preference to moving the camera). In *Sobriety, Obesity & Growing Old*, he draws a view of a building as if it were framed and filmed from below, looking upwards, a technique typical of Expressionist film.

The drawings are also influenced by the techniques of film montage. Sequences are selected and combined, cut and edited so that relationships are made by the viewer, and narrative is suggested by juxtaposing a rapid succession of sequences. Especially in the more recent films, the discourse does not necessarily flow according to chronological time. Sometimes, editing is fluid, at others, jump-cuts occur. Often, as when Kentridge alternates between Felix and Soho in the early films, or between perception and memory, reality and dream in the later ones, he shifts repeatedly between parallel scenes.

Animated drawings are also used as backdrops in the theatre productions that Kentridge has made in collaboration with the Handspring Puppet Company. The first of these, *Woyzeck on the Highveld* (1992), is a multi-media version of Georg Büchner's 19th-century play *Woyzeck*. Transposing this story of a soldier who kills the woman he loves in a fit of jealous rage to the South African context, it explores the economic, social and personal pressures that push people to extreme acts of violence. The Handspring Puppet Company, directed by Basil Jones and Adrian Kohler, the creator of the carved puppets, was initially founded in 1981 as a puppet theatre for children. In 1989 they experimented with life-size puppets and created, in collaboration with the Junction Avenue Theatre Company, an apocalyptic vision of South Africa entitled *Tooth and Nail*, directed by Malcolm Purkey.

Together with Kentridge, as director and creator of animation, Handspring have made a series of unique performances including *Faustus in Africa!* (1995) and *Ubu and the Truth Commission* (1997). These combine on-stage actors/puppeteers, roughly-carved, raw wood puppets or shadow puppets in ink on acetate, with projected film animation, which acts both as the scenery and as a visualisation of the thoughts of the various characters. The productions are characterised by the interrelationship and complex layering of different types of representation and narration: projected images, actors and puppets are all on stage at once and the audience is constantly shifting its attention between them. In this complex experience of different personae, the subject is not univocal or clear, but multiple, shifting. The puppets act like masks worn by the actors, and we project onto them, perceiving them as real, until, suddenly aware of the puppet handler, we snap back into an acknowledgement of the fiction. Sources for these hybrid productions are to be found in the history of English puppet theatre; in Japanese Bunraku; in the precolonial tradition of African puppet theatre, which joins oral story-telling with music, dance

and sculpture; and even in education (puppets are used by the Venda as teaching tools).

Even after having broadened his practice into film, installation and theatre, Kentridge continues to conceive works as extended drawings – a pragmatic and practical form for unselfconsciously jotting down one's ideas and experiences. Drawings can mutate and fluctuate; they can change by erasure and addition. They are an ideal medium for acting and reacting, moving back and forth between the making of spontaneous marks on the paper, and thought. They are also simple to transport, do not cost much to make, and, like prints, are easier to disseminate and communicate than oil paintings, sculpture or installation. Drawing is therefore an ideal medium for an artist working on the periphery of the art world.

As Okwui Enwezor states, '[The] tug of war between what is popular and widely available and what is unique and limited in distribution, has elicited varied responses from artists over the centuries. The woodcut and the printing press, followed by etching, lithography, photography, film and digital imagery, are all techniques of mass reproduction and dissemination that artists – particularly African artists – though still committed to the traditions of the unique, original work of art, have found to be an important means of reaching a wider public'.[6] Printmaking, which came to the fore in South Africa in the 1970s,[7] has had a steady history there since the 1950s when the artist Katrine Harries taught it in Cape Town, promoting black-and-white etching and lithography in the making of books or portfolios. Artists such as John Muafangejo made linocuts that bridged socio-political commentary and religious story-telling in serial, narrative prints.

Kentridge has consistently studied drawings and prints by past artists. These include Goya's *Disasters of War* and Hogarth's satires, to which he dedicated the portfolio of eight etchings *Industry and Idleness,* shown in 1987 as part of a collaborative project 'Three Hogarth Satires', with artists Deborah Bell and Robert Hodgins.

Kentridge has worked with Bell and Hodgins on several occasions since then: on the etching project *Little Morals* (1991); the computer animation and print project *Easing the Passing (of the Hours)* (1992-93), inspired by a phrase from Jorge Luis Borges; on the film with actors and drawings *Memo* (1993-94); and, under the initial impulse of Hodgins, on a series of etchings inspired by Alfred Jarry's play *Ubu Roi* (1888) entitled *Ubu Tells the Truth,* made in 1996.

Jarry's satire about an insane despot, grotesquely abusing his arbitrary power has provided a metaphor for several South African artists working in the wake of apartheid. Kentridge's etchings, which layer Jarry's drawings of Ubu with his own contrasting studies of a naked man, suggest both that a number of disjunctive selves can coexist within the same person and imply that there is an Ubu inside us all. The Truth and Reconciliation Commission, which was set up in 1996, is a series of on-going hearings at which public testimony of atrocities committed during apartheid is given by victims or witnesses seeking redress, as well as by perpetrators of abuses who confess their deeds in exchange for amnesty. Publicly screened on television in South Africa, the hearings are intended to contribute to a healing process and create a context for national reconciliation. By combining the Ubu theme with the meaning and implications of the TRC, Kentridge would develop in 1997 some of his most intense work around this theme: the film and video collage also called *Ubu Tells the Truth,* and the theatre production *Ubu and the Truth Commission*, a collaboration with

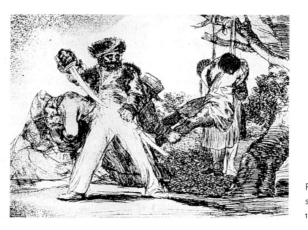

Francisco de Goya, etching from series *Los desastres de la guerra* 1810 - 1820 (first published 1863)

6.
Okwui Enwezor, 'Neglected Artform or Poor Relation? The Importance of Printmaking in Africa' in Kendell Geers, ed, *Contemporary South African Art. The Gencor Collection*, Jonathan Ball Publishers, Johannesburg, 1997, pp.70-71

7.
For an overview of printmaking in South Africa, see Philippa Hobbs & Elizabeth Rankin, *Printmaking in a Transforming South Africa*, David Philip, Cape Town and Johannesburg, 1997

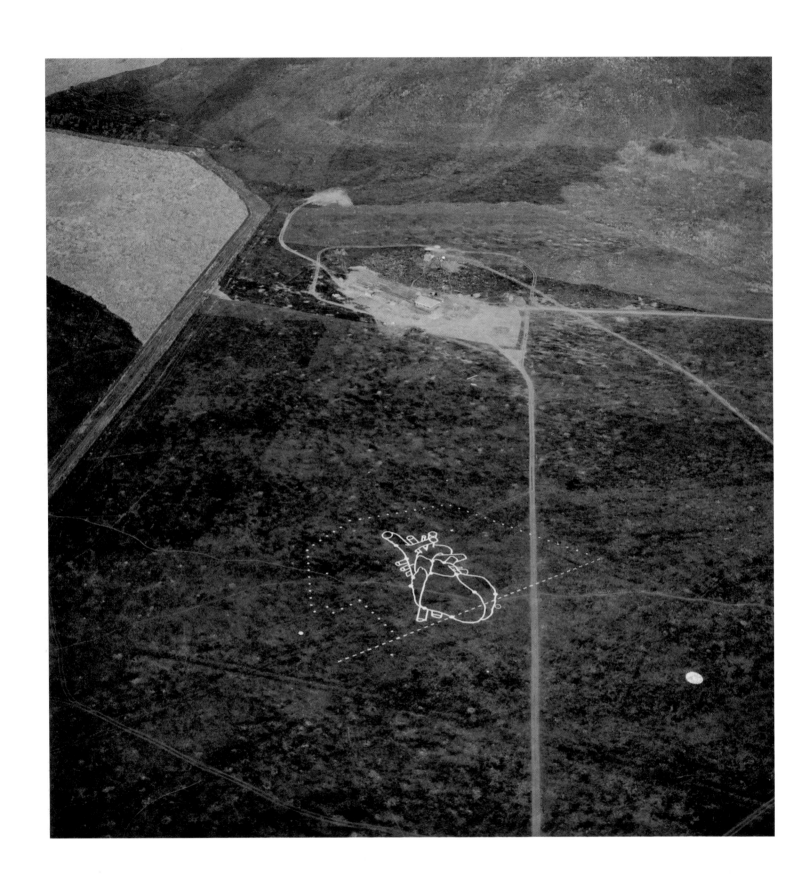

Views of *Memory and Geography*,
multi-media project made in collaboration with Doris Bloom, Rome 1995

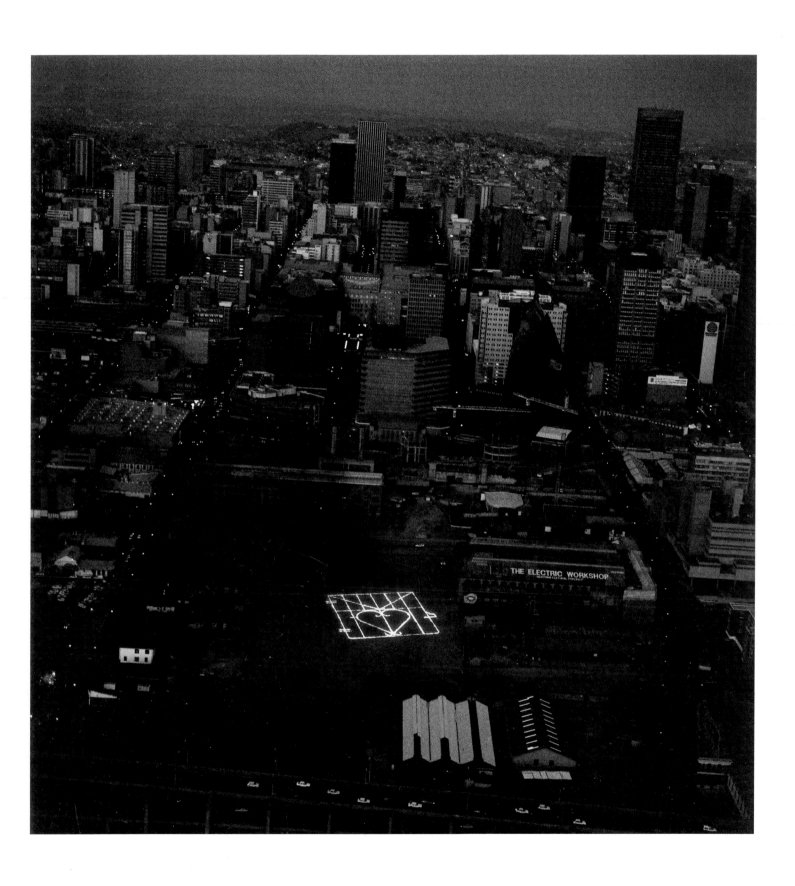

8.
Okwui Enwezor, 'Reframing the Black Subject', *Third Text*, no.40, London, Autumn 1997, p.25

Computer mouse drawings, sketches for *Memory and Geography*, multi-media project made in collaboration with Doris Bloom, Rome 1995

Handspring Puppet Company of Johannesburg and South African writer Jane Taylor.

Kentridge does not fetishise authorship, nor glorify notions of formal and stylistic quality in art. He finds collaboration with other artists rewarding precisely because he values content and dialogue over predefined form, ethics over 'the artist's touch'. His way of working with others recalls a musician's jam session, or community-oriented political and oppositional art, or the workshop theatre that emerges in contexts of social conflict through groups such as Junction Avenue Theatre Company. Collaboration provides a way of going beyond the 'aura' of the unique artwork without recourse to the censoring of manual art practice – the attempt to eliminate all form of subjective presence carried out by many recent artists in response to the authoritarian and reactionary nature of neo-Expressionist art. Another way to achieve this objective is to conceive the drawing as a sketch for something else, such as an animated film (an 'applied' drawing, as Kentridge himself has called his works, alluding to 'applied' versus 'pure' science). Focus shifts away from the drawing itself towards the advancement of the film, and preciousness of authorship is kept in check.

*Memory and Geography* (1995) was a collaboration with the Danish artist Doris Bloom. Conceived as a series of different works, it included an enormous, white-chalk, diagrammatic line drawing of a heart in the barren landscape, to be imagined as if seen from above. This recalled the ancient rock drawings of South Africa, the country's earliest known artistic productions, images engraved and painted on stone surfaces some 30,000 years ago. Kentridge and Bloom did not modify the landscape like many Land artists of the 1960s. They used it as a sheet of drawing paper onto which the white design of the heart functions like a gigantic emblem, a constellation projected from the sky onto the ground. By overlaying this anatomical drawing on the landscape, a metaphor is set up between the land and the body, a theme that recurs again and again in Kentridge's animations. As part of the same project, the artists drew a gigantic utopian gate on

the ground in front of the power plant in Newtown Johannesburg, which was then set alight.

Kentridge's naturally sceptical outlook questions the optimism that harbours the ideal of a 'Rainbow Nation' capable of harmoniously joining many diversities in a new, post-nationalist country. His most recent film, WEIGHING...and WANTING (1998), far from presenting a hopeful picture of the current situation, thematises insecurity, the precarious and fragile nature of all forms of psychic, domestic or social harmony, as well as the endemic nature of conflict. In Okwui Enwezor's words: 'African subjectivity and white interests seem to intersect in the contest for the meaning of identity in post-apartheid South Africa. It appears that the struggle for this meaning hinges on who controls the representational intentionality of the body politic, especially its archive of images: symbolic and literal.'[8] In this context, Kentridge seems to adopt the only viable position: a retreat from the contest over which images should represent the new, decolonised South Africa, focusing instead on the intimate mechanisms of individual anamnesis, remembering one's past illnesses, one's indirect responsibility for the brutal conditions of apartheid, in a process of personal healing that must precede and may lead by extension to broader changes in society.

The official, colonial, 'white history' of modern art in South Africa begins in 1871 with the exhibitions in Cape Town organised by the South African Fine Arts Association. This group of artists was a conservative, academic off-shoot of waning European traditions, far from the new trends, such as Impressionism, that had emerged in Europe. Ironically, while European artists were looking at African art as a source material through which to develop an art of essences, to break with the tradition of European Realism, white South African artists were dismissing the cultural traditions of Africa as 'primitive' curiosities. The earliest colonial painters were illustrators, catering to European audiences with scenic paintings of a distant and exotic place. These images, along with prints from the colonial period commonly found in Europe in the 19th century, form the basis of Kentridge's *Colonial Landscapes* (1995-96). In these charcoal drawings on paper of a lush and bountiful imaginary African landscape, red pastel surveyors' marks indicate how such landscapes were more projections of, and onto, the land than accurate depictions.

« These drawings came from the work I had been doing on *Faustus in Africa!* The source was a 19th-century volume of the diaries of 'African explorers', illustrated with engravings of the exotic other the travellers were passing through. Part of the pleasure of doing the drawings was working with the 'code' of engraved marks, and playing with the mediations from the raw veld, to the sketchbook of the traveller, back to London to the professional engraving shop where the view would be re-dramatised, and engraved, to a hundred years on, looking at these now yellowing pages. The new red marks are both beacons erected in the landscape and the surveyor's theodolite markings of the image in a viewfinder. »[9]

« There is a sense of drawing a social or historical landscape. The process of actually making the drawing finds that history because the landscape itself hides it. »

9.
Statement on *Colonial Landscapes*, 1996, published in leaflets for Annandale Gallery, Sydney, 1996 and Goodman Gallery, Johannesburg, 1997

*The Murchison Fall* and *Arrival at the Stoppage*, loose pages from 19th-century traveller's book, collection of the artist

*Colonial Landscapes* 1995-1996,
charcoal and pastel on paper, 120 x 160 cm each

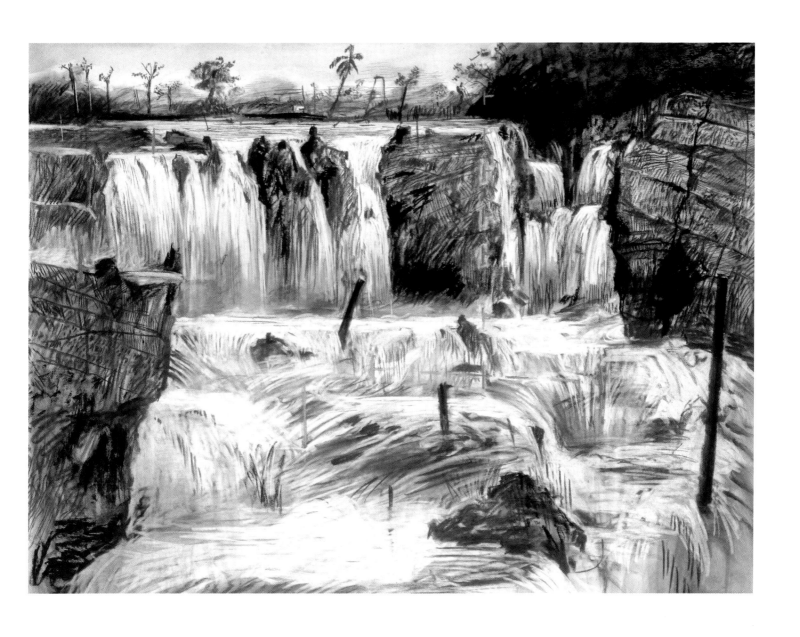

10.
Esmé Berman, *Painting in South Africa*, Southern Book Publishers, South Africa, 1993, p.xix

11.
Jane Taylor, *Colours: Kunst Aus Sudafrika*, Haus der Kulturen der Welt, Berlin, 1996, (catalogue) n.p. (English translation from original author's ms)

In the 19th and early 20th centuries, artists such as Jan Ernst Abraham Volschenk (1853-1936) celebrated a green countryside of pastures and glens. They depicted broad, open spaces in the tradition of Romanticism and European landscape painting, showing little or no interest in depicting the human condition or the history of colonisation embedded within the landscape. This reflects the colonial vision of white South Africans prior to urbanisation, 'accustomed to space and elbow-room... traditional votaries of the freedom of the great sunlit outdoors'.[10] The landscapes that appear in Kentridge's works question these earlier depictions, exposing the fallacy of a romantic ideal of pure, unadulterated 'nature' in an area of Africa where the terrain has been ecologically disrupted and abused by the growth of mining plants. He counters these Arcadian views with the reality of a barren landscape ridden with mining and civil engineering detritus, elements that represent the fact of human passage and are historical traces of the history of South Africa. The landscape appears like a 'drawn' scene or an imperfectly erased 'text' to be recovered and 'read' through. Furthermore, he contradicts the ideal of the empty landscape, by populating his barren wastelands of abandoned machinery and billboards with processions of labourers, thereby rendering 'visible' the erased and segregated population.

The land is also used as a metaphor for the body and vice versa. In *WEIGHING,...and WANTING* for example, physical abuse is associated with the disruption of the landscape when the charcoal marks indicating lacerations on the back of a naked woman are transformed into parts of a civil engineering structure sited in a mining area. 'Bodies, in South Africa, are marked spatially: the dream of the apartheid map was to fix racial identities within designated geographic spaces: "Separate Development"... Ultimately, much of the ideological work of apartheid was to misrepresent the movement of persons back and forth, and to create the phantom that "peoples" had been fixed into given places, that somehow they belonged there for reasons of ethnic affiliation.'[11]

During the 20th century, African artists have operated in various directions, developing sources as varied as Abstract Expressionism, lyrical abstraction, academic landscape painting, Surrealism, or working with popular sign painting, neo-Primitivism and Social Realism. Kentridge's Expressionism, however, seems to be peculiar to South Africa. Contemporary artists there who make direct references to it are developing a tradition that began with the work of Maggie Laubser and Irma Stern in the 1930s and 40s. Stern studied in Germany in the pre-war era, bringing back the legacy of Expressionism in an art of visual images distorted by subjective feelings, which she combined with a knowledge of Munch and African tribal sculpture. Similarly, Wolf Kibel (1903-1938), an Eastern European painter who emigrated to South Africa, brought information about Soutine and Chagall, and developed a raw style of sketchy, unsure contours. Kentridge would develop these Expressionist sources but never conceded to the sensuous delight in colour of the earlier white South African painters, preferring the dark tones of charcoal.

Kentridge's grounding of his work in narrative, which essentially began with his first animated film about Soho Eckstein/Felix Teitlebaum in 1989, also draws on sources from black African, and particularly, South African, art. There may well be an indirect relationship between this approach and the tradition of oral story-telling in Africa, or the poetic narration of legends and

Mine-dump near Germiston, photo William Kentridge

South Africa Landscape

Gerald Sekoto, *Street Scene*, 1947-1950, oil on canvas, 46 x 54 cm, Pretoria Art Museum

Dumile, *Fear* 1966, charcoal on paper, 134.5 x 79 cm, Pretoria Art Museum

histories by the griot. The oil and gouache scenes of Gerald Sekoto (1913-1993) show dusty streets, backyards, ramshackle houses and people engaged in the various activities of daily life in Sophiatown (a settlement on the outskirts of Johannesburg, bulldozed in 1955 in accordance with apartheid directives, its inhabitants dispersed into different ethnic communities of the Soweto conglomerate). These unpretentious images, with their simple, almost cartoon-like depictions of urban slum dwellers, their celebration of the life of the disadvantaged, find echoes in Kentridge's drawings. Sekoto left for Paris in 1947 and spent the rest of his life in exile. His work was generally reappraised in South Africa in the late 1980s.

During the 1960s, a black urban art centring on scenes of township life emerged. Initially growing out of the Polly Street Art Centre under the impulse of Cecil Skotnes, it became known as Township Art. In part, this work was connected with the emergence of independence movements and the global breakdown of colonial power. More importantly, however, it reflected the demands of the South African art market, which would accept nothing but these township scenes (mainly watercolours, drawings and prints) from black artists. However, the art of Dumile (Mslaba Zwelidumile Fene, 1942-1991) stands apart. At a time when European and American artists were involved in Pop Art, Minimalism, Land Art, post-Minimalism and Conceptual Art, he was expanding the Expressionist and Realist tradition. He created ink, crayon and charcoal works on p̶a̶p̶e̶r̶ ̶ ̶ ̶ the framework of the ̶ ̶ ̶ ̶ movement as it develop̶ ̶ ̶ ̶ ̶ships between writers, ̶ ̶ ̶ ̶ Steve Biko and artists in ̶ ̶ ̶ ̶ uth Africa. He finally em ̶ ̶ ̶ 58.

« As a teenager I went to Bill Ainslie's studio for art lessons two evenings a week. He was a very important figure in the Johannesburg art world of the 1960s and 1970s as a teacher. He gave considerable support to black artists who later became significant, particularly Dumile. Dumile made remarkably strong, demonic drawings, either in ballpoint pen on a small scale, or in charcoal on a large scale. That was the first time that I understood the power of figurative, large-scale charcoal drawings – that they could be so striking. I saw him working at Bill Ainslie's studio, and he had the capacity to express things on a scale that I thought drawings could not achieve. He is the key local artist who influenced me. »

Also during this period, the UN censored South Africa and in 1974 voted to suspend the country's membership. The Sharpville massacre of 1960 followed demonstrations against pass laws, leaving 69 dead and 180 wounded. This triggered repugnance for apartheid around the world. Photographs of the massacred bodies, lying bleeding on the ground, form part of the source material for *Felix in Exile* (1994), combined with art historical reference to Goya's *3rd of May 1808* (1814).

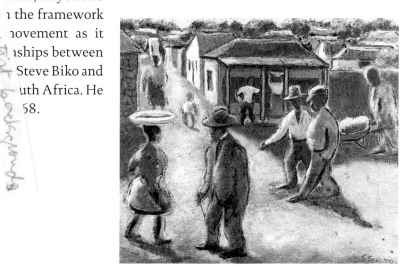

« A friend who was making a documentary on the history of Soweto told me he'd come across some extraordinary police photographs of people who'd been murdered or shot, lying in the veld. Without seeing these photographs, the idea of these images of people lying dead in the veld forced themselves on me as something that could be drawn. When I actually saw the photos themselves, they were very different from how I imagined them. There were people in corridors, people lying in small spaces. In fact, none of them were out in the veld. If I had actually seen the photographs first, I probably would not have made this connection with people lying out in the landscape. When I actually started making *Felix in Exile*, I began with these bodies lying out in the veld. And they were extraordinary photos – drawing them was an important process. The images I was shown were terrifying and impossible to look at, but the moment I started drawing them, a different process happened, in terms of what it meant to look at them. What became interesting was the way in which making drawings of the images, the activity of drawing, in a way tamed the images, made them manageable, made the events they were describing graspable. Drawing something is a way of controlling it – not in real life, but in the life of one's head. One photo came from the massacre outside Sharpville. At the time, I was six years old and my father was one of the lawyers for the families of the people who had been killed. I remember coming once into his study and seeing on his desk a large, flat, yellow Kodak box, and lifting the lid off of it – it looked like a chocolate box. Inside were images of a woman with her back blown off, someone with only half her head visible. The impact of seeing these images for the first time – when I was six years old – the shock – was extraordinary. I understood that the world was not how I had imagined it at all, that things happened in the world that were inconceivable. So I would say that although when I was drawing the bodies for *Felix in Exile* I did not have the Sharpville massacre in mind – this was only a connection I made some months or years later – I'm sure that, in a sense, it was trying to tame that horror of seeing those images. In the

Detail from Francisco de Goya, *Tres de Mayo* 1814, oil on canvas, 268 x 347 cm, Prado Museum, Madrid

Archive photos of Soweto uprising, 1976

*Casspirs Full of Love* 1989, copper drypoint, 163 x 88 cm

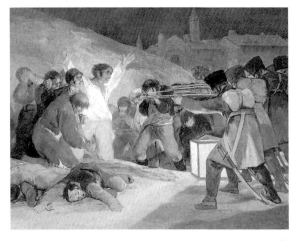
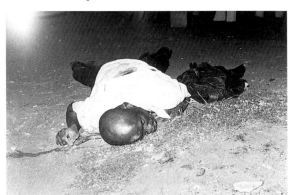

same way, when I was four or five, I had been driving in a car with my grandfather, and out of the side window I saw two men kicking a third man on the edge of the road, which was also, for me, a shocking image of violence. I mention it because that image comes into *History of the Main Complaint*. To go back to the drawings of the bodies: there's obviously the reference to Sharpville, but the actual images that I chose to draw – because I drew maybe only eight out of hundreds of photos – were very close to images I'd seen in classical and Renaissance paintings. One of them reminded me of a figure in Goya's *3rd of May 1808*, of a person lying on the ground. Another, of a person shot in 1992, I recognised today at Brera, in the Mantegna painting of the foreshortened *Dead Christ*. I realised that this was what made me choose that image. »[12]

In 1974, the leadership of BPC (Black People's Convention), the political movement in which Biko was a key figure, was tried under the Terrorism act, for fomenting student unrest. In June 1976, riots broke out in Soweto and in the townships, sparked by protest against the forced use of Afrikaans rather than English in schools. More than 700 people were killed before the end of the riots. Biko was arrested and died in jail while in the custody of the security police the following year.

The progressive international isolation of South African artists in the 1970s, due to the political boycott of their country, meant that they could not exhibit in international exhibitions such as the Venice Biennale. Some responded with a sense of common purpose and engagement. Dumile's portrayal of poverty, brutality and fear in the townships, had preceded by ten to fifteen years an Expressionist style that was to characterise a branch of South African Resistance Art. This term was coined following the Soweto uprising to refer to art politically engaged in the fight against apartheid. Artists, both white and black, including Kentridge and Cyprian ShilaKoé, adopted this style in their vivid denunciations of apartheid society.

The 1980s were characterised by violence and a state of near war with vigilante squads and Casspirs (riot-control vehicles to which Kentridge has dedicated a series of ironic works called *Casspirs Full of Love*). Rubber bullets, water cannons and sharp ammunition were fired against demonstrators. The first State of Emergency was declared in 1985. Young people in the townships created open-air assemblages or 'peace parks', naming them after leaders such as Nelson Mandela. These were destroyed by police forces.

A number of South African artists went into voluntary exile. Some of those who stayed developed forms of Protest art, and there was a tendency towards co-operative community expression and collaborative projects across art forms. A key venue for these events was The Market Theatre complex in Johannesburg, with its annex, The Market Gallery, which had opened

12.
Lecture, Triennale, Milan, 19 November 1997, published in *Facts and Fiction*, ed R. Pinto, Comune di Milano, Milan, 1998

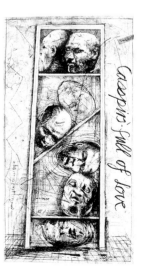

13.
Jane Taylor, *Colours: Kunst Aus Sudafrika*, Haus der Kulturen der Welt, Berlin, 1996, (catalogue) n.p. (English translation from original author's ms)

14.
Afrikaners were Dutch, German and French colonials who reached South Africa in the 1600s. Until 1759, before British sovereignty, the territory of the Cape had been governed by the Dutch East India Company of Holland, on whose initiative the first European settlers had landed. When British rule began, the Afrikaners moved into the interior of the country, where various Boer republics were established, such as the Zuid Afrikaansche Republiek in the Transvaal. Afrikaners, who were farmers, wanted to preserve the autonomy of their community from the British Empire. Diamonds were discovered in 1867, gold in the late 1800s. Wages for the Africans who mined these resources were kept to a minimum through the use of immigrant labour. Afrikaner nationalism had grown during the 19th century in the Boer Republics and was further heightened as a consequence of the Anglo-Boer War (1899-1902) and the brutal treatment of the Afrikaners by the British. The National Party came to power with the 1948 elections. Segregation, the creation of townships and separate education programmes were officially set up to encourage a multinational state in which different ethnic groups could maintain and express their own culture autonomously. Sexual relations between racial groups were banned and whites developed a form of paternalistic racism, which was proposed as positive. African migration towards industrial areas was limited by passes and separate transport. Laws were passed to classify the population into white, coloured and indigenous.

in 1976, and where Kentridge took part in both plays and exhibitions. Art shows such as 'The Neglected Tradition' (1988), curated by Steven Sack, suggested a new history of South African art by reviewing the contribution of black artists since 1930. 'Tributaries' (1985) questioned the boundaries and significance of modernist art, and included works by black rural artists such as Nelson Mukhuba, who combined traditional carving and clay modelling with material products of contemporary urban culture. The need to address issues of cultural diversity, both in exhibition-making and in postmodernist theory, came to the forefront in South Africa, as in the international art arena, by the end of the 1980s. Also at this time the Western notion of 'Fine Arts', central since the Renaissance, was extended in a review of the distinction between Fine Arts and other cultural production, which up to then had been referred to as 'craft' or 'minor arts'.

Following on from this development, in 1991 the Cape Town Triennale exhibition introduced new categories, distinct from painting, drawing and sculpture, in an attempt to include craft-based forms such as beadwork. As a result of this, Kentridge submitted his animated film *Sobriety, Obesity & Growing Old*, which subsequently won an award.

« I had submitted my film to test their boundaries. If beadwork was acceptable, why not film work? A number of the submitting artists were offended by the inclusion of both beadwork and the film. »

When apartheid finally came to an end with the election to power of the ANC in 1994, it became necessary to constitute a new national, post-apartheid identity in a post-nationalist period, through processes of individual and collective memory, shifting from a notion of objective and linear 'history' to the pluralist possibilities of 'histories'. Art, it was felt, could play an important role in this healing process. The first Johannesburg Biennale, in 1995, curated by Lorna Ferguson, set out both to engage local constituencies in this process of identity-building, and to re-inscribe South African Art into the international art world. Kentridge's work could be interpreted as a construction of an allegory of nationhood that stages the process of remembering and recognising through the theme of healing, which occurs on the part of the artist through the experience of drawing itself, and, on the part of the viewer, through viewing the film. While Resistance Art in the 1980s had been mainly characterised by images of popular struggle and battles against apartheid forces, Kentridge's method of joining intimate stories of personal longing and desperation with broader social conflict has been constant throughout his career, even in his earlier drawings. This approach points to a more complex and personal way of representing and constructing subjectivity within the new national narrative: 'Images of individual loss, the textures of private grief, or memory, little places of intimate longing'.[13] Although Kentridge's work in theatre with the Handspring Puppet Company had been internationally renowned since the 1992 production of *Woyzeck on the Highveld*, presented at the Theater der Welt Festival, Munich and in Antwerp in 1993, it was the Johannesburg Biennial that created a first context for his appraisal by the international visual art community, and exhibitions followed in Europe, including the 'Istanbul Biennale' (1995), 'Jurassic Technologies Revenant: Biennale of Sydney' (1996), 'Campo 6, The Spiral Village' (1996), 'Città Natura' (1997), the 'Havana Biennial' (1997) and 'documenta X' (1997).

Kentridge's technique of erasure echoes one of the strategies of racism in the Modern Age. Modernity is a two-sided coin: on the one hand, it values progress, reason and the universal values of the Enlightenment, such as democracy. On the other, it values individual (the person) and collective subjectivity (the nation). When State and Nation coincide, racism develops either on the basis of rendering the group it discriminates against inferior and 'invisible' (erased) by allocating to it the menial tasks in society (oppression), or on the basis of segregation and differentiation of a group because its cultural characteristics are perceived as dangers to the purity and integrity of the dominating group's culture (separation).

As far back as one wants to go in history, human communities have always been aggressed by others, kept at a distance or considered inferior. However, certain specific characteristics of modern racism have emanated from the body of ideas and the social and economic structures of modernity. Racist ideology is dominated by the scientific pretence of objective truth, based on the research and writings of explorers, philosophers, anatomists, physiologists, doctors, phrenologists and anthropologists, especially since the 18th century. But discrimination and violence are also modern in the sense that they are the fruits of the great changes made during the Renaissance with 'discoveries', migrations, openings of market economies, urbanisation and industrialisation of western civilisation. Through colonialism, modernity tended towards integrating peoples into its project, therefore erasing them by dissolving them into Westernised culture.

Apartheid in South Africa combined oppressive discrimination through exploitation with differentiation and separation.[14] In the post-World War II period, South African apartheid became the emblem of the continuation of racism after the Holocaust, and its intimate relationship with capitalist structures of power.

« I envy people who can get on with their work without having to bring the history of the world along with them. At some remote level it is a precondition that dogs my work. »[15]

'At a time when 9,000 Jews were being exterminated each day', wrote George Steiner in 1965, 'neither the RAF nor the US Air Force bombed the ovens or sought to blow up the camps (…) I wonder what would have happened if Hitler had played the game after Munich, if he had simply said, "I will make no move out of the Reich so long as I am allowed a free hand inside my borders". Dachau, Buchenwald and Theresienstadt would have operated in the middle of the 20th-century European civilisation until the last Jew in reach had been made soap (…) Society might, on occasion, have boycotted German wines. But no foreign power would have taken action. Tourists would have crowded the Autobahn and spas of the Reich, passing near, but not too near, the death camps as we now pass Portuguese jails or Greek prison islands (…) Men are accomplices to that which leaves them indifferent.'[16]

Kentridge's art stresses the importance of remembering and takes a stance against the risk of lapsing into amnesia and disavowal of historical memory, as well as of psychic removal, characteristic of society after traumatic events. Guilt, complicity and indirect responsibility are key themes in his art. In connection with this he portrays the intolerable position of being a survivor and a witness. In *Sobriety, Obesity & Growing Old* Felix is a witness of protest marches; in *Felix in Exile* he watches abuses and the shooting of Nandi from his hotel room. And in *History of the Main Complaint* (1996) Soho/Felix observes violent brutality through the window of his car.

15.
From lecture, 1990

16.
George Steiner, 'A kind of Survivor – For Elie Wiesel', in *Language and Silence*, Faber & Faber, London, 1979, reproduced in *After Auschwitz*, ed M. Bohm-Duchen, Northern Centre for Contemporary Art, Sunderland, Lund Humphries Publishers Limited, London, 1995, p.13

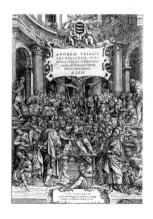

Frontispiece for Andreas Vesalius, *De humani corporis fabrica libri septem*, Giovanni Oporino, Basel, 1555. Biblioteca Angelica, Rome

In many ways, Kentridge's themes recall the pre-occupations of Holocaust survivors, just as his drawings sometimes echo those of labour camp prisoners. The hard physical toil and the notorious 'boxes' – bunk-beds stacked one above the other – depicted in *Mine* bring to mind drawings by artist prisoners in labour camps such as Henri Pieck, Auguste Favier, or Boris Taslitzky. Further associations arise through the imagery of gassing or burning: the crematorium chimney, smoke, the sombre, charcoal atmosphere. And his procession of the dispossessed suggests not individuals, but the dehumanised masses incarcerated in the camps. Yet he never adopts the extreme Expressionism of Zoran Music's skeletal corpses, hovering out of context. The Holocaust transcends its original meaning and becomes a symbol of the tragedy of modernity as a whole.

Prague, Berlin, Vienna and Paris in the 1920s were permeated with the erudite urbanity of European Jewish culture. Caught between Nazism and Stalinism, this was erased. Jews involved in the social utopia of Communism and the Russian revolution, were cast aside when Communism turned to nationalism and technocracy. Kentridge's use of erasure echoes this pitiless law of history: when beaten or shot bodies lie bleeding to death in *Felix in Exile* the landscape reabsorbs them, and little or no traces are left. When, in WEIGHING… *and* WANTING, lying in the lap of his beloved, Soho Eckstein's heart and mind become preoccupied with business, she is erased and turns into a telephone. Erasure, however, is never perfect: it leaves traces.

In 1949, Theodor Adorno stated that after Auschwitz there can be no more lyric poetry. For many reasons, Kentridge does not agree. In Europe and America, after World War II it seemed impossible to render through the mediation of language the horror of the experience, as well as ethically unjust to create an aesthetic experience out of such brutal real-life events. In the face of the nightmare of the Holocaust, witnessed directly or indirectly, through personal testimonies, documentary footage and photographs, silence and mute stupor seemed the only viable and appropriate responses. This ushered in, along with the philosophy of Existentialism, a generation of abstract artists associated with European 'art autre' or 'art informel', or American Abstract Expressionism and Action painting. The artist's gesture became synonymous with gaining a sense of absolute presence, of identification between self and world as the only tenable mode of existence. Pollock's drip paintings, Dubuffet's Art Brut, Wols' tentative and intimate marks and graffiti, or Burri's torn and sutured sacking were examples of this response to the overwhelming nature of recent historical events.

« Alas there *is* lyric poetry. Alas, because of the dulling of sensibilities we must have in order to make that writing or reading possible. But of course, also, thank goodness that such poetry can still be read. The dulling of memory is both a failure and a blessing. »

Image of South Africa

Slimes dam outside Johannesburg, photo William Kentridge

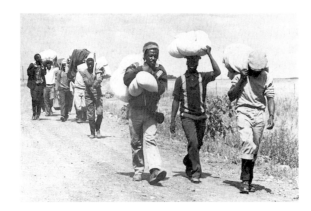

In Western art, this attitude marked the decline of figuration and Expressionism, as well as of the satirical and oppositional art of the pre-war years. Advanced artists felt that a direct representation of concentration camp scenes – barbed wire, striped camp uniforms, brutal guards, watchtowers, etc. – ran the risk of banalising the horror into stereotypical images and spectacle, into predictable and over-explicit representations. By abstracting the representation, art, it seemed, became more universal, and therefore more true. Furthermore, figurative art was identified with pre-war 'arts of power', such as Italian Novecento, or post-war Social Realism. This rejection of figurative art was founded on a notion of authenticity and identification between signifier and signified.

A notion of authenticity, already present in post-war 'informel' abstraction, continued to be central to art throughout the 1960s in Europe and America, even in Arte Povera and Land Art, which emerged in contrast to, and as a rejection of, what appeared to be the social indifference of post-war abstraction and Abstract Expressionism. And even Pop art, which questioned the notion of avant-garde 'originality', could not adopt traditional, mimetic representation. Figuration could be used only in so far as the image was already a 'sign' in and of itself, prior to the artist's appropriation of it – as with billboards, posters and magazine advertisements. In Minimalism, Land Art and Arte Povera, representation was also rejected as inauthentic: in many cases, the site itself, *hic et nunc*, determined the artwork. In other cases, raw and found organic and inorganic materials were used by artists in lieu of representation as 'attitudes become form' (as the title of a well-known exhibition in Bern in 1969 suggested), or artists like Christo 'packaged' the real.

Conceptual art emerged out of dissatisfaction with the ability of Pop and Minimalism radically to disrupt society, and posited critical thought itself as artwork. Based on the politicised cultural critique associated with the New Left and the School of Frankfurt, it rejected the isolated, auratic art object and treated critical language in

terms of its physicality, its modes of production and communication and engagement with the urban environment. However, even though much Conceptual practice was based on active political engagement, it remained the aloof product of intellectual and artistic circles, and was even co-opted by advertising and media. In some ways it failed to reach its objectives. As Jeff Wall has remarked: 'Conceptual art's feeble response to the clash of its political fantasies with the real economic conditions of the art world marks out its historical limit as critique. Its political fantasy curbs itself at the boundary of market economy'.[17]

This created a context for the questioning of the radical nature of Conceptual art by artists working on the periphery of the international art world in places where the effects of capitalism and racism on daily life were all too real. In South Africa, Kentridge perceived Conceptual art as too cryptic, over-intellectualised and removed from the reality of human suffering. In Europe, by the late 1970s, Conceptualism had reached a form of solipsistic isolation from the audience, and a sense of the collapse of its utopian avant-gardism ushered in a reactionary return to tradition and romantic forms of regressive *atelier* painting with New Painting and Neo-Expressionism in the early 1980s. Advanced and politically committed artists could not engage in this practice, which was felt to reinstate Romantic notions of authorship and heroism, beyond any sense of art's role in society. New painting was also associated with the commercialisation and institutionalisation of contemporary art during the 1980s.

It is perhaps precisely because Kentridge's art developed at a distance from Europe and these debates during the late 1970s and 1980s – far from Kiefer and Baselitz – that he was able to take a fresh look at the progressive and socially critical tradition of pre-war Expressionism and figuration. He could therefore question both the anti-iconic nature of modernist, avant-garde abstract art, as well as the Conceptual legacy of the School of Frankfurt. Yet his work is not a nostalgic and reactionary return to figuration because the

17.
Jeff Wall, 'Dan Graham's Kammerspiel', *Art Metropole*, 1991, pp.16.

romantic (and 'phallic') element is absent: humour, a sense of process, poor materials such as charcoal and paper, the provisional nature of each image keep those neo-Expressionist elements at bay.

Kentridge addresses uncertainty and process because they allow the Self to approach the world with humility and openness to change, rather than with preconceptions and authority. He is able to avoid the central, authoritarian modern gaze – the panoptikon – by splitting the Self into many different voices and identities: Soho, Felix, Nandi, Harry, etc. Like his undefined drawing style, these selves are never fixed, but constantly shifting, splitting, condensing and dividing. His questioning of authority runs parallel to his doubts about modernity as a whole. Modernity is the culture of progress and the Enlightenment, but also of colonialism and industrialisation, of idealism and historicism, as well as of scientific thought. His oblique criticism of South African landscape painting by Pretoria artist Jacob Hendrik Pierneef (1886-1957) goes beyond a question of subject matter. His attitude towards the artistic act of representation itself is at odds with Pierneef's vision that beauty and harmony are responsive to mathematical laws. Pierneef's paintings were based on strong, authoritative measurements of space and his compositions were an integrated system of related, regular forms, partly recalling Mondrian, partly Art Deco geometrical stylisation of organic shapes. Paintings such as *Bushveld Game Reserve* (1951) represent a frozen, clean, inhuman landscape, in which time is suspended. Kentridge's *horror vacui* early drawings are messy, dynamic and filled with the drama of humanity.

The modernist dream, as represented through functional architecture, is also re-coded by Kentridge: Soho's 'home' in WEIGHING... *and* WANTING (1998), and Ulisse's palace in *Il Ritorno d'Ulisse* (1998), stem from a house in Sergei Eisenstein's film *The General Line* (1928). These images evoke Le Corbusier's utopia, but also the lost dream of modernism in contemporary suburban architecture.

J.H. Pierneef,
*Bushveld, Game Reserve* 1951,
detail, oil, 65 x 85 cm,
private collection

Le Corbusier, *Villa Savoie*, Poissy,
1928-31

Whether in his recent theatrical productions or in his early drawings, Kentridge rarely offers the viewer the fantasy of a direct gaze onto the world, and the mechanism of vision itself is a theme in his work. In the films, the camera eye and tripod constitute an ambiguous image: it is both the emblem of surveillance, a central, hierarchical and controlling eye, and the artist's gaze, which allows his drawings and films to be made.

Kentridge stages indirect, oblique views that underline the way in which knowledge is negotiated between experience and memory, as well as mediated through communication systems and cultural stereotypes. He often suggests how in life we are subject to the power of the media, how we willingly accept the filters that distance us from a reality we do not want to see, devices that psychically smooth away the crudeness of that reality. The drawings and projected films are filled with images of billboards, which are drawn in the urban landscape – pictures within the picture itself. The theatre productions juxtapose and layer puppets, actors and backdrop projection, causing the audience to shift continuously between different registers of viewing and interpreting the relationship between signifier and signified. In *Felix in Exile* we do not see Nandi directly, but through Felix's memory of her, and even her drawings are viewed through his eyes as he looks through a pile of them in a suitcase. Similarly, the African landscape and the bodies of felled protesters are seen only through Nandi's theodolite, framed by her red contours and marks on the land/paper. In *History of the Main Complaint* (1996), when Soho is ill in hospital, we are granted a view into his body only through picture imaging techniques such as CAT scans and X-rays. As we penetrate his anatomy by way of this mediation – as participants in the doctors'

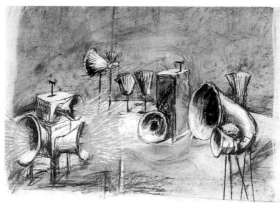

Rehearsal *Ubu and the Truth Commission* 1997

Drawing from *Sobriety, Obesity & Growing Old* 1991, charcoal and pastel on paper, 75 x 120 cm

Drawing for animation from *Ubu Tells the Truth* 1997

Computer drawing

William Kentridge's studio, with camera

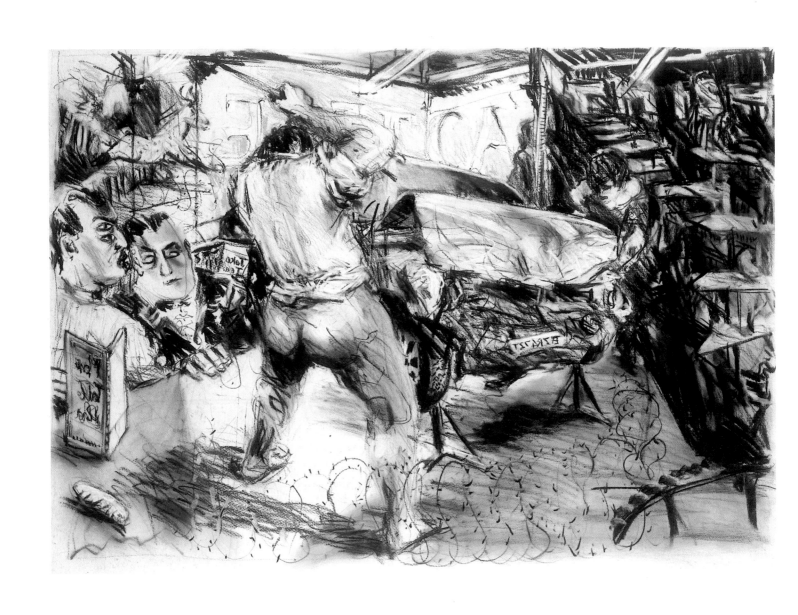

*Panel Beaters* 1986,
charcoal and pastel on paper, 85 x 105 cm

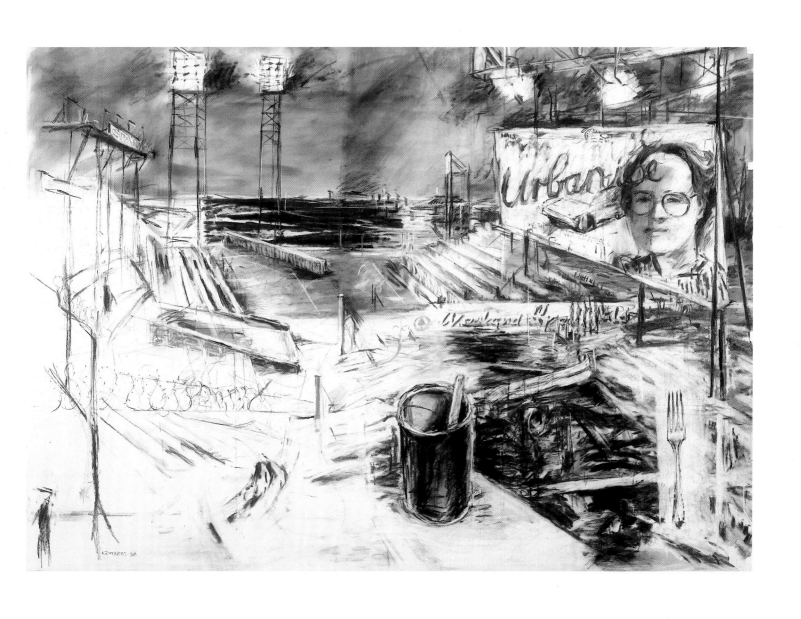

*Urbanise* 1989,
charcoal and pastel on paper, 106 x 180 cm

18.
Trinh T. Min-Ha, *When the Moon Waxes Red*, Routledge, New York/London, 1992, pp.147-152

19.
'Matrix is an unconscious borderspace of simultaneous co-emergence and co-fading of the *I* and uncognized *non-I* neither fused nor rejected, which share and transmit joint, hybrid and diffracted objects via conductible borderlinks. Matrix is a model of a feminine/prenatal rapport conceived of as a shared psychic borderspace in which *differentiation-in-co-emergence* and *distance-in-proximity* are continuously reattuned by metamorphosis created by, and further creating – accompanied by matrixial affects – *relations-without-relating* on the borders of presence and absence, subject and object, me and the stranger (…) In a joint and multiple marginal trans-individual awareness, perceived boundaries dissolve into becoming new boundaries; forms are transgressed; borderlines surpassed and transformed into becoming thresholds (…) Contingent transgressive borderlinks and a borderspace of swerve and encounter emer-

as-encounter. Metamorphosis is a co-poïetic activity in an inter-psychic web that remembers, conducts, transfers and inscribes feminine jouissance, swerve and rapport. Via art the effects of the borderlink's activity are transmitted into the threshold of culture' (Bracha Lichtenberg Ettinger, 'Trans-subjective Transferential Borderspace' in *Doctor and Patient – Memory and Amnesia*, ed Marketta Seppälä, Pori ArtMuseum, Pori, 1996, pp.69-70)

examination – we see internalised signs of his past emerging in the form of telephones and other office tools. Parallel to this, he remembers scenes of roadside beatings to which we are introduced obliquely, through fragments of his partially erased experiences. But the original experiences were already filtered and indirect, witnessed through the windshield of his car: the viewer therefore perceives them doubly mediated. Our obscene gaze is reversed and sent back to us by the eyes of Felix/Soho disquietingly reflected back at us from the rear-view mirror, implicating us through this mirroring in an awareness of possible indirect responsibility.

This oblique and multiple gaze recalls the interrogative, open and non-prescriptive film-making referred to by Trinh T. Min-Ha in 1992: 'More and more, there is a need to make films politically (as differentiated from making political films. (…) the making itself is political (…) A responsible work today seems to me, above all, to be one that shows, on the one hand, a political commitment and an ideological lucidity, and is, on the other hand, interrogative by nature, instead of being merely prescriptive. In other words, a work that involves her story in history; a work that acknowledges the difference between lived experience and representation (…) To work against this levelling of differences [is a]lso to resist the very notion of difference, [whi]ch, defined in the Master's terms always [reso]rts to the simplicity of essences.'[18] Although [Ken]tridge does not claim to make films 'politi[call]y', he does recognise that making them with

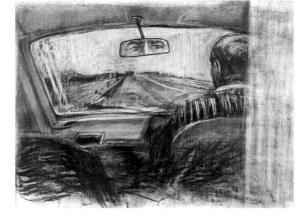

a sense of how they can reflect the ways in which we construct meaning for ourselves can have an implicit, political polemic.

Kentridge's works are narrative in that they suggest a story, even if it is compressed into a single drawing or scene. But the films progress through juxtapositions and cuts between separate scenes, taking on a visionary, dreamy quality, so that no definitive story ever emerges, and the indistinct space between the experience of reality and the experience of the mind is evoked. Mechanisms of condensation and distortion are introduced. There is no linear, temporal progression in the films, and time is especially fractured in the more recent works, where the uneven and subjective perception of duration is evoked – some moments moving faster than real time, others expanding the experience of an instant. Past and present, reality and fiction continuously shift and blend. Like processes of personal memory, the films are disordered: elements are selected, combined, replicated and deleted. They evoke the fact that it is impossible to remember everything, but it is equally impossible totally to forget. And in order to remember, one must be able to forget. By allowing traces of imperfect erasure to remain visible in the images, time is amplified; 'before' and 'now' overlap and subjectivity is experienced as a passage, hovering in a zone between forgetting and recalling.

While staging very personal investigations, the films explore a border zone where Self/Other are not distinguished or defined as opposites. They recall the notion of the psychoanalyst, artist and feminist theorist Bracha Lichtenberg of a 'matrixial gaze' stemming from a notion of feminine prenatal relationship to the world not based on opposition but on the possibility of surpassing borderlines and definitions in a process of continuous metmorphosis and transformation.[19]

Both in terms of style and content, Kentridge's art denies coherence, clarity, static definition, separation between past and present, self and other, stability and universalism, and in so doing creates an art of 'resistance' to modernism *and*

postmodernism. In the same way, his work loses all form of racial (or gender) distinction: it is neither 'black' nor 'white', but simply 'African'. It is an art from a border zone where both 'Europeanness' and 'Negritude' are seen as nostalgic utopias. It explores neither the 'private' dimension of memory nor the 'collective' one of mythology or history. In some ways it is a 'domestic' art, born on the periphery, and grounded in the locality of Johannesburg, refuting emulation of the product of a distant 'centre'. It is an art 'amazed' by the fact that, despite these characteristics, it has managed to reach into parts of the centre it assumed it could not hope to penetrate.

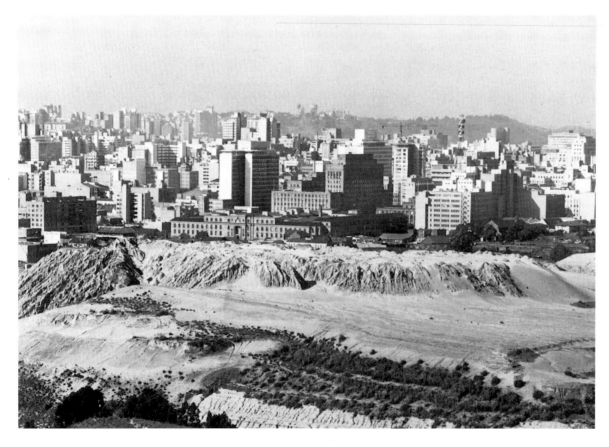

<
Drawing from *History of the Main Complaint* 1996, charcoal on paper, 120 x 160 cm

Johannesburg skyline

# JOHANNESBURG, 2ND GREATEST CITY AFTER PARIS, 1989

Animated film: 16mm film;
video and laser disc transfer
8 minutes, 2 seconds
Drawing, photography and
direction: William Kentridge
Editing: Angus Gibson
Sound: Warwick Sony with
music by Duke Ellington,
choral music
Produced by the Free Film-
makers Co-operative,
Johannesburg
Series of c.25 drawings in
charcoal on paper or charcoal
and pastel on paper;
dimensions variable

This is the first in a series of short, animated films entitled *Drawings for Projection,* which revolve around the characters of Soho Eckstein and Felix Teitlebaum. The animation technique is simple: Kentridge made, and successively altered through erasure and re-drawing, some twenty-five drawings in charcoal and pastel on paper, shooting them on 16mm film at each of the many stages of their evolution. This technique of imperfect erasure, which leaves smudges and traces of the process of production, captures the passing of time and the layering of events in memory, allowing for a certain random quality within a pre-set programme. At the end of the process, Kentridge was left with a set of drawings, each filmed innumerable times and each representing the final stage of one scene of the film.

The film introduces the characters of Johannesburg property developer, Soho Eckstein, his neglected wife, Mrs Eckstein, and the naked dreamer, Felix Teitlebaum. A symbol of capitalist greed and corruption, Soho is always portrayed frontally, behind his desk, wearing a pin-striped suit; Felix, who resembles the artist himself, is often seen from behind, looking out towards the landscape. The title is ironic: set in the urban wasteland of Johannesburg and its surroundings, the film tells of the founding and building of a mining town through the progressive growth of Soho's power and its traumatic effects both on the landscape – presented as though it were a 'drawn', artificial environment, littered with emblems of abandoned civil engineering – and its inhabitants.

Parallel to this story is the tale of desire and love between Felix and Mrs Eckstein. She is portrayed, in Felix's thoughts and erotic fantasies, in association with the imagery of water and bathing; at one point, he offers her a tiny fish, a love token that reappears in later films. This wet imagery of love and sex is presented in opposition to the dry mining landscape, one of many binary oppositions between Soho and Felix. Paper belongs to both worlds: Soho's paper is that of money and business, while Felix's is that of love letters and drawings of, or for, his beloved. The narrative sequence cuts between the images and sounds of the growing

Eckstein empire, through scenes of Felix's affair with Mrs Eckstein, to brief flashes depicting an anonymous, lonely outcast, moving on crutches through an obscure location demarcated by barbed wire, or warming himself by a fire.

The sound was created by South African composer Warwick Sony, who would later collaborate with Kentridge on many other projects. Soho's development towards prosperity is accompanied by the early 20th-century sounds of Duke Ellington. The dispossessed miners, who approach through the urban wasteland in procession from the horizon, almost as if they were part of this damaged landscape, are associated with South African choral music (fictitiously identified by Kentridge as 'The South Kaserne Choir').

Like the captions in a silent movie, words appear on the screen, giving viewers information about the characters' feelings or about events that broadly constitute the narrative sequence. Felix is introduced as 'Captive of the City', Mrs Eckstein as 'Waiting', and when Eckstein obliterates the poor by throwing food at them, the title reads: 'Soho Feeds the Poor'. The film ends after a symbolic battle between the two male figures, who seem almost to become paired parts of a single personality. Felix is victorious. The procession of workers is now reversed, moving back towards the horizon, creating a formal, symmetrical framework suggesting that it is the camera eye that allows the dual struggle – both social and interior – to emerge. The reappearance of the workers also reminds us that there is no final victory after all – the enduring, wider conflict appears to be embedded in the maimed landscape itself.
(CCB)

*In this film, Soho Eckstein (property developer extraordinaire) and Felix Teitlebaum (whose anxiety flooded half the house) fight for the hearts and mines of Johannesburg and the affection of Mrs Eckstein. There is a procession of the dispossessed, Soho feeds the poor. Felix gives Mrs Eckstein a gift of love. Soho and Felix wrestle in the slime dams of the city.* (WK, 1994)

<
Detail of drawing from
*Johannesburg, 2nd Greatest City
after Paris* 1989
charcoal on paper, 96 x 151 cm

Drawing from *Johannesburg,
2nd Greatest City after Paris* 1989
charcoal on paper, 104 x 152 cm

Horst Gossler, 'Not Half
Crazy', Sunday Times,
Johannesburg, 24 March 1991,
p.12

Michael Godby, William
Kentridge, Drawings for
Projection: Four Animated
Films, Goodman Gallery,
Johannesburg, 1992,
(catalogue), n.p.

Hazel Friedman, 'Not for the
Walls but for the Soul…',
The Star Tonight!, Johannes-
burg, 11 March 1992

Charles Hall, 'William
Kentridge', Arts Review,
London, June 1992, p.9

Rosanna Negrotti, 'William
Kentridge', What's On,
Johannesburg, 10 June 1992,
p.10

VB [Vivian Bobka], 'William
Kentridge', Jurassic Technolo-
gies Revenant, 10th Biennale of
Sydney, 1996, (catalogue) p.85

Sue Williamson, Ashraf Jamal,
'William Kentridge: Devils
and Angels', in Art in South
Africa: The Future Present;
David Philip, Cape Town and
Johannesburg, 1996, pp.46-51

David Krut, William Kentridge,
CD-Rom, David Krut
Publisher, Johannesburg, 1998

Okwui Enwezor, 'Swords
Drawn', Frieze, London,
issue 39, March/April 1998,
pp.66-69

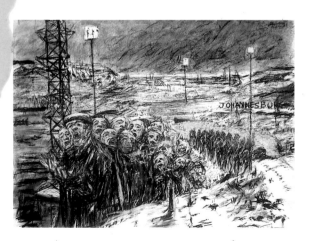

## LANDSCAPE IN A STATE OF SIEGE
William Kentridge
(from *Stet*, Johannesburg, November 1988,
volume 5, no.3, pp. 15-18)

For about a year I have been drawing land-
scapes. They started off as incidental details in
other drawings. A window behind a couple
dancing, an open space behind a portrait.
Gradually the landscape took over and flooded
the interiors. Few of the people in the pictures
managed to retain their place in them. The
drawings are in charcoal on a rough paper so
images that seem solid and dark can be
removed with a swipe of a cloth. Traces are left.
Even after scrubbing the paper there is evidence
of some disturbance. But this is easily over-
grown and incorporated into the drawing.
A few of the drawings are of specific places but
most are constructed from elements of the
countryside around Johannesburg.

*Caution: for External Use Only*
Artists' words or thoughts about their work
must be accepted with caution. Not because we
are dumb or inarticulate, but because these
pronouncements about our work come after
the event. They are justifications or at best,
reconstructions, of a process that has happened
rather than descriptions of a programme that
was decided before the work was done. The
meanings are illusive. It is not that drawings are
meaningless, but that the meaning cannot
really be ascertained in advance. Whatever
people think they are doing, in the end their
hopes and fears and desires emerge. Bad faith
– political or moral or whatever – stands out a
mile and comes home to roost. Hence the
caution on the label.

*Dear Diary*
Tuesday and Thursday afternoons at King Ed-
ward VII Preparatory School. Watching endless
ethnographic films of Mealies being stamped
and Herdboys bringing the Cattle back to the
Mud huts while a Marimba sounded scratchily
from the speaker at the back of the school hall.
Even at five or six this vision of Africa seemed
a complete fiction, far less convincing than the

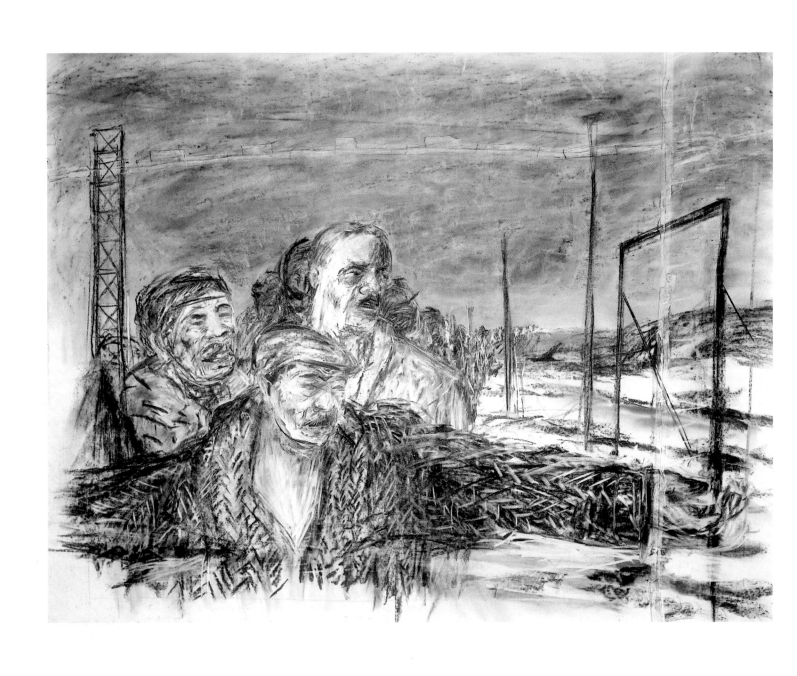

Drawing from *Johannesburg, 2nd Greatest City after Paris* 1989
charcoal on paper, 133 x 165 cm

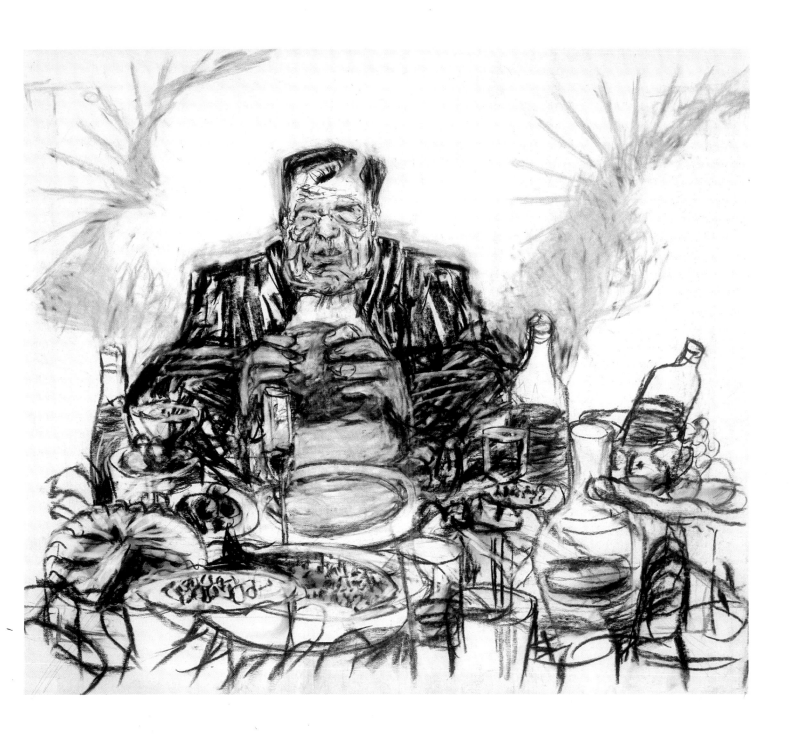

Drawing from *Johannesburg, 2nd Greatest City after Paris* 1989
charcoal on paper, 110 x 118 cm

Tarzan films we were allowed to see at the end of each term. The Africans I knew and met did not live in mud huts guarding cattle, playing drums, they took buses, wore smart hats, lived in small rooms at the back of large houses, listened to the wireless.

*Alexis Preller Out on Parole*
The debate and suspicions that follow the emergence of transitional art at the moment have echoes for me in this dichotomy. And outside the academic arena there are obviously different visions alluded to in say the ANC's image of tribal dancing on their record covers and the post-revolution, Russian Constructivist images in COSATU publicity.

I have always envied people working in France at the turn of the century in their ability to appropriate African iconography, the masks and sculptures, into the formal language of their work without having to deal with the loaded questions that follow any such mention here.

Tribal Africa always has a reactionary smack to it – particularly in the hands of people who have tamed it militarily – only to celebrate its totems as decoration. But even freed from these immediate associations, the idea of an innocent, classless Africa is highly problematic. There is a nostalgia within it, whether in a painting by Preller or its invocation by Black Consciousness groups, a reference to a state of grace that is pure, and ignorant of the constraints and processes of Africa in its dominated state. This idea of a pre-European Africa of innocence is firstly false, and more importantly, it obscures the strange, contradictory relationship between western conquest and tribalism that still endures.

This utopian Africa of mysticism, spiritual healing, untamed nature, is not unlike the Africa as Eden in the paintings of the famous South African landscape artists. The Volschenks and Pierneefs are empty of tribal images but are not unrelated. The landscape is arranged into a vision of pure nature, majestic primal forces of rock and sky. A kloof and escarpment, a tree is celebrated. A particular fact is isolated and all idea of process or history is abandoned. These paintings, of landscape in a state of grace, are documents of disremembering.

Which is not an instantaneous process. The early South African landscape paintings were scientific, cartographic studies. Or directly historical. A number of the early colonial paintings showed scenes of conquest, battles were fought within the landscape. Puffs of gunsmoke and falling Xhosa can be catalogued by the hundred. Later there is a change: the guns are directed more towards other fauna, herds of elephant, charging lions. And only at the end of a long process that corresponds to the completion of the domination of Africa does the pure landscape emerge.

*A Journey into Africa*
From a white suburban house the journey through Africa began across the yard in the servant's room. A foot-pedal Singer and ZCC calendars and photos on the wall. Then I remember trips to the market in Mbabane with mixed smells of over-ripe fruit and fresh basketwork and only later, much later, some awareness of the sculpture being made in Venda and an understanding that in Africa some people do live in mud huts and herd cattle, though not in the way shown in the school films. But then in the heart, in the centre of Africa, in the Houghton house, was Michelangelo's *Last Judgement* and Hobbema's *Avenue of Poplars*, the latter on the cover of *The Great Landscape Paintings of the World*, a book my grandfather gave me.

*London is a Suburb of Johannesburg*
Private maps of familiar places do not correspond to any geographer's projection. Pretoria has always been alien, the foreign place to which my father set off for years of my childhood; working on the Trees and Tile. The place was associated with frustration and anger. It has not become more familiar. And, of course, with a South African passport, all the land to the north is a huge void, something to be taken on trust from pictures in *National Geographic*, (as is Eastern Europe and most of Asia). Parts of London, New York, are more familiar; exten-

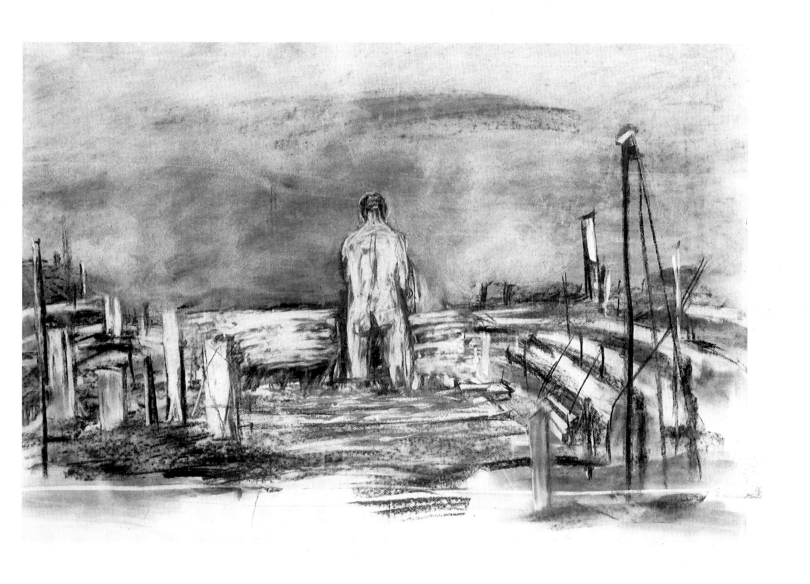

Drawing from *Johannesburg, 2nd Greatest City after Paris* 1989
charcoal and pastel on paper, 71 x 97 cm

sions of Johannesburg, certainly closer than Cape Town.

Hobbema's avenue of trees was a staging post. Halfway between the way nature was meant to be ordered – the spreading oaks and lush greens of colonial children's books – and the non-existent landscape I knew around Johannesburg. At least in this strange painting there was not much to see, a few trees, a road, a ditch a hedge. Not the purple-headed mountain and river running by of the Volschenks and De Jonghs and Pierneefs, which in their own way were as alien as those ethnographic films. (I have since been told by people who have spent time on farms or in the country that there are places that look like these paintings but by now the damage is done.)

Of course, it was also easy to love the Hobbema. It is of a foreign country painted hundreds of years ago, there is nothing to test it against, no context that throws the work into question. But the Volschenks flew in the face of my experience. I had not seen, and in many ways feel I have not yet seen, a picture that corresponds to what the South African landscape feels like. I suppose my understanding of the countryside is an essentially urban one. It has to do with visions from the roadside, with landscape that is articulated, or given a meaning, by incidents across it, pieces of civil engineering, the lines of pipes, culverts, fences. This is essentially a naturalistic approach to drawing the landscape. One of the ways I work is to drive predetermined but random distances, say 6.3 or 19.8km and at that point work with what presents itself. This is largely to get away from the plague of the picturesque (though this is almost impossible). Generally I end up with a catalogue of civil engineering details. It has become clear that the variety of the ephemera of human intervention on the landscape is far greater than anything the land itself has to offer. The varieties of high-mast lighting, crash barriers, culverts, the transitions from cutting, to fence, to road, to verge, to field, are as great as any geological shifts (particularly on the highveld – the beauties of the Cape are different, to be enjoyed, but certainly they don't make me reach for my sketch book).

There are other traces there too. A never-ending chronicle of disasters or almost disasters in the sets of skid marks that punctuate the road. (Even in the flat, straight sections of the NI through the Karroo the number of such traces seldom falls below five per km.) And a sense of a space that has been acted upon, which is not as simple or as bathed in grace as one would wish.

## Magoeba's Kloof and the 1913 Land Act

Of course, even with random stops at the roadside, remarkably beautiful vistas do present themselves. To be blind to that beauty is crass, but to be swallowed up by it seems equally foolish. I do not think there can be any simple response to a place whose appearance is so different from its history.

In a documentary on television there was a shot of forests somewhere in Poland. Deep grey-green pine trees and rolling hills in the soft European light. What is one to make of this landscape? On the one hand seeing this idyllic countryside, on the other hand knowing that is the spot where some hundred thousand people were gassed in the back of trucks during the 1940s. The traces in the landscape are thin. A clearing, a section of the forest where newly planted trees in straight rows are not yet as tall as those around them. In the same documentary there is some ground not dissimilar to the land around Wadeville or Vereeniging, flat featureless, a few horizontal striations in the ground that show where a foundation was, a null expanse, one of the Auschwitz crematoria.

## This Disease of Urbanity

I am not making drawings of sites of local massacres (though I do think that would be an interesting project in itself) but the drawings are of spaces that are not natural or neutral. I think it was Adorno who wrote, 'After Auschwitz there is no more lyric poetry' – that the events of the war should have been so traumatic they have transformed the psyche of all people, have exercised the faculty that makes sense of certain forms such as lyrical poetry. Of course, he was wrong. People's memories and collective memories are extremely short, or at

any rate they are tranquillised to make way for daily living. It takes particular events, films, books to rekindle that memory. And that is why these landscapes of Polish forests have appropriateness to them. They contain an event that has been accommodated, absorbed into the run of daily life.

In Bertrams, the suburb in which I live, there have in the last year been four bomb blasts (at the Standard Bank Arena and Ellis Park – the most recent took place today, an hour ago, and killed three people) and two or three murders. But all is absorbable. One is touched less and less. This desensitisation becomes another form of disremembering. Urbanity by which I mean the ability to absorb everything, to make contradiction and compromise the basis of daily living seems characteristic of how people operate in South Africa. It is at its most exaggerated in white suburban living but I

don't think confined to it. Activists, whose job it is to show up the anomalies around us and not let us slide away from them, have their work cut out.

In spite of everything, one wakes in the morning feeling better.

The current landscape drawings emerge from this arena of urbanity. Which is not to say they are illustrations of it. For the most part the drawings proceed rather dumbly with only occasional stops for assessment or judgement. Elements of a landscape throw themselves up as appropriate and become the structure of a drawing. Pieces of a drawing lose their hold and must be removed. There are no points, geographical or moral, that I am trying to illustrate. The drawings are empirical, naturalistic. But they are approached with some sense that the landscape, the veld itself, holds within it things other than pure nature.

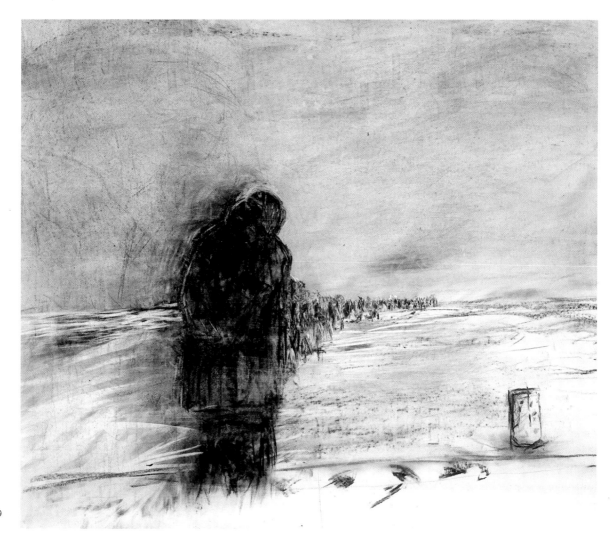

Drawing from *Johannesburg, 2nd Greatest City after Paris* 1989
charcoal on paper, 92 x 130 cm

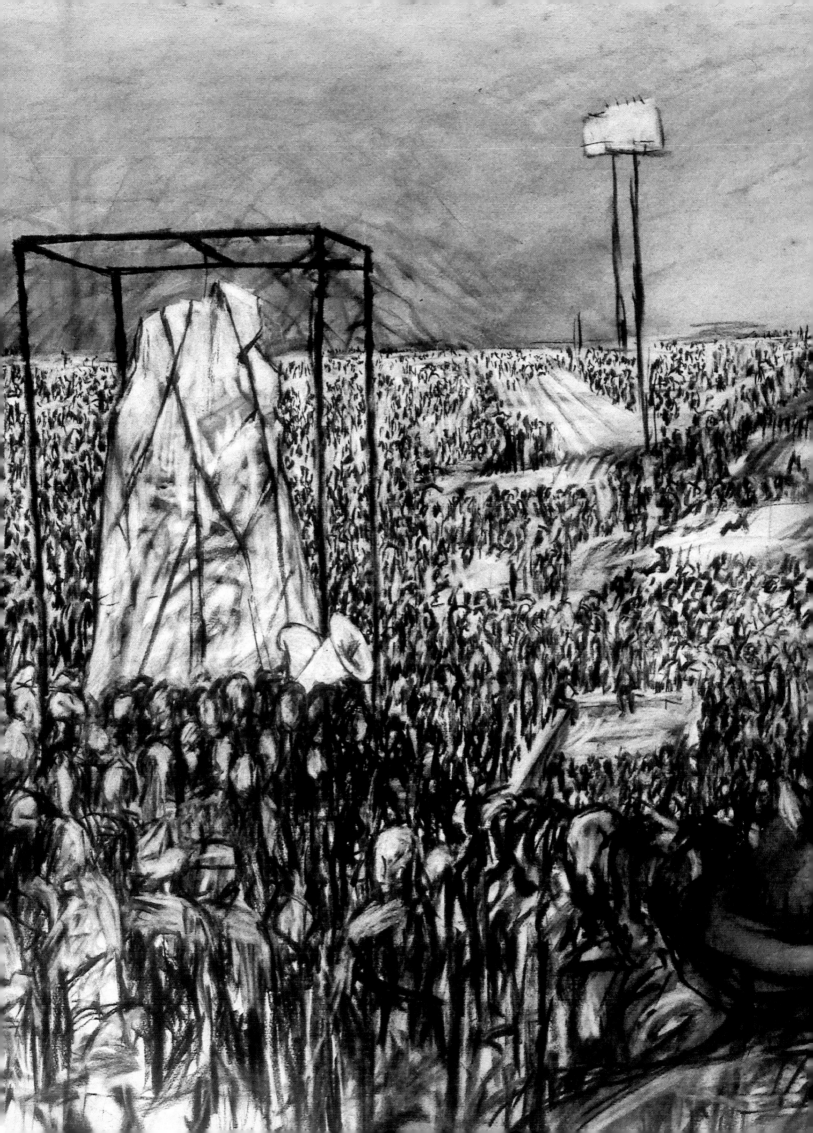

# MONUMENT, 1990

Animated film: 16mm film;
video and laser disc transfer
3 minutes, 11 seconds
Drawing, photography and
direction: William Kentridge
Editing: Angus Gibson
Sound: Catherine Meyburgh,
with music by Edward Jordan
Produced by the Free Film-
makers Co-operative,
Johannesburg
Series of c.11 drawings in
charcoal on paper or charcoal
and pastel on paper;
dimensions variable

*Monument* is Kentridge's second animated film in the continuing chronicle of Soho Eckstein and the exploration of the growth of mining and labour in South Africa, its effects on the landscape and the conditions under which labourers work. The film also focuses on the persuasive power of mass communication in the Modern Age, with oblique reference to the influence of the media in shaping and controlling consciousness.

Loosely based on Samuel Beckett's play *Catastrophe*, it tells the simple story of Soho's public presentation of a monument to labour through two sequences of images. Kentridge again adopts a binary structure of opposition between characters, but, in this case, Felix is not present. In the first sequence, an anonymous African labourer appears with bent head, carrying a heavy load on his shoulders. The drawing focuses on his face, so that only part of his burden of tools is visible. The film cuts to a close-up image of his naked feet, their movement suggested through traces of successive drawings and over-drawings recalling early chronophotographic experiments or the simultaneity of Futurist painting. He is next seen wearing a long, dark coat, entering from the left, walking through the grey wasteland outside the city. Halfway across, he turns towards the horizon and moves away from the viewer's gaze into the landscape.

The second sequence, entitled 'Soho Eckstein Civic Benefactor', provides a contrast to this first scene of burden and loneliness. Microphones snake into the title drawing and Soho appears to the right, holding sheets of paper containing his public speech. The papers turn into megaphones or loudspeakers in the landscape. They emit dark marks that become a black, monochrome square in the centre of the scene. The landscape has changed, characterised now by blank billboards and tall lampposts. From behind the black square, which is slowly erased, a large packaged form appears under scaffolding. This drawing refers partly to Henry Moore's sketches of parcelled sculpture, partly to Christo's wrapped structures and forms, providing a sub-text about the moral and ethical issues involved in the artist's choice of subject and materials. A mass of people emerge from the horizon, coming to the front to form a crowd around this covered monument. A close-up shot of Soho follows; he is speaking to the crowd, gesticulating, his expression pleasant, though perhaps insincerely so. A long-shot of the scene shows the unveiling of the monument. Unexpectedly, it is a depiction of the lonely figure carrying his tools. As the camera eye rises from the feet of the sculpture, chained to the base, to focus on the face, the background noise of the crowd quietens down. The statue's head moves upwards and his eyes blink. He begins to breathe heavily – the figure is alive. (CCB)

*In this film we see Soho Eckstein as civic benefactor, erecting a monument to his and the city's honour. A man from the procession of the dispossessed is immortalised, load still on his back.* (WK, 1994)

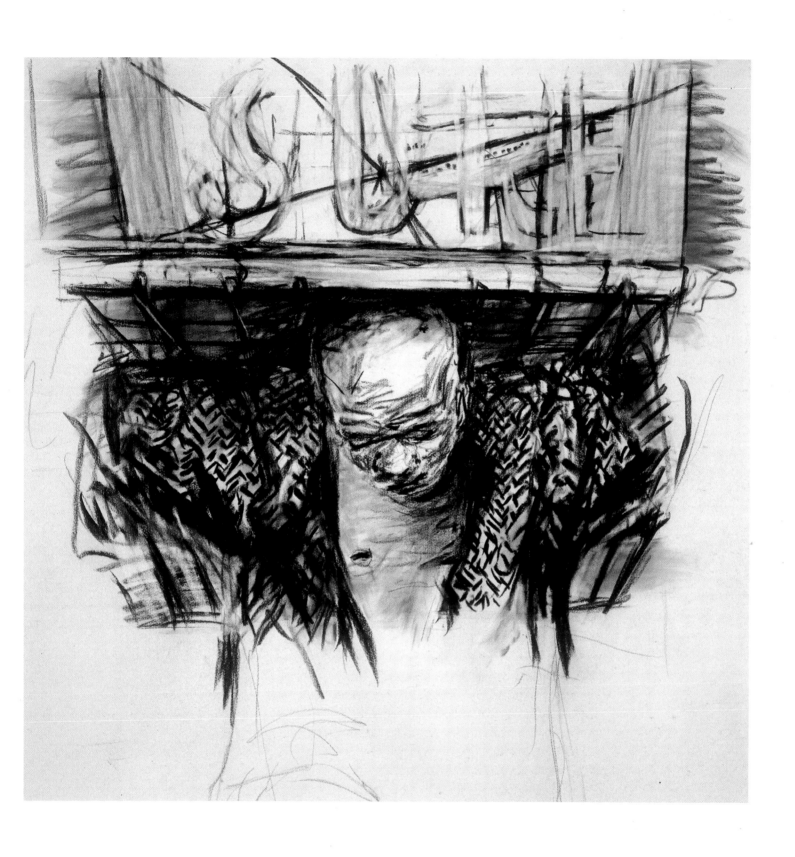

Drawing from *Monument* 1990
charcoal and pastel on paper, 150 x 120 cm

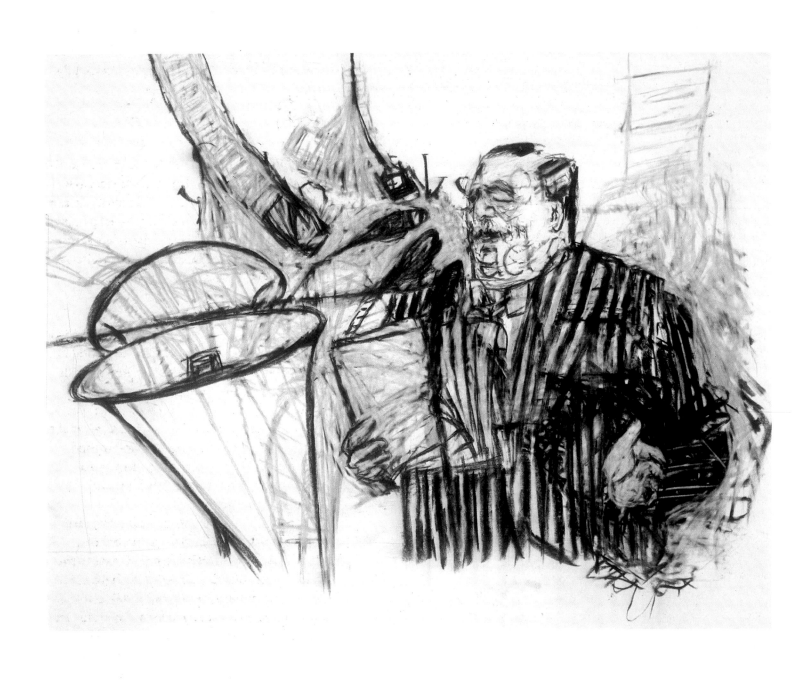

Drawing from *Monument* 1990
charcoal on paper, 120 x 150 cm

*Monument* wins Weekly Mail Short Film Competition, and is screened at the Planet Cinema, Johannesburg, 1990.

Solo exhibition: 'William Kentridge: Drawings for Projection', Goodman Gallery, Johannesburg,
21 February - 14 March 1992 (screened on monitor, with drawing)

Group exhibition: 'Incroci del Sud: Affinities – Contemporary South African Art', group exhibition, Fondazione Levi Palazzo Giustinian Lolin, 45° Venice Biennale, Venice, June - October 1993, organised by the South African Association of Arts in collaboration with Sala 1, Rome, where the exhibition was held from 31 October - 2 December 1993, touring to Stedelijk Museum, Amsterdam in 1994 (screened on monitor)

'Edinburgh International Film Festival', Edinburgh, August 1993
(projected film, shown in a retrospective of Kentridge's animated films)

'Annecy International Festival of Animated Film', Annecy, June 1995
(projected film, shown in a retrospective of Kentridge's animated films)

Group exhibition: 'Mayibuye I Afrika: 8 South African Artists', Bernard Jacobson Gallery, London, 28 September - 28 October 1995 (screened on monitor)

Group exhibition: 'On the Road – Works by 10 Southern African Artists', The Delfina Studio Trust, London, 5 October - 12 November 1995 (screened on monitor)

'Festival des Dessins Animés', Le Botanique, Brussels, February 1996
(projected film, shown in a retrospective of Kentridge's animated films)

Group exhibition: 'Colours, Art from South Africa', Haus der Kulturen der Welt, Berlin, 14 May –18 August 1996 (screened on monitor)

Culturgest, Lisbon, July 1996 (projected film)

Group exhibition: 'Inklusion-Exklusion: Versuch einer neuen Kartografie der Kunst im Zeitalter von Postkolonialismus und globaler Migration', Steirischer Herbst, Reininghaus, Graz, 22 September - 26 October 1996 (screened on monitor)

Solo exhibition: 'William Kentridge', Palais des Beaux-Arts/Paleis voor Schone Kunsten, Brussels, 15 May - 23 August 1998, touring to Kunstverein, Munich, 28 August - 11 October, 1998; Neue Galerie Graz am Landesmuseum Joanneum, 15 November 1998 - 15 January 1999 (screened on monitor)

Michael Godby, *William Kentridge, Drawings for Projection: Four Animated Films*, Goodman Gallery, Johannesburg, 1992, (catalogue) n.p.

Hazel Friedman, 'Not for the Walls but for the Soul…', *The Star Tonight!*, Johannesburg, 11 March 1992

Charles Hall, 'William Kentridge', *Arts Review*, London, June 1992, p.9

Rosanna Negrotti, 'William Kentridge', *What's On*, Johannesburg, 10 June 1992, p.10

VB [Vivian Bobka], 'William Kentridge', *Jurassic Technologies Revenant*, 10th Biennale of Sydney, 1996, (catalogue) p.85

Leslie Camhi, 'Travelling Shots', *Jurassic Technologies Revenant*, 10th Biennale of Sydney, 1996, (catalogue), pp.40-41

David Krut, *William Kentridge*, CD-Rom, David Krut Publisher, Johannesburg, 1998

ART IN A STATE OF GRACE, ART IN A STATE OF HOPE, ART IN A STATE OF SIEGE
(extract from lecture given by William Kentridge at the 'Standard Bank National Festival of the Arts', Winter School, Grahamstown, July 1986)

(…)
*The Pictures I Love are Not for Me*
The great Impressionist and post-Impressionist paintings, like the big Seurat in the National Gallery in London and those Tiepolo skies, are the paintings that give me the greatest pleasure. Immediate pleasure, in the sense of a feeling of well-being with the world. They are visions of a state of grace, of an achieved paradise.

*Art and the State of Grace*
This state of grace is inadmissible to me. I know this is contradictory. The state of the world has not changed that much between the late 19th century and now in terms of human misery. There were factories at the edge of the Seine where Seurat was painting and in bad years the peasants starved in the countryside around Tiepolo's ceilings. But in the paintings the effect is not of history distorted but of a benevolent world.

But it is one thing to be grateful for those lies and quite another to perpetuate them.

There are some artists, from Matisse to the colour-field abstract painters, who have managed to maintain an innocence or blindness and continue working like this to this day without bad faith gnawing at their work. I would love to be able to work like this. But it is not possible.

This impossibility is complex. When I try, the pictures are terrible. Lyricism descends into kitsch or sentiment. Or else the nature of the image changes. Lyricism seems to need a certain self confidence and clear conscience that I lack. The argument of course is nearly circular. If I could work in a lyrical way with colour or image, perhaps that confidence would be there. Certainly I am very aware of the sophistry in ascribing a failure in painting to moral austerity.

Perhaps, working away from here in some European or rural haven, I would be able to

paint apples and colours, but I doubt it. Here, more than most other places, one's nose is rubbed in compromises every day and certainly these are more grotesque than most, but in essence I don't think they are greatly different.

It is always the peasants who pay and purity is an illusion.

### Art and the State of Hope

Tatlin's *Monument to the Third International* is one of the great images of hope. I say 'image' because although the monument existed as a model, I know it only through photographs. These are enough. It is the project rather than the actual object that is moving. I imagine that the greying concrete pylons of the actual monument, a thousand feet high, would be monstrous. But there is in the image of Tatlin and his assistants clambering around the model – huge enough in itself – a hope and certainty that I can only envy. Such hope, particularly here and now, seems impossible. The failure of those hopes and ideals, their betrayals, are too powerful and too numerous. I cannot paint pictures of a future like that and still believe in the pictures.

Which may not be necessary. Good propaganda can come from craft and conscientiousness rather than convention. Although it is hard. In the few posters I have designed on request, irony (the last refuge of the petty bourgeois) creeps through and passion is reduced to a bitter joke. Ultimately, my belief in the democratic socialist revolution is tainted. Not by doubting its need or desirability but

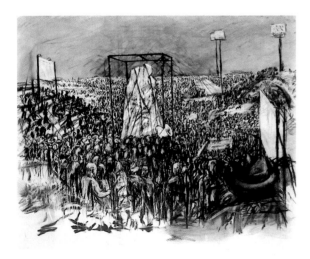

because it seems unwarranted optimism to think it will occur and because, even if it did, I do not know how I would fit into it.

Where does that leave me, with neither a belief in an attained (even partial) state of grace, nor with a belief in an immanent redemption here?

### Art in a State of Siege

Max Beckmann's painting *Death* is a beacon for endangered souls. It accepts existence of a compromised society and yet does not rule out all meaning or value, nor pretend these compromises should be ignored. It marks a spot where optimism is kept in check and nihilism is kept at bay. It is in this narrow gap he charts that I see myself working. Aware of, and drawing sustenance from, the anomaly of my position. At the edge of huge social upheavals, yet also removed from them. Not able to be part of these upheavals, nor to work as if they did not exist.

This position of being neither active participant nor disinterested observer is the starting point and the area of my work. It is not necessarily the subject of it. The work itself is so many excursions round the edge of this position.

### After Auschwitz there is, alas, Lyric Poetry

This position, the arena in which I work (this fox hole, it often feels like) is not a unique one. It is the condition of many people if not all of us. I am just emphasising it, as it seems central to me. There is not a day or hour in which it does not present itself to me (not as anguish, that only too rarely, but as a nudge at least). And it is central to my activity of working. Other people, I'm sure, are aware of it but are able to work without it impinging on what they are doing.

Its central characteristic is disjunction. The fact that daily living is made up of a non-stop flow of incomplete, contradictory elements, impulses and sensations.

But the arresting thing for me is not this disjunction itself, but the ease with which we accommodate it. It takes a massive personal shock for us to be more than momentarily

Drawing from *Monument* 1990
charcoal on paper, 120 x 150 cm

moved. Turning from page-three horror stories in the newspaper to the sports or arts pages is swift, and, bad conscience, if it exists at all, lasts for only a moment.

## This Disease of Urbanity

Urbanity, the refusal to be moved by the abominations we are surrounded by and involved with, hangs over us all. This question of how passion can be so fleeting and memory so short-lived gnaws at me constantly. It is a deep-rooted question.

As a child (I am a second child and hence a peace-maker; reconciling opposites has been a job for life), I remember the shock of realising that a rage that had been unquenchable a few minutes before, and which it seemed could have as its outcome nothing less than the maiming of its object, had now drained, and that the anger directed towards the offending person, though not less deserved, was now false. What happened to that anger, how could it just evaporate like that?

The questions now do not seem so different. What is the atmosphere in which we live that enables the shocks and clashes of daily life to leave us so calm? And the degree of calm is quite astonishing.

## White Guilt Come Home

White guilt is much maligned. Its most dominant feature is its rarity. It exists in small drops taken at infrequent intervals and its effects do not last for long. But the claim goes further than this. People far closer to the violence and misery still return out of the tear smoke and an hour later are cooking their dinners or watching 'The A-Team' on television.

(...)

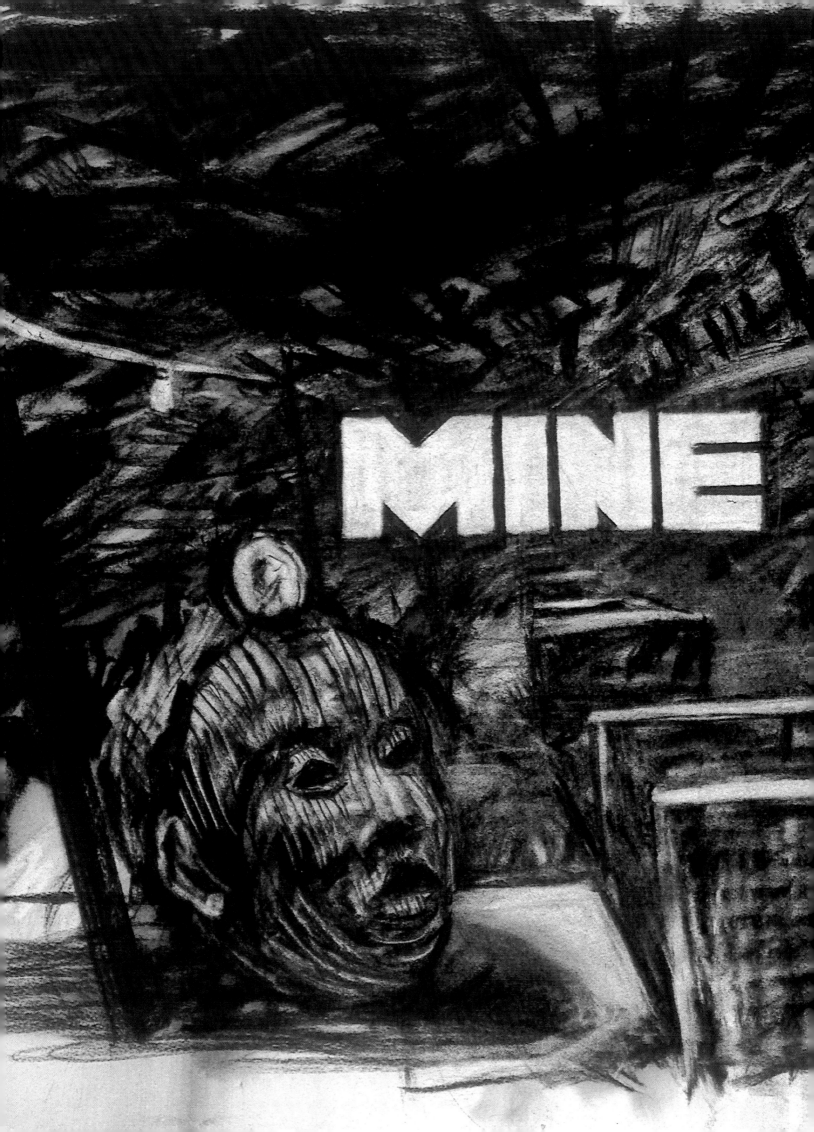

# MINE, 1991

Animated film: 16mm film;
video and laser disc transfer
5 minutes, 50 seconds
Drawing, photography and
direction: William Kentridge
Editing: Angus Gibson
Music: Dvorak's *Cello Concerto
in B Minor,* Opus 104
Produced by the Free Film-
makers Co-operative,
Johannesburg
Series of c.18 drawings in
charcoal and pastel on paper;
dimensions variable

The third animated film made by Kentridge about Johannesburg magnate, industrialist and developer, Soho Eckstein, *Mine* is often shown by the artist as the second in this series, before *Monument.*

The film portrays a day in the life of the mines and is structured according to an opposition between up and down – above and below the surface of the ground. Soho's realm of Capital and idle pleasures is above ground, in his bed and office, while the hidden, removed and claustrophobic world of the labourers is in the mine below. It is a visual representation of Soho's exploitation of both the body of the land (its gold ore) and the body of the labourers, revealing his psychic removal of 'white guilt' and his ignorance of the reality of slavery, pain, suffering, cold, danger and death endured by the miners.

The film begins in the dark with a thundering sound reminiscent of underground wagons moving on rails. This atmosphere of nocturnal subconsciousness is interrupted by the music of Dvorak and the fixed image of a head that could be both that of a miner wearing a lamp, or a crowned *Ife* head from Nigeria, an image that alludes to a colonialist or touristic exoticising view of Africa. Out of the deep, horizontal perspective in the first scene, the title of the film emerges expressionistically like an iron wagon from the background. The view then shifts to a vertical cross-section of a mine. A lift carries workers up the shaft, out onto the land, which is transformed into Soho's bed. Below the bed/ground, parallel to Soho's awakening, a dormitory with bunk-beds and communal showers, recalling the nightmares of a Nazi concentration camp, is the scene for another awakening, that of the cold miners. One of them warms his hands by the red flame of a large brazier. Shifting from above to below and vice-versa, the film continuously correlates parallel, yet contrasting, actions.

The plunger of Soho's cafetiere descends like an inverted periscope down through his breakfast tray, cutting through his bed, into layers of earth, detritus, tools and heads. It carries the viewer's gaze into memory and acknowledgement. The lowest layer is the mine tunnel in which workers are drilling, opening voids of light. The tunnels take on the diagrammatic shape of an old slave-ship with people squeezed into every possible space. Above ground, Soho starts his day's work; now his coffee plunger turns into a cash-register or adding machine that spits out rolls of paper and masses of labourers, their bodies solidifying into gold ingots or blocks of modernist architecture. A lone figure in the dormitory below, seen from behind, recalls the silhouette of Felix in other films. Something is carried upwards through the mines and set onto Soho's desk. It is a tiny, live rhinoceros. This symbol of Africa turned into a trinket mirrors the image of the tribal head at the beginning of the film and draws attention to the ecological damage wreaked by industry. Soho clears his desk, which turns back into a bed, to make space for his new pet to play. (CCB)

*In this film we see Soho Eckstein as Mine Owner, excavating from the earth an entire social and eco history. Atlantic slave ships,* Ife *royal heads, and finally a miniature rhinoceros, are dragged up through the miners embedded in the rocks to Soho having his morning coffee.* (WK, 1994)

<
Detail of drawing from *Mine* 1991
charcoal on paper, 60 x 75 cm

Drawing from *Mine* 1991
charcoal on paper, 60 x 100 cm

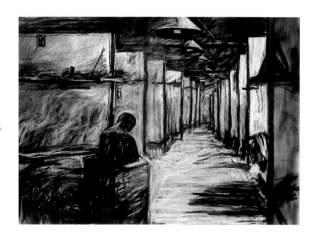

*Mine* wins Weekly Mail Short Film Competition (Fiction), Johannesburg, August 1991

Solo exhibition: 'William Kentridge: Drawings for Projection', Goodman Gallery, Johannesburg, 21 February - 14 March 1992 (screened on monitor, with drawings)

Solo exhibition: 'William Kentridge', Ruth Bloom Gallery, Los Angeles, organised by Vanessa Devereux, May 1993 (screened on monitor, with drawings)

Group exhibition: 'Incroci del Sud: Affinities – Contemporary South African Art', Fondazione Levi Palazzo Giustinian Lolin, 45° Venice Biennale, June - October 1993, organised by the South African Association of Arts in collaboration with Sala 1, Rome, where the exhibition was held from 31 October - 2 December 1993, touring to Stedelijk Museum, Amsterdam in 1994 (screened on monitor)

'Edinburgh International Film Festival', Edinburgh, August 1993 (projected film, shown in a retrospective of Kentridge's animated films)

'Annecy International Festival of Animated Film', Annecy, June 1995 (projected film, shown in a retrospective of Kentridge's animated films)

Group exhibition: 'Mayibuye I Afrika: 8 South African Artists', Bernard Jacobson Gallery, London, 28 September - 28 October 1995 (screened on monitor)

Group exhibition: 'On the Road – Works by 10 Southern African Artists', group exhibition, The Delfina Studio Trust, London, 5 October - 12 November 1995 (screened on monitor)

'Festival des Dessins Animés', Le Botanique, Brussels, February 1996 (projected film, shown in a retrospective of Kentridge's animated films) Group exhibition: 'Colours, Art from South Africa', group exhibition, Haus der Kulturen der Welt, Berlin, 14 May - 18 August 1996 (screened on monitor)

Culturgest, Lisbon, July 1996 (projected film)

Group exhibition: 'Inklusion-Exklusion: Versuch einer neuen Kartografie der Kunst im Zeitalter von Postkolonialismus und globaler Migration', Steirischer Herbst, Reininghaus, Graz, 22 September - 26 October 1996 (screened on monitor)

Group exhibition: 'Città/Natura: mostra internazionale di Arte Contemporanea', organised by Palazzo delle Esposizioni, Villa Mazzanti, Rome, 21 April - 23 June 1997 (projected as installation with four drawings from series *Colonial Landscapes*, 1995)

Solo exhibition: 'William Kentridge', Palais des Beaux-Arts/Paleis voor Schone Kunsten, Brussels, 15 May - 23 August 1998, touring to Kunstverein, Munich, 28 August - 11 October, 1998; Neue Galerie Graz am Landesmuseum Joanneum, 15 November 1998 - 15 January 1999 (screened on monitor)

Michael Godby, *William Kentridge, Drawings for Projection: Four Animated Films,* Goodman Gallery, Johannesburg, 1992, (catalogue) n.p.

Hazel Friedman, 'Not for the Walls but for the Soul…', *The Star Tonight!,* Johannesburg, 11 March 1992

Charles Hall, 'William Kentridge', *Arts Review,* London, June 1992, p.9

Rosanna Negrotti, 'William Kentridge', *What's On*, Johannesburg, 10 June 1992, p.10

V.B. [V. Bobka] 'William Kentridge', *Jurassic Technologies Revenant*, 10th Biennale of Sydney, 1996, (catalogue) p.85

Leslie Camhi, 'Travelling Shots', *Jurassic Technologies Revenant*, 10th Biennale of Sydney, 1996, (catalogue) pp.40-41

Carolyn Christov-Bakargiev, 'Città/Natura', *Comune di Roma,* Palombi Editore, Rome, 1997, p.20

Kendell Geers, *Contemporary South African Art, The Gencor Collection*, Jonathan Ball Publishers, Johannesburg, 1997, pp.74-75

Iwona Blazwick, 'City Nature', *Art Monthly*, London, June 1997, no. 207, p.9

David Krut, *William Kentridge*, CD-Rom, David Krut Publisher, Johannesburg, 1998

'FORTUNA': NEITHER PROGRAMME NOR CHANCE IN THE MAKING OF IMAGES
William Kentridge
(Lecture, 1993, published in *Cycnos: Image et Langage, Problèmes, Approches, Méthodes,* Nice, vol.11 no.1, 1994, pp. 163-168)

INTRODUCTION

I am an artist living and working in South Africa. I have mainly worked with static, two-dimensional images, but have, over the last few years, been working on a series of short films, which I term *Drawings for Projection*. Their starting point is the drawings I have been making and the films began simply as a record of these drawings coming into being (and at times disappearing). They have since become films in their own right. (…) [*Mine*] is the second in the series, though the most recently completed.

*Film Mine, Summary*

Disclaimer: I am not a theoretician. The observations I have to offer about the film and the origin of the images in it are made after the event, an attempt to reconstruct processes. The observations are limited – I am talking about my specific way of working and make no claim as to the general applicability of the processes I describe, although I am, of course, interested in the extent to which these processes are common or usual.

*Stone Age Film-Making*

The technique I employ to make these films is very primitive. Traditional animation uses thousands of different drawings filmed in succession to make the film. This generally means that a team of animators have to work on it, and flowing from this, it means that the film has to be worked out fully in advance. Key images are drawn by the main animator and in-between stages are completed by subordinate draughtsmen. Still other people do inking and colouring.

The technique I use is to have a sheet of paper stuck up on the studio wall and, half-way across the room, my camera, usually an old Bolex. A drawing is started on the paper, I walk across to the camera, shoot one or two frames,

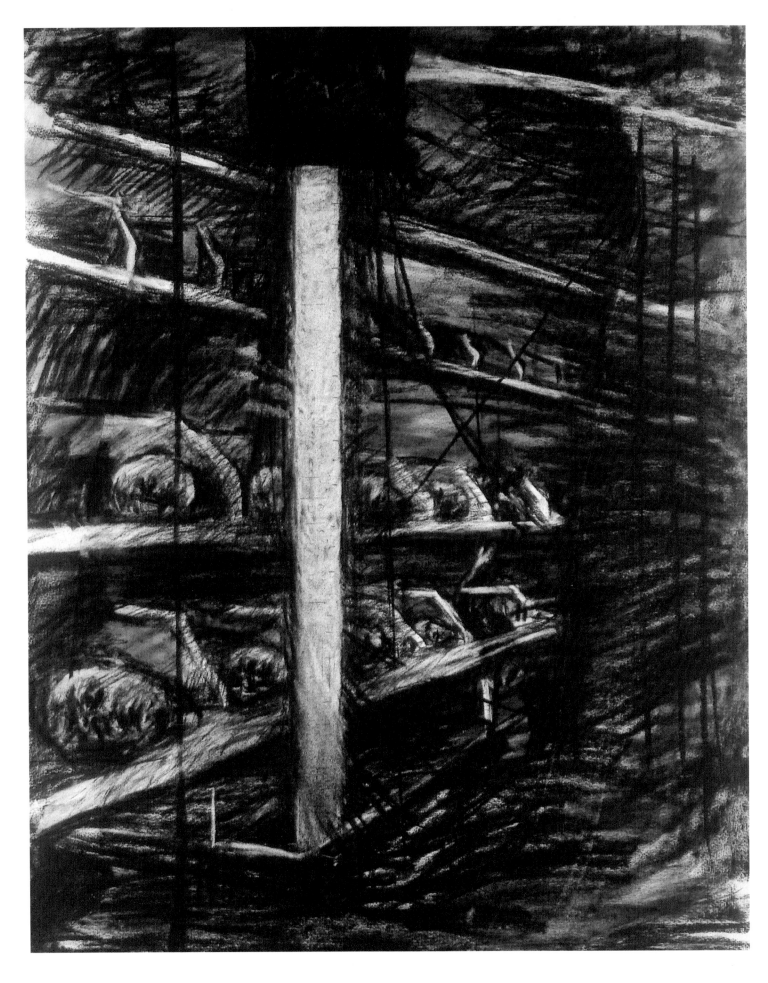

Detail of drawing from *Mine* 1991
charcoal on paper

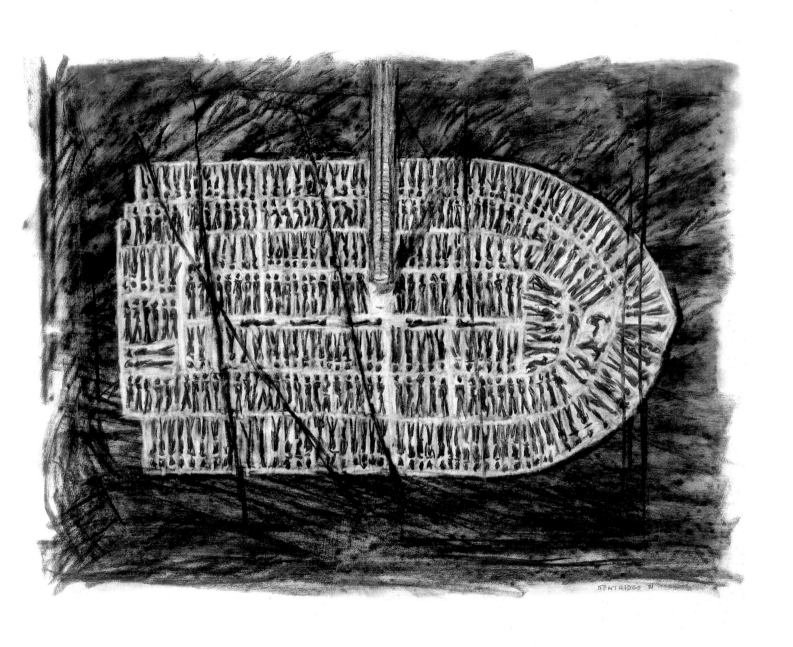

Drawing from *Mine* 1991
charcoal on paper, 83 x 123 cm
National Museum of African Art, Eliot Elisofon Photographic Archives, Smithsonian Institute
photo: Franko Khoury

walk back to the paper, change the drawing (marginally), walk back to the camera, walk back to the paper, to the camera, and so on. So that each *sequence* as opposed to each *frame* of the film is a single drawing. In all there may be twenty drawings to a film rather than the thousands one expects. It is more like making a drawing than making a film (albeit a grey, battered and rubbed about drawing). Once the film in the camera is processed, the completion of the film, editing, adding sound, music and so on proceeds like any other.

*What the Technique Allows*
As I mentioned, I started filming drawings as a way of recording their historys. Often I found – I find – that a drawing that starts well, or with some interest in its first impulse, becomes too cautious, too overworked, too tame, as the work progresses. (The ways in which a drawing can die on you are depressingly numerous.) A film of the drawing holds each moment. And of course, often, as a drawing proceeds, interest

shifts from what was originally central, to something that initially appeared incidental. Filming enables me to follow this process of vision and revision as it happens. This erasing of charcoal, an imperfect activity, always leaves a grey smudge on the paper. So filming not only records the changes in the drawing but reveals too the history of those changes, as each erasure leaves a snail-trail of what has been.

*How the Film came to be What it is*
The drawings are all made in charcoal. Directly, because that is the medium I was using when I started filming the drawings. (Though the same process can be followed, of course, with an oil painting.) But the ease with which charcoal can be erased, with an eraser, with a cloth, even with a breath, makes it particularly suited to this process. And of course, the rough monochromatic drawings refer back to early black-and-white movie making. I am not blind to the nostalgia inherent in this. The nature of this nostalgia, for a period in which political

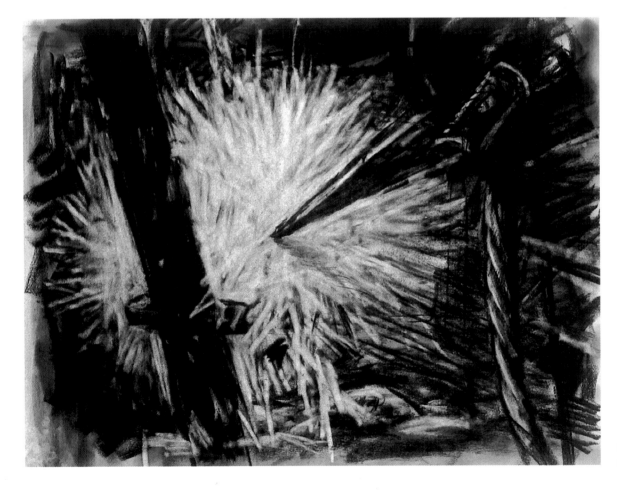

Drawing from *Mine* 1991
charcoal on paper, 60 x 75 cm

image-making seemed so much less fraught, is meat for another discussion. Here, I would just note, as it refers to other points I want to make, the way in which different elements, different causes and impulses come together to make a final meaning. The contingent fact o f using charcoal, the contingent fact of the imperfection of the erasure, the shakiness of the camera, all produce a film that has a very specific nature, and for which I have to take responsibility, but which was not consciously, deliberately or rationally planned.

What I want to talk about now is how the film came to be just as it is, where some of the specific images come from.

When I set out to make this film, my determination was a) that it would have a woman protagonist and b) it would not involve Soho Eckstein, the mine-owner in this and the central character in the other three films. I had an image of 'Liberty at the Barricades', another of a dancing woman clothed in newspapers. I was determined to have a clear storyboard before commencing on the film.

For two weeks I looked into space and brooded. I drew Liberty at the Barricades, got nowhere and then conceded: I would allow myself to start with Soho, the war-horse from the other films. He would make a short entrance before his daughter, Liberty Eckstein took over. In the end she did not get a look in. I had to relinquish my determination and find a gentle entrance to the film.

Which in this case is the drawing of the cross-section of the earth, a geological land-scape. This was the first day's work: the landscape and the mine-lift ascending the shaft. The lift ascending was done largely to feel I had a good first day's work. I could get several seconds of screen time from that lift – which is very easy to do. It is just a black square, rubbed out and repeated a few milli-metres higher. This I think is important. The thought was not, what is the clearest, best way of showing miners getting to the surface, but rather, how can I feel that the film (the making

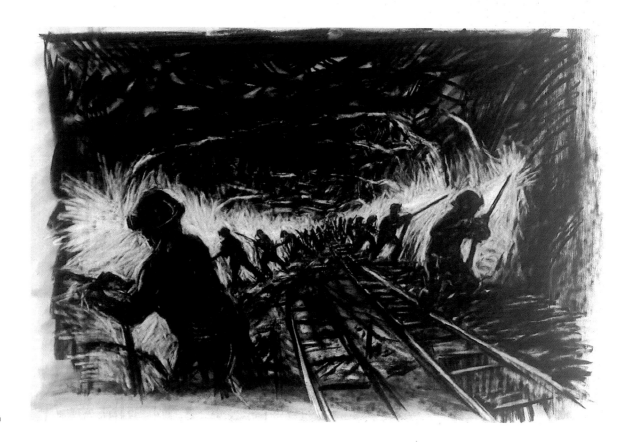

Drawing from *Mine* 1991
charcoal on paper, 75 x 120 cm

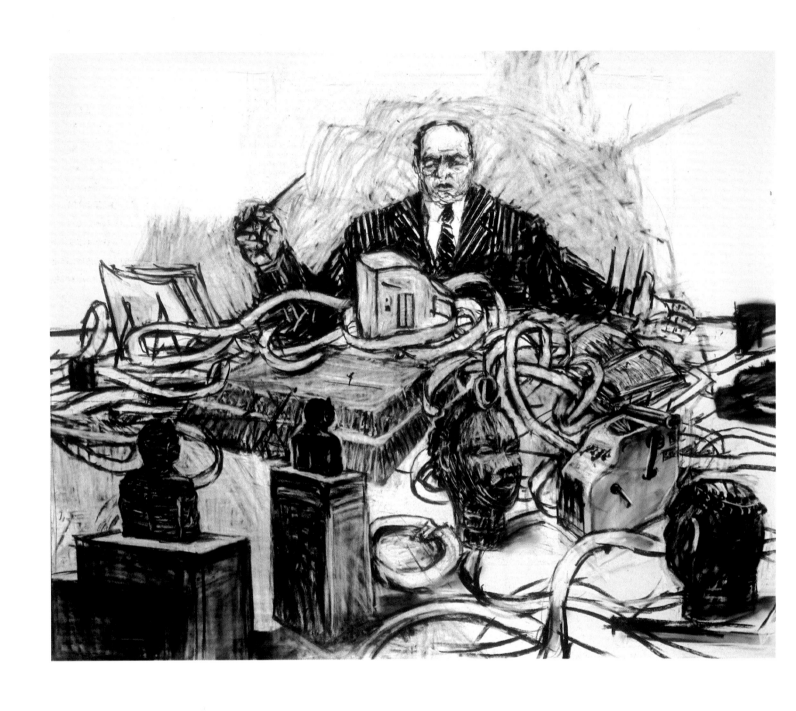

Drawing from *Mine* 1991
charcoal on paper, 120 x 150 cm

of it) is underway? (Measured in seconds, this obsessive project makes one into a miser of frames filmed and seconds completed. It takes the assistance of a profligate editor who abandons metres of film to the floor of the editing room to keep this tightfistedness in check.)

So there is an impurity in the impulse behind the first image. But one that I think neither validates nor invalidates the image. All strategies for conjuring images can only be assessed after the event.

(The pure light of inspiration, for me, is always to be treated with caution. Things that leap out as 'good ideas' are often best left at that. It is in the physical act of their coming into being, and in the form they finally achieve that they have to show their worth, and often things that start rather in the alleys and sluices of the mind, hold their own in the end.)

### Crowd

This is all by way of explanation of the opening of the film with the lift cage and the crowd emerging. This crowd merits a word. Their origin has a huge amount to do with the particular technique I use. In a film using actors one would need a huge budget, thousands of extras, helicopters, an elephantine crew and a military administration to capture the huge crowds emerging from the ground. With this charcoal technique, each person is rendered with a single mark on the paper. As more marks are added, so the crowd emerges. The crowds draw themselves. It is far easier to draw a crowd of thousands than to show a flicker of doubt passing over one person's face.

What we have here then, is not a search for cheap seconds, but an openness to what the technique makes possible. Already something other than a planned story is being followed. These crowds have featured in all four films, in the others as more directly political crowds. It may be of interest to note (and here I do not know how to apportion responsibility) that these images of crowds emerged in my work in 1989, the year of the start of the political thaw in South Africa when, for the first time in my memory, huge political processions surged through the streets.

In *Mine* the crowds emerge as the next logical step of the black square reaching the surface of the drawing.

### Eearthquake

The next thing that happens is that there is a sort of earthquake and Soho Eckstein, the protagonist, turns over in his bed – the landscape becomes his blanket. His entry is a *deus-ex-machina* to end the sequence of the crowd emerging – how long would they emerge for, where would they go? But what this formal solution did was to set the stage for the film. Here we must distinguish between my needs as a maker of the film, and the needs of the viewer of the film, who requires riddles and answers for the story to proceed.

We now have a film with the miners on one hand, and Soho Eckstein on the other.

### Cigar Smoke

At about this point – three days into the drawing of the film (and each of these films is a three- or four-month project) I started gathering other material for the mine sequence of the film. I still thought there would be an opening to the film – Liberty Eckstein was still waiting rather forlornly in the wings. I was uncertain how to get Soho out of his bed into his office (his usual locale in the other films). To fill the time, Soho smokes his cigar. First it turned into a bell, which he rings. But this was a dead end. I do use it in the film, but it does nothing to alter Soho and did not help me, in making the film, to advance it.

### Cafetiere

The next thing I worked on was the cafetiere. It is not the next image in the film, but the next drawing. The second half of the making of the film consists of filling out the shapes and structures that have emerged. Making linking sequences, working backwards and forwards.

The cafetiere in the film is a drawing of the one that was in my studio that morning. It could as easily have been a teapot. And it was only when the plunger was half way down, in the activity of drawing, erasing it, repositioning it a few millimetres lower each time that I saw,

I knew, I realised (I cannot pin an exact word on it) that it would go through the tray, through the bed and become the mine shaft. The sensation was more of discovery than invention. There was no feeling of what a good idea I had had, rather, relief at not having overlooked what was in front of me, and a sense of being really stupid not to have realised earlier what had to happen.

I am not claiming the moment or image as a particularly potent one, but what does fascinate me is to know where that image came from. It was not planned. I could not have predicted it at the start of the day. It was not an answer to a question I had posed myself – 'what is a domestic object that has affinities with a mine lift?' What was going on while I was in the kitchen preparing something to drink? Was there some part of me saying 'Not the tea, there, you fool, the coffee, not espresso, the cafetiere, you daft… Trust me. I know what I'm doing'. If I'd had tea that morning, would the impasse of Soho in bed have continued?

(There is a whole question of 'found' images and objects, the way many artists surround themselves with images, objects, photos to act as talismans in the 'finding' of images, which I can't begin to talk about but which occupies some of the same field, I think.)

*Fortuna*
To summarise so far. I have mentioned three things: the landscape with the black block of the mine lift moving through it, which we could categorise as an image of inauthentic origin; the crowd emerging – an image thrown up by the technique; and the coffee-plunger lift shaft – an image thrown up by incidental circumstances. Each of these images and materials are central to the film, at its very heart. None of them came about through a plan, a programme, a storyboard; neither obviously, did they come about through sheer chance. 'Fortuna' is the general term I use for this range of agencies, something other than cold statistical chance, and something too, outside the range of rational control.

*Rest of the Film*
The rest of the film emerged fairly directly. Once I had the mine shaft there were all the images to imbed in the rock. The men trapped underground, the showers. These images, and the sleepers, were first done to accompany the shaft, and only while drawing them did I think of using them twice – above ground and then in the rocks. The image of the North Atlantic slave ship was thrown up by the plan of the mine shafts. And there is the similarity between these slave diagrams and the serried ranks of people carved on West African granary doors; and the superficial similarity between a lamp on a miner's helmet and the crown on *Ife* sculptures of kings suggested the range of things being mined.

The provenance of all the images is not interesting. I think I used the first few just to show the sort of processes in use.

It is a rather arcane way of working and, of course, a large amount of images that throw themselves up this way have to be discarded. For me, this process has emerged out of necessity. Ideas, images come so grudgingly that I need all the aids, stratagems and incantations I can find. Some people have an ability to sit on their own and follow through a coherent line of thought on their own. They start with a vague impulse and emerge with a concrete plan. This capacity eludes me. When sitting contemplating I either go round in tight circles or slip into neutral and vegetate. An activity is essential for me. It is only when physically engaged on a drawing that ideas start to emerge. There is a combination between drawing and seeing, between making and assessing that provokes a part of my mind that otherwise is closed off.

In the sphere of words, it takes a concrete act of either talking or writing for this process to happen. There are several similarities between the processes of speech and those of making images I have been describing.

First, in the similarity one can detect between making a drawing that has been planned in advance, following a programme, and performing a speech (rather like this one) that has been written in advance. I would suggest that in ordinary conversation this way of

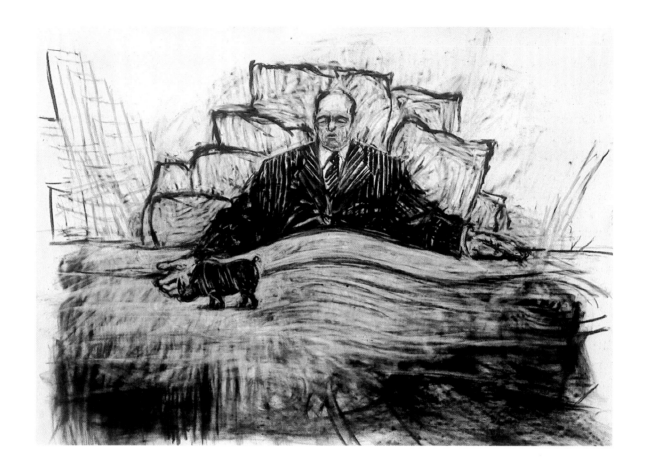

Drawing from *Mine* 1991
charcoal on paper, 120 x 150 cm

arriving at the words spoken is rare. Only occasionally do we test a sentence in our heads before speaking. Generally – and here the process I have described and the nature of the speech get closer – there is an impulse and knowledge of the general direction we want to go in. But then there is a reliance on habit, experience and the unconscious parts of the brain for a sentence to emerge that is formally connected and gets to the destination you had anticipated. One does not regard this as strange. (No more than one regards as strange the tongue's ability to manoeuvre round the mouth while talking or eating without getting torn to shreds by the teeth. It is only when one bites one's tongue and tries to control its location that one realises how much we rely on these directing, controlling and inventive parts of the brain that are generally sealed off from us.)

And allied to this process – in use all the time – in which one's brain is going backwards and forwards along the sentences, checking, getting them in line before the light of day, in which one's brain is far ahead of one's plodding consciousness – allied to this process are the occurrences when not only do thoughts emerge as grammatically saying what you intended, but in the very activity of speaking, generated by the act itself, new connections and thoughts emerge. Rather like in the example of the coffee plunger I gave – new destinations are reached.

I think the process I have described is neither unfamiliar nor surprising, but I would emphasise how central, rather than occasional it is, at any rate in my way of working, and would suggest too that this reliance on 'fortuna' in the making of images or text, mirrors some of the ways we exist in the world, even outside the realm of images and texts.

69

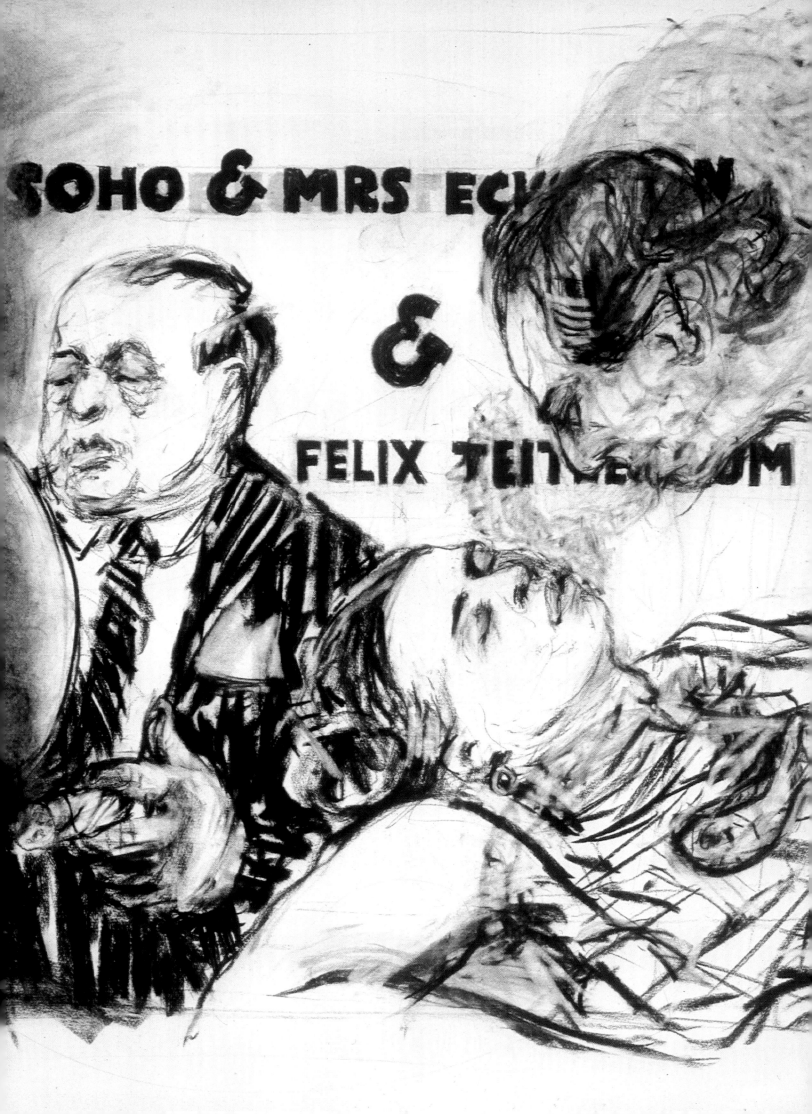

# SOBRIETY, OBESITY & GROWING OLD, 1991

Animated film: 16mm film; video and laser disc transfer
8 minutes, 22 seconds
Drawing, photography and direction: William Kentridge
Editing: Angus Gibson
Music: Dvorak *String Quartet in F* Opus 96; choral music of South Africa; *M'appari* aria from *Martha*, Friedrich von Flotow, sung by Enrico Caruso
Series of c.25 drawings in charcoal on paper or charcoal and pastel on paper; dimensions variable

This fourth animation in the Eckstein/Teitlebaum series depicts the collapse of Soho's empire (or, rather, Soho 'collapsing' his empire), which is represented as a modern city of skyscrapers that recalls Johannesburg in the 1950s. The film returns to the theme of Felix's relationship with Mrs Eckstein and to the consequent competition and conflict between the two male characters, introduced in *Johannesburg, 2nd Greatest City after Paris* (1989).

The narrative of *Sobriety, Obesity & Growing Old*, however, emerges more clearly than in the preceding films, which were often structured as a series of almost independent episodes. It tells the story of Soho's loss of his wife, who leaves his world of architecture and rationality for Felix's open landscape of megaphones, loudspeakers and passion.

The film opens with a protest march. As it enters the empty landscape, loudspeakers and megaphones absorb the blue from the sky. Felix, sitting naked in this setting, 'Listens to the World', as the caption tells us. The scene cuts to Soho's office. Uncharacteristically, though he is still shown at his desk, he is seen from behind. A framed picture of Mrs Eckstein is on the desk, contrasting with the view from the window overlooking the city. A black cat on the desk wakes up and turns into a telephone. After this prologue, Felix enters, offering a small fish to Mrs Eckstein. While Soho lies alone in his bed, Felix and Mrs Eckstein listen to the world together through earphones, watching the marchers. There are signs of a shifting perspective on Soho's character, such as the blue that begins to emerge from his building, implying that he is experiencing a birth of feelings of love and longing absent in earlier films.

The water of Felix's love floods Soho's office as he sits and watches the couple making love on the screen of the picture frame. Under the pressure of Felix and Mrs Eckstein's passion, represented by this water, crushed by the weight of loss and solitude, the buildings of Johannesburg literally melt and crumble. After this catastrophe, Soho is left alone in the landscape with his cat, his loneliness under-scored by the captions 'HER ABSENCE FILLED THE WORLD' and 'COME HOME'.

The camera eye shuts, creating an ellipse in the story, and then opens again onto a medium shot of Soho and Mrs Eckstein reunited in the centre of the barren landscape. They are accompanied by the mellifluous, nostalgic sound of an old recording of Caruso singing the aria *M'appari*. Felix sits alone, just as he had at the beginning of the film. Water fills the space around the prone couple while, from the curved horizon in the background, the protest marchers advance.

Whereas in earlier films, social injustice and human suffering were at the forefront, in *Sobriety, Obesity & Growing Old* the political is kept in the background of what seems to be mainly a psychological drama of love, longing, loss and solitude. However, this is also the first film in which the urban masses are not depicted as passively submissive to power, but are a united crowd. Carrying red banners, they actively march through the city, taking their destiny into their own hands. This is a direct reflection of events in South Africa at the time: opposition to the apartheid regime, demonstrations and marches, which were followed by the lifting of the ban on political organisations (1990) and the relaxation of most of the State of Emergency regulations and restrictions (1991). There is an even stronger feeling in this film than in the first that Felix and Soho are two sides of a single, complex personality. Soho is shown to be capable of awareness and longing, perhaps even of guilt and repentance, and therefore becomes a victim of his own past, less powerful but also more human. Not only is he seen at times from behind, as Felix was, but his bald head indicates ageing. Both he and Felix are associated with loudspeakers and megaphones tools that project the senses, instruments through which to transmit from a position of power (the megaphone on top of the Eckstein Building), or through which to listen from a position of awareness, (as in the scenes of Felix sitting in the suburban landscape surrounded by loudspeakers). If Soho represents white power in South Africa during apartheid, this transformation from the flat, stereotypical

<
Detail of drawing from *Sobriety, Obesity & Growing Old* 1991 charcoal and pastel on paper, 120 x 150 cm

Drawings from *Sobriety, Obesity & Growing Old* 1991 charcoal on paper, 120 x 150 cm each

characterisation of the first few films, to a more rounded figure capable of emotions, metaphorically points to the progressive growth of awareness within the white community, along with the rise of activism and organised protest on the part of the black community. By implication, it underscores how these parallel kinds of awareness could contribute to toppling the system of segregation. (CCB)

*A further stage in the show-down between Soho and Felix. Soho's empire collapses. The world is too hard to deal with. He implodes the city. Alone in the wasteland he calls to his wife, 'COME HOME'. Felix is left on his own in the wasteland.* (WK, 1994)

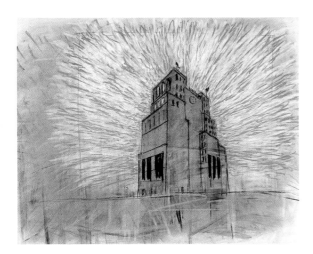

*Sobriety, Obesity & Growing Old* wins Rembrandt Gold Medal, 'Cape Town Triennial Exhibition', Cape Town, 1991

Solo exhibition: 'William Kentridge: Drawings for Projection', Goodman Gallery, Johannesburg, 21 February - 14 March 1992 (screened on monitor, with drawings)

Group exhibition: 'Incroci del Sud: Affinities – Contemporary South African Art', Fondazione Levi Palazzo Giustinian Lolin, 45° Venice Biennale, June - October 1993, organised by the South African Association of Arts in collaboration with Sala 1, Rome, where the exhibition was held from 31 October - 2 December 1993, touring to Stedelijk Museum, Amsterdam in 1994 (screened on monitor)

'Annecy International Festival of Animated Film', Annecy, June 1993 (projected film)

'Best of Annecy Festival', Museum of Modern Art, New York, 1993; touring to Centre Georges Pompidou, Paris

'Edinburgh International Film Festival', Edinburgh, August 1993 (projected film, shown in a retrosepctive of Kentridge's animated films)

'Annecy International Festival of Animated Film', Annecy, June 1995 (projected film, shown in a retrospective of Kentridge's animated films)

Group exhibition: 'Mayibuye I Afrika: 8 South African Artists', Bernard Jacobson Gallery, London, 28 September - 28 October 1995 (screened on monitor)

Group exhibition 'On the Road – Works by 10 Southern African Artists', The Delfina Studio Trust, London, 5 October - 12 November 1995 (screened on monitor)

'Festival des Dessins Animés', Le Botanique, Brussels, February 1996 (projected film, shown in a retrospective of Kentridge's animated films)

Culturgest, Lisbon , July 1996 (projected film)

Group exhibition: 'Inklusion-Exklusion: Versuch einer neuen Kartografie der Kunst im Zeitalter von Postkolonialismus und globaler Migration', Steirischer Herbst, Reininghaus, Graz, 22 September - 26 October 1996 (screened on monitor)

Solo exhibition: 'William Kentridge', Palais des Beaux-Arts/Paleis voor Schone Kunsten, Brussels, 15 May - 23 August 1998, touring to Kunstverein, Munich, 28 August - 11 October, 1998; Neue Galerie Graz am Landesmuseum Joanneum, 15 November 1998 - 15 January 1999 (screened on monitor)

Michael Godby, *William Kentridge, Drawings for Projection: Four Animated Films*, Goodman Gallery, Johannesburg, 1992, (catalogue) n.p.

Hazel Friedman, 'Not for the Walls but for the Soul…', *The Star Tonight!*, Johannesburg, 11 March 1992

Charles Hall, 'William Kentridge', *Arts Review*, London, June 1992, p.9

Rosanna Negrotti, 'William Kentridge', *What's On*, Johannesburg, 10 June 1992, p.10

Esmé Berman, *Painting in South Africa*, Southern Book Publishers, Pretoria, 1993, p.317

VB [Vivian Bobka] 'William Kentridge', *Jurassic Technologies Revenant*, 10th Biennale of Sydney, 1996, (catalogue) p.85

Kendell Geers, *Contemporary South African Art, The Gencor Collection*, Jonathan Ball Publishers, Johannesburg, 1997, pp.74-75

David Krut, *William Kentridge*, CD-Rom, David Krut Publisher, Johannesburg, 1998

Okwui Enwezor, 'Swords Drawn', Frieze, London, issue 39, March/April 1998, pp. 66-69

'I've done many drawings of floods. Floods at the Opera House, floods all over things. I think that the Pantheon in Rome would be wonderful if it had a metre of water in it and everybody was wandering and wading through it. I don't have a theoretical wish for that to happen in the Pantheon because that would represent, or be a symbol of, something specific. It's just that when I actually walk into the Pantheon I ache for that to be the situation. I have no idea where it comes from, and I've never had a specific idea of water being cleansing. I just have a sense of the wanting of that water, and welcoming it when it appears in the drawings or in the images like that. (…) This is not a theme but a recurrent image, a feeling that does go through my drawing. A longing for water, for buckets being poured over people.'
(William Kentridge quoted in Amanda Jephson and Nicholas Vergunst, ADA, no.4, Cape Town, December 1987 - January 1988, pp.6-7)

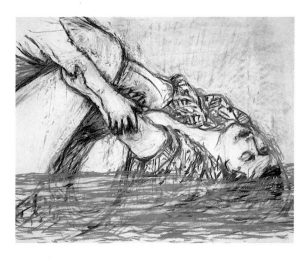

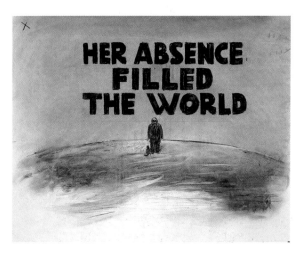

DEAR DIARY:
SUBURBAN ALLEGORIES AND OTHER INFECTIONS
William Kentridge
(excerpts from lecture at the Decorative Arts Society, Johannesburg, 21 September 1990)

In the 18th century and before, there was a hierarchy of image-making, some pictures were thought to be more important and worthwhile than others.

Top of the list came religious paintings: annunciations, saints, martyrs. This is where all the big commissions were, followed slightly down the ladder by history paintings: kings, princes, treaties being signed, surrenders accepted. Big subjects and big paintings. These were the big themes of the day; this is where the serious artists should be.

(…)

All calls for culture as a weapon for relevant art have implicit in them the same hierarchy of subject matter. Serious art should deal with certain matters and not with others. Here, let us erect quickly two separate beacons. The first, which I am not so concerned with, we could call the Sachs and anti-Sachs beacon – that is, external pressures over what art should or should not be made. The second, which I am interested in tonight, has to do with the personal acceptance of this pressure of importance, moment, relevance. Let me stress that this is a personal beacon we are circling. Many artists are fortunate not to be drawn to it and are only concerned with the Sachs/anti-Sachs flashing light, which is generally encountered as an annoyance, a set of hoops to be jumped through or ducked under.

The personal beacon is much harder to deal with. I am referring to the space in my head occupied by the situation in which I live my daily life. As a shorthand we could say 'apartheid'. I am referring to the way it seems to loom up and block all avenues of retreat. All questions get circumscribed by it. All facets of life are affected by it. It is not that other subjects do not exist, it is rather that they transform themselves into it, or it colonises them.

There are two reasons for this. Firstly, it is obviously a correct analysis of our lives. Behind

Drawing from *Sobriety, Obesity & Growing Old* 1991
charcoal and pastel on paper, 70 x 100 cm

Drawing from *Sobriety, Obesity & Growing Old* 1991
charcoal on paper, 120 x 150 cm

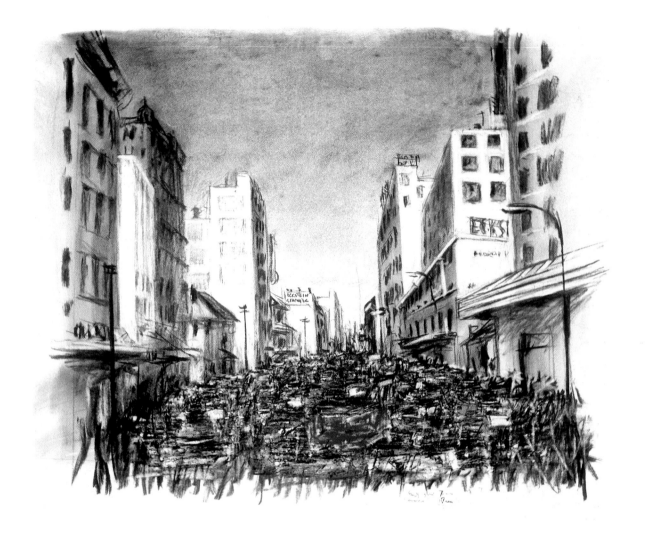

Drawing from *Sobriety, Obesity & Growing Old* 1991
charcoal and pastel on paper,
70 x 100 cm

our daily lives, in which we are oblivious to the pain, trauma and dislocation around us – this is not a criticism, it is a condition of daily life: world spirit seldom impinges itself on us when eating supper – is a world shaped and given a structure by our particular history, and a responsibility for this we cannot escape. Here, please understand, I am talking about a rational understanding of the basis of our lives.

The second reason comes from the first and has to do with the sense of responsibility or guilt engendered by this understanding. It causes all work, certainly all reflective work, to be seen from the standpoint of redemption. In other words, it gives an overall moral perspective to one's project. Not to say that one is hoping to make the world a better place. Concrete results, or even the hope of them, have nothing to do with the force of this need. It is working from the perspective of redemption, rather than working *for* redemption.

These two elements – our history, and the moral imperative arising from that – are the factors for making that personal beacon rise into the immovable rock of apartheid. To escape this rock is the job of the artist.

These two constitute the tyranny of our history.

And escape is necessary, for as I stated, the rock is possessive, and inimical to good work. I am not saying that apartheid, or indeed, redemption, are not worthy of representation, description or exploration, I am saying that the scale and weight with which this rock presents itself is inimical to that task.

*Detour*
Here, for a moment, let us leave the map we are on and look briefly at this same problem, the tyranny of apartheid as subject, in other media. Part of the dismal failure of some recent films about South Africa is the fact that the film's

starting point is to show apartheid. The rock is faced head on. Squads of extras are dressed, and either police or comrades are marshalled, to take part in these exercises to scale the rock. The rock always wins. Certainly there are some PR victories along the way, some hearts and minds changed, some tears extracted. But overall, the impression left is feeble. Even when the group of climbers is limited and the story focuses on only a few people rather than THE PEOPLE ON THE MOVE, the films are defeated by the fact that the people inhabiting the film are being used as a metaphor, as a way of revealing something other than themselves.

One of the reasons for the success of *A World Apart* [Chris Menges, 1987] was its commitment to its own story: the conflict between the mother and daughter was the engine that drove the film. Its weakest moments were when it felt it had to pay homage to the shadow of the rock looming over it. I am not saying that mothers and daughters are better subjects for films than apartheid, I am saying that subjects that have an origin outside of a particular object may often be more illuminating in their oblique light than the full searchlights of the project that stares straight at this object. The difficulty I am trying to show is that this object is so large, our distance from it so small, that it is difficult to get any sort of obliqueness into our view.

(…)

Let us recapitulate briefly. We have established the outer borders of the map, somewhere between pure spirit manifesting itself, and the ego out for a walk – an area roughly corresponding to the terrain of dreamwork. Within this area we have come across an important landmark, which we have called the tyranny of history.

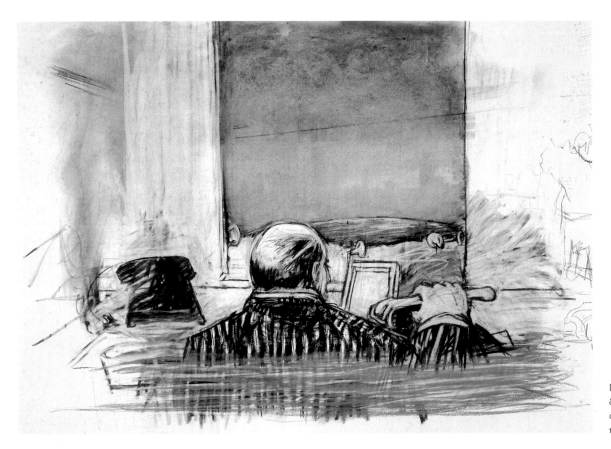

Drawing from *Sobriety, Obesity & Growing Old* 1991
charcoal and pastel on paper,
120 x 150 cm

## News from Abroad

The next beacon, and this brings us back to my dream, stands opposite the history beacon and represents the weight of the tradition of image-making I have worked through and in. It is Charybdis to the tyranny of history's Scylla.

In a summarised form, the tradition of the Scylla moves from the Renaissance through various local schools to the origins for modernism in 19th-century France. The familiar progression from Impressionism, post-Impressionism, to Cubism, Expressionism, to Surrealism. The hop across the Atlantic in the 1940s to the Abstract Expressionists in New York. And then various other forms and schools of abstract painting, colour field. Now, this is a very simplified and not very accurate summary of that history – but it was this tradition that existed as a pressure during my art training, and it still exists as a pressure in the sense of proclaiming that only that which is formally innovative is of value.

According to this rendering of art history, other movements and painters that occurred alongside these main movements are subsidiary and quaint, not central: Dada the amusing infant that grows into Surrealism, Beckmann a side show left over from Expressionism. And the movements or painters that have come after the high point of modernism are all regressive, essentially sentimental.

(...)

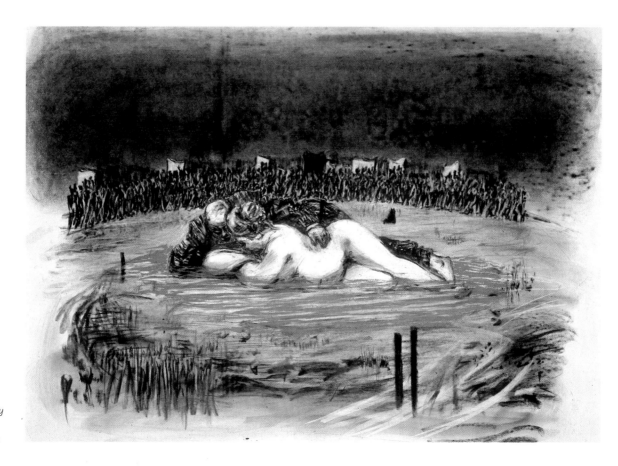

Drawing from *Sobriety, Obesity & Growing Old* 1991
charcoal on paper, 120 x 150 cm

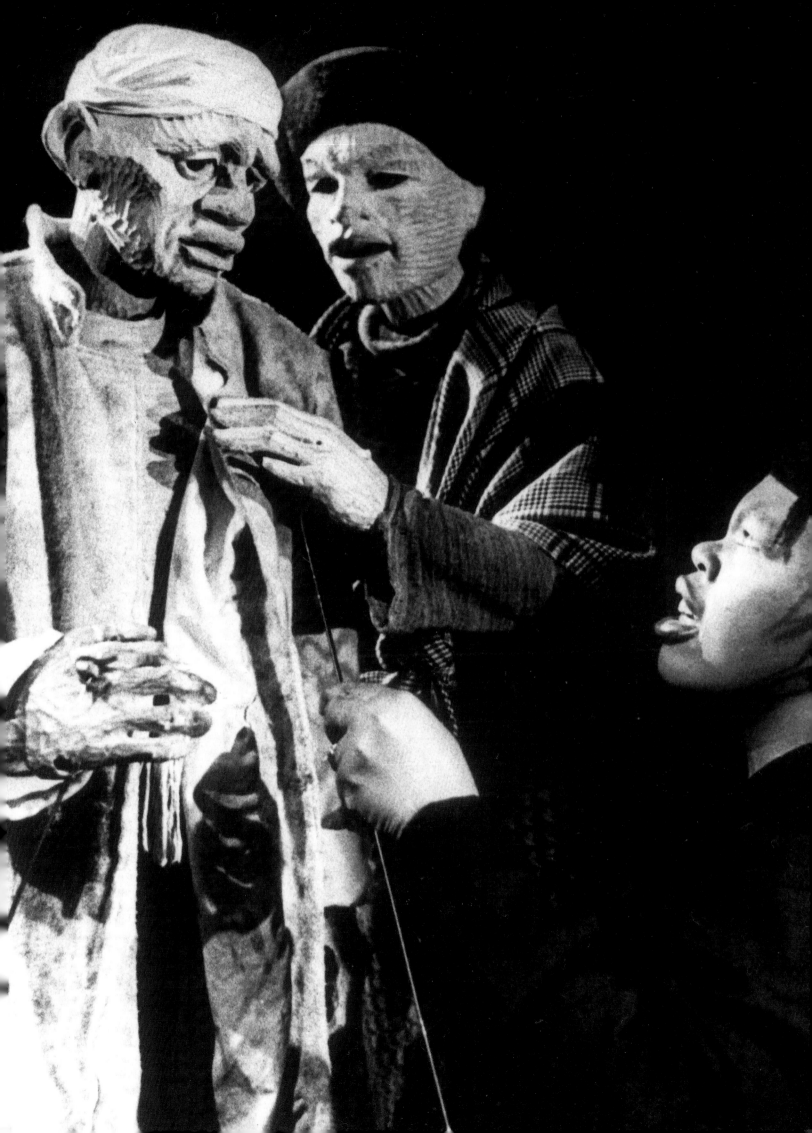

# WOYZECK ON THE HIGHVELD, 1992

Theatre production with
puppets, actors and animation
c.1 hour, 20 minutes
Production: The Handspring
Puppet Company
Project Co-ordinator:
Basil Jones
Director: William Kentridge
Designers: Adrian Kohler and
William Kentridge
Animation:
William Kentridge, with the
assistance of Erica Elk and
editing by Thabo Nel
Puppet maker: Adrian Kohler,
with the assistance of François
Viljoen and Erica Elk
Sets: François Viljoen
Music: accordion music
written and performed by
Alfred Makgamelele;
additional music written by
Edward Jordan and Steve
Cooks; additional accordion
music performed by
Mike van Graan; cello, Clare
Hooyburg; extract from Alban
Berg's *Wozzeck*
Sound Design:
Wilbert Schübel
Lighting Design:
Mannie Manim
Cast: Woyzeck (Louis Seboko),
Maria (Busi Zokufa),
The Miner (Tale Motsepe),
Margaret (Tale Motsepe)
Andries (Tale Motsepe),
the Captain (Basil Jones),
the Doctor (Adrian Kohler),
the Barker (Tale Motsepe)

<

Rehearsal *Woyzeck on the
Highveld*, Johannesburg, 1992,
photo: Ruphin Coudyzer
(Courtesy Handspring Puppet
Company)

Rehearsal *Woyzeck on the
Highveld*, Johannesburg, 1992:
Woyzeck and doctor puppets,
© Friedemann Simon

Rehearsal *Woyzeck on the
Highveld*, Johannesburg, 1992:
Louis Seboko with Woyzeck
puppet and Woyzeck puppet
with constellation,
photos: Ruphin Coudyzer
(Courtesy Handspring Puppet
Company)

All puppets carved by
Adrian Kohler

*Woyzeck on the Highveld* was the first collaboration between William Kentridge and the Handspring Puppet Company of South Africa. By combining puppet theatre with animated films, they expanded the possibility of both media. The result is a complex, layered and epic vision of multiple personae in a dark and sinister tale, shifting continuously between three levels: back-projected animation, live actors and puppets. The harsh space of the landscape described in the animated, deeply etched charcoal drawings led to the decision to carve the puppets from roughly hewn, raw wood – a new departure for Handspring. Kentridge's method of exposing the process of manufacture in his art fits well with Handspring's Bunraku-inspired expedient of allowing the puppeteers to remain visible on stage.

The play is based on the uncompleted work, *Woyzeck*, by German playwright Georg Büchner, who died prematurely in 1837. Büchner came from a small backwater near Darmstadt whose social structure was still feudal despite the abolition of serfdom in 1820. Peasants and labourers were heavily taxed by a nobility that lived in isolated splendour. In 1834, Büchner formed a revolutionary action group of students and labourers, expressing his radical views in the form of pamphlets. His plays articulate a deep social consciousness; he was the first major writer to put the lives of working-class people centre stage.

Many productions, in theatre, music and film, have been inspired by *Woyzeck*, including Alban Berg's opera *Wozzeck* (1915/1925), Werner Herzog's film *Woyzeck* (1979) and the Bread and Puppet Theatre's interpretation directed by Peter Schumann in New York in 1981. Büchner's version was based on the true story of an impoverished wig-maker, barber and engraver who fathers an illegitimate child, joins the army in Leipzig and falls in love with a woman. Discovering that she is also having affairs with other soldiers, he flies into a fit of jealous rage and stabs her to death. In the early 1800s, this story was the subject of heated debate centred on questions of sanity and moral culpability.

*Woyzeck on the Highveld* is set in contemporary South Africa, yet makes stylistic reference to early Expressionism. Its main theme is personal dilemma, dealing with class, sex, anger, frustration, revenge and guilt. It also explores the economic, political, social and personal pressures that push people to extreme acts of violence. A black, migratory labourer, Woyzeck has an affair with Maria, for whom he works as a servant. She calls him Harry, a name often used by Kentridge in his early drawings and animations for leaders of the dispossessed. His rival is a miner. In a fit of desperation, Harry kills Maria and the play ends in a pool of red, flooding the back-projected screen above the stage.

In the video animation, charcoal drawings depict the poor, urban townships of South Africa, a crowded dance hall, a mine, and the wasteland landscape of the Highveld around Johannesburg. Constellations, written words, stylised drawings of objects such as bones or a gun looming in the sky, function like allegorical emblems. (CCB)

*One's looking from the performer's face saying the lines next to the puppet, through to the puppet, and back to oneself. And although one is very aware, and sees quite clearly the artifice and how it's all done, how the manipulation is achieved, and where the voices are coming from, nonetheless, essentially, one's attention is on that puppet as the agent of the play.* (WK, 1992)

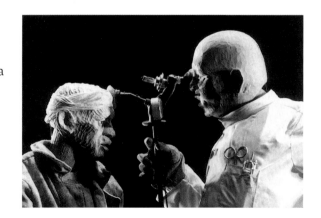

1992: 'Standard Bank National Arts Festival', Grahamstown, 7 - 12July (Premiere); 'Arts Alive Festival', Market Theatre, Johannesburg, September - October

1993: European tour including Theatre Der Welt, Munich and De Ark, 'Antwerp '93', Antwerp

1994: Toronto; 'International Kunstenfestival', Brussels, Stuttgart, Granada, Glasgow, Bochum, Braunschweig, Berlin, Goteborg, New York ('International Festival of Puppet Theatre'), Chicago

1996: Hong Kong, Adelaide ('Adelaide Festival'), Wellington, Bogota, Jerusalem, Avignon

*Woyzeck on the Highveld,* Market Theatre, Johannesburg, 1992, programme notes

Kathy Berman, 'The Puppets Bare All', in *Cue,* Grahamstown Festival, 1992

Garalt MacLiam, 'Exceptional Synthesis a Wonder to Behold', *The Star Tonight!,* Johannesburg, 11 September 1992, p.4

Kathy Berman, 'Mixed Medium Marvel', *Vrye Weekblad,* Johannesburg, 17 September 1992

Darryl Accone, 'Animated Encounters in 3-D', *The Star Tonight!,* Johannesburg, 18 September 1992, p.4

Charl Blignaut, 'Making Sense of Darkness', *Vrye Weekblad,* Johannesburg, 18 - 24 September 1992, p.14

Raeford Daniel, 'Woyzeck on the Highveld', *The Weekly Mail,* Johannesburg, 18 - 24 September, 1992, p.24

Rosemary Simmons, 'Romancing the Plate', *Printmaking Today,* London, vol. 2 no.4, Winter 1993, p.7

Robert Von Lucius, 'Das Wunder in der Puppe', *Frankfurter Allgemeine Zeitung,* Frankfurt, 5 July 1993, p.27.

Margaret Heinlen, 'Woyzeck on the Highveld', *Puppetry International,* UNIMA, New York, 1994, premiere issue, p.20

Penny Francis, 'Woyzeck on the Highveld, Handspring Theatre', *Animations,* London, August - September 1994, p.18

Lawrence Van Gelder, 'Woyzeck, as Puppet, Still Yanked Around by Life', *New York Times,* New York, 8 September 1994, pp. C13, 16

Hedy Weiss, 'Puppets People Expand Woyzeck', *Chicago Sunday Times,* Chicago, 16 September 1994

Ruth Sack, 'Faust's Journey to Africa', *Mail and Guardian,* Johannesburg, 15 - 22 June 1995, p.31

Renate Klett, 'The Voice of Africa', *Theater Heute,* Berlin, 9 September 1995, pp.8-9

Geoffrey V. Davis, Anne Fuchs, 'An Interest in the Making of Things. An Interview with William Kentridge', in *Theatre and Change in South Africa,* Harwood Academic Publishers, Amsterdam, 1996, pp.140-151

René Solis 'Woyzeck et Faust en ombres africaines', *Libération,* Paris, 13 July 1996

Olivier Schmitt 'Inattendus parfums d'Afrique du Sud', *Le Monde,* Paris, 13 July 1996

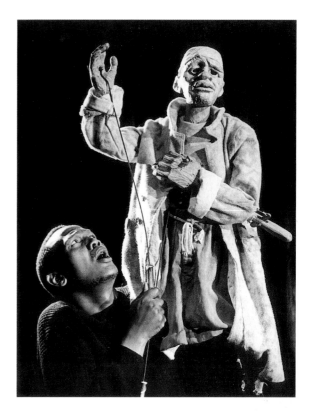

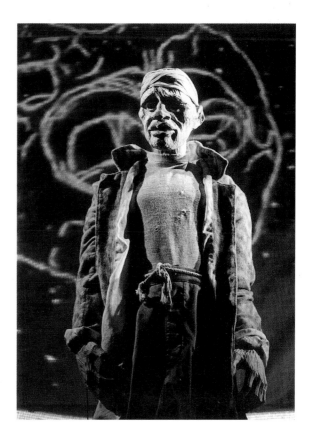

William Kentridge
(from *Woyzeck on the Highveld,*
The Market Theatre, Johannesburg, 1992,
programme notes)

I first came across the play *Woyzeck* in Barney Simon's remarkable production in the old Arena Theatre in Doornfontein in the 1970s. Characters and images from the play have floated on the edges of my consciousness since then. For many years I have wanted to do some form of a production of the work, as it has seemed to me that the anguish and desperation of Büchner's text does not need to be locked into the context of Germany in the 19th century and that the similar circumstances that exist in South Africa today make this play completely eloquent in a local setting.

The second source of this production is to be found in the desire to work with puppetry in general and the Handspring Puppet Company in particular – to work in an area in which performance and drawing come together, to try to see if one could find an emotional depth and weight without recourse to the obvious technique of psychological transformations of an actor's face.

The third source is the animated film that I have been making. The cumbersome and archaic technique of charcoal drawing and erasure that I use imposes severe limitations on the mobility and interaction of the drawn figures. Working with puppets and these animated films attempts to bring the possibilities of versatile three-dimensional movements into the work I have been doing.

This is my first experience of working with puppets, and the discoveries have been enormous. Each day of rehearsal has brought revelations of the things that puppets can do better than their living counterparts (try training a rhinoceros to write or an infant to fly on cue). Also worth watching out for is that strange condition where the manipulation of the puppet is completely transparent, where, in spite of seeing the palpable artificiality of the movement of the puppet, one cannot stop believing in the puppet's own volition and autonomy.

THE MUSIC OF WOYZECK ON THE HIGHVELD
William Kentridge
(from *Woyzeck on the Highveld,*
The Market Theatre, Johannesburg, 1992,
programme notes)

In the middle of the documentary film 'Two Rivers' there is a fragment of a street musician playing an accordion outside the Johannesburg Station. The remarkable quality of his playing and singing has haunted me since I saw the film eight years ago. When starting on this production we listened again to the music on the soundtrack of that film, made a recording of it and sent people throughout the land armed with cassette players. Eventually we tracked down the musician himself, Alfred Makgamelele, now living in Alexandra Township and performing to huge crowds outside Park Station every Saturday morning. His music forms the core of the play. An extra song on accordion was played for us by Mike van Graan, and Clare Hooyburg, a 3rd-year music student at Wits University, provided a counterpoint on the cello to Mr Makgamelele's accordion. Edward Jordan, who had done the music for my animated film *Monument*, took time off from releasing his first solo album to write additional music, which he and Steve Cook added to the musical raw material we had collected. There is also a 27-second extract from Alban Berg's opera *Wozzeck*.

AN INTEREST IN THE MAKING OF THINGS
(excerpts from interview with William Kentridge by Geoff Davis and Anne Fuchs, 15 September 1992, published in G. Davis, A. Fuchs, *Theatre and Change in South Africa*, Harwood Academic Publishers, Amsterdam, 1996, pp.140-151)

(...)
The current production of *Woyzeck on the Highveld* is a mixture of drawings and filmmaking and theatre. At times I thought about it simply as a director, another time I thought: 'it's just a drawing that has gone into other

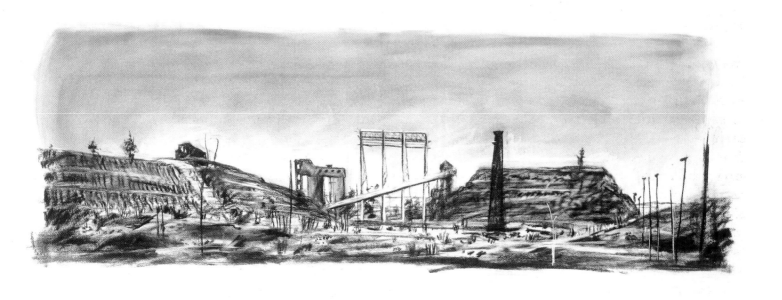

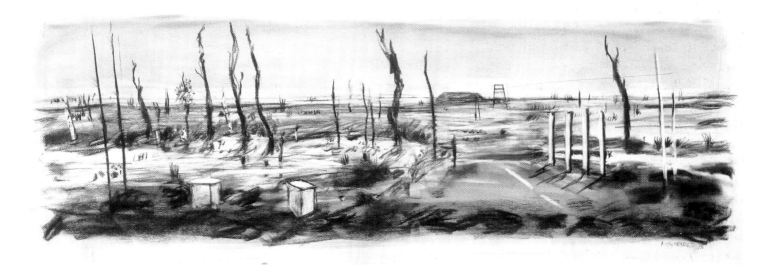

Drawing from *Woyzeck on the Highveld,* used in animation for theatre production, 1992
charcoal on paper

directions as well.' Over the years there have been specific ways of working, which have to do with painting or film-making or with theatre, here, there is a greater transference of strategies of working from one form into another.

(…)

In the production of *Woyzeck on the Highveld* there is a sequence in which Woyzeck has to lay a table. The corresponding scene in the original is that of Woyzeck shaving the Captain, which for the puppets is too clumsy and messy. And when I did the sequence, it started with an animation of objects moving round a table, getting more and more out of control: a metaphor for Woyzeck's inability to cope with the world. At that stage it wasn't completely clear whose table it was going to be. It was really a sense of playing with animation that could work on a screen and that would have a relation to something happening on the acting surface below the screen. At that stage I think there was the idea that the Captain eating at his table was going to take up a large part of the play, which was going to be constructed around the Captain's dining table. But it was very much a game that was being played by myself, of what objects could be brought on, how they could move. It didn't have a root directly in the play, it didn't have a root, when I was doing it in my head, directly in any particular personal history.

(…)

Now that the sequence is finished and Woyzeck performs it, I realise very strongly that it has a direct reference back to an old manservant who used to serve at my parents' table when I was a child – to his panic and inability to deal with the niceties of bourgeois etiquette around a table. But that, in a sense, is something that I have recognised once it's finished, and it's one of the reasons why that scene works powerfully.

(…)

I'm always interested in the area in which meaning comes: it's not something that's just storyboarded and scripted in advance, it's between programme and it's also, obviously, not complete chance. It's not putting a pin down in the middle of a dictionary and using

Drawing from *Woyzeck on the Highveld*, used in animation for theatre production, 1992 charcoal on paper

that as the reference material. It's somehow that one's unconsciousness is a step ahead, or makes connections that are there. For me, an actual metaphor for that way of understanding the construction of meaning in work would be conversation, where, on the one hand, you could rehearse a sentence before you utter it and you simply perform something you've thought out in your head – which would be like planning a drawing or a piece of work entirely in advance and performing it. But generally, one has a vague sense of what one is going to say but one relies on one's brain and tongue to put coherent grammatical sentences together that you can't anticipate entirely at the beginning, but which make sense at the end.

But more than that, very often in the activity of that conversation, in that physical activity of talking, new thoughts develop; things that you didn't know at the beginning make sense at the end. And that way of working seems to me very important in the way of constructing the meaning, both in the drawings and in the animated films and, to a certain extent, in the theatre. In theatre work it's harder if you start with somebody else's script. In film work it's impossible if you are working with a large crew. You have, in terms of time and cost, to have planned everything in advance. But with the animated films, where it's simply me and a piece of charcoal and a sheet of paper and a camera in a studio alone, it's very easy to start a sequence without knowing necessarily how it links together and how it will end. I think that's my general relationship to meaning.

(...)

In the Woyzeck production there has certainly been input, as I would imagine there is in most productions, from the actors, and in terms of the design and making of the puppets. Of course, there was not just an input – it was a real collaboration. But overall it was very important that I felt it was my vision, my story, to be able to push into shape, the way it would if I were simply working on a drawing.

(...)

We had started work on *Woyzeck* and the play was nearly finished before I actually remembered that when I was at High School I had done a series of poster and set designs for a hypothetical production of *Woyzeck* as an art project. I think I had heard a recording of the opera that had fascinated me and I'm sure the photograph of Walter Berry in his beret as Woyzeck on the record cover was a key. When we decided that we were going to work together on a production – Basil Jones, Adrian Kohler from Handspring Puppets, and myself – Woyzeck wasn't by any means a starting point. We were going to work on something together and initially it was assumed we would write a new piece. But I'm not a writer, and I just got more and more traumatised and terrorised by the idea of having to write a play. In the first notebooks – it was eighteen months ago – and before the word 'Woyzeck' had come up, the characters that were present already included someone with the megaphone (because that has been an image present from a series of drawings that has its origin in a photograph of Lenin speaking into a megaphone I had seen in John Willet's *The New Society*. Also, one sees that horn in Max Beckmann's paintings). So that character comes from somewhere between the photograph from the 1920s and a Beckmann painting. That was one character that existed. The character of Woyzeck is similar to

Drawings from *Woyzeck on the Highveld*, used in animation for theatre production, 1992
charcoal on paper

the character that I used in a version of Hogarth's engraving called *Industry and Idleness*. First of all he becomes Lord Mayor of Derby Road, the street in Bertrams adjacent to the house I live in. And I had also used this particular man as an actor in a short film called *T. & J.* (Tristan and Isolde), making a version of the opera in which he wears a herring-bone coat, walking across the landscape. So this character who had also been in various drawings was definitely going to be in the play. Initially, he was going to be carrying a huge load on his back, a bit like a Goya drawing of someone, an Atlas character carrying a pack on his back. So he was present; then there was going to be the usual business man, Soho Eckstein, as he has been in the animated films, who was going to be in the script. These were all characters that I was interested in turning into three dimensions as puppets and taking them out of the drawings.

Another starting point of the project was a sense of the landscape of the terrain that is south of Johannesburg; an area and landscape that is defined by industrial detritus, by failed civil engineering projects. And at various stages we looked at some Mayakovsky plays – at the *Mystery-Bouffe* – looking to see whether we could rewrite it for puppets. *Woyzeck* came up as an idea and when it came up, we thought 'OK, that sounds great as a starting-point', but it was really only going to be a starting point. At one point we had extra characters, we had the Captain's wife, we had the police Captain, we had the Soho Eckstein character seducing Woyzeck's wife at some stage, and it became a completely different story. We had a puppet that was going to eat everything on the table, a puppet that would expand to the width of the stage. Also, we had someone with a huge megaphone that was such a size we could operate glove puppets inside the bowl of that megaphone as a sort of stage within a stage. So there are still things to be done.

But once it came down to the nuts and bolts of saying 'How is the story going to be done? What is it going to be about?' it became clear that there was more than enough on our plate, tailoring it all down, and at that point, with very minor changes, the play transposed – not just effortlessly – onto a South African context and absorbed the set of characters that were there in advance of that particular production. The new ones, obviously, are the doctor, who hadn't been in my scheme, Maria, and the accordion player Andries. (Although the accordion player – who hadn't been in the list of characters in my head – had been present as a character in film scripts that I had written and in a series of drawings.) The newspaper woman, the sort of deathlike figure, was again something that came from drawings, and once we had that puppet she had to be given something to do, so she was given some of Margaret's lines, which was fairly easy. It wasn't as if the play had to be wrestled into finding the characters that one could transpose it into, those were prior to it.

(…)

If one was working with a rough technique of these drawn landscapes and drawn environments (we could have chosen, for example, just simply to film the terrain south of Johannesburg and use that for our backdrops), we needed the characters to match this roughness, so that there wasn't a huge distinction between what you saw on the screen behind and the puppets in front. And that was obviously, both in terms of scale and in terms of breaking away from naturalism, far easier to do with puppets than with fancy cosmetics or actors. There's also a sense in which when the manipulators are visible and next to the puppets, (which they are in a large number of significant scenes in the puppetry play), they are not simply obstructions getting in the way of seeing the play, they act as aides to the action, and chaperones to the story being told, which, in terms of what happens to the character of Woyzeck, creates a different meaning too from what we would have achieved by simply using an actor.

(…)

Even when you don't see the manipulators, one is very much aware that these are not live people and that these are puppets you are watching. When you actually see the manipulators with them, in a way, you are usually able

to accommodate their awkwardness and the things they can't do.

(…)

The man on whom the character [of Harry] is based is Derek Buys. He lives in the neighbourhood where I live in Bertrams, which is a fairly rough, inner-city area of Johannesburg. At one stage in his life he was a maths teacher, but now he is essentially, I suppose, a down-and-out hobo, very much known in the area, very much based in the area, and I have used him as a model for a number of drawings and pictures. Woyzeck came from the drawings and not directly from the man, but he's certainly present through the drawings. That was one sort of local talisman, making sure that, yes, this is the way such a character could be in the world. I mean Woyzeck in Büchner's play is very much more part of a clearly stratified society. Woyzeck is employed as a Private in the army. In South Africa, if one is actually talking about the bottom of the social pile… if somebody has a regular job and a regular income, he is relatively speaking part of a privileged group. And the huge bulk of the population, increasingly so, are people at the edge or below that, who've got jobs for a short amount of time and who don't have a regular place to live, or live in squatter settlements. They are the informal part of the economy rather than people who can rely on health benefits or anything that even Woyzeck could have had as a Private in the army in Germany in the 1830s. So I think that change of social position in our production is an accurate one. To have had Woyzeck as a soldier in the South African army would have introduced a far greater number of distortions and abnormalities into the relationships of the story than it does this way.

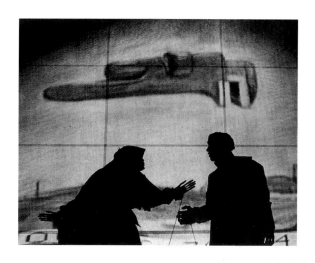

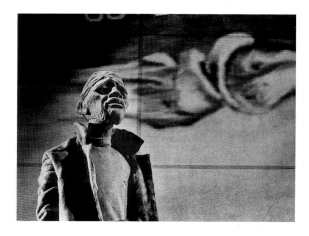

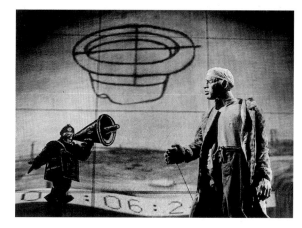

Rehearsal *Woyzeck on the Highveld,* Johannesburg, 1992: Margaret and Woyzeck puppets; Woyzeck puppet and sky omens, photos: Ruphin Coudyzer (Courtesy Handspring Puppet Company)

All puppets carved by Adrian Kohler

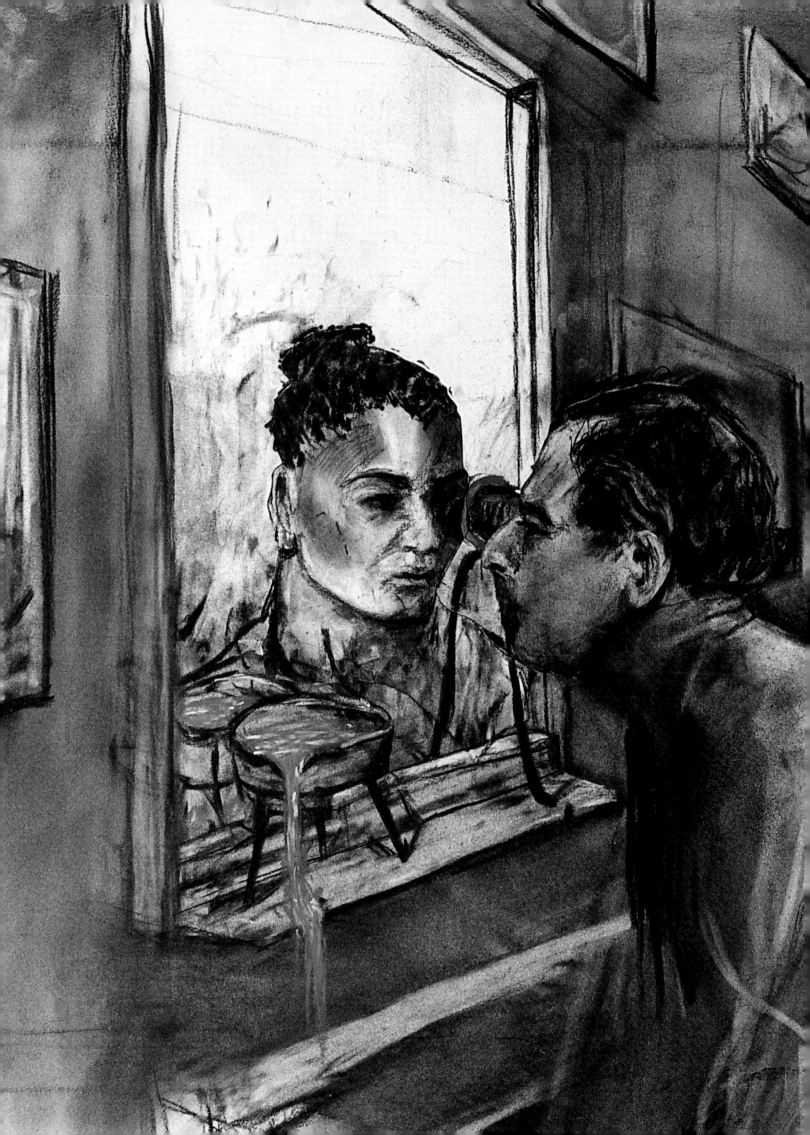

# FELIX IN EXILE, 1994

Animated film: 35mm film;
video and laser disc transfer
8 minutes, 43 seconds
Drawing, photography and
direction: William Kentridge
Editing: Angus Gibson
Sound design:
Wilbert Schübel
Music: composition for string
trio by Philip Miller
(performers: Peta-Ann Hold-
croft, Marjan Vonk-Stirling,
Jan Pustejovsky); 'Go Tlapsha
Didiba' by Motsumi Makhene
(performed by Sibongile
Khumalo)
Series of 40 drawings in
charcoal, pastel and gouache
on paper; dimensions variable

The fifth in the Soho Eckstein/Felix Teitle-baum series, *Felix in Exile* concentrates on Felix, while Soho is temporarily erased from the story.

The film begins with an indistinct view of a landscape resembling the mining and industrial wasteland of the Witwatersrand outside Johannesburg. It then cuts to a close-up of a hand, drawing surveyor's marks and measurements on paper, and this is immediately followed by a view of the African woman, Nandi, who is making the drawing. Behind her is a surveyor's theodolite (an instrument for measuring angles).

As in the earlier films, two points of view are juxtaposed, but they are not presented in opposition as the characters of Felix and Soho were. Felix is portrayed naked and alone in a dismal hotel room adorned only by a bed, chair, mirror, sink and bidet. He is looking at a suitcase full of Nandi's drawings. Nandi observes the land with surveyor's tools and instruments, drawing what she sees. She is measuring and recording on paper the evidence of violence and brutal massacre so that it will not be reabsorbed into the terrain. She also looks at the sky at night, seeing emblems and images in the constellations above. As she draws, her vision materialises into orange-red silhouettes around bodies with bleeding wounds, lying in the landscape. Isolated in his room, Felix cannot directly 'see' the landscape, nor the marches of protesters, nor the dying, bleeding bodies covered in newspapers, who are absorbed into the landscape. He sees only Nandi's drawings, and through her eyes, through what she sees in her round lens, he is granted an oblique and indirect vision onto the violence perpetrated on the body/terrain of Africa.

Nandi's drawings look much like Kentridge's – a device that causes the viewer to confuse reality and representation, art and life within the film – itself a representation. Similarly, sheets of paper fly off from Nandi's drawing-board or from Felix's suitcase, and are blown into the sky or onto the walls of the hotel room where they form an interior landscape. Papers cover bodies like bandages and return as drawings.

By shaving, Felix erases his own reflection from the mirror, but Nandi, as if on the other side of the membrane between art and reality (represented by the mirror), inundates his room with water and encounters him through a double-ended telescope, which they both look into together. Felix and Nandi embrace in the pool of water. Nandi begins to draw; beacons or markers rise up from the ground. This process of drawing could be read as a metaphor for the attempt to reconstruct a post-colonial and post-apartheid identity through memory and awareness of colonialism, violence and racism, rather than through its erasure. In charting the landscape, Nandi is reappropriating the tools that were once used to dominate the terrain, in an active attempt to map new histories and geographies, a 'new' South Africa.

Felix, meanwhile, is lonely and anxious, an imprisoned and impotent onlooker. As Nandi bathes in a pool, she is shot and falls to the ground like the bodies that she had drawn earlier in the film. The hotel room fills with water, the papers peel from the wall and Felix is left alone in the pool of her lost body, his back to the viewers, looking out at the barren terrain. (CCB)

*Felix is alone in a room (I assume Paris, from the title of the first film). The landscape of the East Rand fills his suitcase and walls. The terrain is filled with bodies. These corpses melt into the ground. A new woman, Nandi, surveyor of this landscape, meets him across his mirror. She is absorbed into the ground. Felix returns to her pool.* (WK, 1994)

*Felix in Exile was made at the time just before the first general election in South Africa, and questioned the way in which the people who had died on the journey to this new dispensation would be remembered – using the landscape as a metaphor for the process of remembering or forgetting.* (WK, 1997)

Drawing from *Felix in Exile* 1994
charcoal on paper, 120 x 150 cm

Drawing from *Felix in Exile* 1994
charcoal and pastel on paper,
120 x 160 cm

Drawing from *Felix in Exile* 1994
charcoal on paper, 120 x 150 cm

Drawing from *Felix in Exile* 1994
charcoal and pastel on paper,
120 x 150 cm

Solo exhibition: 'Felix in Exile',
Goodman Gallery,
Johannesburg,
16 October - 5 November 1994
(screened on monitor)

'Annecy International Festival
of Animated Film', June 1995,
(projected film, shown in a
retrospective of Kentridge's
animated films)

Group exhibition: 'Mayibuye
I Afrika: 8 South African
Artists', Bernard Jacobson
Gallery, London,
28 September - 28 October
1995 (screened on monitor)

Group exhibition: 'On the
Road - Works by 10 Southern
African Artists', The Delfina
Studio Trust, London,
5 October - 12 November 1995
(screened on monitor)

'Festival des Dessins Animés',
Le Botanique, Brussels,
February 1996,
(pr *Felix in Exile*

14 May - 18 August 1996
(screened on monitor)

Group exhibition: 'Inklusion-
Exklusion: Versuch einer
neuen Kartografie der Kunst
im Zeitalter von Postkolonial-
ismus und globaler Migration',
Steirischer Herbst,
Reininghaus, Graz,
22 September - 26 October
1996 (screened on monitor,
with drawings)

Group exhibition:
'documenta X', Museum
Fridericianum, Kassel,
21 June - 28 September 1997,
(video projection on wall)

Solo exhibition: 'William
Kentridge', The Drawing
Center, New York,
8 January - 14 February 1998
(video projection on wall)

Solo exhibition: 'William
Kentridge', Stephen Friedman
Gallery and A22 Gallery,
London, 6 March - 18 April
1998 (screened on monitor)

Solo exhibition: 'William
Kentridge', Palais des
Beaux-Arts/Paleis voor
Schone Kunsten, Brussels,
15 May - 23 August 1998,
touring to Kunstverein,
Munich, 28 August -
11 October, 1998; Neue Galerie
Graz am Landesmuseum
Joanneum, 15 November 1998 -
15 January 1999
(screened on monitor)

Sue Williamson, Ashraf Jamal,
'William Kentridge: Devils
and Angels', in *Art in South
Africa: The Future Present*,
David Philip, Cape Town and
Johannesburg, 1996, pp.46-51

Kendell Geers, *Contemporary
South African Art, The Gencor
Collection*, Jonathan Ball
Publishers, Johannesburg,
1997, pp.74-75

Paul Sztulman, *documenta X
Short Guide*, documenta und
Museum Fridericianum,
Kassel, Veranstaltungs -
GmbH, Cantz Verlag, 1997, n.p.

William Kentridge,
'Amnesty/Amnesia', in
*Politics – Poetics documenta X
the book*, conceived by
Catherine David and
Jean-François Chevrier, Cantz
Verlag, Ostfildern-Ruit, 1997,
pp.606-608

Leslie Camhi, 'Mind Field',
*The Village Voice*, New York,
27 January 1998, p.89

Roberta Smith, 'William
Kentridge', *The New York
Times*, New York, 6 February
1998, p.E36

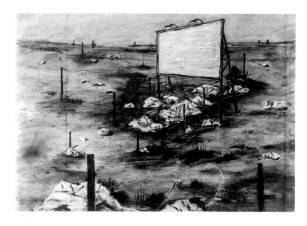

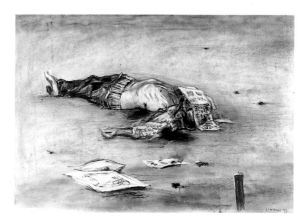

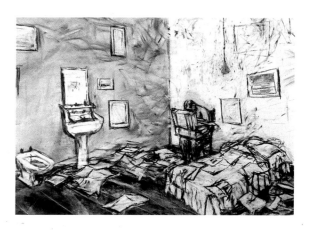

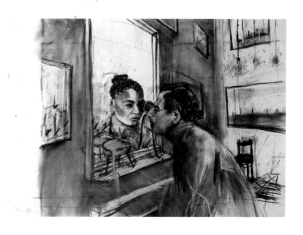

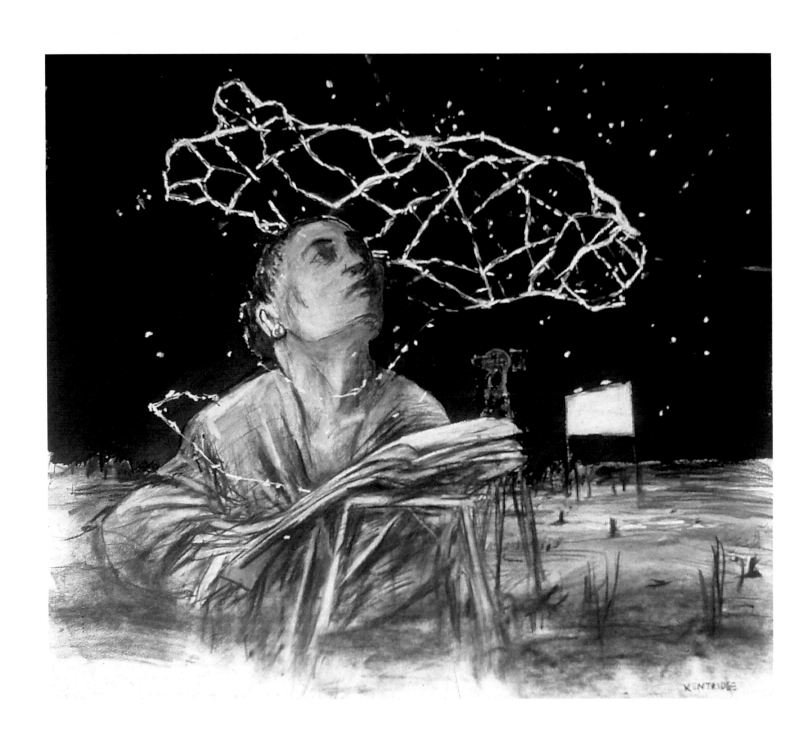

Drawing from *Felix in Exile* 1994
charcoal and pastel on paper, 80 x 120 cm

FELIX IN EXILE: GEOGRAPHY OF MEMORY
William Kentridge
(originally presented in longer form as a lecture
at North Western University, Illinois, USA,
November 1994. An abridged and edited ver-
sion was published in *Felix in Exile*, exhibition
leaflet, Goodman Gallery, Johannesburg, 1994.
Further edited versions were published in
German in *Ici et ailleurs Hier und anderswo*,
Graz, 1996, (catalogue) pp.163-165; *Inclusion/
Exclusion: Versuch einer neuen Kartografie der
Kunst im Zeitalter von Postkolonialismus und
globaler Migration*, Steirischer Herbst, Graz,
1996, (catalogue) pp.245-246; *Politics-Poetics
documenta X the book,* conceived by Catherine
David and Jean-François Chevrier, Cantz
Verlag, documenta and Museum Fridericianum
Veranstaltungs-GmbH, 1997, pp.606-608)

This film was made between September 1993
and February 1994, in the period just before the
General Election. It is the fifth in a series chron-
icling the saga of Soho Eckstein (property
developer extraordinaire) and Felix Teitlebaum
(whose anxiety flooded half the house).

*Panic/Picnic*
*Felix in Exile* had a number of starting points.
The first was in a series of phrases or word
games, a kind of kinetic, concrete poetry I was
playing with on a computer. Simple transitions
such as 'exit/exist', 'historical/hysterical',
'the sweet smell of Jasmine and hysteria':

> FELIX
>
> EXILE  AMNESTY
>
> ELIXIR  AMNESIA

I have a contradictory response to these word
games. On the one hand I am wary of the par-
ticularly Anglo-Saxon tendency to rely on puns
and alliteration as a substitute for ideas. On the
other hand, we have to trust in things that at
the time seem whimsical, incidental, inauthen-
tic. This is not to say that the starting point will
transform itself from something ephemeral to
something solid, but rather, that it gives an
entry point and that through the process of
working that ensues, connections, inventions,

images are generated that can both rescue the
origin and find a heart of the material that
might otherwise not have been evident.
Let me stress here that it is in the process of
working that my mind gets into gear – by which
I mean the rather dumb physical activity of
stalking the drawing, or walking backwards
and forwards between the camera and drawing;
raising, shifting, adapting the image. I am not
saying that this is a universal way of working,
but that in my case it is vital (and in a sense
explains the need to spend these months,
or years, involved with what at times was
perilously close to becoming a form of
occupational therapy).

*Surviving his Life*
The second starting point was an image I had of
Soho shaving, losing his face in the mirror, and
a film of him trying to retrieve his own image.
'I will not survive my life' was the note that
went with it at the time. For quite a while after
the film began, I assumed that this would be
the heart of the film. It was only after the near-
anagram of Felix in Exile insisted itself that
Soho left the project, and the shaving sequence
diminished.

*Bodies in the Landscape*
The third and central starting point, was a
series of police forensic photographs of murder
victims. In fact, the starting point was not the
photos, but a friend's description of having
seen these photos of bodies in landscapes.
In fact, nearly all of the photos are of bodies in
small rooms or small open spaces, alleys, corri-
dors. But in my head, sight unseen, the descrip-
tion of them as bodies in landscape was prior.
The photographs served as references for draw-
ings that in a sense had already constructed
themselves. In the end, the photographs I used
were ones that came closest (in most, not all
cases) to these prior images I had of corpses in
landscapes. Which if I think back now, have
their roots in the body lying on the ground in
Goya's *3rd of May 1808.*

As with all the films, the process of con-
struction is one of moving backwards and for-
wards from images as they emerge. After about

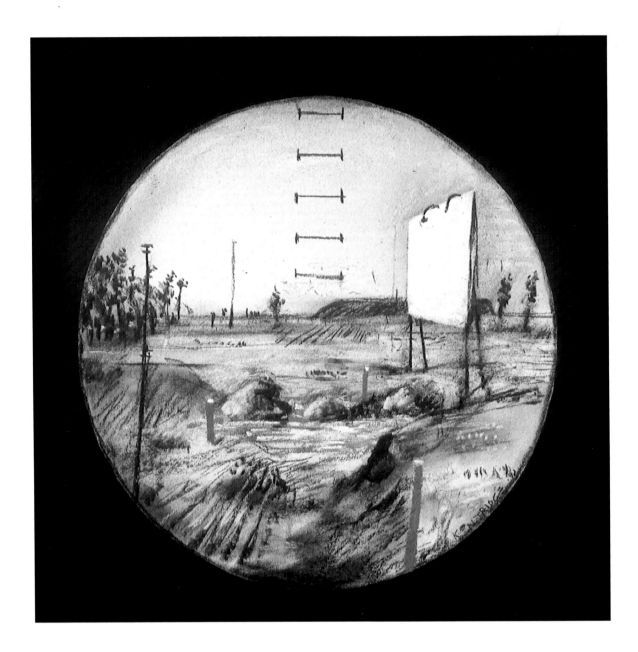

a week of drawing, there are approximately forty seconds of film. When these rushes are viewed, the first hypothetical film is formed around them, and the next few weeks' work is based on this. When this new work is in turn put onto the editing table, and inter-cut with the first material, new pressures and values are put onto the first images. Things tangential to the film suddenly become central to it. Other elements that I had thought of as vital do not maintain their place in the film. In this way, for example, the Cassandra figure, Nandi, found her way into the film. Initially, she was simply one of the corpses about to be absorbed by a landscape; as the weeks progressed, it became clear that she was very central to the film.

### Reprocessing the Landscape

The landscape of *Felix in Exile* is that of the East Rand – the mining areas near Johannesburg. Virtually all the mines in this area are now derelict. This was also the centre of manufacturing in the country, but a large number of the factories have not survived the various recessions of the last few years. So it is an area that has a nostalgia built into it. Everything in it alludes to the past.

### Received Landscapes

The central thing about this landscape is that it is the very antithesis of landscape as received wisdom. One of the first art books I was given as a child was *Great Landscapes of the World*,

Drawings from *Felix in Exile* 1994 charcoal, pastel and gouache on paper, 45 x 54 cm each

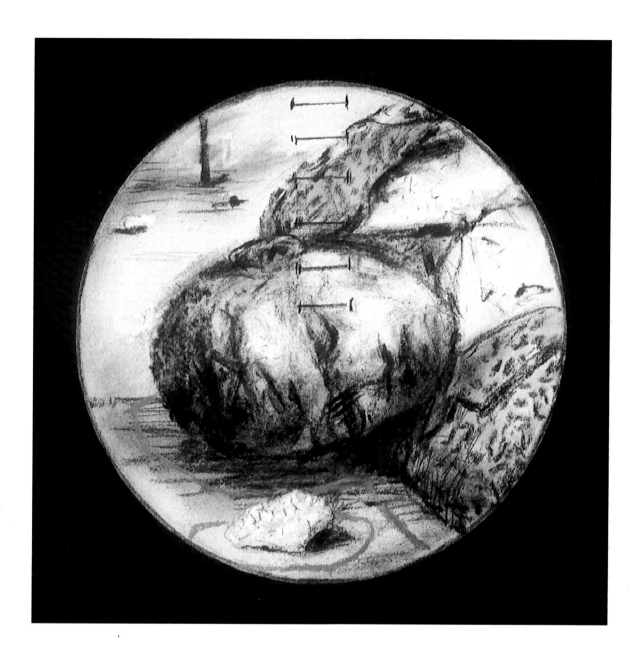

which included Bruegel (*Fall of Icarus*), Corot, Courbet (*Forest and a Stream*), Constable's *Hay Wain*, a jungle of Le Douanier Rousseau. Hobbema's *Avenue of Poplars* stood out, I remember, for its awkward bleakness (I wondered how they could use it on the cover of the book). These landscapes were all utterly inviting and utterly removed from the land around Johannesburg. They functioned as pictures of a verdant paradise, but as one that did exist elsewhere and which I/we had been cheated of. The suburban garden of the house I lived in was, I am sure, as lush as any of these paintings, but this was a miniaturised copy – not the real thing.

The other received landscapes of my childhood were those of English children's books, which contained a world of village-wood-stream-field. The experience of Johannesburg was completely other. The veld around the city had no trees, no waters, and at best, dry, mealy stubble.

A central characteristic of the East Rand terrain, is that it is a landscape constructed rather than found. This, only in the most direct sense since the structure of what one sees is given not by natural phenomena such as mountains, rivers, lakes, forests, but by things that have been made – mine dumps, drainage dams, pipelines, abandoned roadworks. It is a landscape that is explicitly social. It is also temporal – everything in the landscape has the

signs of having been put there and having been made – all features have the potential to be unmade (the yellow mine dumps, a feature of my Johannesburg childhood, have almost all been physically excavated, turned into a slurry and pumped through gold reprocessing plants).

This terrain therefore stands in bleak opposition, not only to the verdant landscapes of children's literature and of European utopian painting, but also to other strains in South African landscape painting such as the geological approach to landscape one finds with painters like Pierneef.

*Amnesty/Amnesia*
The landscape hides its history. The general nature of terrain and landscape as image is to appear as fact. The power of both the childhood landscapes I have referred to and of the paintings of people like Pierneef is that they appear out of time. As if they would give us a truth other than their being a single moment in a process that precedes and will surpass the instant represented.

I am getting onto tricky terrain here. I want to claim that there is a similarity between a painting or drawing, which is oblivious to its position in history, and the terrain itself, which also hides its history. The art-historical point, I am not particularly interested in here, though I think an interesting investigation could be made into the successive depopulation of colonial landscape paintings – a depopulation following and corresponding to the conquering of these terrains. I am really interested in the terrain's hiding of its own history and the correspondence this has, not only with painting, but with the way memory works. The difficulty we have in holding onto passions, impressions, ways of seeing things, the way that things that seem so indelibly imprinted on our memories still fade and become elusive, is mirrored in the way in which the terrain itself cannot hold onto the events played out upon it.

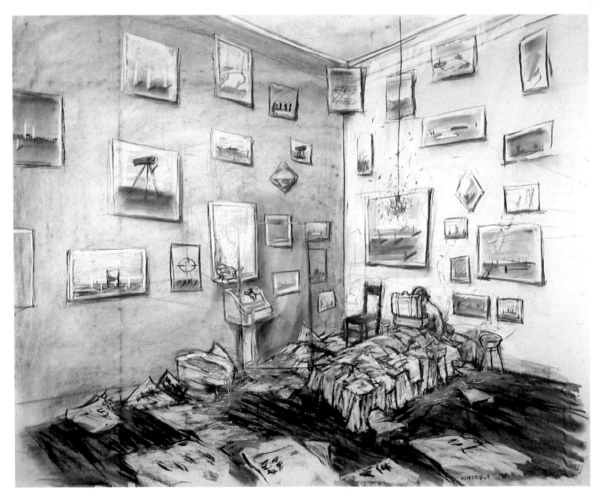

Drawings from *Felix in Exile* 1994 charcoal and pastel on paper, 120 x 150 cm each

I mean this in a very crass way. Sites of events, massacres, battles, celebrations, retain scant record of them. The name Sharpeville conjures up a knowledge of the massacre outside the police station in the township near Vereeniging. And perhaps images from photographs, documentary films that may have been seen. But at the site itself, there is almost no trace of what happened there. This is natural. It is an area that is still used, an area in which people live and go to work. It is not a museum. There are no bloodstains. The ghosts of the people do not stalk the streets. Scenes of battles, great and small, disappear, are absorbed by the terrain, except in those few places where memorials are specifically erected, monuments established, as outposts, as defences against this process of disremembering and absorption.

In the same way that there is a human act of disremembering the past, both immediate and further back – which has to be fought through writing, education, museums, songs and all the other processes we use to try to force us to retain the importance of events – there is a natural process in the terrain through erosion, growth, dilapidation that also seeks to blot out events.

In South Africa, this process has other dimensions. The very term 'new South Africa' has within it the idea of a painting over of the old, the natural process of disremembering, the naturalisation of things new.

In *Felix in Exile* the bodies in the landscape are connected to this process. I was interested in recording the people. Giving burial to these anonymous figures in the photographs. And in erecting a beacon against the process of forgetting the routes of our recent past. It is also a way of fighting against the vertigo produced by looking around and seeing all the old, familiar landmarks and battle-lines so utterly shifted and changed.

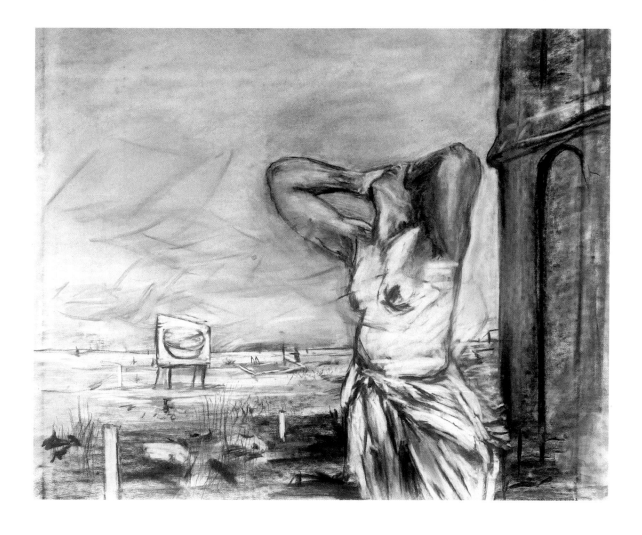

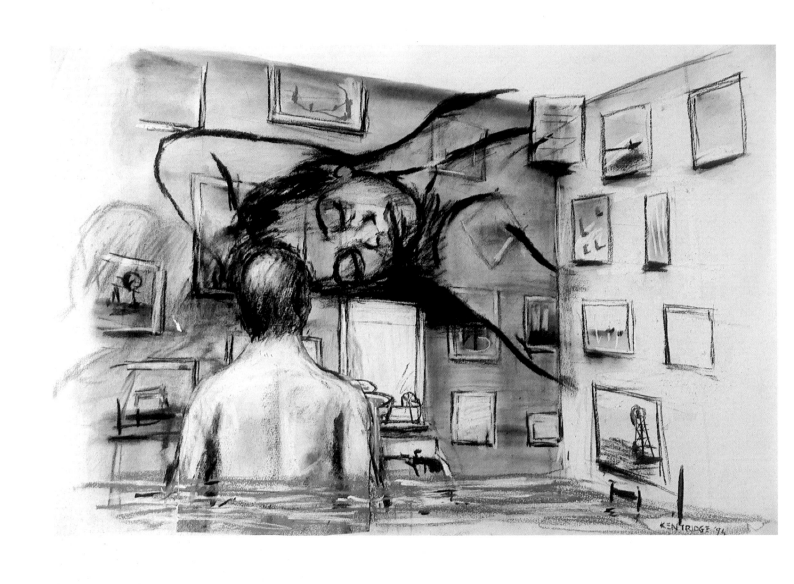

Drawings from *Felix in Exile* 1994
charcoal and pastel on paper, 120 x 150 cm each

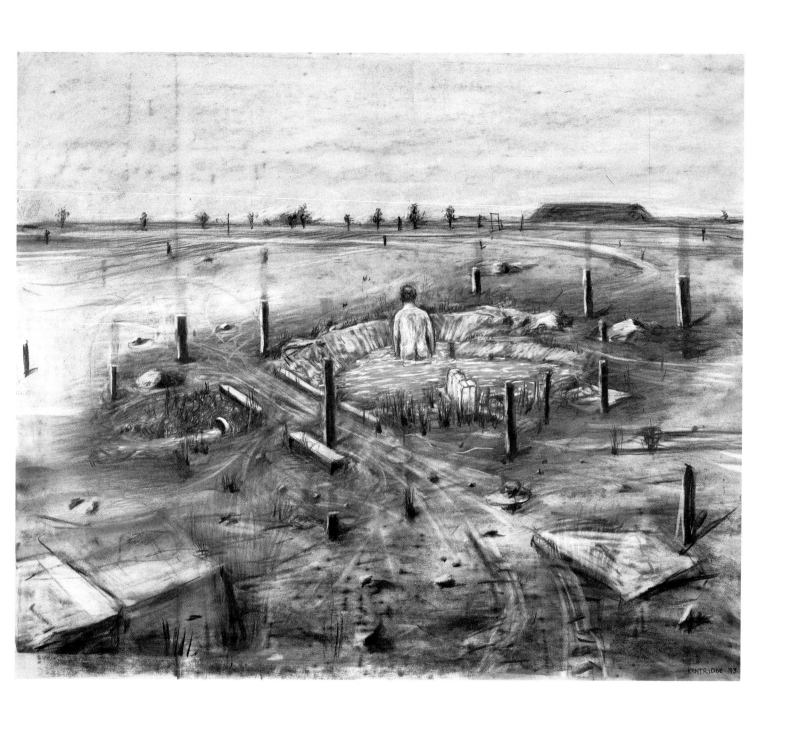

 **HANDSPRING PUPPET COMPANY**

 **& MANNIE MANIM PRODUCTIONS**
in association with
**THE MARKET THEATRE COMPANY**
Present

# FAUSTUS IN AFRICA!

Directed by
**WILLIAM KENTRIDGE**

# FAUSTUS IN AFRICA! 1995

Theatre production with
actors, puppets, back-projected
animation
c.2 hours, 20 minutes
Handspring Puppet Company
and Mannie Manim
Productions
Series of c.92 drawings and
fragments used for animation
Director: William Kentridge
Text: Based on Johan Wolfgang
von Goethe's Faust,
with additional text by Lesego
Rampolekeng
Set design: Adrian Kohler and
William Kentridge
Animation:
William Kentridge, with the
assistance of Hiltrud Von
Seydlitz
Lighting: Mannie Manim
Sound Design:
Wilbert Schübel
Costumes: Hazel Maree,
Hiltrud Von Seydlitz
Music: James Phillips,
Warrick Swinney
Puppets: Adrian Kohler, with
the assistance of Tau Qwelane
Production co-ordinator:
Basil Jones
Cast: Dawid Minnaar
(Faustus), Leslie Fong
(Mephisto), Busi Zokufa
(Gretchen and God), Louis
Seboko (Johnston), Antoinette
Kellermann (Helen of Troy and
Witch), Basil Jones and Adrian
Kohler (Hyena).

<
Poster for Faustus in Africa! 1995

Drawing from
Faustus in Africa! 1995
charcoal on paper, 53 x 85 cm

The original Faust legend has its roots in the story of a German astrologer who lived around the end of the 15th century. Having inherited a fortune, which he quickly squandered, he was said to have made a pact with the devil, giving up his soul to eternal damnation after death in exchange for more earthly years of indulgence and adventure.

Johan Wolfgang von Goethe examined in his writings the world of the Enlightenment, with all its possibilities and dangers; in Kentridge's words 'a brutal society, shot through with disorder and insanity'. The pact with the Devil that is made by the eponymous character in his epic *Faust* (Part I, 1808; Part II, published posthumously in 1832) is not only made in order to attain wealth and power. Faust is seeking the quintessence of European identity: formalised knowledge. *Faustus in Africa!* explores, with both drama and humour, the overbearing weight of Europe upon Africa; the Devil representing the western desire for power. It weaves together several elements: Goethe's *Faust,* an additional text by Lesego Rampolekeng, references to 16th-century German puppet plays, and the sound of African rap. The play opens with a noisy scene of the Devil's underworld, which closely resembles a three-dimensional version of Soho Eckstein's desk, covered in papers, money, ringing phones, typewriters, an archaic switchboard and other old-fashioned instruments of white-collar power. In this African version of *Faustus*, the rationalism of the Enlightenment has turned into modern colonialism, and Faustus loses his soul to Mephisto in exchange for 'African' adventures and experiences. The projected landscapes refer to colonial, European fictions of what Africa should look like.

Having made his pact, Faustus goes on Safari, shooting not only animals but also a portrait of Goethe, in what appears to be an amusement arcade. He buys the legendary *Ife* heads from Sotheby's in London. He has delightful meals during which he literally 'consumes' Africa (a spoon digging down into the stratified earth of the continent recalls the coffee plunger in *Mine*; the incisions of his knife cutting into the food become the arbitrary borders of the colonies). He desires, and receives, the love of Gretchen (whose puppet representation resembles Nandi in *Felix in Exile*). He enters into the slave trade, and sees wars.

Faustus, his servant Johnston, Gretchen, Helen of Troy and the Devil's Hyena are puppets manipulated by actors; their movements and characters are a compound of human actor and rough-hewn puppet, each appearing to have more than one self. Mephisto, the only supernatural figure, is paradoxically, the sole character played by a human actor alone. Though this is an innovative interpretation of the play, the setting and theatrical devices are often old-fashioned, explicitly recalling early theatre.

At one point, for instance, a puppet runs on the spot in front of the moving image of a landscape projected behind.

Hand-drawn maps of Africa, shown in the animation, locate the story to a place on the Equator, a colonial town in Mozambique characterised by the block-like buildings of European urban development. European culture is also represented by the modern science of entomology as a scientist's pin stabs a mosquito. But the mosquito becomes a needle in Faustus' arm: the Devil's lure.

In his extreme old age, Faustus looks through an album, the back-projected animation showing his thoughts and memories: bodies hang from trees and then disappear in the landscape. Time has won, and the Devil comes to collect. The puppet Hyena grabs at Faustus' neck, but just as Faustus is about to go down to hell, he is reprieved by a South African general amnesty and asked to assist the new Emperor he has helped crown. Faustus and Mephisto are needed for the 'realpolitik' of the world.

Faustus' loss of soul echoes Soho's crumbling empire in *Sobriety, Obesity & Growing Old*, but his quest for knowledge resembles Felix's desire to see in *Felix in Exile*. (Felix, however, remains a passive witness, never agreeing to the pact.) Kentridge may critique the colonisation of the continent, but he does not idealise a status-quo ante, a utopian, pre-European Africa. The play ends on an open-ended dilemma. (CCB)

*I am trying to capture a moral terrain in which there aren't really any heroes, but there are victims. A world in which compassion just isn't enough.* (WK, 1990)

1995: 'Kunstfest Weimar, 22 - 25 June (Premiere); Hebbel Theater, Berlin, 27 June - 1 July; 'Standard Bank National Arts Festival', Grahamstown, 4 - 8 July; Market Theatre, Johannesburg, 12 July - 5 August; Zurich, Ludwigsburger, Munich, Prague, Stuttgart, Hannover, Basel, London, Remscheid, Gutersloh, Erlangen, Lisbon, September-November

1996: 'Adelaide Festival', Adelaide, 13 - 16 March; 'KunstenFESTIVALdesArts', Brussels; Bochum, Hannover, Dijon, Jerusalem, Ellwangen, Hamburg, Copenhagen, St Polten, Polverigi, Avignon, May - July; Seville, Marseilles, Rome, Tarbes, Toulouse, Strasbourg, Paris, Sochaux, Bourg en Bresse, Chambery, October - December

1997: US Tour: Washington, Chicago, Springfield, Northamptom, April

Kate Turkington, 'Faustus in Africa', *Arena*, Johannesburg, 1995, p.14

Frank Quilitzsch, 'Ein Teufelspakt mit dem schwarzen Kontinent', *TLZ*, Berlin, 24 June 1995

Peter Laudenbach, 'Faust aus Afrika', *Berliner Zeitung*, Berlin, 29 June 1995, p.27

Raeford Daniel, 'Brilliant Adaptation', *The Citizen,* Johannesburg, 19 July 1995, p.21

Mark Gevisser, 'Empire in all its delirium', *Mail & Guardian Weekly*, Johannesburg, 21 - 27 July 1995

Gillian Anstey, 'International critics in a frenzy over SA play', *Sunday Times*, Johannesburg, 23 July 1995, p5

Peter Hawthorne, 'The Devil You Know', *Time Magazine*, New York, 14 August 1995, p.62

Sue Williamson, Ashraf Jamal, 'William Kentridge: Devils and Angels', in *Art in South Africa: The Future Present*, David Philip, Cape Town and Johannesburg, 1996, p.46-51

Peter Ward, 'Faustus in Africa: Operation Orfeo', *The Australian*, Sydney, 15 March 1996

James Waites, 'Drawing on an African Experience', *The Sydney Morning Herald*, Sydney, 27 March 1996, p.21

Jean-Marie Wynants, 'Faust s'impose en Afrique', *Le Soir*, Brussels, 9 May 1996

René Solis, 'Woyzeck et Faust en ombres africaines', *Libération*, Paris, 13 July 1996

Olivier Schmitt, 'Inattendus parfums d'Afrique du Sud', *Le Monde*, Paris, 13 July 1996

Sarah Kaufman, 'The Soul of a Puppet', *The Washington Post*, Washington, 3 April 1997, p.C1

Richard Christiansen, 'Faust Myth Comes Alive in Striking New Form', *Chicago Tribune*, Chicago, 1997

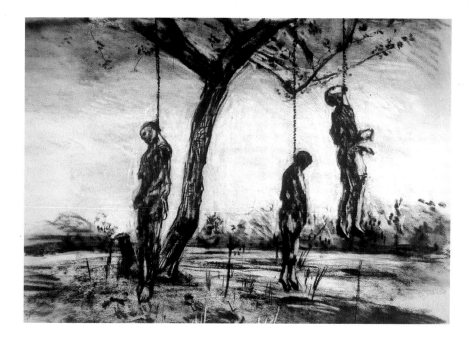

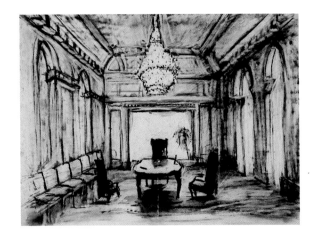

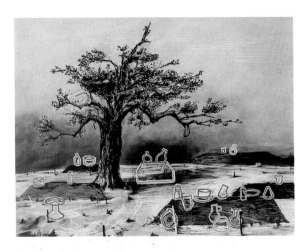

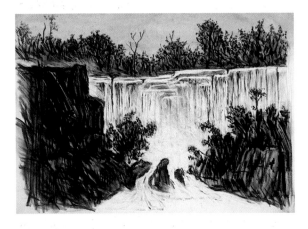

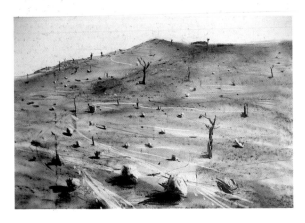

Drawings used in the animation
for *Faustus in Africa!* 1995
charcoal on paper,
72 x 103 cm, 120 x 160 cm,
76 x 106 cm and 58 x 83 cm

DIRECTOR'S NOTE
William Kentridge
(from *Faustus in Africa!* 1995,
programme notes)

When I was 12 years old, in a *Time Life* book on the mind I came across a chart of great geniuses of all time, ranked according to putative IQ. Heading the list, like the top-money winner on this year's PGA, was Goethe, a name quite unknown to me amongst the Einsteins (sixth position I think) and Mozarts (third). A few months later I was given, among the atlases, dictionaries, and fountain pens that constitute the typical presents for a Bar Mitzvah, a two-volume translation of Parts One and Two of Goethe's *Faust*. For approximately the next twenty-five years, the books stood unopened on my bookshelf.

The production *Faustus in Africa!* has a number of starting points, one of which was the silent rebuke of the Goethe on the bookshelf. During the period of stalking or avoiding the text, I tried to find other versions, other less daunting tellings of the story, and considered at different times everything from Marlowe, to Georges Sand, to Gertrude Stein, to Lunacharsky's pre-revolutionary *Faust*, to Bulgakov's marvellous version, *The Master and Margerita*. (The Hyena in our production gives a nod and cocked leg to Bulgakov's cat.) But in the end there was no avoiding the power and strangeness of the two volumes. The play we finally ended up with uses sections of Part One, fragments of Part Two, and new material written by the South African poet, Lesego Rampolekeng (finding affinities between the rhythms of rap and *knittelvers*). All this, with the aim of locating a place where the play ceases to be a daunting other – the weight of Europe leaning on the southern tip of Africa – and becomes our own work.

The second point of entry was the fields of colonial imagery in the libraries and archives around Johannesburg. Weeks were spent looking through old magazines, maps, advertisements and images from colonial wars. This lexicon of images gave us the starting point to develop the characters, the settings, the inter-

actions of the scenes of the play. (Faust was based on a daguerreotype of a Belgian explorer; Helen, on a 1920s cigarette advertisement.) This world of images became the bedrock on which to test the idealism of Goethe's *Faust* against the rather more earthy materialism of colonial Africa. To see if a riposte could be given to Hegel's high-handed dictum (written at the same time Goethe was writing his *Faust*) that 'after the pyramids, World Spirit leaves Africa, never to return'.

The third point was the puppet work – wanting to develop and extend what we had done in *Woyzeck on the Highveld*, wanting to play further with the ambiguities of a performance made up of the combination of puppet and actor. We also wanted to take the idea of the rough carving of the puppets even further: Mephisto's brass band is carved with a chain saw and router. Engineering techniques that Adrian Kohler wanted to develop determined some characters and scenes.

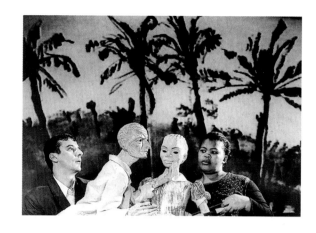

## UNTITLED STATEMENT WILLIAM KENTRIDGE

(from *4th International Biennial of Istanbul*, The Istanbul Foundation for Culture and Arts, Istanbul, 1995, (catalogue) p.166; reproduced in German as 'Faustus in Africa' in *Inklusion-Exklusion: Versuch einer neuen Kartografie der Kunst im Zeitalter von Postkolonialismus und globaler Migration*, Steirischer Herbst, Reininghaus, Graz, 1996, {catalogue} p.247)

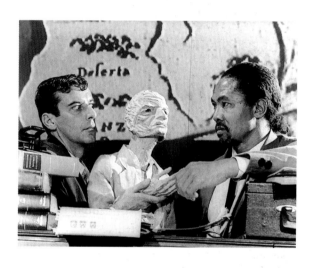

The drawings in the exhibition were all produced during the making of the theatre production *Faustus in Africa!*, a play using puppets, actors and animated projection. The projected drawings formed the backdrop, sometimes showing scenery or the location of certain scenes and other times showing details of what Faustus and other characters were looking at, or the thoughts or fears of the characters.

The process of drawing for theatre works in both the following ways: initially the drawings are 'applied drawings' done in the service of other needs, viz., the demands of each scene of

Rehearsal *Faustus in Africa!*, Johannesburg, 1995:
Dawid Minnaar and Busi Zokufa with Faustus and Gretchen puppets;
Dawid Minnaar and Leslie Fong (as Mephisto) with Faustus puppet;
Puppet from Mephisto's brass band
photos: Ruphin Coudyzer
(Courtesy Handspring Puppet Company)

All puppets carved by Adrian Kohler

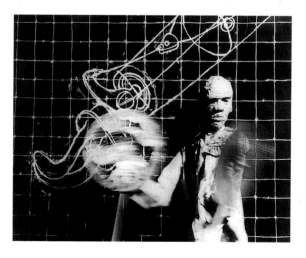

Drawing used in the animation for *Faustus in Africa!* 1995
charcoal on paper, 120 x 160 cm

the play. They illuminate certain parts of the text and situate each character. Each drawing is altered innumerable times as it is filmed, and abandoned as the requirements of the moment are met.

But the demands of the scene also do strange things to the drawings. They are done with speed and without hesitation – because each moment of their drawing and filming is provisional – to be seen for $\frac{1}{25}$ of a second. My constant moving backwards and forwards to the camera also changes them. They are done 'on the run' rather than in a mood of contemplation. The subject matter, and often the composition, arises from something outside the drawings, which makes them far less predictable, frequently less cramped.

In the end, the whole stage production, with its months of rehearsals, complicated sets, whole machinery of lights, sound, stage and audience, becomes an extraordinarily cumbersome way of arriving at the suite of drawings.

The Eidophusikon was the 18th-century invention of Philip James de Loutherbourg, designer of stage scenery, lighting and machinery. His Eidophusikon showing various imitations of natural phenomena, represented by moving pictures, was a small theatre in which audiences saw not performances with actors, but simply a procession of different stage sets – scenery with various scenic effects.

Drawings used in the animation for *Faustus in Africa!* 1995 charcoal on paper, diameter 118 cm, 120 x 160 cm and 45 x 62 cm

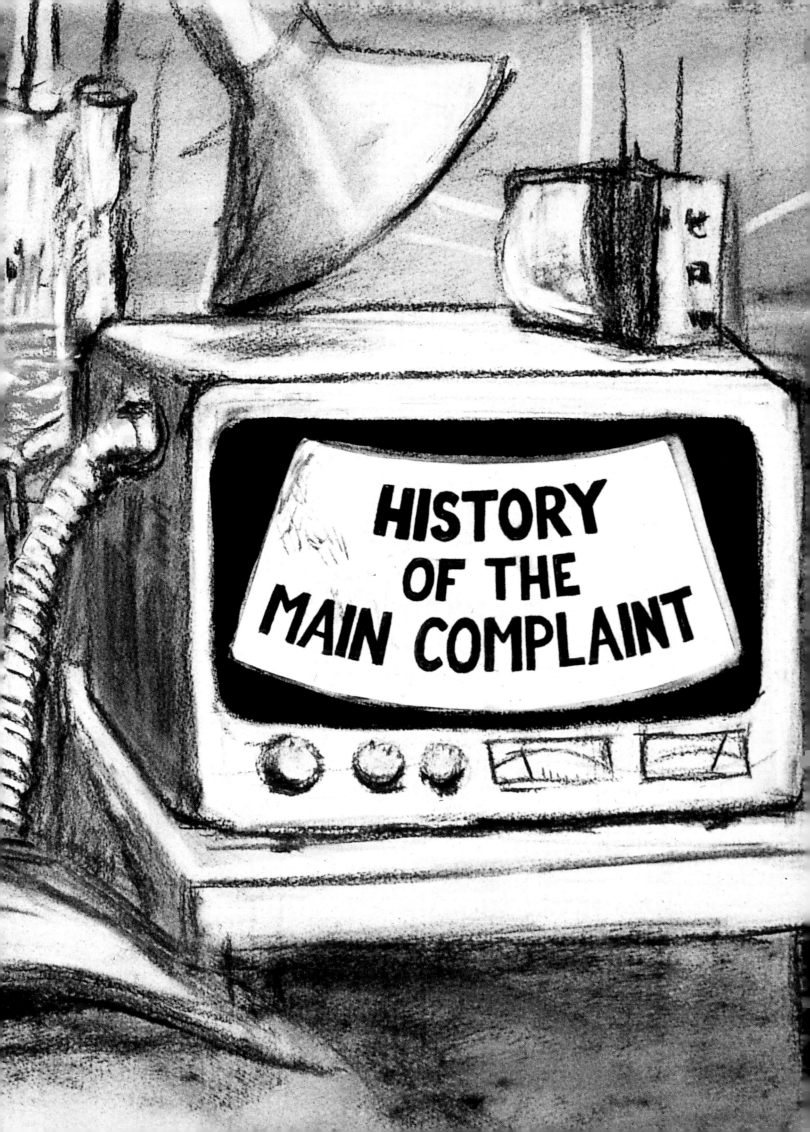

# HISTORY OF THE MAIN COMPLAINT, 1996

35mm film transferred to video
and laser disc
5 minutes, 50 seconds
Drawing, filming and
direction: William Kentridge
Editing: Angus Gibson
Sound: Wilbert Schübel
Music: Madrigal by
Monteverdi.
Series of c.21 drawings in
charcoal and pastel on paper;
dimensions variable

This is the sixth film in the ongoing saga of Soho Eckstein and Felix Teitlebaum. It was made shortly after the establishment, in April 1996, of the Truth and Reconciliation Commission, a series of public hearings into abuses of human rights perpetrated during the apartheid period. These hearings, in which individuals told their personal stories, were held in order to retrieve lost histories, to make reparation to those who had suffered, to provide amnesty, and to create a general context for a new post-colonial and post-apartheid era of national reconciliation. The underlying theme of *History of the Main Complaint* is Soho's personal recognition of responsibility.

The film opens onto a view of an empty city street; a sheet of newspaper blows in the wind, a distant siren wails. There is a sense that we are witnessing the aftermath of momentous events. The film cuts to a hospital ward. Soho lies alone in a bed behind a white curtain.

On the soundtrack is a madrigal by Monteverdi. He is in a coma, wearing a respiratory mask; his eyes are closed, his mouth gaping. Though hi-tech machines including X-rays, Magnetic Resonance Imaging, CAT scans, sonars etc. report on his heartbeat and other bodily functions, the room recalls a 19th-century ward – the hospital of a country in which cosmetic renovation is a luxury.

A doctor in a pin-striped suit, almost a clone of Soho, or a self-projection, appears near his bedside with a stethoscope, which he places on unusual parts of Soho's body. A drawing of an X-ray shows the sensor as it penetrates the body and moves down his spine, again recalling Soho's cafetiere plunger in *Mine*. The X-ray seems to breathe.

More and more doctors appear around Soho as bells and phones ring – the sounds and traces of his previous life as an empire builder. These doctors are not so much healers as explorers of the body. They remind us that, at the close of the Middle Ages, the study of anatomy marked the dawn of modernity through the birth of experimental science.

A view of the interior of the body on a sonar screen turns into a view onto the outside world through the windshield of a moving car. Out of the almost abstract, grey magma of the medical screening, visions of typewriters and telephones emerge. It is as if traces of Soho's buried past are emerging. The more Soho recognises, acknowledges, these internal tools, the more his sensitivity to events beyond his own ego is heightened.

The film shifts back and forth between the doctors' probing gaze into the body through their machines and Soho's view through the windscreen. Though it is Soho driving, seen from behind, it is Felix's eyes that stare out at us from the rear-view mirror in an endless mirroring of the gaze. In earlier films, the merging of these two characters was merely implied; now, it is actually taking place.

The tests on Soho's body run parallel to his memories of witnessing the infliction of brutal violence on black Africans, whose bodies lie on the sides of the road. Red crosses signal the exact point of their injuries. These external lacerations are set against Soho's internal wounds, and a correspondence is established between the pain inflicted on others and the self-brutalisation of Soho's soul.

Soho dreams of, or remembers, an accident in which his car hits a man on the road. His sense of responsibility is awakened and he is no longer able to lie unconscious as a disengaged witness of events. In his hospital bed, he sits up, opening his eyes wide. But as the white curtains around the bed also open, the besuited figure of Soho, reinstated at his paper-strewn desk, is revealed. The question of Soho's moral progress is thus left open-ended. We have witnessed his journey of recognition, but now that he has returned to his familiar world we question its impact, or even whether it actually took place. (CCB)

*The film started as a sketch for an opera project scheduled for next year. I needed to see whether it was possible to combine the technique of charcoal animation I use, with the music of Monteverdi. And to see whether there was a rapport between the 17th-century music and the very 20th-century systems of viewing the body – CAT scans, sonars, X-rays, Magnetic Resonance Imaging etc. (WK 1996)*

Group exhibition: 'Faultlines: Inquiries into Truth and Reconciliation', The Castle, Cape Town, 16 June - 31 July 1996 (Premiere) (projection onto small white board on a blackboard easel)

Group exhibition: 'Jurassic Technologies Revenant', 10th Sydney Biennale, 27 July - 22 September 1996 (video projection on wall)

Group exhibition: 'Campo 6, The Spiral Village', Galleria Civica d'Arte Moderna e Contemporanea, Turin, 28 September - 3 November 1996; touring to Bonnefanten Museum, Maastricht, 19 January - 25 May 1997 (triptych projection onto wall alongside two slide projections of a skull X-ray and a chest X-ray)

Solo exhibition, 'Applied Drawings', Goodman Gallery, Johannesburg, 2 - 22 March, 1997 (on monitor, with drawings)

Group exhibition: 'documenta X', Museum Fridericianum, Kassel, 21 June - 28 September 1997, (video projection on wall)

Solo exhibition: 'William Kentridge', The Drawing Center, New York, 8 January - 14 February 1998 (video projection on wall)

Solo exhibition: 'William Kentridge', Stephen Friedman Gallery and A22 Gallery, London, 6 March - 18 April 1998 (screened on monitor with 14 drawings)

Solo exhibition: 'William Kentridge', Palais des Beaux-Arts/Paleis voor Schone Kunsten, Brussels, 15 May - 23 August 1998, touring to Kunstverein, Munich, 28 August - 11 October 1998; Neue Galerie Graz am Landesmuseum Joanneum, 15 November 1998 - 15 January 1999 (triptych projection from laser disc onto wall alongside two slide projections of a skull X-ray and chest X-ray, with drawings)

VB [Vivian Bobka], Jurassic Technologies Revenant: 10th Biennale of Sydney, Art Gallery of New South Wales, Sydney, 1996, (catalogue), p.85

Sue Williamson, Ashraf Jamal, 'William Kentridge: Devils and Angels', in Art in South Africa: The Future Present, David Philip, Cape Town and Johannesburg, 1996, pp.46-51

Leaflet for 'Applied Drawings', Goodman Gallery, Johannesburg, 2 - 22 March, 1997

Paul Sztulman, documenta X Short Guide, documenta und Museum Fridericianum, Veranstaltungs -GmbH, Cantz Verlag, 1997

William Kentridge, 'Amnesty/Amnesia', in Politics – Poetics documenta X the book, conceived by Catherine David and Jean-François Chevrier, Cantz Verlag, Ostfildern-Ruit, 1997, p.608

Kendell Geers, 'Kentridge Bridges the Gap', The Star, Johannesburg, 14 March 1997

Roger Taylor, 'Memento', World Art, Melbourne, May 1997, pp.46-50

Michael Godby, 'William Kentridge's History of the Main Complaint: Narrative, Memory, Truth', in Sarah Nuttal and Carli Coetzee, Negotiating the Past: the Making of Memory in South Africa, Oxford University Press, Cape Town, 1998, pp.100-111

David Krut, William Kentridge, CD-Rom, David Krut Publisher, Johannesburg, 1998

Leslie Camhi, 'Mind Field', The Village Voice, New York, 27 January 1998, p.89

Roberta Smith, 'William Kentridge', The New York Times, New York, 6 February 1998, p.E36

Okwui Enwezor, 'Swords Drawn', Frieze, issue 39, London, March/April 1998, pp. 66-69

## AMNESTY/AMNESIA
William Kentridge
(extract from essay published in *Politics – Poetics documenta X the book*, conceived by Catherine David and Jean-François Chevrier, Cantz Verlag, Ostfildern-Ruit, 1997, p. 608)

*History of the Main Complaint* was made eighteen months or so [after *Felix in Exile*] at the time that the Truth and Reconciliation Commission was set up here to look at past responsibilities. And so the questions of collective or individual responsibility for past abuses were in the air. Not that I have a single coherent explanation of the paths of the film – but I suppose it is true that Soho can only be wakened from his coma by an acknowledgement of immediate responsibility (for the death of someone in a car accident!) A case in which there may not be blame but there is responsibility. But, of course, Soho is not killed by this responsibility – and can even accommodate it (condensed and displaced into the objects on his desk). There is something of a convergence between Soho and Felix in the film. The driver of the car is Soho, the eyes in the rear view mirror are Felix's.

While making the film I was also fascinated by the new ways of seeing the body using X-rays, CAT and MRI scans, sonar, etc. What is hidden under the skin? And is our blindness to this similar to our blindness to the effects of our actions?

## HISTORY OF THE MAIN COMPLAINT
William Kentridge
(unpublished text, 1998)

*…my physicians by their love are grown Cosmographers, and I their map, who lie Flat on this bed…*   John Donne

Soho Eckstein in a coma. In his hospital bed. Surrounded by surgeons trying to rouse him. How to find the weight keeping him unconscious, how to find the event to rouse him. (…)

One of the starting points of the film was the range of new systems and technologies for looking at the body, MRI scans, CAT scans, sonar, and of course, X-rays. There was both the pleasure of making drawings based on these images (there is a great affinity between the velvety grey tones of an X-ray and the softness of charcoal dust brushed onto paper) and also a sense that these ways of looking inside the body function as a metaphor for looking inside thought processes or conscience. The murky world of a sonar scan does two things. In its fractured, shifting black dots and grey swirls it feels like a piece of crude charcoal pointillism (like the X-rays, it is a natural for the 'stone age' animation technique I use). And in its very obscurity, its demand for 'seeing into' (as we 'see into' a cloud to make a familiar image from it) it points to the world of interpretation of drawings, uncertainly, provisionally, a sense or meaning from the glimpses we get of our unconscious.

I think there is a way in which we desperately hang onto the surfaces of things, particularly the surfaces of our bodies. Our insides are a foreign terrain, we take them on trust but resist being led there. The same way that we resist (both consciously and unconsciously) looking too deeply into our fears, hopes and consciences.

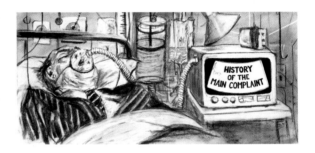

As with the other films I have made, *History of the Main Complaint* was made without a script or storyboard. The idea is for the film to develop in the way a drawing might. Starting with an initial image or idea but allowing that in the very physical process of making the film (or drawing) new connections will emerge, new emphases be taken. So in the end the film (or drawing) is more than could have been consciously planned. The hope is that without directly plunging a surgeon's knife, the arcane process of obsessively walking between the camera and the drawing-board will pull to the surface, intimations of the interior.

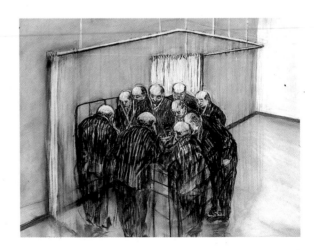

Drawings from *History of the Main Complaint* 1996 charcoal and pastel on paper, 100 x 120 cm, 70 x 120 cm, 120 x 160 cm and 120 x 160 cm

Drawing from *History of the Main Complaint* 1996 charcoal and pastel on paper, 106 x 75 cm

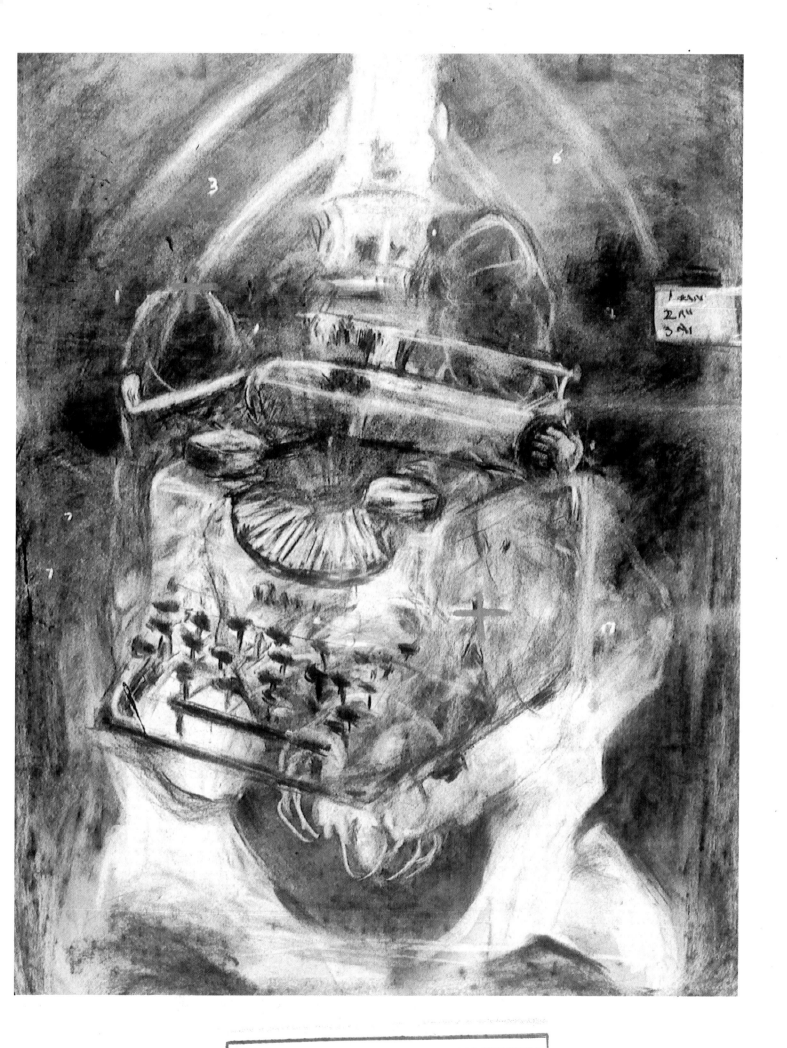

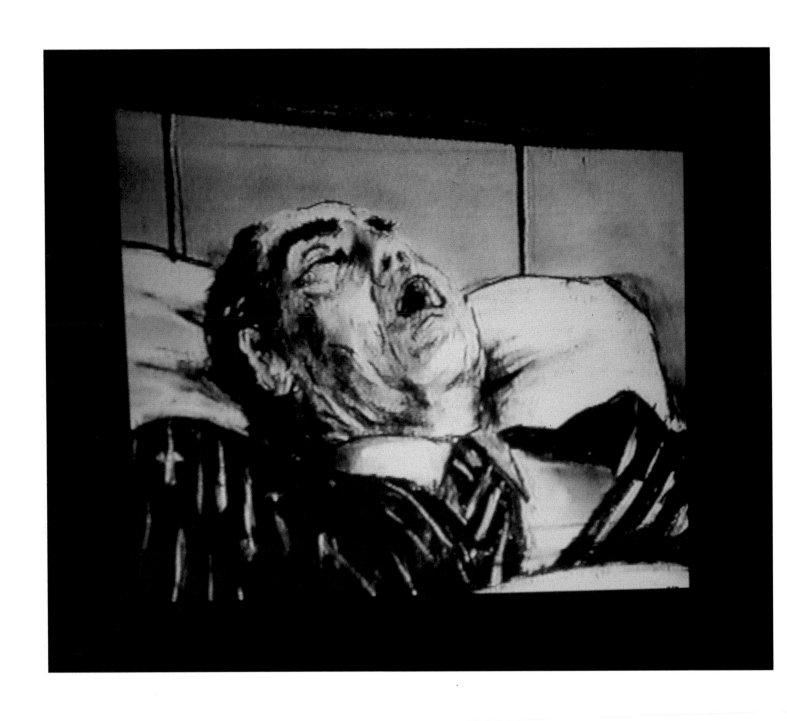

Drawing from *History of the Main Complaint* 1996, charcoal and pastel on paper, 100 x 120 cm,
detail of installation view: 'Faultlines: Inquiries into Truth & Reconciliation', Cape Town, 1996
photo: Mark Lewis (Courtesy Jane Taylor)

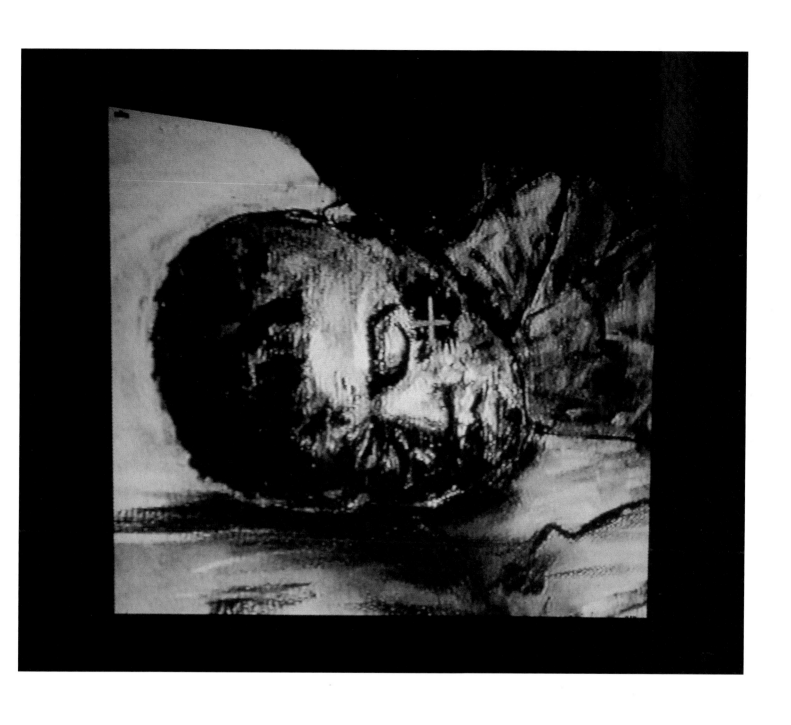

Drawing from *History of the Main Complaint* 1996, charcoal and pastel on paper, 100 x 120 cm,
detail of installation view: 'Faultlines: Inquiries into Truth & Reconciliation', Cape Town, 1996
photo: Mark Lewis (Courtesy Jane Taylor)

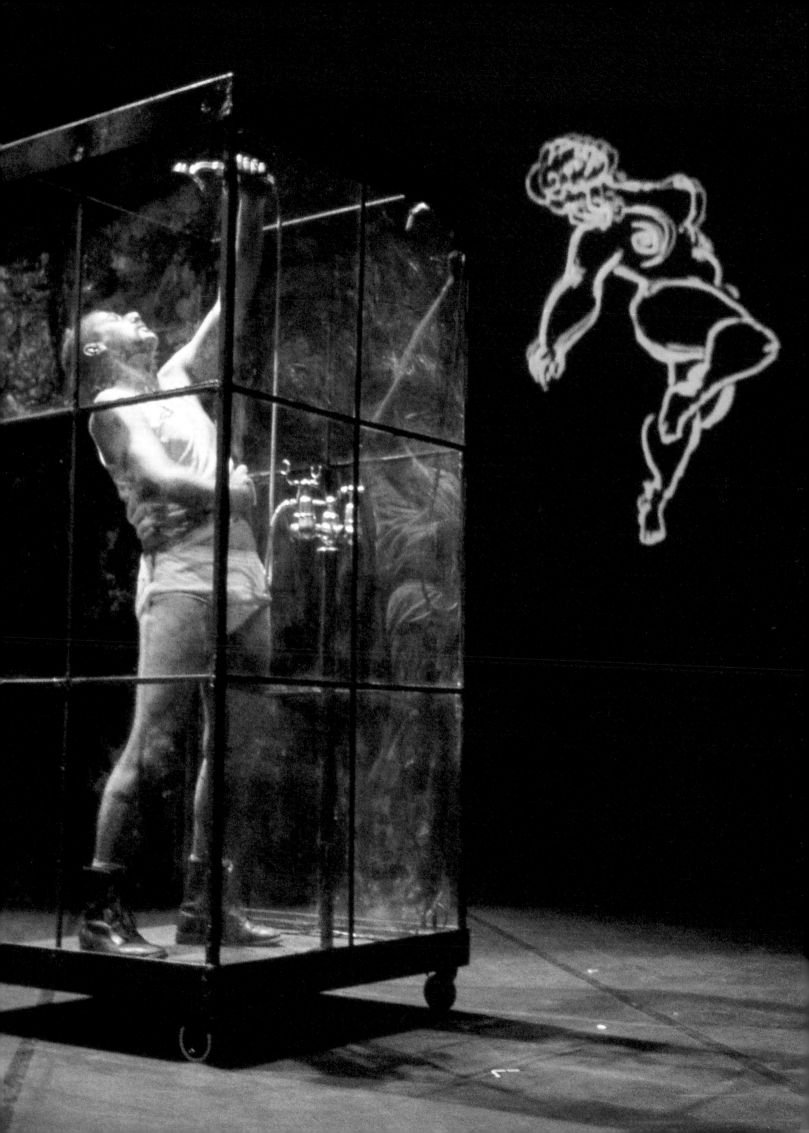

# UBU PROJECTS, 1996-97

In 1888, the French dramatist Alfred Jarry wrote the play *Ubu Roi* as a satirical and grotesque expression of the way in which arbitrary power engenders madness. He achieved this through the portrayal of a ridiculous but devastating despot, who was also a licentious libertine, an emblem of the clumsy and brutal deeds done in the service of a calculating state. Jarry counters this arbitrary power with what he called 'pataphysics' – the science of imaginary solutions – unmasking its absurdity through farce, rather than empowering the tyrant by granting him serious presentation. *Ubu Roi* has inspired countless artists and writers, and Jarry's approach was to lead to a new genre – the Theatre of the Absurd. From a South African perspective, Ubu is a particularly powerful metaphor for the insane policy of apartheid, presented by the state as a rational system.

In 1975, Kentridge performed the role of Captain McNure in Junction Avenue Theatre Company's production *Ubu Rex* (an adaptation of Jarry's play). Just over twenty years later, in 1996, the artist Robert Hodgins, with whom Kentridge has often collaborated, suggested a group show of prints on the theme of *Ubu*. In response, Kentridge developed a series of etchings in which he layered chalk representations of Jarry's cartoon-like, outline drawings of Ubu with his own contrasting textural and tonal drawings of a naked man, stemming from photographs of himself in the studio. The result was a series of outrageous images entitled *Ubu Tells the Truth*, which were exhibited in the show 'Ubu: ±101' in Grahamstown, 1997, along with works by Hodgins and Deborah Bell. The dovetailing of these images is not only a further exploration of Kentridge's familiar theme of the co-existence of disjunctive selves within the same person, but also implies that Ubu is an endemic part of any individual. By grappling with this Ubu within oneself – as Soho Eckstein does in *History of the Main Complaint* – he may perhaps be controlled and contained within the individual, and by implication, within society.

After making the etchings, Kentridge began to think of animating the blackboard, cartoon-style Ubu drawings into a new film *Ubu Tells the Truth* (1997). This animation has been exhibited on its own and with wall drawings, and was also used (although edited differently), in the theatre performance *Ubu and the Truth Commission* (1997).

The play did not stem directly from a desire to readdress the Ubu theme. Wishing to continue his collaboration with Handspring Puppet Company following *Woyzeck on the Highveld* (1992) and *Faustus in Africa!* (1995), Kentridge had been planning a new play about the experience of waiting. They had considered an adaption of Samuel Beckett's *Waiting for Godot* for puppets, but had been unable to get permission. At the same time, the writer and curator, Jane Taylor, was reflecting on the meanings and implications of the devastating stories being told during the hearings of the newly inaugurated Truth and Reconciliation Commission. These projects eventually merged in a collaboration that would explore the personal tales of atrocity related by witnesses to the TRC, as well as the confessions of perpetrators of abuse, as symbols of the larger national narrative of reconciliation.

The resulting play, scripted by Taylor, and performed by Handspring, combined Adrian Kohler's puppetry with Kentridge's animation and direction. The horror of the testimonies would be counterbalanced by the extravagant wildness of Ubu.

The vulgar and ghoulish Pa Ubu, with his grotesque spiral belly, rides the phallic, three-headed beast of apartheid (a diabolical Cerberus stemming from Jarry's character, Palcontents). His absurd presence underlines the farce-like nature that even the historic and tragic events of South Africa can assume. A killer and torturer for the apartheid state, Pa Ubu is eventually reprieved and reintegrated into an idealised vision of a new world. Like Mephisto in *Faustus in Africa!,* he is represented, for the majority of the performance, solely by an actor. The witnesses are played by puppets and actors, their words taken from the actual testimonies presented to the Truth Commission, spoken in the original languages. The crude, rough carving of the puppets evokes time, experience,

marks of abuse. A further puppet, in the form of a crocodile, is an imaginative, animated version of a paper shredder – an emblem of furtive guilt.

Just as Kentridge had layered radically different styles of drawing in the etchings, in his animation, burlesque constantly switches to contrasting factual material. This film differs from the preceding ones not only in the cartoon-like, caricatured figure of Ubu, but also in its method of production and in a more direct engagement with the violence and brutality of events in South Africa leading up to the end of apartheid and the 1994 elections. The process of successively altering charcoal and pastel drawings on paper is still employed, but Kentridge also collages together schematic, white chalk drawings on black paper, paper cut-outs, and documentary photographs and footage. This archival material ranges from images of police with whips, lashing into a running crowd in Cato Manor in 1960, or storming a group of students at Wits University during the State of Emergency in 1985, to footage from the Soweto uprising of 1976.

While the play *Ubu and the Truth Commission*, scripted by Taylor, clearly implies that theatre has a role to play in national catharsis and reconciliation, Kentridge's animated film *Ubu Tells the Truth* has a less defined message, a more open-ended approach. It is a disjointed, jerky, often brutal montage of sound and image, full of jump-cuts, badly drawn cartoons and visually disturbing juxtapositions. The ugly depths of crime and suffering are probed with scatological imagery recalling a scene from Jarry's play in which Ubu serves 'pschitt' to his guests at a banquet. Although moral outrage is, of course, suggested, the film does not appear to offer the viewer any pre-defined ideological position.

In one sequence in the animation, when Pa Ubu removes his clothes, his body becomes a tripod and his head mutates into a radio, a cat, a camera. The camera may be a tool of authoritarian surveillance and control, but it is also the artist's instrument for the fluid recording and erasing of images. Kentridge seems to be suggesting that art does have a role to play in society, but not through definitive judgements and prescriptions. For Kentridge, the artwork invites the viewer to begin a process of self-anamnesis, acknowledging the complex nature of human experience and the constant potential for inhuman action.

Kentridge continued to explore the Ubu figure through a series of large *Ubu* drawings and a group of prints entitled *Sleeper*. The *Ubu* drawings have occasionally been presented alongside others made in white chalk on a black wall in order to create a theatrical space, adjacent to which was a tripod supporting a monitor showing the film *Ubu Tells the Truth*. The tripod echoes the one that replaces Ubu's skeleton in the animation itself, underlining still further the artist's complex identification with the figure of Ubu. (CCB)

*How does one deal with the weight of evidence presented to the Truth and Reconciliation Commission?... How to absorb the horror stories themselves and the implications of what one knew, half knew, and did not know of the abuses of the apartheid years? (The broad shape, some of the specific violences were known. The minutiae, the domestic edges to the violence – what people were doing as they became the victims, how people moved from a domestic setting to being the perpetrators of the violence – the specific syntax to the giving and absorbing of suffering – was not known.) The need to work with this material came from the urgency of the questions raised by this dissection. Not that I expect a piece of theatre to provide specific answers to how one deals with private and historic memory, but that the work (of making the piece, perhaps of watching it) becomes part of the process of absorbing this legacy. (WK, 1996)*

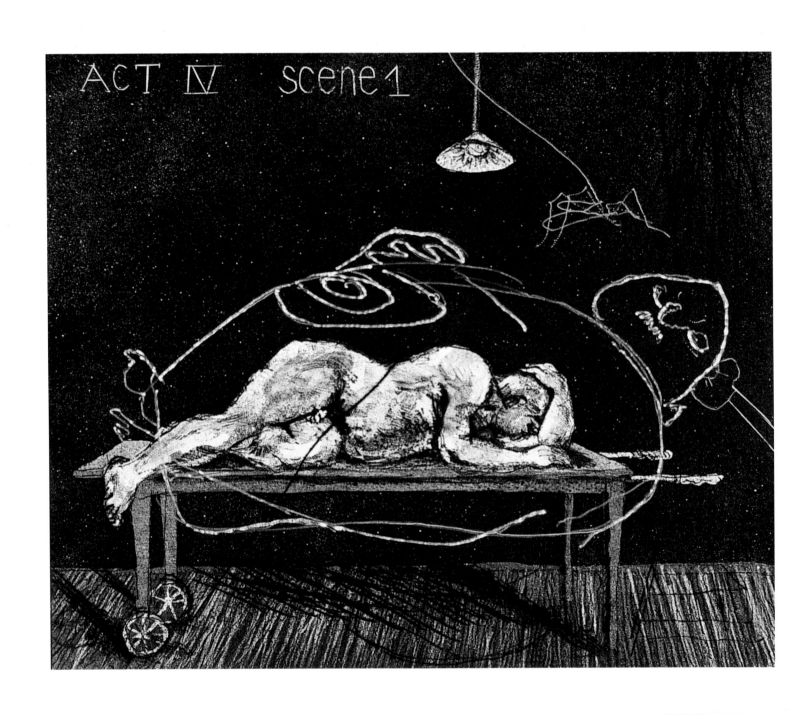

*Act IV scene 7*, from the portfolio of 8 etchings *Ubu Tells the Truth* 1996-97
hardground, softground, aquatint, drypoint and engraving, 26.3 x 30 cm

UBU TELLS THE TRUTH, 1996-97
Portfolio of 8 etchings
all 26.3 x 30cm; hardground,
softground, aquatint, drypoint
and engraving; Caversham
Press: *Act I Scene 2*; *Act II Scene
1*, *Act III Scene 5*; *Act III Scene
4*; *Act III Scene 9*; *Act IV Scene
1*; *Act IV Scene 7*; *Act V Scene 4*.

UBU AND THE TRUTH
COMMISSION, 1997
Theatre production with
actors, puppets, animation
Production: Handspring
Puppet Company, Mannie
Manim Productions and Art
Bureau, Munich
Director: William Kentridge
Writer: Jane Taylor
Set design: Adrian Kohler and
William Kentridge
Animation:
William Kentridge, with the
assistance of Tau Qwelane and
Susie Gabie
Puppet Maker: Adrian Kohler,
with the assistance of
Tau Qwelane
Choreography: Robyn Orlin
Music: Warrick Sony and
Brendan Jury
Lighting design:
Wesley France
Sound Design:
Wilbert Schübel
Costumes: Adrian Kohler,
Sue Steele
Production co-ordinator:
Basil Jones
Film Editor:
Catherine Meyburgh
TRC research: Antje Krog
Cast: Dawid Minnaar (Pa Ubu),
Busi Zokufa (Ma Ubu and
witness puppet character),
Louis Seboko (puppet
character), Basil Jones
(puppet character), Adrian
Kohler (puppet character).

PRESENTATIONS
1997: 'Kunstfest' Weimar,
17 - 22 June, (Premiere);
'Standard Bank National Arts
Festival', Grahamstown,
11 - 13 July; 'Avignon Festival',
Avignon, 19 - 23 July;
The Market Theatre, Johannes-
burg, 31 July - 30 August;
European tour: Zurich,
Geneva, Basel, Romainmotier,
Hannover, Rungis, Ludwigs-
berg, Nantes, Kristiansand,
Neuchatel, Dijon, Erlangen,
Munich, September -
November
1998: Spier, Stellenboch
(South Africa)

UBU TELLS THE TRUTH, 1997
35mm animated film collage
of charcoal drawings on paper,
chalk drawings on black paper,
documentary photographs and
film, transferred to video and
laser disc, 8 minutes projected
onto wall
Drawing, photography and
direction: William Kentridge
Editing: Catherine Meyburgh
Music: Warrick Sony and
Brendan Jury
Series of c.30 drawings in
charcoal on paper; dimensions
variable

EXHIBITIONS AND
PRESENTATIONS
Group exhibition: 'Sexta
Bienal de La Habana:
el individuo y su memoria',
Centro Wifredo Lam, Havana,
May - June 1997 (Premiere)

Group exhibition: 'Site', Santa
Fé, 15 July - 15 October 1997

Group exhibition: '2nd Biennal
Johannesburg Biennale 1997.
Trade Routes: History and
Geography', AICA, Africus
Institute for Contemporary
Art, 12 October 1997 -
18 January 1998
(video projection on wall)

Group exhibition: 'Delta',
ARC Musée d'Art Moderne
de la Ville de Paris, Paris,
4 December 1997 - 18 January
1998 (video projection on wall)

Solo exhibition, 'William
Kentridge', Stephen Friedman
Gallery and A22 Gallery,
London 6 March - 18 April
1998 (video projection, with
seven drawings, plus cut-outs)

Solo exhibition: 'William
Kentridge', Palais des
Beaux-Arts/Paleis voor
Schone Kunsten, Brussels,
15 May - 23 August 1998,
touring to Kunstverein,
Munich, 28 August -
11 October 1998;
Neue Galerie Graz am
Landesmuseum Joanneum,
15 November 1998 -
15 January 1999
(projection from laser disc)

LARGE FIGURATIVE DRAWINGS,
1997
Seven drawings entitled
*Project Drawings* (also titled
*A Project for Havana and Santa
Fé*), all 1997: *Cartographer*,
*The Sleeper*, *Flagellant*, *Project
Drawing Figure 1(Man with
Microphone)*, *Project Drawing
Figure 2 (Listener)*, *Project
Drawing Figure 3;* 3 drawings
of *Cyclist* (also titled *Ubu on
a Bicycle*), all 1997, charcoal,
gouache, pastel, raw pigment
on paper, 200 x 100cm

LARGE ETCHINGS (SLEEPER), 1997
Series of four etchings entitled
*Sleeper*, each 97 x 193cm,
edition of fifty: *Sleeper and
Ubu*, aquatint and drypoint;
*Sleeper – Red*, aquatint and
drypoint from 2 plates; *Sleeper
– Black*, aquatint and drypoint
from 2 plates, *Sleeper I*, single
plate drypoint
etching/aquatint

*Ubu and the Truth Commission*,
programme notes, 1997

Rory Doepel, *Ubu: ± 01
William Kentridge,
Robert Hodgins, Deborah Bell*,
The French Institute of South
Africa and the Art Galleries,
University of the Witwater-
srand, Johannesburg, 1997

Marilyn Martin, 'The New
South Africa – Facing Truth
and Transformation', in Martin
Hope, *Contemporary Art from
South Africa*, Oslo, 1997,
(catalogue) pp.1-18

Lorenz Tomeruis, 'König
Ubu's Terror in Afrika',
*Welt am Sonntag*, 29 June 1997

Catherine Bédarida, 'Les anges
et les démons sud-africains de
William Kentridge', *Le Monde*,
Paris, 1 July 1997

Jürgen Berger, 'Alles im
Rohzustand', *Tageszeiting*,
Berlin, 7 July 1997

René Solis, 'Ubu d'après
apartheid', *Libération*, Paris,
12 July 1997

Hazel Friedman,
'The Horror…', *Mail and
Guardian*, Johannesburg,
August 8 –14, 1997, p.7

Andrew Worsdale, 'Pulling
Strings', *The Sunday Times*,
Johannesburg, August 17, 1997,
pp.14-16

Donald G. McNeil Jr.
'Theatre Spotlights Horrors
of Apartheid', *International
Herald Tribune*, Paris,
6 August 1997, p.2

Robert Brand, 'Ubu's Exploits
Hold a Mirror to SA's Violent
Past', *The Star*, Johannesburg,
August 8 1997, p.11

Jane Taylor, *Ubu and the Truth
Commission*, University of
Cape Town Press, 1998

David Krut, *William Kentridge*,
CD-Rom, David Krut
Publisher, Johannesburg, 1998

Okwui Enwezor, 'Swords
Drawn', Frieze, London,
issue 39, March/April 1998,
pp. 66-69

Francesco Bonami, *Delta*,
ARC. Musée d'Art Moderne
de la Ville de Paris, Paris 1997
(catalogue) n.p.

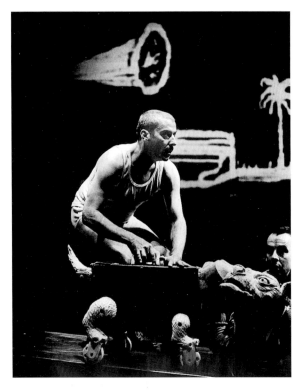

WRITER'S NOTE
Jane Taylor
(from Jane Taylor, *Ubu and the Truth Commission*, University of Capetown Press, 1998, pp.ii-iii, vi-vii)

*Truths and Reconciliations*

In early 1996, almost exactly two years after South Africa's first non-racial national election, the Truth and Reconciliation Commission (TRC) began its work. The Commission had a momentous mandate. It was to solicit South Africans who considered themselves as agents, victims or survivors of human rights violations perpetrated in the apartheid era to testify before a national forum. The purposes of this process were various: to retrieve lost histories, to make reparation to those who had suffered, to provide amnesty for acts that were demonstrably political in purpose. One of the larger purposes of the Commission is to create a general context through which national reconciliation might be made possible.

What has engaged me as I have followed the Commission, is the way in which individual narratives come to stand for the larger national narrative. The stories of personal grief, loss, triumph and violation now stand as an account of South Africa's recent past. History and autobiography merge. This marks a significant shift, because in the past decades of popular resistance, personal suffering was eclipsed – subordinated to a larger project of mass liberation. Now, however, we hear in individual testimony the very private patterns of language and thought that structure memory and mourning. *Ubu and the Truth Commission* uses these circumstances as a starting point.

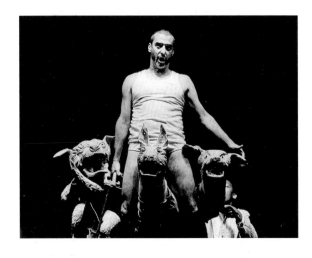

*The Origin of the Project*

*Ubu and the Truth Commission* had several points of origin, some arising out of the Handspring Puppet Company, some from other projects, and some from William Kentridge. I can only address here where the project began for me. In 1996 I initiated a series of cultural activities, *Fault Lines*, which was a programme of events including an art exhibition, poetry readings by writers from South Africa,

Performance *Ubu and the Truth Commission*, Johannesburg, 1997: Dawid Minnaar (as Ubu) and Adrian Kohler with Brutus puppet; Dawid Minnaar (as Ubu) with Brutus puppet; Adrian Kohler and Dawid Minnaar with Niles puppet, photos: Ruphin Coudyzer (Courtesy Handspring Puppet Company)

Germany, Chile, Israel, Norway, the Netherlands, Portugal, Canada, Sudan and Zimbabwe, on issues relating to questions of war crimes; reparation, memory and mourning; as well as an academic and arts conference; a student radio project; a community arts initiative, and a workshop for media covering the TRC. My purposes were multiple.

Primarily, I wanted to foreground the role that artists could play in facilitating debates around the Truth and Reconciliation Commission. Following the premise that artists habitually deal with issues of betrayal, sadism, masochism, memory, I felt that to ignore what the arts could bring to these processes was to waste an extremely valuable resource. Further, it is my feeling that through the arts some of the difficult and potentially volatile questions, such as why we betray or abuse each other, could be addressed without destabilising the fragile legal and political process of the TRC itself.

(…)

*Ubu in South Africa*
In *Ubu and the Truth Commission*, I have taken [the figure of Alfred Jarry's Ubu Roi] and have characterised him using a style of burlesque derived in part from Jarry. The language is in ways deliberately archaic in order to situate Ubu as an anachronism, a figure who lives within a world of remote forms and meanings. This character is then placed within a new dispensation, the world of the Truth and Reconciliation Commission in South Africa.

Rather than represent any particular figure from South African history, Ubu stands for an aspect, a tendency, an excuse. Nonetheless, he does at times speak in voices reminiscent of those we have heard in South Africa during the TRC hearings. I have then set his linguistic world against the languages arising from the actual testimony that has emerged out of the Truth and Reconciliation process. The testimony is drawn from the hearings, which have given us access to the stories of both survivors and perpetrators of atrocities committed during the apartheid era. Over the past eighteen months of listening to the disjuncture between the testimony of those looking for amnesty and those seeking reparation, it has been chilling to note the frequency with which an act of astonishing cruelty has been undertaken, as it were, negligently, with no sense of the impact of such actions on other human lives; when confronted with the families of victims or survivors, those perpetrators who seem to have some capacity for remorse, appear to be shocked at observing, as if from the outside, the effect of their behaviour. Others simply show no response at all, so profound is their denial, or the failure of moral imagination. Our purpose in this play, was to take the Ubu character out of the burlesque context, and place him within a domain in which actions do have consequences. The archaic and artificial language that Ubu uses, with its rhymes, its puns, its bombast and its profanities, is set against the detailed and careful descriptions of the witness accounts, which have been in large measure transcribed from TRC hearings. Ubu is confronted within his own home by those whom he has assailed.

It is as if Cause and Effect are registered through different modes of expression in the play; this carries through into the performance styles that have been used.

(…)

*The Writing Process*
The first phase was a discussion with William Kentridge, Basil Jones and Adrian Kohler, in which we agreed in principle about using Ubu to explore the TRC. At the end of 1996 we then had a series of workshops with the Handspring Puppet Company performers, during which period I got some sense of the actors' capacities, and was introduced to the basic style of performance of the puppets. During these workshops we also discussed some of the non-naturalistic elements that might be introduced, such as the three-headed dog. We engaged in a very free process of experimenting with new hybrid forms, somewhere between animation and puppetry, in which drawn figures were manipulated by hand, and then filmed frame by frame as a sequence of individual drawings, rather like the technique used for more conventional animation. Through these various workshops,

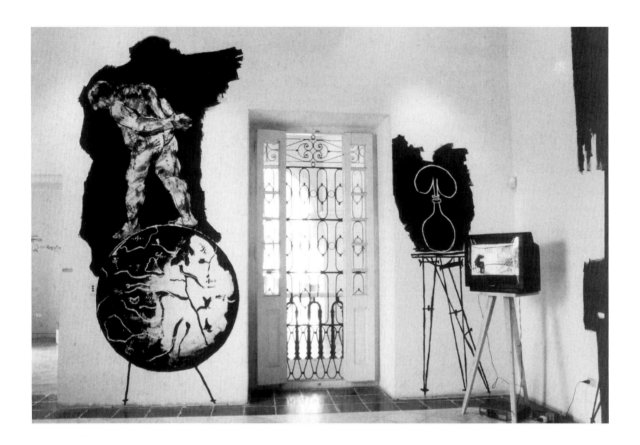

those involved in the process developed an increasing sense of the possibilities of the forms we were evolving. My writing emerged very much out of these explorations. One of the great advantages of working with Handspring Puppet Company has been its own experiments in non-naturalistic idioms, which allowed us creative freedom, notwithstanding the weighty documentary imperatives of the TRC itself.

Through the workshops, we determined that Pa and Ma Ubu would be played by live actors with no puppet equivalents. These characters thus exist, as it were, on one scale. The witnesses, who are represented by puppet-figures, exist on another scale, and a great deal of their meaning arises out of this fact. Puppets can provide an extraordinary dimension to a theatrical project of this kind, because every gesture, is, as it were, metaphorised. The puppet draws attention to its own artifice, and we as audience willingly submit ourselves to the ambiguous processes that at once deny and assert the reality of what we watch. Puppets also declare that they are being 'spoken through'. They thus very poignantly and com-

pellingly capture complex relations of testimony, translation and documentation apparent in the processes of the Commission itself.

(…)

DIRECTOR'S NOTE
William Kentridge
(from Jane Taylor, *Ubu and the Truth Commission*, University of Capetown Press, 1998, pp.viii-xv {originally given as a lecture at 'Het Theatre Festival', Antwerp, September 1997}

*The Crocodile's Mouth*
In South Africa at the moment there is a battle between the paper shredders and the Photostat machines. For each police general who is shredding documents of his past, there are officers under him who are Photostatting them to keep as insurance against future prosecutions. On stage, I wanted to show a shredding machine. But a real machine, noisily and slowly going through reams of paper, did not seem very remarkable. We thought of using a bread-slicer on stage as a metaphor, but were daunted by the thought of all that wasted, sliced bread each

Installation view:
*Ubu Tells the Truth* 1997
'Sexta Bienal de La Habana: el individuo y su memoria', Courtesy Centro Wifredo Lam, Havana, May - June 1997
photo: Gerhard Haupt

night. We thought of doing a drawing or animation of the shredding machine, and projecting it on screen, but I baulked at the thought of those hours of drawing the spaghetti trails of shredded paper. Then we thought 'we already have three dogs on stage, why not feed the evidence we want to shred to a dog?' But their mouths were too small to swallow a video tape or ream of documents. So we asked, 'what has a wide enough mouth to swallow whatever we want to hide?' Hence the crocodile's mouth.

The Truth and Reconciliation Commission is an enquiry established in terms of the negotiated settlement between the outgoing Nationalist Government and the incoming ANC Government of South Africa. The brief of the Commission is to examine human rights abuses that occurred in South Africa over the past thirty-five years. There are two parts to this process. Victims and survivors come to the Commission to recount their stories of what happened to them or members of their families (many of those involved did not survive their story and it is left to mothers and brothers to give evidence). The second part of the process is the amnesty hearings, in which perpetrators of these abuses may give evidence of what they have done. The inducement? A full confession can bring amnesty and immunity from prosecution or civil procedures for the crimes committed. Therein lies the central irony of the Commission. As people give more and more evidence of the things they have done, they get closer and closer to amnesty and it becomes more and more intolerable that these people should be given it.

The Commission itself is theatre, or at any rate, a kind of ur-theatre. Its hearings are open to the public, as well as being televised and broadcast on the radio. Many of the hearings are presided over by Archbishop Tutu in full purple magnificence. The hearings move from town to town, setting up in a church hall, a school venue. In each venue the same set is created. A table for the witnesses (always at least as high as that of the Commissioners so the witnesses never have to look up to the Commissioners); two or three glass booths for the translators. A large banner hangs on the wall behind the commissioners: 'TRUTH THROUGH RECONCILIATION'. One by one witnesses come and have their half hour to tell

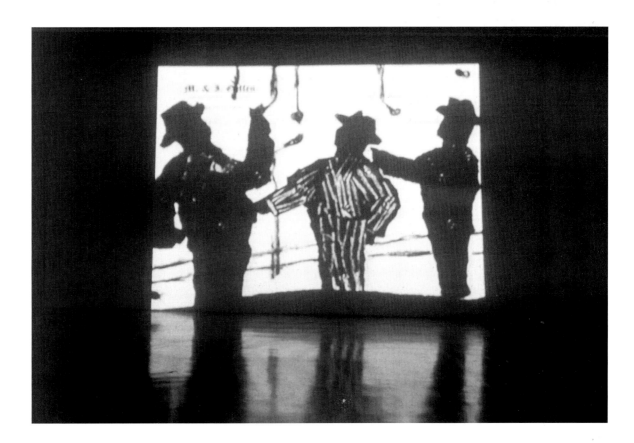

Installation view:
*Ubu Tells the Truth* 1997
'Delta', Paris, 1997 - 1998,
Courtesy ARC, Musée d'Art
Moderne de la Ville de Paris

their story, pause, weep, be comforted by professional comforters who sit at the table with them. The stories are harrowing, spellbinding. The audience sit at the edge of their seats listening to every word. This is exemplary civic theatre, a public hearing of private griefs, which are absorbed into the body politic as a part of a deeper understanding of how the society arrived at its present position. The theatre rekindles each day the questions of the moment. How to deal with a guilt for the past, a memory of it? It awakes every day the conflict between the desire for retribution and a need for some sort of social reconciliation. Even those people (and there are a lot) who will have nothing to do with the Commission and who are in denial of the truths it is revealing are, in their very strident refusals, joining in the debate.

Both the process of the Commission and the material coming out of it have been a source of new theatre in South Africa. Three plays have run at The Market Theatre complex in Johannesburg that deal with our recent past and the commission.

But in the face of the strength of the theatre of the Commission, the question arises, how can any of us working in the theatre compete with it? Of course, we can't and don't try to. The origin of our work is very different and even if in the end it links directly to the Commission, this is secondary rather than primary. Our theatre is a reflection on the debate rather than the debate itself. It tries to make sense of the memory rather than be the memory.

To go on a fast and brief digression into the origin of this our most recent play, *Ubu and the Truth Commission*, I have for some years been working with the Handspring Puppet Company in Johannesburg, making pieces of theatre that combine animation, puppets and actors – not out of some deep aesthetic principle or programme, but rather, out of the fact that I make animation, and Handspring make puppet theatre, and we wanted to see what would happen if we combined the two. Some readers may have seen *Woyzeck on the Highveld*, which we performed in 1993, and *Faustus in Africa!*,
which we performed two years ago. *Faustus* was a huge undertaking and after it was done the Handspring Puppet Company and I decided to do a minimal production – two actors, maybe one fragment of animation. Something we could do and survive. *Waiting for Godot* threw itself up as an option. It would work very well for puppets, with perhaps only one fragment of animation in the middle, when Lucky and Pozzo THINK. But we reckoned without the Beckett fundamentalists who would not give permission for us to leave out even a comma from the stage directions. We then thought how we could find a neo-Beckettian text to work with. None of us had the courage or skill to write our own. We then thought of working with a found text: this, in the hope of finding the words that people use to describe extreme situations, a bed-rock connection between human experience and the language we use to talk about it. We thought of starting on a project that would gather oral testimonies from land-mine victims waiting in rural orthopaedic hospitals in Angola and Mozambique, this project was called *Waiting Room*.

At about this time I was working on a series of etchings based on Jarry's *Ubu* (for an exhibition marking the centenary of the first production of *Ubu Roi* on stage in Paris). These etchings involved a drawing of a naked man in front of a blackboard. On the blackboard were chalk drawings of Jarry's Ubu with his pointed head and belly spiral. After the etchings were done, I wanted to animate the chalk Jarryesque drawings and then thought that if these were animated, so should the figure in front be. I then asked a choreographer friend if she wanted to do a piece using a dancer in front of a screen, in which a schematic line-drawing of Ubu would be moving. Thus the *Ubu* project was begun. Panic mounted. I realised I could not do both the *Ubu* and the *Waiting Room* projects. There were not enough weeks for animation. In desperation I combined the two.

At this time too, the first hearing of the Truth Commission began and it rapidly became clear that if we were looking for found texts we had an avalanche of remarkable material arriving every day. Even as I started the process of

convincing the participants in the different projects that it made sense to combine them, it became clear that in some ways the contradictory projects – sober documentary material and wild burlesque – could make sense together. The material from the Truth Commission could give a gravitas and grounding to *Ubu* (which was always in danger of becoming merely amusing). At the same time the wildness and openness of Jarry's conception could give us a way of approaching the documentary material in a new manner and so enable us all to hear the evidence afresh.

This was the central challenge with which we started. Only now, with the production completed and on the stage, can we get any feeling whether the inauthenticity of the origins of the piece has damned it ineluctably or whether in spite of (or as I believe) because of, this strange, only half-coherent beginning, were we able to find pieces of the play, images, literary conceits, changing physical metaphors that we would never have arrived at if we had started from a sober beginning. How can we do honour to this material from the Truth Commission? In so far as I have a polemic it is this: to trust in the inauthentic, the contingent, the practical as a way of arriving at meaning, I will elaborate on this later.

A question that arose was how to deal with the witnesses' stories on the stage – these formed the found text of the original project. Quite early on we knew that the witnesses would all be performed by puppets (with the speaking manipulators visible next to them – our usual way of working) and that Ma and Pa Ubu would be played by actors.

There were two routes to this decision. The first as an answer to the ethical question: what is our responsibility to the people whose stories we are using as raw fodder for the play? There seems to be an awkwardness in getting actors to play the witnesses – the audience being caught halfway between having to believe in the actor for the sake of the actual witness who existed out there, but was not the actor. Using a puppet made this contradiction palpable. There is no attempt to make the audience think the wooden puppet or its

manipulator is the actual witness. The puppet becomes a medium through which the testimony can be heard.

But it would be false to say that our route to the decision to use puppets for these parts came this way. Rather, we knew from the beginning that Pa and Ma Ubu would be human actors as that had been the premise for the first dance/animation conception, and by the same token, we knew that the witnesses would be puppets because that had been the premise of the *Waiting Room* project. The more honourable route to the decision about performance style, the first 'ethical' route, is a justification after the event.

But the decision brought a whole series of meanings and opportunities in its wake, the most important of which was that witnesses could appear in different corners of Ubu's life, not only at the witness stand as we had originally anticipated. They were also able to generate a whole series of unexpected meanings that became central to the play. For example, we experimented with a scene in which Ubu is lying on a table and above him a puppet witness gives evidence on the death of his child. We tried it first with the witness standing behind Ubu's hips. The body of Ubu became an undulating landscape, a small rise in the ground, behind which the witness spoke. We then tried the same scene with the witness behind Ubu's head. Immediately the testimony of the witness became a mere dream of Ubu, the story was taken from the witness and became Ubu's confession. We put the witness behind Ubu's legs again and he was back in the landscape. We then tried to see how close the puppet could get to touching Ubu without breaking the double image. Extremely close we found. And then we tried it with the witness touching Ubu's hip with its wooden hand. An extraordinary thing happened. What we saw was an act of absolution. The witness forgave, even comforted Ubu for his act. This was a series of wholly unexpected meanings, generated not through clarity of thought, or brilliance of invention, but through practical theatre work. This is the second polemic I would make: a faith in a practical epistemology in the theatre – trusting in,

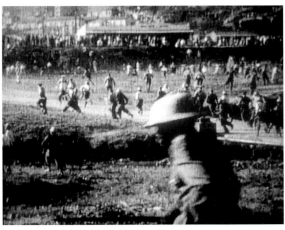

Drawings and documentary
footage for *Ubu Tells the Truth*
1997 and for animation in theatre
production *Ubu and the Truth
Commission* 1997

and using, the artifices and techniques of theatre to generate meaning.

It also works in reverse. With the animation dance scene, I had the clear idea of creating a character made up of the live actor in front of the screen and a schematic representation or cartoon of the same character on the screen. Both would be seen together, and together, would generate the richly complex person. Confidence in the ideas gave the strength to begin the project. However, it became clear within twenty minutes of starting this that it would not work. For reasons of synchronisation, parallax, lighting, stilted performance, it became impossible and this central principle was thrown out. Next polemic: Mistrust of Good Ideas in the Abstract. Mistrust of starting with a knowledge of the meaning of an image and thinking it can then be executed. There is, for me, more than an accidental linguistic connection between *executing* an idea and *killing* it.

But to go back to the question of the witnesses and their testimonies, which is the central question we grappled with in the heart of our play. As I have said, our solution was to use puppets. (Even here it was not quite so simple. At first we realised how brilliant was our conception of using puppets because, at the Commission, not only did one have witnesses giving evidence, but one also had a translator of that evidence. Two speakers for the same story and *our puppets need two manipulators!* One manipulator could tell the story in Zulu and the other could translate. But it did not work. The stories could not be heard. In the end we banished our translators to a glass booth – Ubu's shower – and made a difference between the natural voice of the witness and the artificial, public-address voice of the translator.)

But there have been other solutions to the question of how to deal with the raw material thrown up by the Truth Commission. As I said earlier, there were two other plays running at The Market Theatre that deal with the Truth Commission. The first, *The Dead Wait*, is a conventional play. It is a fictional reconstruction of an event from the war in Angola, recounting a soldier's return to South Africa and his attempt to make his confession for a crime that he committed. Although this play comes out of the context of the Truth Commission, it is not directly about the Commission and its processes.

The other play, *The Story I Am About To Tell*, was made by a support group for survivors who have given evidence before the Commission. It is a play designed to travel around various communities to spread awareness of the Commission and engage people in debate around questions raised by the Commission. Their solution was to have three of the witnesses play themselves. That is, three people who were giving evidence before the Truth and Reconciliation Commission returned each night and on stage, gave evidence again. The mother of a lawyer whose head was blown up by a booby-trapped walkman describes crawling on her knees into the room where the shattered body and head lay. A man describes three years on death row, waiting to be hanged for a crime he did not commit. A woman describes being arrested, interrogated and raped by security police. Their evidence is the central, but not the only, element of the play, most of which is set in a taxi full of people going to a Truth Commission hearing. Three professional actors play the bit parts, provide comic interludes, and lead the scripted debates about the Commission, and the three 'real' people give their testimony.

And yet it is only a partial solution to the questions raised by the Commission. Because what the 'real' people give is not the evidence itself but performances of the evidence. There is a huge gap between the testimony at the Commission and its re-performance on stage. And these are not actors. In fact, it is their very awkwardness that makes the performance work. One is constantly thrown back, through their awkwardness, into realising that these are the actual people who underwent the terrible thing they are describing. The most moving moment for me was when the survivor of three years on death row had a lapse of memory. How could he forget his own story? But of course, he was in that moment a performer, at a loss for his place in the script. I have no clear solution to the paradoxes that this half-testimony, half-performance raised, but

describe it as one of many possible ways of dealing with the material.

The Truth and Reconciliation Commission was faced with a similar problem of doing justice to the testimonies. There was a divergence between the emotions expressed by the witnesses telling their stories and the version given by the translators. It was felt that much of the heart of the testimony was lost when it came back through the translators. So for a short while the Commission had the disastrous idea of encouraging the translators to copy and perform the emotions of the witnesses in their translations. This was soon stopped.

The question of how to do justice to the stories bedevils all of us trying to work in this terrain. With *Ubu and the Truth Commission*, the task is to get a balance between the burlesque of Pa and Ma Ubu and the quietness of the witnesses. When the play is working at its best, Pa Ubu does not hold back. He tries to colonise the stage and be the sole focus of the audience. And it is the task of the actors and manipulators of the puppets to wrest that attention back. This battle is extremely delicate. If pushed too hard, there is the danger of the witnesses becoming strident, pathetic, self-pitying. If they retreat too far, they are swamped by Ubu. But sometimes, in a good performance, and with a willing audience, we do make the witnesses' stories clearly heard and also throw them into a wider set of questions that Ubu engenders around them.

It sounds recondite, but again, I will say that it is only on the stage, in the moment, that one can judge how the material is given its weight. This changes both from performance to performance and from audience to audience.

Purely in the context of my own work, I would repeat my trust in the contingent, the inauthentic, the whim, the practical, as strategies for finding meaning. I would repeat my mistrust in the worth of Good Ideas, and state a belief that somewhere between relying on pure chance on the one hand, and the execution of a programme on the other, lies the most uncertain, but the most fertile ground for the work we do.

But I have no fixed opinion on which of the three plays I have referred to is the best way to go. I think I have shown that it is not the clear light of reason or even aesthetic sensibility that determines how one works, but a constellation of factors, only some of which we can change at will.

Each of the different pieces of theatre I have described can, and has, had enormous impact on their respective audiences. After one performance of *The Story I Am About To Tell*, a spectator was inconsolable. Her tears were for the stories, but also she said that they were for anger and regret, that never in her life in Munich had there been a similar theatre of testimony. A friend was deeply moved by *The Dead Wait*, the play about the war in Angola. He had served as a soldier in that war. And after a performance of *Ubu and the Truth Commission*, a woman came up to us, obviously moved by what she had seen. She said she was from Romania. We expressed surprise that the play had been accessible to her, as it was so local in its content. 'That's it', she said, 'it is so local. So local. This play is written about Romania'.

INTERVIEW WITH DAVID KRUT
(extracts from*William Kentridge*, CD-Rom, David Krut Publisher, Johannesburg, 1998)

I think in many ways the large *Ubu* drawings are autobiographical, or they are certainly self-portraits, in a way that is possible because they didn't start off as that. I wasn't saying 'How do I do a new drawing of myself? How do I show who I am ?' I started off saying 'I need to do a drawing of Ubu, I don't have an UBU present, I will have to stand in for Ubu and because I am not being myself I can be ridiculous, I can be grotesque, I can dance, I can jump, I can parade, I can ride a small child's bicycle', and always with the idea that I was doing a drawing of Ubu.

(…)

With the large *Ubu* drawings I wanted to try create a drawing of a full-size human, but with-

out it becoming too descriptive – keeping the looseness and the roughness that existed in the small etchings, the looseness and the roughness that had come because the thumb-prints and the hand-prints were too large for the figure that they were trying to describe. And the starting point for these drawings was laying sheets of paper out on the floor and marking it in all different sorts of ways and encouraging my children and my cats to run across the sheet of paper, having first stepped in trays of charcoal dust; pushing a small bicycle around and around on the sheet of paper; covering a rope with charcoal dust and walloping the sheet of paper; and into these marks and into these bruises of the paper, gradually pulling the shape of the figure into its black silhouette.

(…)

For the installations that I did in Havana for the Havana Biennial, and in Santa Fé for 'Site', I was trying to see if one could start pushing the drawings into a theatrical space, using the room in which the drawings were to be presented as part of the substantive drawing itself.

(…)

In both Havana and Sante Fe there is a video element – some of the animations from *Ubu and the Truth Commission* – and what I was starting to work towards with those two installations was a way of making the actual television monitor into part of the drawings, in this case sculpturally – by placing the monitor not on the usual stand but onto a tripod, which represented the object itself being shown on the television set, which was the Ubu skeleton as tripod. So when you looked at the screen you saw the tripod moving and then you realised that the screen itself was, as it were, the head of the tripod installed in space. This question of sculptural video installations is one element of new work that I am thinking about.

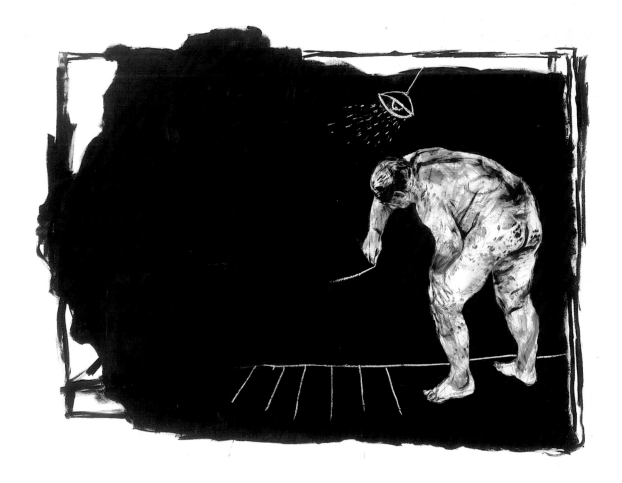

*Cartographer* 1997
gouache, charcoal and pastel
on paper, 120 x 160 cm
Courtesy Goodman Gallery,
Johannesburg

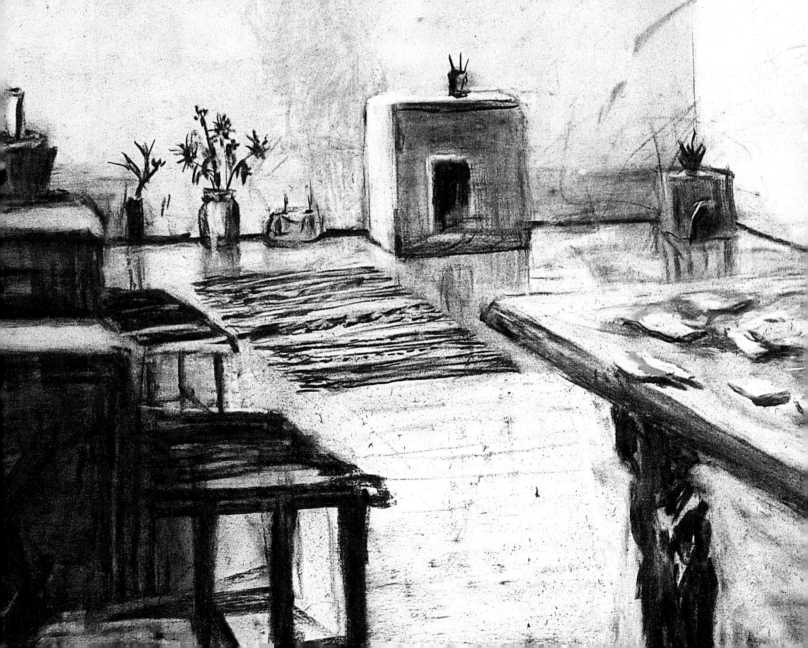

# WEIGHING… and WANTING, 1998

35mm film transferred to video
and laser disc
Drawing, photography and
direction: William Kentridge
Editing: Angus Gibson and
Catherine Meyburgh
Sound: Wilbert Schübel
Music: Philip Miller
Series of c.40 drawings in
charcoal and pastel on paper;
dimensions variable

This is the seventh animation in the series chronicling the rise and fall of Soho Eckstein. Several years separate the making of this film from the riots, uprisings, repression and atrocities during the State of Emergency in the 1980s. More than ten years had gone by since the Soweto uprising, and four since the national elections of 1994, which brought the ANC into power. It was the beginning of a period of reconciliation, in which a new national identity founded on memory was being constructed. This theme of reconciliation lies at the heart of the film.

During this period Kentridge was also working on his first opera, *Il Ritorno d'Ulisse* and there are many close links between this film and the tale of Ulysse's return to Ithaca. The story of Ulysses is of a home-coming, the end of an epic series of events, a reconciliation with the Gods after years of wandering as punishment, an awakening and a form of psychic integration. The main narrative of *WEIGHING… and WANTING* also suggests a home-coming, but here the theme is dealt with in a more ambiguous way. Centring on the character of Soho Ecsktein, Kentridge presents what may be the end of a journey, or is perhaps only a beginning, a reconciliation, or possibly, merely the longing for reconciliation, an event that may be real or only fictive, a dream, a moment of passage.

The film focuses on the way in which forgetting and remembering are closely intertwined. Events fade into the distant background of our landscape and our minds, yet our identity is shaped by this forgetting, and by our sense of guilt that we forget. Kentridge's method of incomplete erasure in his drawings echoes this process of disremembering, as well as the traces of the past in the form of mining and civil engineering structures manifest in the landscape around Johannesburg.

At the centre of the film is the image of a rock, which functions as an allegory, a condensation of different metaphors. It is a part of the landscape and it is the landscape itself. It is the brain and the place where memory occurs. It represents the stratification of events and is time itself. It is also a weight that oppresses the landscape.

From a general point of view, the film is simply structured: a precarious state of equilibrium is broken and, after a crisis, there is a return to a state of calm. But on closer inspection, it reveals a constant spatio-temporal confusion between past, present and imagined future; inside and outside; the mind and the world; microcosm and macrocosm; dream and reality. Such confusion evokes states of mind between sleep and consciousness.

The film begins with the drawing of a white, blue-rimmed teacup and saucer. This image of fragile domesticity is followed by a view of a living-room, with a fireplace, flowers in a vase. The room is empty, but there are fragments of paper spread out on a table. A word appears on the wall: 'WEIGHING…', followed by the words 'and WANTING' – the latter implying both longing and inadequacy. This writing on the wall derives from the story in the Book of Daniel of King Balthasar's vision of a disembodied hand inscribing a text on the wall of the hall in which he is feasting. Balthasar is the son of Nebuchadnezzar, King of Babylon, who conquered the Jews, bringing the youngest and most brilliant, including Daniel, to his court as astrologers, visionaries and interpreters of his dreams. While Nebuchadnezzar learns humility through Daniel's insights, Balthasar worships gold, silver and iron gods, and drinks wine out of vessels stolen from the Temple in Jerusalem. He offers Daniel gold in exchange for his interpretation of the inscription: 'God has numbered the days of your kingdom and brought it to an end; you have been weighed in the balance and found wanting.' The same night, Balthasar is killed.

Various references to this biblical story appear in Kentridge's latest film. A brain-scanning machine resembling a crematorial oven suggests the end of a life, and perhaps, echoes the Holocaust. The two plates of an old measuring scale move up and down periodically throughout the film. An empty landscape with a pool of blue water also recalls the world of *Felix in Exile*. It is unclear whether this is a depiction of an environment prior to colonisation and modernisation, or whether it has been abandoned as a worthless wasteland. A large rock

<
Detail of drawing from
*WEIGHING… and WANTING*
1997
charcoal and pastel on paper

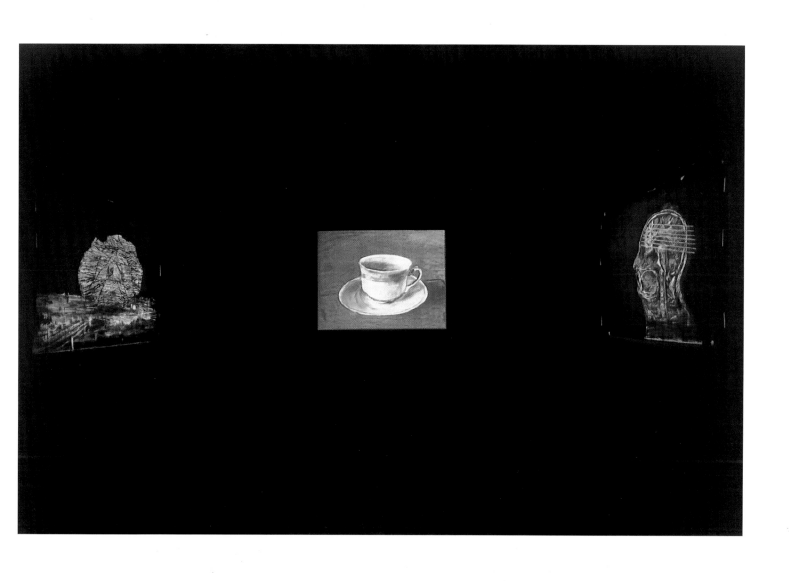

Installation view: *WEIGHING… and WANTING* 1997
Museum of Contemporary Art, San Diego 1998
photo: Pablo Mason (Courtesy Museum of Contemporary Art, San Diego)

appears in the landscape, resembling a brain. The body of Soho Eckstein/Felix Teitlebaum (by now the two figures have merged) enters into the CAT scan machine/oven. A head, shown in profile, of someone simultaneously resembling Soho, Felix and the artist himself, is penetrated by medical scanners. Layers of his brain are X-rayed, reaching a stratum that reveals a brief vision of a mine: a procession of workers, fragments of distant voices. The film cuts abruptly to another landscape. In the distance, protected by tall trees, is a house, based on a building in Sergei Eisenstein's *The General Line* (1928). Whether this is an original modernist house or an example of late-modernist, suburban architecture is left ambiguous. The water of passion in Kentridge's early films has turned into a protected swimming pool of balanced desire.

A man, Soho, is seen in long-shot, walking down a path towards the house. Perhaps he is returning home, after a journey. He stops, picks up a stone. After a temporal ellipsis, we see Soho inside the house, sitting at the table, inspecting the rock. The scales are on the table, along with the pieces of paper. The film shifts to views of the world, fragments of the past inside the rock. We see Soho, fully clothed, lovingly embracing a thin, naked woman wearing glasses (a sign of age, but also of wisdom – could she therefore represent Daniel?). The film shifts back to views of the rock in the landscape.

Images of the outdoor world and the life of South Africa often represent instants of awareness in Kentridge's films, and the film focuses on Soho's personal narrative and on his recollections of his past life, both personal and public. Listening to the cup, as if it were a sea shell, he delves into his mind and into the rock, finding a story of growth and power. Black charcoal marks on paper turn into drawings of civil engineering structures. The image of the woman is erased by emerging representations of an iron framework, popping up in the landscape (recalling Soho's development of Johannesburg in *Johannesburg, 2nd Greatest City after Paris*). Soho rests his head on her lap, but she vanishes and he finds himself reclining on a telephone. In later frames, it is he who is erased from the picture. Marks in the landscape become scars on his naked back. The drawing of the ironwork appears, like in Balthasar's vision, on the wall of the living-room, the black charcoal marks of this drawing toppling and transforming into letters. Words appear, reading: 'In whose lap do I lie?' recalling Ulisse's monologue upon waking on the beach in Monteverdi's opera *Il Ritorno d'Ulisse in Patria* (Act I, Scene VII): 'Am I asleep, or am I awake?/ What countryside do I see again?/What air do I breathe?/On what soil do I tread?'

Scenes of conflict between Soho and the woman follow. She beats him, shattering the teacup; chaos is expressed in black and red marks on the paper, as well as in torn fragments. Soho is back in the house. Alone. From within the rock, the woman is reborn. He listens, they meet again, the fragments are put together. The camera moves back until the rock is again viewed as a whole. We see the living room with a basin of water on the table, the pieces of paper have gone. Soho's head rests on the rock outside. It is night and he is breathing. Is he asleep? Was it a dream? Did he never really reach the house? (CCB)

*How does one bring the entire representation of the world inside one's head?* (WK, 1998)

Drawing from
*WEIGHING... and WANTING*
1997
charcoal and pastel on paper,
78 x 100 cm

Group exhibition: 'Vertical
Time', Barbara Gladstone
Gallery, New York,
10 January - 21 February 1998
(projected on wall)

Solo exhibition: 'William
Kentridge', Museum of
Contemporary Art, San Diego,
24 January - 12 April 1998
(projected on wall with
drawings)

Solo exhibition: 'William
Kentridge', Palais des Beaux-
Arts/Paleis voor Schone
Kunsten, Brussels,
15 May - 23 August 1998,
touring to Kunstverein,
Munich, 28 August -
11 October 1998; Neue Galerie
Graz am Landesmuseum
Joanneum, 15 November 1998 -
15 January 1999
(screened on monitor from
laser disc)

Leslie Camhi, 'Mind Field',
*The Village Voice*, New York,
27 January 1998, p.89

Cotter Holland, 'Vertical
Time', *The New York Times*,
New York, 30 January 1998

Leah Oliman, 'A Laconic Film,
Far from Silent', *Los Angeles
Times*, Los Angeles, 8 February
1998, p. 58-59

Okwui Enwezor, 'Swords
Drawn', *Frieze*, London,
issue 39, March/April 1998,
pp. 66-69

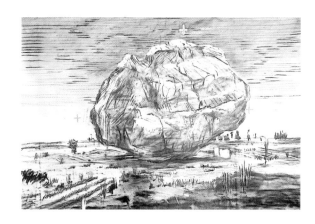

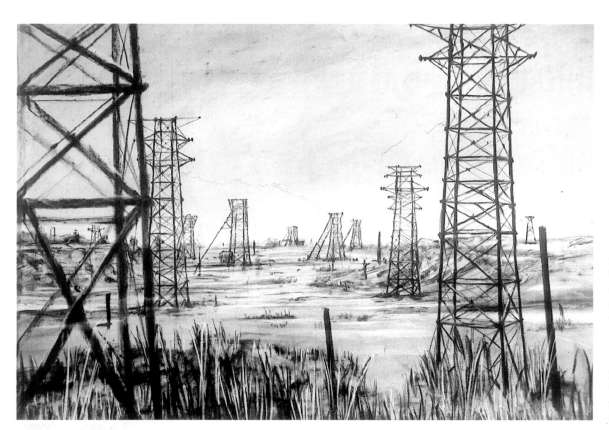

Drawings from
*WEIGHING… and WANTING*
1997
charcoal and pastel on paper,
120 x 160 cm each

Detail of drawing from
*WEIGHING… and WANTING*
1997
charcoal and pastel on paper

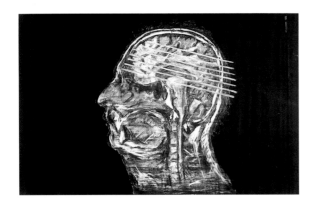

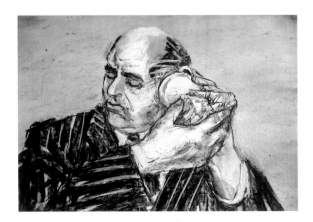

Drawings from
*WEIGHING… and WANTING*
1997
charcoal and pastel on paper,
120 x 160 cm and 63 x 84 cm

THE COMFORT OF A STONE
William Kentridge
(from an unpublished letter to Carolyn
Christov-Bakargiev, 15 March 1998)

A starting point for the film was a dream I had in which I was inconsolable. A stranger came up to me in a waiting room and tried to calm me down by getting me to look at pictures and texts on the wall of the room.

Which led me to think of the writing on the wall in the Book of Daniel in particular, and in general to consider the activity of spending one's life writing on the wall – which, as we know, is not the same activity as interpreting this writing. Initially, I thought the film would be full of texts on the wall but in the end they were pared down to Soho's single question: 'In whose lap do I lie?' I was also going to use the phrase 'the comfort of a stone', but this became an image and so was left off the wall.

The next chain of connection was to think of other truths revealed as images on a wall, which became an idea of Plato's shadows on the wall of the cave. I think this is how the geological elements of the film began. I needed to draw a cave, so had to get into the cave, and started with the rock face and the rock. This rock had to serve both as wall and as container. The wall of Soho's house is like a domestic counterpoint to the rock.

And the rock is another way of drawing the inside of Soho's head. I had seen the MRI brain scans of a friend's head and knew they had to be in the film – not for their meaning but for the urgency with which I wanted to draw them (which is always a mixture between the formal interest – how the fixed images of the scan translate themselves into charcoal and pastel – and the chain of associations the image leaves in its wake). The naturalistic rendering of certain oblique slices through the head become distorted, grotesque evocations of a head – they are used, fragmented, in the violent, *petit mal* towards the end of the film.

### Soho's House

Soho's house was drawn eight years before the rest of the film was made. I had spent two weeks as artist-in-residence at the National Gallery of South Africa in Cape Town in 1990 – just after making the first of the Soho Eckstein films, *Johannesburg, 2nd Greatest City after Paris*, and wanted to start on a new film. And so I took down to the National Gallery a box of sketches, photographs and books to start to tease out a new narrative. One sequence drawn was of a series of carved African heads that become domestic objects – a telephone, a lawn-mower. This was entitled *Soho's Collection*. A second sequence was of an abandoned swimming pool that fills up with these domestic items – the lawnmower, a sewing machine. To connect them I drew Soho's house.

The house is two things. Immediately, it is based on a utopian, worker's house from Eisenstein's film *The General Line*. In the film there is a paddock with livestock in front of the house, not a swimming pool. But more profoundly, the reason for being drawn to the Eisenstein house in the first place, and then portraying it, was the fact that it reminded me of the International Style house of Lower Houghton – a suburb of Johannesburg. Houses familiar from friends whom I visited as a child and that I drove past. My memory of these houses as a child was of their gloom, coldness, unnaturalness, of the glass-brick walls, black concrete patios. I'm sure that it was this mixture of the utopian moment in the Eisenstein combined with the practical disillusion of what the houses were really like that was so seductive in the image.

The film was never completed – it never really got underway. But the animated sequence of the house remained, and it became the house of the Captain in *Woyzeck on the Highveld* (the captain was based on Soho, so it seemed right to give him that house). The swimmingpool sequence was also used in the play. It became Soho's house in *WEIGHING... and WANTING*, and again makes a cameo appearance in *Il Ritorno d'Ulisse,* where its rectangular forms are pressed into service as Ulisse's palace. (Ulisse is based on Soho too, so

the association still seems right.) The interior of the house in the film is taken from the inside of a Johannesburg house built in homage to Le Corbusier.

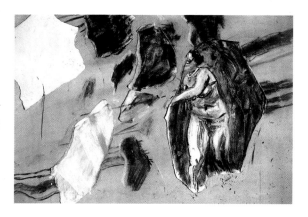

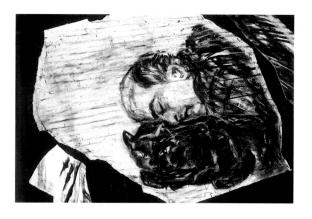

Fragments of drawings from
*WEIGHING... and WANTING*
1997
charcoal and pastel on paper

Drawing from
*WEIGHING... and WANTING*
1990
charcoal and pastel on paper,
120 x 150 cm

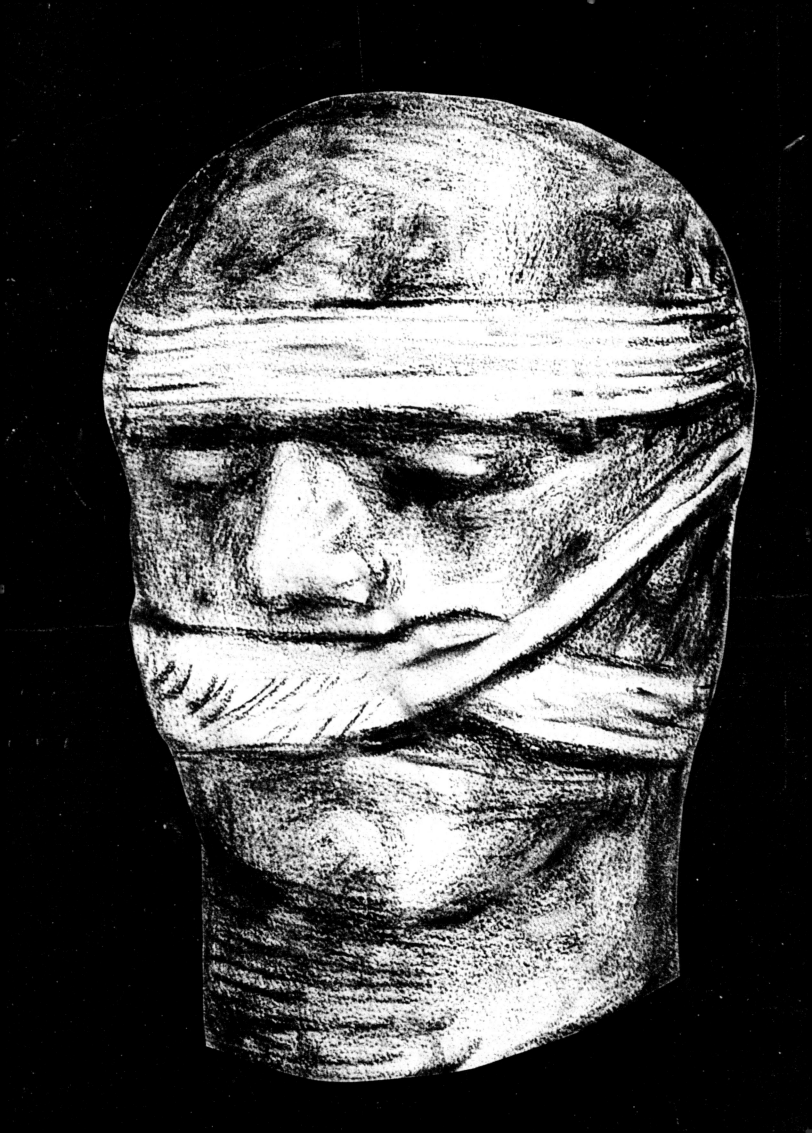

# IL RITORNO D'ULISSE, 1998

Opera with singers, actors, puppets and back-projected animation
c.90 minutes
Series of c.45 drawings and fragments used for animation
Production: Handspring Puppet Company, La Monnaie/De Munt KunstenFESTIVALdesArts, Wiener Festwochen
Director: William Kentridge
Musical Direction: Philippe Pierlot
Musicians: Ensemble Ricercar
Music: Claudio Monteverdi, *Il Ritorno d'Ulisse in Patria*, 1641
Libretto: Giacomo Badoaro
Animation: William Kentridge, assisted by Anne McIlleron, Aviva Spector.
Film editing: Catherine Meyburgh
Puppet master: Adrian Kohler, with the assistance of Tau Qwelane, Nina Gebauer
Set design: Adrian Kohler and William Kentridge
Lighting: Wesley France
Costumes: Adrian Kohler, realised by Sue Steele
Production co-ordinator: Basil Jones
Tour Director: Wesley France
Puppeteers: Adrian Kohler, Busi Zokufa, Louis Seboko, Basil Jones, Tau Qwelane
Singers: Scot Weir (Ulisse), Wilke Te Brummelstroete (Melanto, Anfinomo), Peter Evans (Telemaco, Pisandro), Guillemette Laurens (Penelope), Jaco Huijpen (Nettuno, Antinoo), Margarida Natividade (Minerva), Stephanne van Dijk (Eurimaco, Giove)

<
Fragment of drawing from
*Il Ritorno d'Ulisse* 1998
charcoal on paper

The story of Ulysses is an ancient and epic one. In Homer's *Odyssey*, it is a twenty-year journey through space, time and experience, caused by conflict with the gods, and permeated by a longing for home. After many trials, Ulysses is finally forgiven in a form of psychic integration or awakening, and can return to Ithaca where he must win back his wife, Penelope, through competition with her suitors before revealing his true identity.

Monteverdi's opera, *Il Ritorno d'Ulisse in Patria* (1641) recounts the events of the closing books of the *Odyssey*, with added comments in the Prologue from the allegorical figures of Human Frailty, Time, Fortune and Love describing Man as 'fragile, wretched and distressed'.

In 1995, after directing *Faustus in Africa!*, Kentridge received a proposal from Frie Leysen of the KunstenFESTIVALdesArts in Brussels to collaborate with the Handspring Puppet Theatre on a Monteverdi opera. It was decided that they would create a shortened, ninety-minute version of *Il Ritorno d'Ulisse in Patria* for singers, puppets and animation. As in their previous productions, the audience would be moving constantly between an engagement with the fictional personae of the puppets and an awareness of the theatrical machinery – the manipulators of the puppets, visible on stage. This would be echoed by the operatic form in which attention shifts between the fictional character and the actual singer.

Kentridge's *Il Ritorno d'Ulisse* is set in the late 20th-century world of contemporary South Africa. Its hub is the Second Act, in which Ulisse must confront Penelope's suitors. Throughout the narrative, he lies, not on the beach of Ithaca, as in the original opera, but in a Johannesburg hospital bed, longing to return home, for a journey that may or may not have begun. Hanging on to life, in his feverish state of dreams and visions he remembers the stories of the Greek hero, Ulisse. His mind is flooded with images, ranging from those of classical Greece to the Italian 17th century, to the present day. He is both in the story, and watching it from his bed, 'doubled' by two puppets. Ulisse's home, depicted in the animated drawings forming the backdrop to the opera, resem-

bles the building in WEIGHING. . . *and* WANTING. It evokes the modernist dream of functional and rational architecture, implying that Ulisse's yearning also expresses a melancholic sense of distance (in time and space) from modernism.

There are also many parallels between this opera and *History of the Main Complaint* (1996), a first attempt to join Monteverdi's music with the *Drawings for Projection*. In that film, Soho Eckstein lies in a coma, dreaming, or remembering his life as a long car journey in which events are seen through the filter of a windshield, paralleled by a medical journey through his body. The doctors in pin-striped suits around his bed – men of the 20th century, one might say – resemble the chorus in the opera.

Through the animation and the set design of *Il Ritorno d'Ulisse*, associations are constantly set up between the South African theatre of life where brutal and inhuman acts were committed in the name of rationalism, and the anatomy theatre of modern medicine, as it has been represented since the 16th century in works like Andreas Vesalius's *De humani corporis fabrica* (1543) through to Hogarth's vicious caricatures of anatomy lessons in *The Reward of Cruelty* in the 18th century. Kentridge's portrayal of the body under scrutiny by doctors also recalls his own early charcoal drawings such as the triptych *Dreams of Europe* (1984/85).

The anatomy theatre is a symbol of the birth of modern science, in which doctors dissect and study bodies that are already dead, for the purpose of gaining pure knowledge and furthering their science. Kentridge subtly questions this objective, depersonalised approach by contrasting it with the parallel narrative of his film, which is structured like a process of medical anamnesis – the subjective recollection of the living patient's personal history for the purpose of diagnosis and healing. Kentridge always focuses on the personal narrative, the private story of the individual, not on grand, abstract accounts of South Africa or apartheid. And healing is acknowledging, negotiating a balance between remembering and forgetting,

drawing and erasing, two sides of the same coin in the uncertain journey of life. Just as Penelope sews during the day and undoes at night what she has sewn, postponing her marriage to one of her suitors, Kentridge draws and erases his images.

Ulisse, like Soho/Felix in WEIGHING... and WANTING, is sorry, longing and aware. He is a dreamer and a visionary, caught between his memories of grand plans and his own frailty and mortality. As his name (*oulos ischea* – 'wounded thigh') etymologically suggests, he is a 'scarred' man. His childhood wound, inflicted by a wild boar, has healed but left him with a mark by which he will be recognised upon his return home.

But by removing the last two words of the opera title – 'in Patria' ('to the Homeland') – Kentridge raises the question: to what place is Ulisse returning? Is there a real homeland in our diasporic, post-colonial global landscape? (CCB)

*The sense has to be of Ulisse Eckstein (a 20th-century man in a hospital bed) leading us into the world of the opera. This world, though referring to the 1940s and 1950s, might also allude to the world of classical Greece and 17th-century Italy. So, for example, a doctor's 40s-style stethoscope forms the basis of the ancient Grecian bow that the suitors have to pull.* (WK, 1998)

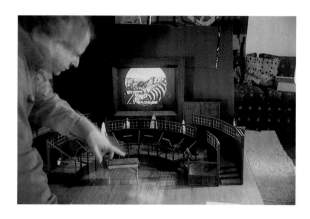

Lunatheater, Brussels, organised by KunstenFESTIVALdesArts and La Monnaie/De Munt and Vienna Festwochen, 9 May 1998 (Premiere); touring Sofiensäle Vienna; Hebbel Teater, Berlin; Civic Theatre, Amsterdam during 'Holland Festival'; Werthalle, Zürich for 'Theater Spektakel'.

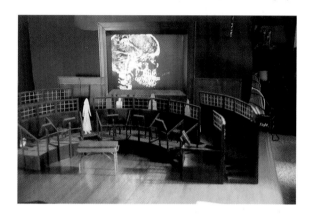

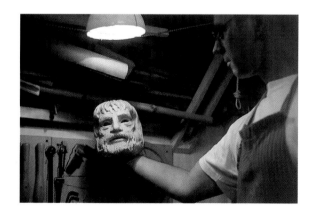

Rehearsal *Il Ritorno d'Ulisse,* Brussels, 1998

Adrian Kohler (Handspring Puppet Company) holding a puppet head for *Il Ritorno d'Ulisse* 1998

Drawings used in the animation for *Il Ritorno d'Ulisse* 1998
charcoal on paper, 80 x 105 cm and 45 x 54 cm

Drawings used in the animation for *Il Ritorno d'Ulisse* 1998
charcoal on paper, 45 x 56 cm and 120 x 160 cm

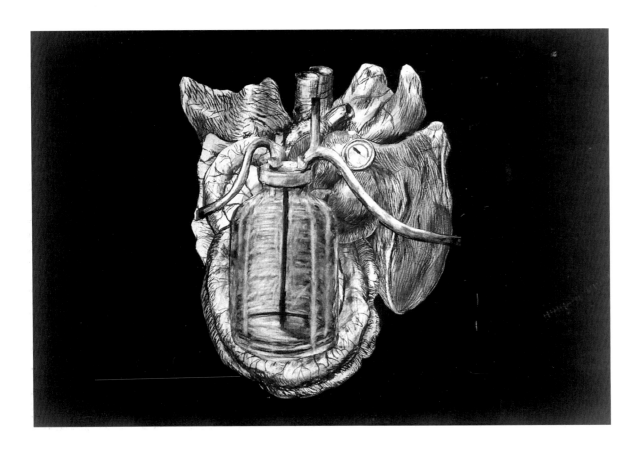

LETTER TO FRIE LEYSEN
FROM WILLIAM KENTRIDGE
(unpublished extract, 22 January 1996)

Concerning the opera, I have been working in two directions. Primarily, on a new animation to find out if there is a compatibility between Monteverdi and the drawings. And listening to the madrigals and the operas. AND THINGS ARE STARTING TO MAKE EXCITING SENSE. The new film (*History of the Main Complaint*) is about half drawn: Soho Eckstein in bed with an unspecified illness. Most of the film is views of the body, X-Rays, CAT scans, sonars, etc., and journeys in his car windscreen. Two things are happening. The views of the body seem to be a rich vein to explore and draw, and will become one of the visual sources for the opera. And secondly, it seems that the Monteverdi music has a surprising congruence. In practical terms, I will bring a rough edit of a section of the film with me when I come to Brussels, together with fragments of Monteverdi so we can play. (The narrative of the current film is not, of course, the narrative of the opera.)

Now, how to describe the opera? The heart of it is Act 2 of *Il Ritorno* (the section with Penelope and the suitors), and fragments from Acts 1 and 3. The framing conceit is Ulisse in his hospital bed, in need of revival. His journey home is a journey through himself. (Literally, through X-rays, images and events through scans.) On stage, these images are on a screen. A chorus of doctors are around the body of Ulisse (in suits like Soho's).

(…)

And it is through these scans, through Ulisse himself (his anxietiese) that we get to his vision of Penelope and the suitors. Rooting the opera part in his post-operative delirium gives a way of dealing with the problem of the classical theme, the early music, the late 20th-century production. (Has Ulisse had multiple bypass surgery? Prospects of drawing this seem fantastic – the fine stitching of the human body and Penelope's fine stitching of her tapestry will yield something rich.)

I don't know if this is making sense to you but there is a sense in it.

So these are some of the elements. A visual

Fragments of drawings used in the animation for *Il Ritorno d'Ulisse* 1998 charcoal on paper

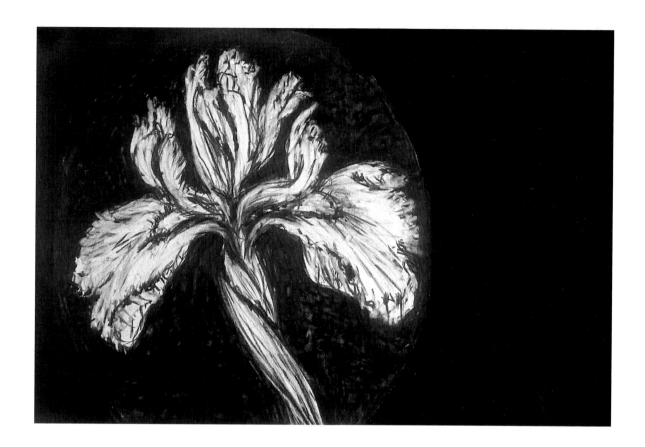

vocabulary based on the body (16th- and 17th-century engravings combined with modern imaging techniques, sonar, magnetic resonance, CAT, X-rays). Playing with Penelope's sewing all day and undoing at night what she has done all day. (Undoing a drawing – animation in reverse can here be rooted, rather than just be a novel effect.)

Lots of open ends at the moment. Perhaps a gradual widening of the gap between Ullisse in bed and his image of himself as the returning hero. So, for example, when he has to draw the bow to beat the suitors, we see one Ulisse (i.e. one puppet Ulisse) with Penelope, drawing the bow, and at the same time, see the first (identical puppet) Ulisse dying in his bed.

(…)

GENERAL NOTES
(William Kentridge, March 1996)

For puppet work, scenes have to be kept relatively short.

For animation, many of the longer pieces have to be edited down (for example Penelope's first lament).

Doubling of characters for singers should not be confusing as the puppets give the primary clue as to which character is singing, rather than the person of the singer.

Scenes move between 20th-century hospital bed with Ulisse in it, to the world of legend.

Ulisse is doubled (puppet-doubled), so he can both be in the hospital bed and in the world of the story, and can view himself in the story from the hospital bed.

In the end, his recovery and reunion with Penelope is seen from the bed where the second Ulisse dies.

The gods form a link between the hospital and the world of Greece.

The tone of lament and pessimism of the prologue and some of the cautions of the Gods are the primary reality; the happy ending of Penelope and Ulisse a projection of the Ulisse dying in the hospital bed.

UNTITLED STATEMENT
(William Kentridge, Brussels, January 1998)

Ulisse's scar from when he was injured as a child by a boar is the only thing that identifies him. This old wound, which I can enter through the drawing, becomes an erupting volcano. And here I have reproduced the muscle of the human heart. I penetrate it through the drawing as if it were a laser operation and the journey in the vessels transforms it into a raging sea. And here is the Iris, which symbolises Penelope: its petals slowly unfurl and then close again. For the lovers I have drawn the outline of a scene in a baroque theatre. A black curtain reveals the stage, which soon extends to infinity, becoming modern streets in Johannesburg, valleys and landscapes.

UNTITLED STATEMENT
Basil Jones, (Production Co-ordinator), January 1998

It will be the first time the puppeteers will not be speaking at all. Because we don't have to think about a vocal performance, we will be able to develop a new realm of subtlety in the movement. The breath of the singers will remain the basis for this, but I am watching people for unconscious hand gestures, which sometimes add a particular nuance to an emotional moment.

In direct contrast we will also be exploring absurdist and anti-naturalist movement, especially with Penelope's three suitors, as well as with the Ulisse puppet, who will float up from the operating table, looking down at his double below. We'll be doing something ordinary singers could never achieve: the puppets will be suspended right inside the music, like astronauts floating in space.

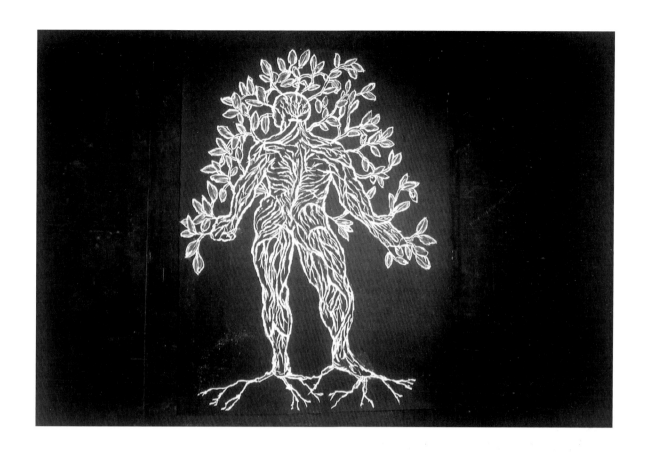

Fragments of drawings
used in the animation for
*Il Ritorno d'Ulisse* 1998
88 x 120 cm and 86 x 120 cm
white chalk on black gouache
on paper

# CHRONOLOGY AND ANTHOLOGY

*For the purposes of this Chronology, William Kentridge's interrelating artistic activities have been categorised under the headings Visual Art, Film and Theatre. Animated films are referred to under Visual Arts when shown in a gallery context and under Film when screened cinematically. Films and videos using actors are listed under Film. Multi-media, live events can be found under Theatre. Other participants in group exhibitions are identified only in shows involving no more than 20 artists.*

William Kentridge was born in Johannesburg on 28 April 1955. After attending King Edward VII School in Johannesburg, he studied from 1973-76 at the University of Witwatersrand where he received his Bachelor of Arts majoring in Politics and African Studies. From 1976 - 78 he was a student at the Johannesburg Art Foundation under Bill Ainslie. During the following two years he taught etching at the Johannesburg Art Foundation and in 1981-2 studied mime and theatre at the Ecole Jacques Lecoq in Paris. After working as Art Director on TV series and feature films, in 1988 he was one of the founder members of the Free Filmmakers Co-operative, based in Johannesburg. He has worked extensively in theatre both as actor, designer and director, was a member of the Junction Avenue Theatre Company, and based in Johannesburg/Soweto, from 1975 to 1991. In 1985, after an interval of some years, during which he was active in film-making, he began to draw again, showing his work in art exhibitions. In 1989 he created his first animated film in the Soho Eckstein/Felix Teitlebaum series, *Johannesburg, 2nd Greatest City after Paris*. In 1992 he made his first theatre project in partnership with Handspring Puppet Company, *Woyzeck on the Highveld*. In 1995, his collaborative project *Memory and Geography* was shown at the Johannesburg Biennial and since then, his works have been included in major international exhibitions ranging from the Sydney, Havana and Istanbul Biennials to 'documenta X'.

## 1975

**VISUAL ART**
Makes drawings, paintings and linocuts

**THEATRE**
Plays Captain MacNure in *Ubu Rex* (adaptation of Alfred Jarry's *Ubu Roi*), directed by Malcolm Purkey, Junction Avenue Theatre Company, a Box and University Player Production, Nunnery Theatre, Johannesburg, May 20 - 31

Plays Goat in *The Goat That Sneezed* by Pippa Stein, directed by Malcolm Purkey, Junction Avenue Theatre Company, Nunnery Theatre, Johannesburg, December

## 1976

**THEATRE**
Designs *Fantastical History of a Useless Man*, devised at Wits University by Kentridge, Purkey, Stein, von Kotze, Sitas, Stanwix, Jacobson, Sack, Fitzgerald and Kroonhof, directed by Malcolm Purkey, Junction Avenue Theatre Company, Nunnery Theatre, Johannesburg, July

*Tooth and Nail. Rethinking Form for the South African Theatre*
*Malcolm Purkey*

In its fifteen-year history, Junction Avenue Theatre Company has created a number of original plays. From *The Fantastical History of a Useless Man*, which opened in 1976 at the Nunnery Theatre, Wits, to *Sophiatown*, which premiered at The Market Theatre, Johannesburg in 1986, from *Randlords and Rotgut*, to the 'people's plays' *Security* and *Dikitsheneng*, from *Marabi*, based on Modikwe Dikobe's *Marabi Dance*, to *Will of a Rebel*, an Expressionist exploration of the life and work of Breyten Breytenbach, the company has been driven by a passion to improvise stories that critically reflect the mad world of apartheid in all of its manifestations.

All these plays have been created collectively in theatre workshops, usually over a period of six months, the group meeting three or four times a week at night, after the members have completed time in their more conventional jobs. Research, oral testimony, yoga and theatre games, exercises and African dance, music workshops and the study of sociology are some of the strands that have made up the electric whole, designed to unleash the creative energies needed to forge a workshopped play.

I have always regarded the theatre workshop as a very special idea with a particular meaning for South Africans. In international theatre debates this century, we have had many powerful arguments for the value of collective play making and the magic of the sacred workshop space, but in South Africa a vital element is added. The workshop is a space where South Africans can momentarily leave the monster of apartheid behind them and meet as equals, without prejudice, to work creatively together.

(…)

Most of the work the company has created has been conceived as militantly oppositional and locates itself firmly in the anti-apartheid tradition. We have taken on the task of revealing 'hidden history' and telling stories from the point of view of the oppressed. In taking on the question of history and telling those stories the state wants hidden, the company has largely relied on a model for theatre-making that is based on a strong concept of character development and narrative structure and is indebted in part to a kind of Social Realism and in part to the theories of Brecht.
(G. Davis, A. Fuchs, *Theatre and Change in South Africa*, Harwood Academic Publishers, Amsterdam, 1996, pp.156-158)

1977

VISUAL ART
Makes series of etchings

THEATRE
Co-designs set, poster and programmes with Steven Sack for the children's play *Wooze Bear*, by Pippa Stein and Malcolm Purkey, directed by Malcolm Purkey, Nunnery Theatre, Johannesburg, 18 - 22 July

*Fantastical History of a Useless Man* performed again in Cape Town, directed by Ken Loach, July

1978

VISUAL ART
Group exhibition: 'Exhibition', Akis 101 Gallery, Johannesburg, 1 - 30 November
With work from the Bill Ainslie workshop by Bill Ainslie, Jill Bailie, Ricky Burnett, David Koloane, Gabriel Mashile, Steven Sack, Jenny Stadler
Exhibited works: *Family portrait*, oil on board, (destroyed); untitled drawing of group on beach, charcoal on paper

FILM
First animated film, *Title/Tale*, with Stephen Sack and Jemima Hunt, 8mm, 2 minutes

THEATRE
Helps devise and performs in *Randlords and Rotgut*, based on an essay by Charles Van Onselen, directed by Malcolm Purkey, Junction Avenue Theatre Company, Nunnery Theatre, Johannesburg, February - March

Plays Tristan Tzara and designs *Travesties* by Tom Stoppard, directed by Malcolm Purkey, The Market Theatre, Johannesburg, from 25 May

Designs *Play it Again, Sam* by Woody Allen, directed by Barney Simon at The Market Theatre, Johannesburg, October

## Randlords and Rotgut
### (Unatrributed)

*Randlords and Rotgut*, running at the Nunnery submits us to an experience that we are forced to respond to critically. The experience is the society of early Johannesburg, which functions as a model to explain the historical roots and predicament of white, English, South African society.

Devised from a research paper by Charles van Oselen, the play, ostensibly looks at the impact of liquor in the pre-Boer War Transvaal.

The play follows the fortunes of Sammy Marks (played with consummate sauveness by William Kentridge), who obtained from Kruger a liquor monopoly and opened the first distillery in the Transvaal. Liquor was subsequently used in the mines as a method of labour control and profit maximisation and became one of the strategies used by mine-owners to keep a docile, exploitable work force, one of the prerequisites of the mining industry.

This backfired, however, as drunkenness lead to a loss of working hours and profits ('Time is Money') and prohibition ensued. But an illegal liquor traffic continued unabated with Marks reaping in profits on all sides.

Along with liquor, the play focuses on strategies of control and relationships and hierarchies of power and ownership, which created specific lifestyles, attitudes and social patterns that still persist today.

The play is structured around a binary view of society – the owners and the non-owners or workers – and the reciprocal relationship between the two.

(…)

The play is instructive and educative, yet it still remains theatre – a total theatre of song, dance, comedy, pantomime, pageantry and tableau. And Patti Henderson as the commentator provides lucid contemporary hindsight comment by way of song.

(Staff Reporter, *Wits Student*, Johannesburg, 13 February 1978)

## Zany Quadrille
### Raeford Daniel

Shaw once said of Wilde that he was, perhaps, the only true playwright: 'He plays with everything.'

He might have said the same of Stoppard. In this marvellous invention, a kind of parodied extension of Wilde's *Importance of Being Ernest*, the wonder boy of the theatre weaves a wickedly funny web in which four famous contemporaries, Lenin, James Joyce, Dadaist Tristan Tzara and Henry Carr, fortuitously together in Zurich in 1917, are made to dance a preposterous quadrille.

It is a dance of incredible agility, whirling, tossing this way and that the world-shaking ideas of the time – among them the stirrings of social revolution, the conflict between anarchy and 'bourgeois individualism' in art.

And this lively production, in which Malcolm Purkey makes an impressive professional debut as director, full rein is given to Stoppard's intentions.

(…)

William Kentridge's Tzara is a curiosity, stilted and patently contrived in both speech and movement, it is nevertheless bold and assertive, making a positive contribution to the ensemble orchestration and narrative flow.

(*Rand Daily Mail*, Johannesburg, May 1978)

### VISUAL ART
First solo exhibition: 'William Kentridge', The Market Gallery, Johannesburg, 4 November - 1 December
Exhibited works: c.30 monoprints including *Pas de Deux*; *Déjeuner sur l'Herbe*; *Pyramus and Thisbe*; *The Deportees*; *Civil Defense*. Drawings, pencil on paper, including *The Birth of Venus*

### FILM
Creates an untitled, 8mm, 2-minute flip-book animation, never publicly screened

### THEATRE
Makes debut as director with the play *Will of a Rebel* by Ari Sitas and Haunchen Koornhof, Junction Avenue Theatre Company, Nunnery Theatre, Johannesburg, 19 - 31 March

Helps devise and acts in *Security* by A. von Kotze, Junction Avenue Theatre Company, performed in community halls around Johannesburg and Durban, October - December

## Breyten the Man – and the Cause
### RJ Greig

Breyten Breytenbach pinpointed so many conflicts of creative white South Africans that the Junction Avenue Company wanted to make a play about him. And so, last year, members of the company, which has been involved in making plays, began their work about the Afrikaans poet who, in exile, joined a resistance movement and returned to imprisonment. 'Breytenbach took the path of exile where his writing flourished, but he felt the need to return', William Kentridge, one of the Junction Avenue members, explained this week. 'As a radical white, he was isolated from other whites. He was alienated from the laager. Yet it's worth remembering that he's in a tradition of Afrikaner radicalism – the Afrikaans trade union women of the 1930s were also part of that. That tradition tends to get forgotten. As a white in opposition, he felt politically impotent. 'No, I don't think we are romanticising a failure. In any case, why should one have trumped-up heroics? The point is to sediment the roots of failure, to dissect its causes. Breytenbach wasn't entirely crushed by his imprisonment. He is still writing.

(…)

We want to show the particularity of this individual but also the forces that affect him, unpeeling him, showing how he rejects the South African Moloch, the god that eats its own.

(*The Star*, Johannesburg, 16 March 1979)

## From the Courtyard
### Erica Emdon

Kentridge's work is disquieting and perhaps this is where his appeal lies. His work contains little colour – one is struck by dark greys, black and white. Almost all of the monotypes consist of figures in dark courtyards, similar to a prison exercise yard. The figures are always being watched from above by faceless grey individuals. This backdrop – which links all the individual works – infuses the work with qualities of claustrophobia. The characters are ridden with tension. They are never alone in their dismal courtyards – even in the private act of love, the same faceless figures peer down at them. The vision seems to be people living in a closed, dark omnipresent society from which there can be no escape

(…)

Throughout, there is a balance between the artist's autobiographical approach and the social context

(*Financial Mail*, Johannesburg, 23 November 1979)

THEATRE
Scripts and directs *Dikhitsheneng*, Junction Avenue Theatre Company, performed at community centres around Johannesburg

VISUAL ART
Solo exhibition: 'Domestic Scenes', The Market Gallery, Johannesburg, 1 - 21 February Exhibited works: portfolio of 40 etchings entitled *Domestic Scenes* 1980-81, hardground, aquatint, softground and dry-point. Series of 8 untitled drawings 1980-1, black floor polish on canvas. *Seated Man Being served by Standing Companion*; *Birth of Venus* (drawing); *A White Annunciation 1*; *Woman and Lamp*; *Lunch in the Garden* (drawing); *A Circus* (drawing)

Group exhibition: 'National Graphic Show', South African Association of Art, Belville, Cape Town, April. Wins First Prize Exhibited works include: portfolio of etchings *Domestic Scenes: Domestic Scenes A Wild-Life Catalogue*; *Domestic Scenes They Also Wait who Only*; *Domestic Scenes Preparations for that Day*; *Clotho Lachesis & Atropos (PTY.) LTD*, (coloured etching); *The Exhibition: Our Lady's Final*; *The Exhibition: A Private Viewing*, (monoprint)

FILM
Co-directs with Hugo Cassirer *Howl at the Moon*, 40-minute video fiction, filmed in backyard of his parent's house, 72 Houghton Drive, Johannesburg

THEATRE
Designs sets for *Wooze Bear and the Zoo Bears*

FILM
Wins American Film Festival Red Ribbon Award For Short Fiction for *Howl at the Moon*, screened in New York, September

THEATRE
Designs set for version of Euripedes' tragedy *The Bacchæ*, Junction Avenue Theatre Company, directed by Malcolm Purkey, The Market Theatre, Johannesburg, September - October

Writes children's play *Emily's Wheelbarrow Show and the Infamous Mr Sterntrap*, directed by Malcolm Purkey, Wits Theatre, Johannesburg, December 1983 - January 1984

*Musing over Masks*
*Stephen Davimes*

When is your face not your face?

When you're acting in a Greek Tragedy where the masks and props are designed by Johannesburg set designer and theatre 'omni-person', William Kentridge.

Twenty-eight-year-old William's shoestring sticking-plaster theatrical masks are part-face, part-mask, part-animal or part-bird, depending on how and in which scene they're used. And they're to be used in a production of Euripides' 'The Bacchæ', opening at The Market Theatre on Monday.

(…)

Acting with masks is fairly innovative for South Africa.

The actors' performance will be determined by the masks.

'There's a tendency for people in the acting profession to act with the voice and the head', says William. 'The use of masks will now bring the body into focus.'

(…)

A few are designed to be worn on the top of the head (…) so that when an actor bows his forehead, he physically looks like a particular animal, such as a bird. When he lift his face again, he can then talk to the audience while showing his face.

(*Sunday Express*, Johannesburg, 11 September 1983)

FILM
Writes, directs and edits *Salestalk*; film-fiction, 16mm, 30 minutes, Kentridge's only film made entirely with existing objects, people and places

THEATRE
Revival of *Dikhitsheneng*, directed by Malcolm Purkey, The Market Theatre, Johannesburg, 27 March

Directs *Catastrophe* by Samuel Beckett, Wits Theatre, Johannesburg, September

As part of the Junction Avenue Theatre Company, wins Olive Schreiner Prize for Drama for *Randlords and Rotgut*, Cape Town, September

Plays role of manager in *A Noose for Scariot Impimpi*, a play by a shop-steward's collective aimed at trade union members, Durban, performed in community centres and halls around Durban

VISUAL ART
Solo exhibition: 'William Kentridge', Cassirer Fine Art, Johannesburg, 15 - 27 April
Exhibited works: *Interval in the Dress Circle* 1984/85, charcoal and pastel on paper; *Tropical Lovestorm* 1984/5, charcoal and crayon on paper; *Dreams of Europe* 1984/5, (Coll. National Gallery, Cape Town); *Watteau's Tea Room* 1984/5, charcoal and crayon on paper; *In the Musey Room* 1985, oil on board; *Woman on an inclined plane* 1984, bronze sculpture; *Man in a high chair* 1984, bronze sculpture

Group exhibition: 'Cape Town Triennial 1985', South African National Gallery, Cape Town, 18 September - 2 November, (Merit Award), touring until November 1986 to Port Elizabeth, Bloemfontein, Kimberley, Pietermaritzburg, Durban, Johannesburg, Pretoria
Exhibited works: *The Conservationist's Ball: Culling, Gamewatching, Taming*, (triptych), charcoal, pastel and gouache on paper.

Group exhibition: 'Eleven Figurative Artists', The Market Gallery, Johannesburg, 10 - 30 November
With Ilona Anderson, Deborah Bell, Neil Goedhals, Robert Hodgins, Jeffrey Lok, Jan Neethling, Anne Sassoon, Joachim Schonfeldt, Paul Stopforth, Frank Van Schaik

Exhibited works: *Grace Before Meals* 1984, charcoal on paper; *Portrait of MP* 1985, charcoal on paper

Group exhibition: 'Paperworks Exhibition', Natal Arts Society, Durban, April
Exhibited works: *Family Portrait*, (Collection Durban Art Gallery)

Group exhibition: 'Tributaries', curated by Ricky Burnett, held in a shed behind The Market Theatre, Johannesburg, January
Exhibited works: *Dreams of Europe (Stages of Cruelty)* 1984, triptych charcoal drawing, based on Hogarth's *The Rewards of Cruelty*

FILM
*Salestalk* wins Blue Ribbon Award, American Film Festival, New York and is screened at the 'London Film Festival', London, October

*David Goldblatt*, black and white, 50-minute documentary, directed by Kentridge, screens on Channel 4 in the United Kingdom

Makes *Vetkoek/ Fête Galante* 1985, animated film with actors and drawings, 16mm, 2 minutes, 41 seconds

THEATRE
*Catastrophe* performed again, The Market Theatre, Johannesburg, July 1985

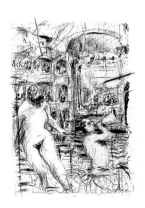

*Powerful Imagery of Haunted World in Charcoal*
*Samantha James*

Although the figures are sometimes loosely drawn, the atmosphere and imagery in these charcoal compositions is immensely powerful. Kentridge is a master of the dramatic angle. The drawings give the impression of being snatches of an almost haunting world; remembered, visualised and fantasised in separate chambers of the mind.

He continues this feeling by dividing some of the pictures with a gap, as if they are envisaged (literally) with two minds. They portray yearning and decadence with a boldness of line; generating such force it becomes a substitute for appropriate action.
(*The Star*, Johannesburg, 26 April 1985)

*William Kentridge's Rich and Expressive Art*
*Joyce Ozinski*

All too often with contemporary art one finds oneself wondering if the artist has anything much to say. William Kentridge's drawings happily do not inspire such doubts. His charcoal drawings are rich and expressive. They reflect a lively and informed intellect and strong feelings. Wit and a sense of irony add additional layers of meaning.

Kentridge is an actor, director and film-maker. As one might expect, his art is fundamentally narrative, though the structure is surreal rather than chronological. He is particularly skilled at conveying gesture. The light or dark charcoal marks conveying the language of the body are precise and evocative.

He compresses perspective, makes strange juxtapositions and creates ineluctable relations between people and objects, generating an intense interaction.

Textures are rendered directly and sensuously and the light and shadow fall with an almost physical solidity.

Kentridge says that this exhibition reflects his experience during a year spent in Europe, and that his imagery is drawn from very diverse pictorial sources.

For anyone living in a post-colonial context, European culture looms large, either as a source of inspiration or as a problematic aspect of one's identity. Kentridge's response to this European heritage is a complex one.

In 'Dreams of Europe' he immerses himself in the decadence and sensuality of the *haute bourgeoisie*. One thinks of Ezra Pound's description of Europe as an old bitch gone in the teeth. The title refers to real dreams, not hopeful aspirations, and the last picture in the triptych, with its stuffed animals and reference to Goya, summons up a culture in which materialism has suffocated the spirit.

'In the Musey Room' takes its title from James Joyce's book *Finnegan's Wake*. It is a drawing of the reading room at the British Museum. The second half of the sentence 'and mind your head goin' in' is a reminder that an uncritical reverence for European culture has its hazards.

The complexity of Kentridge's responses and the skill and imagination with which he transforms them into images make this an unusually interesting and rewarding exhibition.
(*Rand Daily Mail*, Johannesburg, May 1985)

*A Lesson in Dramatic Architecture*
*Joe Podbrey*

Samuel Beckett's 'Catastrophe' was inspired by the imprisonment of dissident Czech playwright Vaclav Havel. Under the direction of William Kentridge, it makes the kind of impact it was intended to make – that no amount of mental torture and degradation can kill the human spirit; that the final spark can never be quite extinguished.
(*Business Day*, Johannesburg, 17 July 1985)

VISUAL ART
Wins The Market Theatre Award at 'New Visions Exhibition' and Quarterly AA Vita Award for 'William Kentridge', Cassirer Fine Art, 1995

Group exhibition: 'Visions', The Market Gallery, Johannesburg, 6 - 26 April
Exhibited works: *Johannesburg. Three prospects (Dunkeld, Germiston* and *Tuileries),* triptych, charcoal on paper; *Haley's Comet*, dry-point etching

Group exhibition: 'Claes Eklundh, William Kentridge, Thomas Lawson', Simon/Neuman Galleries, New York, 28 May - 28 July
Exhibited works: four drawings in charcoal on paper

Group exhibition: 'But, this is the Reality', The Market Gallery, Johannesburg, 20 July - 2 August and 11 - 16 August
With Alan Crump, Neville Dubow, Leon Du Plessis, Jan Erasmus, Neil Goedhals, Michael Goldberg, Jeff Lok, Suzette Munnik, Jon Nankin, Malcolm Payne, Ivor Powell, Colin Richards, Nina Romm, Ronald Rosenberg, Steven Sack, Stan Sher
Exhibited works: *The Need for Utopian Thinking: a Johannesburg Childhood* 1986, a back-lit slide in a frame showing a tyre in a swimming pool; *Vetkoek/Fête Galante* 1985

Solo exhibition: 'William Kentridge', Cassirer Fine Art, Johannesburg, 3 - 15 November. A selection of the works also shown at the South African Arts Association, Pretoria, 24 November
Exhibited paintings, drawings and etchings: *The Confidences; Panelbeaters; Do not Disturb; Breakfast in the Ante Chamber; Flood at the Opera House; Out the Water; Ou Kaapse Weg; Cutting near Laingsburg; Tuis Vervaardig; Nitrous Oxide; Can we Leave?; Can we Stay?; Table Boarders; Alice with Hyena*

FILM
*Salestalk* screens at 'Durban Film Festival' and 'Cape Town Film Festival', May

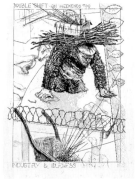
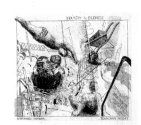
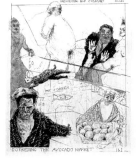
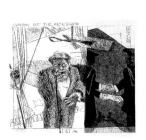

*Talent sets Trap for Kentridge*
*Samantha James*

(…) Magnificent imagery, appearing to feast upon the illogical quick-silver substance of dreams, it arrests the eye and intrigues the mind.

These complex drawings reflect a kind of netherworld of bizarre occurrences jockeying for release into reality.

(…) people and places appear to have been set down by the artist just as they arose in his mind, no matter how irrational their association or circumstances. The effect is often a brilliant, uncensored, theatrical drama in which the protagonists are truth and sham.

The characteristic images of echoing halls and diminishing perspectives, derelict cars and naked figures are in evidence, as are ragged wire, car tyres and hapless animals.

It's as if the artist's clear sight touches a focal point and facades of activity trail in its wake through his powerful draughtsmanship.

Whole atmospheres of emotional conflicts are condensed into the defensive rejecting tilt of a head of the caressing relieved angle of a limb; suggestions of infinite understanding and the rejection of actuality are given in a double set of eyes in a single face; stabbing black marks reveal the tension and turmoil of individual figures; and sometimes scenes are quite lyrical.

The artist is wonderfully at home with charcoal and pastel, uncertain and explorative with a paintbrush; his etchings are exquisite. (…)

A theme of yearning is recurrent. In a beautiful drawing, a fluffy-haired child cuddles a spotted animal, which permits itself to be clutched while it looks beseechingly outward; beside them is an empty bowl, which seems to offer no hope of sustenance for the creature; in another work, a woman holds a similarly forlorn animal.

In a tender and sensitively drawn picture, two men looking out to sea apparently establish their position on a map. In this work the artist's style has changed, as if its inspiration is natural and unpressured: surrounding space is allowed to form its own artistic

weight. The same thing occurs in another drawing of two figures who appear to be hacking at a car, and once more in a picture of a man whispering to another while he looks towards a mirror, which is frequently a symbol of truth.

There is constant symbolic reference to a variance from a natural state of affairs. In Homer's *Odyssey* the goddess Circe would give travellers magic potions which changed them into pigs, and one of the works shows this sorceress as she walks away surrounded by her warthogs.

A warthog or pig is ubiquitous in the drawings. Regarded by some religions as an unclean animal, during the Middle Ages the pig was thought to be a symbol of lust and traditionally overcome by chastity.

In medieval physiology, when the 'humours' which determined human temperament were associated with animals of similar nature, the pig was regarded as a melancholic, and it would seem that introspective contemplation is the foundation for the artist's creative conceptions.

Words are written into the pictures, often as graffiti, as if the artist is saying that the writing is there on the wall to be observed; a 'No Smoking' warning is given as directly as if it reads 'No Sex'.

'Nitrous Oxide' is written into a depiction of a dentist's rooms, which seems to suggest the unpleasant experience of someone in hysteria, being put to sleep with laughing gas. In this same work, an old man swings back and forth in the midst of a flurry of small fish – an early symbol of Christianity – while some dishonesty in the situation appears to be remarked by a set of large false teeth on the floor.

(…)

(*The Star*, Johannesburg, 14 November 1986)

VISUAL ART

Group exhibition: 'Three Hogarth Satires', with Deborah Bell and Robert Hodgins, University Art Galleries, Johannesburg, from 12 April. The same etchings were shown again in the group exhibition 'Hogarth in Johannesburg', Cassirer Fine Art, Johannesburg, from 2 August
Exhibited works: *Industry and Idleness* 1986-87, 8 etchings after Hogarth printed at the Caversham Press: *Double Shift on Weekends Too*, sugar-lift aquatint, dry point and engraving; *Responsible Hedonism*, aquatint, drypoint and engraving; *Forswearing Bad Company*, aquatint, engraving and drypoint; *Waiting Out the Recession*, aquatint, engraving and drypoint; *Promises of Fortune*, hard ground, engraving, aquatint and drypoint; *Buying London with the Trust Money*, hard ground, aquatint, engraving and drypoint; *Lord Mayor of Derby Road*, drypoint and engraving; *Coda*, aquatint and drypoint

Solo exhibition: 'In the Heart of the Beast'; Vanessa Devereux Gallery, London, (during 'Portobello Contemporary Arts Festival'), 22 April - 19 May
Exhibited works: drawings and prints

Wins Standard Bank Young Artist Award, 'Grahamstown Festival', Grahamstown. A solo exhibition 'Standard Bank Young Artist Award' is held in July, touring for a year to: Tatham Art Gallery, Pietermaritzburg; University Art Galleries, University of the Witwatersrand, Johannesburg; University Art Gallery UNISA, Pretoria, 15 - 25 October and Durban Art Gallery, Durban
Exhibited works, all 1986 and 1987: *Suburban Suite: Glad Rags*, ink, wash, charcoal and pastel; *Plunge Pool*, ink wash, charcoal and pastel; *Padkos*, ink wash, charcoal and pastel; *Retief's Kloof*, ink wash, charcoal and pastel; *Narcissus at Retief's Kloof*, ink, wash, charcoal and pastel. *Drawings for a Procession: Pension Barrow*, charcoal and pastel; *Stadium*, charcoal and

pastel; *The General from Derby Road to Ellis Park*, charcoal and pastel; *Aide de Camp*, charcoal and pastel. *The Embarkation* (triptych) charcoal and pastel; *Study for The Embarkation*, charcoal and pastel; *Preliminary drawing for The Embarkation*, charcoal. *Industry and Idleness*, 8 etchings after Hogarth printed at the Caversham Press: *Double Shift on Weekends Too*, sugar-lift aquatint, dry point and engraving; *Responsible Hedonism*, aquatint, drypoint and engraving; *Forswearing Bad Company*, aquatint, engraving and drypoint; *Waiting Out the Recession*, aquatint, engraving and drypoint; *Promises of Fortune*, hard ground, engraving, aquatint and drypoint; *Buying London with the Trust Money*, hard ground, aquatint, engraving and drypoint; *Lord Mayor of Derby Road*, drypoint and engraving; *Coda*, aquatint and drypoint. *Three Festival Drawings*: *Grande Jetté*, charcoal and pastel; *Private View*, charcoal and pastel; *Exposition*, charcoal and pastel. *I*, charcoal, pastel and gouache; *II*, charcoal, pastel and gouache; *III*, charcoal, pastel and gouache. *Close Up*, charcoal, pastel and gouache; *Long Shot*, charcoal, pastel and gouache

FILM

Makes *Exhibition*, animated film, 3 minutes, 16mm, later transferred to video

THEATRE

Helps devise and co-designs *Sophiatown*, directed by Malcolm Purkey, Junction Avenue Theatre Company, February - April

---

*Standard Bank Young Artist Award*
*Alan Crump*

As with some of the major innovators of the earlier part of this century, the barriers between the performing and visual arts sometimes become indivisible. Kentridge is one of the few artists in this country who has produced work in theatre, stage design, and film with equal ease and virtuosity. His past tertiary education records shows how reluctant he was to commit himself to one creative discipline too early in his career. Political science, philosophy, fine arts and later theatre study in Paris, reveal the young artist's demand for a broader lateral base to the acquisition of knowledge. His refusal to specialise immediately has proved to be essential in laying the foundations for this present exhibition. The confidence and intelligence that this work reveals is testament to that foundation of cross-disciplinary ground work. Literary, theatrical, historical and contemporary political ideas are continually used and sometimes even abused in some of his works, e.g. in the Hogarth etching series, *The Idle Apprentice* becomes a millionaire.

Since his first one-man show at The Market Gallery in 1979, this artist has produced several exhibitions of which some of the individual works reveal exceptional insight and skill. What makes Kentridge's work so intriguing for the historian, critic and the public, are the various layers of information that exist in the work between the source material and the final drawing or etching. He is able to crystallise and synthesise past and present vernacular and sacred images into highly individual and personalised contemporary statements. Many of Kentridge's references and initial studies are historically based but the end product is by no means dwarfed by the earlier masterwork. *The Embarkation for Cythera* (Watteau) or *Las Meninas* (Velàzquez) are influences both in composition and content for the artist, but these paintings remain only points of departure. Today, the contemporary artist feels free to use past and present whenever it is deemed appropriate. Kentridge epitomises this thinking. In the triptychs, for example, the narrative often becomes a circular metaphor (a dog becomes a cheetah becomes a hyena becomes a dog). The dog may be from Watteau, the hyena from a present day photograph.

Initially there may be a pervading melancholia in many of the works in this exhibition. This would only be an initial response for this ambience is superficial. There is always a counterbalancing of wit and humour that questions the absurd 'condition' in which we live.

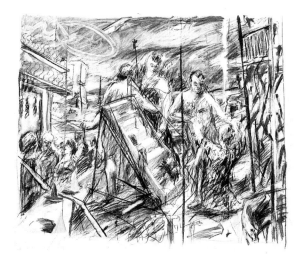

---

Kentridge's works have not the horror of Goya, the cynicism of Hogarth nor the supposed escapism of Watteau. The works are urgent but subtle reminders of the unfolding present and how history continually repeats itself. These universal patterns have always been a constant bewilderment to the creative mind. The great artists mentioned above recorded this in their time. William Kentridge is revealing this to us in South Africa today.
(The Broederstroom Press, Grahamstown, 1987, (catalogue) n.p. Partially reprinted in *Art Design Architecture*, no.4, 1987, p.6)

*Standard Bank Young Artist Award*
*Elza Miles*

In William Kentridge's collection of drawings and etchings for the Grahamstown Arts Festival two distinct approaches are discernible: the one Anglo-Saxon and the other Euro-Continental. The two have a common denominator. William Hogarth (1697-1764) and Antoine Watteau (1684-1721) were both perceptive observers of social circumstances in their respective eighteenth century societies. Both saw in theatre and acting a counterpart to everyday life, which they reflected in their art.

(…)

Watteau's 'Fêtes Galantes' culminated in his masterpiece of 1717, *L'Embarquement pour L'Ile de Cythéra* (Louvre), which ensured his membership of the Royal Academy.

(…)

On entering the Academy, Watteau submitted the Louvre version under the title of *Pélerinage á L'ile de Cythéra*. Considering the sunset and paired-off pilgrims ready to leave the island, one assumes the completion of their pilgrimage. Votive offerings have been brought to Venus and blessings bestowed on the couples.

This ambiguity is significant for Kentridge's rendering of the Louvre *Embarquement*, forming the leitmotif not only of the drawings on exhibition, but also of the Hogarth-inspired etchings. The poetic reality emphasised in each work of the collection is that Cythera exists. Whether the pilgrims are arriving or departing is irrelevant.

In ancient times Cythera was called the 'purple island' from its rich murex deposits. The Spartan, Chilon, once maintained that the island could just as well have been sunk. Watteau depicts the island at the hour when the golden light of a setting sun transforms it into a dream world, whereas a concreteness is displayed in the landscapes that Kentridge depicts. The living space of his pilgrims is a weekend country retreat (*Retiefskloof*), the suburban swimming pool (*Plunge Pool*, *Responsible Hedonism*), the roadhouse restaurant (*Padkos*, right-hand panel of *The Embarkation*), a dirt road (middle panel of *The Embarkation*), the city with its neon sign, barbed wire barricades, municipal palings, motor vehicles and useless steps. With the exception of the charlatan apprentice succeeding in London (*Buying London with the Trust Money*), the environment is typically South African.

Every action, every undertaking portrayed by Kentridge emphasises the transience of such an existence. And while these moments of grace last, each pilgrim is looking for his counterpart, his alter ego.

The pilgrimage is encompassed in the masterly triptych, *The Embarkation*. Noticeable in the centre panel is the multitude of tracks belonging to vehicles turning off on a gravel road detour in the Waterberg (Northern Transvaal). A deserted eating place next to the road (white-washed concrete table and bench) with an enigmatic nude next to the table arrests one's attention in the panoramic vision. Involuntarily a relation is established between this female and the garlanded statue of the Watteau painting. This place is Cythera and the pilgrims have left their traces.

(...)

Kentridge's exploration of the paths taken by fate distinguishes him as a creator of images in South African fine art. His rendering of the confrontation between the individual and his counterpart remains filmic. In this way he involves a contemporary dramatic medium, the film, and not Hogarth's or Watteau's stage. His adaptation of both the Hogarth and Watteau source material premises a visual rendering that is not obstructed by the narrative line connecting the episodes. The spilling over of one graphic form into another is filmic, as is particularly noticeable where the fan in *Waiting out the Recession* is transformed into a dramatic departure foreshadowing death.

In this 'purple' place, which could just as well have disappeared under the water, one is struck by man's frenzied pursuit of his alter ego. Only when he finds it can he complete the pilgrimage as a full being. In *Retiefskloof* the young man turns his back on his companion. Poussin's *Narcissus and Echo* is revived in a local setting. On the edge of the swimming pool, with his dog as headrest, the young man finds confirmation in his reflection (invisible to the outsider) while the woman in the pool becomes a futile echo.

Man's search for completeness is closely linked to this yearning for water. The swimmer finds fulfilment in the refreshing water despite the barbed wire fence dividing the natural pool (*Retiefskloof*). In a moment of action the Narcissus figure dives towards his counterpart (*Plunge Pool, Responsible Hedonism*).

The sleeping man of *Padkos* finds his companion in *The Embarkation*. He is no longer isolated from human contact and on the back of his vehicle he transports saplings, which are to take root in the protective enclosure of iron palings.

In *Industry & Idleness* Hogarth emphasises the difference between virtue and sloth. His moral is simple: the diligent apprentice is rewarded and the sluggard is ruined.

In Kentridge's interpretation of his material the distinction between good and evil is not so definite. He is no moralist. His portrayal of the experiences of the Mayor of Derby Road as well as that of the 'successful' businessman (bribing his way to obtain an LL.B degree), is a constant endeavour to reconcile the two 'opposites' of the self. They are one and the same plodder living in a delusion of achievement: the one is in control of a fraction of the local avocado market (*Forswearing Bad Company*); the other propagates the boycott of South African fruit overseas while he is attempting to buy the universe with embezzled trust money. Their effort to unite with their ideal self-images assumes different forms, only to be repeatedly refuted. Initially they act as separate individuals: the one claims sole right to his native ground while the other tries to conquer the world. Only when their shortcomings are identified – alcoholism and fraud – does the individual recognise himself in the objective reflection of a camera lens. An accusing gesture seals his fate (*Lord Mayor of Derby Road*). The impostor (B.A.LL.B.) 'dives' to his counterpart, the corpse of Lord Mayor of Derby Road, in an assimilative death (*Coda*).

Thus the fate of the individual is determined on the pilgrimage to Cythera.

(The Broederstroom Press, Grahamstown, 1987, (catalogue), n.p.)

*In the Name of Art: a Reflection on Fine Art*
Steven Sack

South African art, like all art, must of necessity be understood within a specific social context, in this instance that of the apartheid political structure. The South African landscape has been arranged and rearranged to suit the needs of racial Capital and white supremacy. The images following this article are emblematic of some aspects of that political landscape and attempt to give a selective view of fragments of the visual culture found on the Reef, where gold was discovered and mined, and around which a metropolis grew. Out of the dusty metropolis of Johannesburg, an artculture underwent a painful and slow birth, and has ironically found its feet in the difficult times of the 1980s. South African fine art, mural art and poster art of the 1980s has been bold and challenging, and above all affirmative of personal and social freedom. It has developed a capacity to address rather than suppress the immense force of the political manipulations that characterise life in apartheid South Africa. It has offered an alternative vision to that of the other competing visual ideologies of state and Capital. This liberatory visual culture has penetrated the iron shield of Christian National Education and has challenged the stranglehold of state television and corporate advertising. In the streets as well as art schools, galleries and museums, a critical and liberatory vision of and for South Africa has matured. This new artculture has had to negotiate the many complex forms of repression, denial and co-option, engineered in the name of 'civilised standards', 'racial purity' and 'corporate identity'.

Art has had many definitions and it is made in the name of many visual ideologies, some more poetic than others. The poetry of the apartheid state has been one of severe faces, stampeding horses and more recently, modernist abstraction (the image of reformed apartheid).

(...) culture is carefully monitored and made available selectively so as to prevent the 'conscientisation' of the masses. The state has constantly intervened (...) particularly as regards the more popular art forms such as posters, film and theatre and there has been censorship and control continually on the distribution of critical or 'protest' art. Cultural venues are controlled so as to prevent the free flow of cultural ideas and to monitor the accessibility of liberatory visual ideology.

Despite this policy, a vibrant and independent non-racial culture has been forged by artists and cultural activists working in alternative, privately organised venues – community centres and art centres.

(...)

(from a paper given at the conference 'Culture in Another South Africa', December 1987, Amsterdam, published in eds W. Campschreur and J. Divendal, *Culture in Another South Africa*, Zed Books Ltd, London, 1989, pp. 74-75)

*Editors' Introduction*
David Bunn and Jane Taylor

Almost a year after the introduction of the second State of Emergency in June 1986, the Botha regime, in announcements by its propaganda arm, the Department of Information, claims to have reduced violence in the country to a minimum. Yet even the most servile government newspapers speak of an 'uneasy calm' and continue that Manichean style of rhetoric that habitually depicts white dread in terms of looming black clouds on the horizon.

For progressive South African writers and activists, however, this is not the time to brood on images of peace before the storm. In the past twelve months, almost 35,000 people have been detained, including much of the leadership of democratic extra-parliamentary

organisations and trade unions. Journalists, artists and writers have also been severely affected, and rank among the lists of 'disappearados' or those brutally murdered by unknown assailants.

This special issue of *TriQuarterly* appears at a time when a wave of state repression has virtually eliminated the effectiveness of certain mass organisations. Moreover, in the past twelve months there has been an unprecedented, unexpectedly direct assault on the freedom of writers to express themselves openly. Represented in this issue are some of the most innovative and articulate new voices from South Africa; yet each one of these is haunted by the echo of another in solitary confinement, or another who has felt called upon to stop writing and start organising.

The 'South Africa' that emerges from the combined evidence of these various stories, poems and political documents is structurally different from versions of the same land suggested by texts five years ago. This is now a country at war, or intent on its liberation struggle, or in the initial stages of a revolution that has so far forced the white military state to show its first line of defences against the people: a new generation of riot-control vehicles called Casspirs, Buffels, and Hippos; water cannons that shoot purple dye with an irritant chemical; rubber bullets, birdshot, buckshot and 7.62mm bullets; and the widespread use of vigilante squads. This is to say nothing of the systematic violence against detainees under police care. Naturally the public consciousness of violence is noticeable in a way it was not five years ago.

(…)

Overseas viewers and readers were bombarded with news about South Africa in 1986. However, despite the intensity of the coverage, overseas analysis of political events in this country is sometimes determined by stereotypes of South Africa common in the 1960s. American analysts for instance, studiously avoid making connections between capitalism and apartheid's labour practices. In similar fashion, writing in the country, to many overseas, is forever associated with severe state censorship and Calvinist paranoia. Looking back at 1985, though, it is difficult to comprehend how a regime such as the present one could tolerate as much incendiary internal criticism as it did.

(…)

In 1985, one could attend a mass rally, or funeral, with relative freedom, joining hands with those gathered together to mourn for the victims of apartheid. Speakers at such gatherings would often call for mass, united action against exploitation, and the event would usually be punctuated by poetry, theatre, liberation songs and other gestures of cultural defiance.

(…)

Symbolically, the current State of Emergency in South Africa represents the Botha government's crisis-riddled attempt to control the uncontrollable: the historical imperative moving this country towards a new social order. Their present struggle to forge a new, oppositional South African culture clearly is based upon long-term objectives. The oppositional model of self-definition and artistic explanation is one designed for a post-revolutionary, non-racial South Africa. To the state, such an imperative is both insulting and deeply seditious, and it has responded with the most repressive legislation in the history of this country. Even certain conservatives now admit cautiously that we are living in a police state, and unusual fractures are also appearing in the enamelled surface of white, working-class solidarity.

(…)

Though it is true that much South African art, including Gavin Younge's sculptures, William Kentridge's drawings and Billy Mandindi's prints, all travel fairly well, we want to remind readers that inside South Africa their power is far greater. There is also the danger of some of these images being read, in pseudo-ethnographic style, as 'primitivist' or 'naive', whereas their very power depends on an ability to confront directly a ruling-class discourse in South Africa, which

itself has imposed exactly those sorts of terms. (One obvious reason why linocuts are a significant art form in this country at the moment is the ease with which it is possible to produce the image, reproduce it and use it politically. A similar political impetus sometimes produces in South African writers a greater concern for the performance of their work than for the publishing of it.)

(*South Africa: New Writing, Photographs and Art*, special issue of *TriQuarterly Magazine*, Northwestern University, Evanston, 1987, pp.13-14, 19-21, 29. Reprinted by University of Chicago Press, Chicago, 1988)

*Introduction*
*Michael Godby*

(…) the set of eight prints that constitute William Kentridge's *Industry & Idleness* is remarkable for its paradoxical relationship with Hogarth's series. Of the three Johannesburg artists, it is Kentridge who appears to take the most liberties with his model in terms of the characters he creates, the settings and the narrative sequence; yet he has retained absolutely Hogarth's structure of the juxtaposition of extreme opposites. Thus, whereas Hogarth has his two apprentices start from identical beginnings and end with a vast gulf between them, Kentridge has his two figures start at opposite poles but end in the same place. Moreover, Kentridge shares with Hogarth's period a delight in the potential of irony. The inversion of the expected relationship between action and reward, or cause and effect, is a devastating satirical tool that Hogarth himself used on occasion, but which was exploited most forcefully by his literary contemporaries, John Gay and Henry Fielding.

If the contrast of extreme opposites contributes to a certain cautionary-tale quality in Hogarth, in Kentridge it gives evidence of the South African nightmare. Whereas Hogarth was ironic in the improbable goodness and badness of his two figures, Kentridge is ironic in his creation of characters who are entirely plausible in the South African situation.

(…)

Unlike Hogarth, and unlike artists of the Weimar period with whom they are often superficially compared, neither Robert Hodgins, nor Deborah Bell, nor even William Kentridge, presents society in the form of a coherent structure: the polarities of Kentridge's series imply the idea of society as a whole, but his figures of Industry and Idleness are manifestly products of society rather than representatives of it. Whereas Hogarth invariably defined the social status of his figures, relating this status to a broader social structure, and whereas George Grosz, for example, provided infinite variations on the theme of Capital and the Military conspiring to suppress the Proletariat, Hodgins, Bell and Kentridge are rarely so analytical, tending to work in terms of expression and experience. Thus the figures of Hogarth and, more obviously, Grosz, operate as symbols and even, despite Hogarth's protests to the contrary, as caricatures of certain elements of society, whereas the figures of the Johannesburg artists, however grotesque, are presented to the spectator as credible individuals. Their preoccupation with people and a lively concern with the society around them have led the Johannesburg artists, each in an individual way, to a recognition of the oppressed state of those who appear to be powerful. It is the enduring irony of the South African situation that as long as one part of the community is suppressed, no other part can be free.

(…)

(*Robert Hodgins, William Kentridge and Deborah Bell: Hogarth in Johannesburg*, Witwatersrand University Press, Johannesburg, 1990, pp.18-20)

VISUAL ART

Two-person exhibition: 'William Kentridge and Simon Stone', Gallery International, Cape Town, 29 March - 15 April
Exhibited works: 14 drawings in charcoal and pastel on paper: *Reservoir* 1988; *New Modder* 1988; *Ellis Park Open Cast* 1988; *Pension Barrow* 1987; *Masked Ball* 1988; *Flood at the Opera* 1986; *Carnival in Derby Road* 1987; *Ascot Pavement* 1987; *Glyndebourne I* 1987; *Glyndebourne II* 1987; *East Rand* 1987; *Small Modder* 1988; *Ramp* 1987; *Small Reservoir* 1988. 3 lithograph prints: *Pap Fish* 1987; *Dream of Fishes* 1987; *Alley Cat* 1987

Solo exhibition: 'William Kentridge', Cassirer Fine Art, Johannesburg, 6 - 19 November
Exhibited works: c.30 drawings in charcoal and pastel on paper; series of three silkscreens printed at Caversham Press, Natal: *Art in a State of Grace*; *Art in a State of Hope*; *Art in a State of Siege*

FILM

Co-directs with Angus Gibson *Freedom Square and Back of the Moon*; 50-minute documentary on Sophiatown for Channel 4 Television, United Kingdom

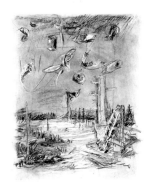

*Revealing the Truth of Veld that Lies*
Rose Korber

(…) In [Kentridge's] art, literary, theatrical and art-historical references abound, jostling with contemporary political allusions that are underscored by his earlier training in political science and philosophy. The work is rich in ambiguity and contradiction. 'Disjunction' is the word he likes to use to describe this central characteristic – 'the fact that daily living is made up of a non-stop flow of incomplete, contradictory elements, impulses and sensations'.

The seventeen landscapes currently on view at Gallery International in Hout Street represent yet another departure for this remarkable 33-year-old artist. (…) it is the landscape with all its 'human traces and residues' that has primarily occupied him over the last six months.

'One thing that has always struck me about the depiction of South African landscape', he says, 'is that it has never corresponded to the landscape as I have seen it. What is usually depicted is the landscape observed, in a motorcar, while driving through it, rather than into it; and it is usually described as an alien, antagonistic, "other".'

'The landscapes I have most respected have been the little Jentsch watercolours of Namibia; these were the starting point for my drawings. So my pictures are, in a sense, anti-picturesque: I am trying to get as far as possible away from a Volschenkian or Pierneefian vision of the veld.'

Essentially Transvaal or Highveld landscapes, these drawings are given their structure, says the artist, 'by the traces of engineering, roadworks, signs and hoardings that go through them.

'It's a characteristic of these rather desolate, barren and unstructured pieces of veld that you have a perfect, white line drawn through it by a pipeline, which runs totally straight all the way across it. Or you might, in an undulating landscape, have a sudden level horizon, where there was once a mine dump. This has now become part of the landscape.'

Titles such as *Masked Ball, Flood at the Opera House* and *Glyndebourne* are a reminder of Kentridge's intense interest in the artifice of the theatre. Some of these, he explains, began as 'interiors with landscapes; and, as the drawings progressed, the visions through the windows took over and engulfed the drawing and the domestic residues in the landscape'. In some cases, this 'disjunction' worried him, and he removed it: in others, it has been left in.

(…)

(*Weekly Mail*, Johannesburg, April 1988, p.24)

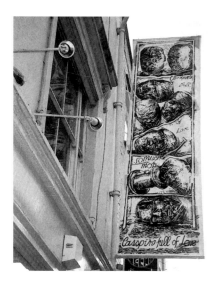

VISUAL ART
Makes *Johannesburg, 2nd Greatest City after Paris*, first animated film in series *Drawings for Projection*, 16mm; video transfer; 3 minutes, 11 seconds

Group exhibition: 'South African Landscapes', The Everard Read Gallery, Johannesburg, 18 March - 21 April
Exhibited work: *Outside Uniondale*, mixed media on paper

Solo exhibition: 'Responsible Hedonism', Vanessa Devereux Gallery, London, 14 May - 20 June
Exhibited works: c.25 drawings: *Responsible Hedonism* 1988, charcoal and chalk; *Responsible Hedonism* 1989, charcoal and pastel; *Casspirs Full of Love* 1988, charcoal and pastel; *Casspirs Full of Love* 1988, encaustic; *Casspirs Full of Love* 1989, edition, copper drypoint; *Ellis Park* 1987, charcoal and pastel; *Reservoir* 1988, charcoal and pastel; *Let Go Scot Free* 1989, inkwash, charcoal, pastel and gouache; *Lovers at the Hatchery* 1989, pastel and gouache; *Dans le Boudoir* 1989, charcoal and pastel; *Highveld Landscape with Duomo* 1988, charcoal and pastel; *Art in a State of Grace* 1988, silkscreen; *Art in a State of Hope* 1988, silkscreen; *Art in a State of Siege* 1988, silkscreen; *Battle Between Yes & No* 1989, silkscreen; *Battle Between Yes & No* 1989, copper drypoint; *Masked Ball* 1989, bitumen, inkwash, pastel and chalk; *The Hatchery* 1989, ink, charcoal, pastel and gouache; *East Rand* 1987, charcoal and pastel; *More Yes than No* 1989, bitumen, gouache, ink and charcoal; *BBQ* 1988, inkwash; *Elephant/Study* 1989, pastel; *Domesticate* 1989, bitumen, chalk and inkwash

Group exhibition: 'African Encounters', Dome Gallery, Brooklyn, New York, 20 June - 1 July, touring to Washington DC, July
Exhibited work: *Trout Hatchery* 1989, charcoal/pastel on paper

FILM
*Johannesburg, 2nd Greatest City after Paris* (1989) screened at 'Weekly Mail Film Festival', Johannesburg, October (Premiere)

*Resistance Art in South Africa*
Sue Williamson

A jagged faultline cuts through recent South African history. It is a year, 1976, the year the children of Soweto decided to resist their oppression. Peaceful protest was met with police gunfire, and soon Soweto was aflame. The furious sparks set the rest of the country alight; hundreds died, thousands fled. In the space of a few months, things in South Africa had been changed forever.

The flames melted the oppressive ice that had frozen South Africans, black and white, into apathy for so long. Slowly the glacier began to move. It was a time for counting the cost, for accepting responsibility, for asking the question, 'What could I have done, what can I do now, to work for freedom?' New organisations mushroomed in opposition to the state, new possibilities for action came into focus.

I was one of those jolted out of lethargy by Soweto, and this book concerns the way the artists of my generation responded to the truths made clear by the events of 1976, the issues we addressed, and the work that followed. It is also about the growth of the idea that art is not necessarily an elitist activity, and that popular cultural resistance has a vital role to play in the life of the community and the struggle for freedom.

(…)

The poet Breyten Breytenbach wrote of this time: 'The white artist… cannot dare look into himself. He doesn't wish to be bothered with his responsibilities as a member of the "chosen" and dominating group. He withdraws and longs for the tranquillity of a little intellectual house on the plain, by a transparent river.

'His culture is used to shield him from any experience, or even an approximation of the reality of injustices. The artist who closes his eyes to everyday injustice and inhumanity will without fail see less with his writing and painting eyes too. His work will become barren.'

(…)

In a recent interview with the Johannesburg *Weekly Mail*, Chris Hani, chief-of-staff of Umkhonto we Sizwe, the military wing of the African National Congress, had this to say about white South Africans: 'Their life is good. They go to their cinemas, they go to their *braaivleis* [barbecues], they go to their five-star hotels. That's why they are supporting the system. It guarantees a happy life for them, a sweet life. Part of our campaign is to prevent that sweet life.'

Hani could have been talking about the diners in Kentridge's *Breakfast in the Antechamber* (1986), seemingly unaffected, as yet, by the kind of war-movie background to their meal.

'I suppose I'm interested in doing the opposite to a movie poster, which fragments its plot into a number of little scenes', says Kentridge. 'I take a number of very different, contrasting images and put them together to make a coherent whole.'

(…)

Kentridge's love of posters led to three striking silkscreens in 1988 – *Art in a State of Grace, Art in a State of Hope* and *Art in a State of Siege*. The first is about an art that sees no further than its own pleasant horizons; the second believes optimistically that art can help to bring about the success of the revolution; the third concedes the possibility of defeat. The imagery used in this poster draws on the planned celebration of Johannesburg's centennial year.

Kentridge puts forward as his symbol for the city's hundredth year a bloated businessman grown rich on the gold that brought Johannesburg into instant being in 1886. The celebrations were, in fact, cancelled after an outcry from concerned citizens who felt that the city had nothing to be proud of. Kentridge's powerful image, with its overtones of George Grosz's comments on Nazi Germany, reinforces that view.

(David Phillips, Cape Town & Johannesburg, 1989, pp.8, 30-33)

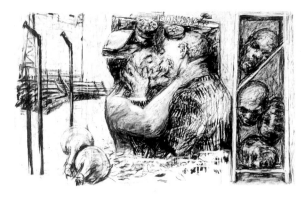

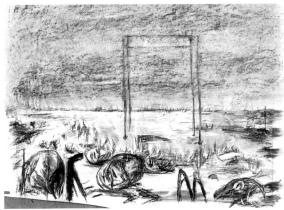

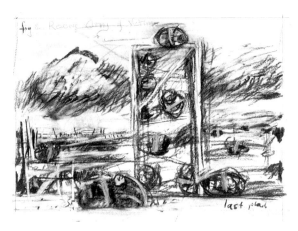

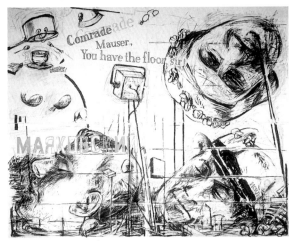

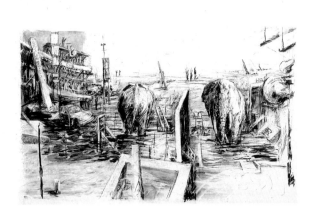

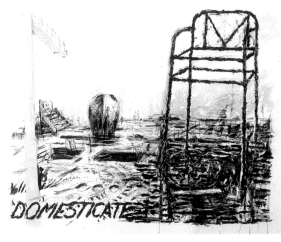

VISUAL ART

Makes *Monument*; second animated film in series *Drawings for Projection*, 16mm, video transfer, 3 minutes, 11 seconds

Solo exhibition: 'William Kentridge: drawings and graphics', Cassirer Fine Art and Gallery on The Market, Johannesburg, 30 April - 23 May
Exhibited works at Cassirer Fine Art include: *Olivetti Calculator* 1989, charcoal pastel on cream paper; *Floating Dancer* 1989, charcoal pastel on cream paper; *Dancers with Olivetti Calculator* 1989, charcoal pastel on cream paper; *The Battle Between Yes and No* 1989, silkscreen; 4 drawings and etchings in the series *Casspirs Full of Love* 1988-9; *Fused into a Particularly South African Riddle* (also titled *Negotiations Minuet*) 1990, charcoal pastel on cream paper. Exhibited works at Gallery on the Market: *Develop, Catch-Up, Even Surpass* 1990, charcoal and pastel on paper; *Smoke, Ashes Fable* 1990, charcoal pastel on cream paper

Group exhibition: 'Art From South Africa', Museum of Modern Art, Oxford, organised in association with 'Zabalaza Festival', London, 17 June - 23 September, touring to Warwick, Aberdeen, London, Bolton, Stoke on Trent and Nottingham until 27 July 1991
Exhibited works: *Johannesburg, 2nd Greatest City after Paris* 1989 (screened on monitor); *Smoke, Ashes Fable* 1990, charcoal pastel on cream paper

Solo exhibition: 'William Kentridge: drawings', Gallery International, Cape Town, 29 October - 10 November
Exhibited works: *Anti-waste* (1990) charcoal and pastel; c.20 drawings of landscapes

1    2
3    4
5    6

FILM

*Monument* 1990, wins Weekly
Mail Short Film Competition
and is screened at the Planet
Cinema, Johannesburg, 23 June

*Johannesburg , 2nd Greatest City
after Paris* 1989, screens (during
'Zabalaza Festival') at ICA,
London, June 1990 (projected
film)

Directs *T&I*; 12-minute video
fiction without actors or draw-
ings. Screens at the FIG Gallery,
Johannesburg, September

### Kentridge's Free-floating Art of Ambiguities
*Ivor Powell*

(…) The large charcoal drawings lying scattered about the studio
floor, standing in rolls or pinned in huge arcs across the walls are
equally tough and hard-edged in quality. Made up of two bodies of
work, one dealing with the idea of processions, emblematic and
almost hieratic in their rhythms and composition, the other with a
series of disembodied floating heads, mainly derived from cultural
figures in post-revolutionary Russia, the work nevertheless has a
commonality in that it all deals, Kentridge says, with victims.

The procession theme is explored in a series of large drawings
made up of separate panels and strung together in arcs so large that
Kentridge has had to spread his forthcoming show over two galleries:
Cassirer Fine Art, where it was originally scheduled, simply did not
have walls long enough to accommodate some of the pieces, and so
the exhibition will now be jointly hosted by Cassirer and the Gallery
on the Market.

The processions ironise the traditional, triumphant deployment of
the format of friezes and frescoes. Far from, being heroic, Kentridge's
figures are 'desperados, no-hopes, drunks and pimps'. In rags and fray-
ed theatrical costumes, borne up on crutches and carrying hyenas like
babies on their backs, they bitterly mock Hailie Selassie's dictum on
Third World development, which stretches across the picture surface.

These often cynical ironies are further developed in the strange
quiescent heads of three cultural heroes of revolutionary Russia
– playwright Mayakovsky, photographer Rodchenko and poet Emilia
Ginsberg – which float in a kind of dream space amid technological
relics from their time.

'It is about people who were at one stage buoyed up by an idealism
around the turn of the century – before that idealism crashed.'

(…)

'One of the reasons one is making images in the first place, rather
than writing, is because certain objects or parts of the work seem
appropriate to it without your being able to give a clear reason why.
It's one of the principles I work with to allow disjunctions, to encour-
age things that shouldn't be together.'

(…)

But until then the process is, if not random, at least ad hoc.
Landscapes are enriched by what Kentridge describes as a 'domestic
element', motifs as improbable as cutlery and his daughter's feeding
bowl – elements drawn from his immediate surroundings and made
to play off against the given elements of the landscape. It is as though
the real-time process of making the picture – the trips to the fridge,
images of his sleeping daughter, the chaos of the Bertrams street on
the other side of the high wall – is being brought into contact with the
external imagery, and fused into a single overwhelming and peculiarly
South African riddle.

Kentridge points with obvious pleasure to little disjunctive
touches recorded on the surface of his pictures: a drum labelled
'flame retardant' being used as a brazier; beggars dressed in grand
theatrical style; the title *Casspirs Full of Love* – from a message heard
on Forces Favourites where a mother wished her son on the border a
good tour of duty, a safe return… and sent the message 'with Casspirs
full of love'.

At the same time, the freedom Kentridge claims as the right of the
artist has to do with a kind of free-floating, relatively detached percep-
tion of the world surrounding him. He recounts with pleasure a recent
visit from Harry the tramp – one of the recurring characters in Kent
ridge's work – who lives in the streets around the artist's house. Harry
was on a routine expedition in search of money or food.

'But he was dressed in a Salvation Army general's jacket complete
with sashes and epaulettes, as if he were dressed to model for Goya.
You sometimes get these moments of confirmation, reassurances that
what you are doing is not completely up the wall.'

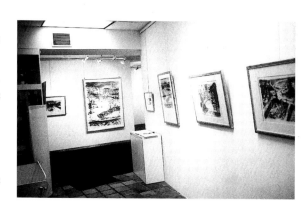

But often there is the anxiety that it is completely up the wall.

'Once you're working on a theme, it becomes a very dumb process, something fairly unconscious between what your head thinks and what your shoulder and wrists do. It's a kind of informed change. In a sense, all the work I do is provisional. That is why I have quite a generous attitude towards myself in exhibitions. Exhibitions are the only real opportunity you have for assessing the work, for finding out which ones really work and which don't.

'I'm happy to take part in, and have taken part in, debates around cultural politics in South Africa, the status of the cultural boycott, what constitutes progressive art. On one hand I have a verbal position on those questions and on the other there's the work, which doesn't ask those questions, though I suppose in a sense it does provide some kind of answer.

'I'm essentially interested in an art that is political but which allows an ambiguous politics, an art that encompasses as many ambiguities and contradictions as there are.'
(*Weekly Mail*, Johannesburg, 26 April, 1990, n.p.)

## 1991

VISUAL ART

Makes *Mine*; third animated film in series *Drawings for Projection*, 16mm, video transfer, 5 minutes, 50 seconds

Makes *Sobriety, Obesity and Growing Old*; fourth animated film in series *Drawings for Projection*, 16mm, video transfer, 9 minutes, and wins Rembrandt Gold Medal at 'Cape Town Triennial', 1991

Group exhibition: 'Little Morals', Taking Liberties Gallery, Durban, May
With Deborah Bell, Robert Hodgins
Exhibited works: *Little Morals* 1990, portfolio of 8 sugar lift, hardground, engraving etchings published by Caversham Press: *Taking in the Landscape*; *Preparing for the Day*; *Practical Considerations*; *Procession of the Delegates*; *Negotiations Begin*; *Anti Waste*; *Growing Old*; *Reserve Army*

Group exhibition: Newtown Galleries, Johannesburg
Exhibited works: 5 large untitled heads 1991, gouache and charcoal; 40 small gouache collages

Group exhibition: 'Gala', The Arts Association of Bellville, Cape Town, 13 February - 9 March
Exhibited work: *Glyndebourne* 1989, drawing on paper

FILM

*Mine* 1991, wins Weekly Mail Short Film Competition (Fiction), August

## 1992

VISUAL ART

Solo exhibition: 'Drawings for Projection', Goodman Gallery, Johannesburg, 21 February - 14 March. Wins Quarterly Vita Award
Exhibited works: 4 animated films (screened on monitors), with 41 drawings: *Johannesburg, 2nd Greatest City after Paris* 1989, with drawings *Captive of the City*; *Felix in the Bath*; *Procession of the Dispossessed*; *Fish Kiss*; *Procession in the Landscape with Highmast*; *Procession in the Landscape with Close-up of Harry*; *Close-up Woman in Procession*; *Felix in the Pool*; *Soho in the Pool*; *Procession walking into the Landscape*. *Monument* 1990, with drawing *Crowd and Covered Monument 1*. *Mine* 1991, with drawings *Mine Title Drawing*; *Soho asleep with Spade*; *Soho with Coffee Plunger and Cup*; *Mine Shaft*; *Mine Shaft and Slave Ship*; *Single Miner*; *Miners in Tunnel*; *Drill Close-up 1*; *Drill Close-up 2*; *Drill Close-up 3*; *Soho's Desk with Ife Head*; *Soho in Bed with Rhinoceros*; *Mine Tunnel with Props. Sobriety, Obesity & Growing Old* 1991, with drawings *Growing Old Title Drawing*; *Soho's Headquarters*; *Soho & Mrs Eckstein & Felix Teitlebaum*; *Soho Abandoned (with gasmask)*; *Overflowing Horns with Felix and Mrs Eckstein*; *Felix and Mrs Eckstein and Procession in Landscape*; *Johannesburg Skyline*; *Procession in Harrison Street*; *Mrs Eckstein's Thighs and Fish*; *Mrs Eckstein and Bath Flood*; *Receivers in the Landscape*; *Her Absence Filled the World*; *Soho in the Landscape Talking to Cat*; *Felix Listens to the World*; *Soho and Mrs Eckstein in the Landscape*. *Drawing for Projection. House for Incomplete Film.*
A reduced version of this exhibition travels to Vanessa Devereux Gallery, London 14 May - 20 June
Exhibited works: 10 drawings from films, 4 gouache collage works on paper: *Head I, Head II, Head III, Head IV*, all 1992. 2 gouache collage works on paper: *Iris I* 1992 and *Iris III* 1991

FILM

Makes *Easing the Passing (of the Hours)* in collaboration with Deborah Bell and Robert Hodgins, computer animation transferred to video, 10 minutes, screening at open air event 'The Art Fair', Waterfront, Cape Town, December 1 - 4 (Premiere)

THEATRE

Conceives and directs *Woyzeck on the Highveld*, in collaboration with Handspring Puppet Company, from Georg Büchner's play 'Woyzeck', 'Standard Bank National Festival of the Arts', Grahamstown 7 - 12 July (Premiere), touring to 'Arts Alive Festival', The Market Theatre, Johannesburg September - October

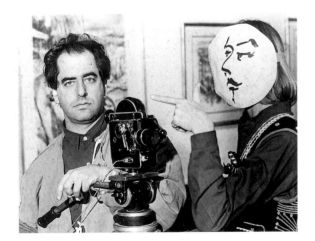

*William Kentridge. Four Animated Films*
*Michael Godby*

The technique William Kentridge uses to make his animated films is extraordinarily simple in comparison with commercial productions in the genre. Kentridge uses a sequence of drawings on an easel that is placed in a fixed relationship to a film camera. A drawing is made, filmed for a few frames, altered to introduce the idea of movement, and filmed again. A drawing might be changed and filmed in this way anything up to five hundred times before the narrative demands a new scene; and a drawing might be re-used, perhaps several times, if the narrative calls for a return to that scene. Occasionally the camera is brought forward to focus on a single part of a drawing and the developments that occur within it; and very rarely a drawing is moved in minute stages in front of the camera to show the slow discovery of a form or a space. Thus, approximately twenty drawings remain from the production of an eight-minute film.

Unlike the commercial technique of cel animation, which uses a new drawing for every frame of film, Kentridge adjusts his drawings by the introduction of new marks or the erasure of pre-existing ones. As far as the drawings are concerned, this technique means that they carry the traces of every bit of action that took place in the scene. And as far as the films are concerned the technique causes a certain jerkiness that is utterly distinct from the seamless flow of images of commercial animation. Kentridge in fact rejoices both in the suggestive openness of his forms and in the visible layering of images that tends to preclude any single fixed reading. We shall see that in his presentation of both character and narrative, Kentridge also tends to refuse a final, authoritative account of events.

(…)

All William Kentridge's animated films comment, with greater or lesser insistence, on the enormous gulf between the rich and the poor, the powerful and the oppressed (…) It seems that the potential for narrative of the film medium has enabled Kentridge to assert his understanding of the two worlds being connected like opposite sides of the same coin. Thus, while the actual experience of the poor is explored only in *Monument* and *Mine*, their presence in the other two films is shown to influence the development of events. In *Johannesburg*, they continue to assert their rights in the face of Soho's oppression and in *Growing Old* they seem even to contribute to the dissolution of the Eckstein empire.

Labour and the oppression of labour are rendered emblematically in *Monument*. The single figure of Harry is shown struggling through an empty landscape, weighed down by an enormous load. With great

ceremony, and to rapturous applause, Soho Eckstein unveils his gift to the people, which is none other than a representation of Harry's toil made permanent. As may be apparent in civic sculptures of miners and other labourers in Johannesburg and elsewhere, the capitalist position of power in society would seem to be confirmed, even extended, in the ritual acceptance of the oppression of the poor.

(…)

The demands of the poor do impact on the course of events, but the main narrative interest of these films is the ongoing contest for Mrs Eckstein between Soho and Felix.

In *Johannesburg*, Soho Eckstein is represented aggressively taking on the world and building up his empire. Mrs Eckstein, however, is introduced from the outset as 'Waiting', and is clearly neglected by her husband in the pursuit of his ambitions; in fact, she seems to be waiting for her own kind of fulfilment. Felix Teitlebaum is introduced as 'Captive of the City' and as possessing an anxiety that fills half the house: this condition would seem simultaneously to preclude achievement in the material world, that is Soho's domain, and to indicate an interior sensitivity that appears to represent an alternative style of life. In any event, Felix and Mrs Eckstein come together, first through fantasy, in Felix's bathtub, and then through the metaphorical images of fish and water. The very poetry of these images contrasts with the acquisitive materialism of Soho Eckstein's world; and water, besides its obvious potential for cleansing and regeneration, is suggested in this context to be a medium of voluptuousness and freedom. In *Growing Old*, the appeal of this freedom affects even Soho Eckstein, who calls for his wife to return, as he oversees the destruction of his empire and former life-style. The marchers in the background make the point that the political landscape has not changed; but Soho is able at last to enjoy his own private redemption. Caruso's achingly beautiful *M'Appari* may express equally Soho's joy on discovering a new life or Felix's yearning for Mrs Eckstein at the end of their affair.

(…)

Kentridge uses very large pieces of charcoal to achieve the open, gestural quality of his forms; and he applies his few patches of colour, notably blue for water in *Johannesburg* and *Growing Old*, with equal disdain for detail and finish. This looseness of drawing in Kentridge's work in fact has several functions. Most obviously, it tends to confirm the absence of precise identity and reference in both the figures and the setting, acting as a visual equivalent for the schematic quality of the *dramatis personae*. In addition, the openness of the drawn form invites the spectator to participate in the co-operative act of producing both form and meaning in each scene: Kentridge draws on the

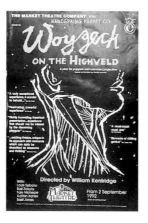

spectator's ability to put flesh on the bones of a few drawn lines, to supply the significance of an occasional art-historical reference (particularly from Goya in this sequence of films), and to distil some form of meaning from the musical sound-track and apply it to the reading of the scene at hand. Moreover, the gestural lines give a suggestion of expressive energy to the figures, a quality of vitality that is exploited, needless to say, in the representation of the figures in motion. And the loosely-drawn forms lend themselves to rapid recreation in the succession of frame after frame of animated movement.

The openness of the forms, and their resistance to any fixed reading, retains for the artist a space for invention. Kentridge uses the looseness of the forms, the suggestive quality of their physical dimension, to mutate their reality into totally new forms. A bed that was never finally a bed can readily be transformed into a desk (*Mine*), and the mobile form of a cat can become in turn a telephone, a gas mask and a bull-horn, amongst other things (*Growing Old*).

(…)

Kentridge's use of types to represent entire classes or sections of the population is well illustrated in *Monument* and *Mine*. In *Monument* the single figure of Harry is made to stand for the labouring poor and his conversion into a statue is shown as an attempt to render their condition of oppression permanent. In *Mine*, on the other hand, labour is illustrated in the variety of its life below ground and it is the idea of Capital that is collapsed into the single form of Soho Eckstein. In both films the individual figure achieves meaning through the suggestion of conflict with its opposite. In the two films that feature the contest for Mrs Eckstein, the significance of the drama is clearly not exhausted by the unfolding of the narrative on a literal level. The social reality of the main figures is burlesqued and the opposition between Soho and Felix is represented in the most general terms: inasmuch as Mrs Eckstein is invariably passive, it is possible, even, to imagine the contest over her as the conflict between two parts of the same personality. The figures, therefore, stand not simply as individual characters nor as illustrations of particular social forces but as manifestations or personifications of loosely defined but consistently oppositional human qualities or conditions such as clothed/naked, authority/freedom, doing/being, utterance/receptivity, materialist excess/libidinal transcendence, taking/giving, and so on.

The images that attend the figures of Soho and Felix give expression to their potential as metaphor. Soho Eckstein is invariably represented with some or other form of communications equipment. He has telephones, bells, typewriters, sirens, microphones, bull-horns,

loudspeakers and ticker-tape machines in abundance. Unlike Felix, who is often represented listening to the world through head-phones or a public address system, Soho uses his equipment in an effort to control the world. Soho's equipment, therefore, is a medium of desire, an assortment of instruments that brings reality into being. In fact, their position at the interface between what might be imagined as the real world and the world of Soho's own creation is signalled by the fact that these instruments themselves are most often brought into being by the force of Soho's will.

The particular symbol of Felix is, of course, water. Unlike Soho's array of communications equipment, which appears to confirm or even extend his control over the material world, water acts to transform reality. As in baptism, water has the potential to cleanse and regenerate; and as an obvious metaphor for libidinal energy, water is presented as Felix's way to self-fulfilment. This life-style is shown to be opposed to the materialism of Soho's world, not only in the fact of Felix's affair with Soho's wife, but also in the corrosive action of the water on the material fabric of this world. At the end of *Growing Old*, water in effect destroys Soho's empire but returns to protect him in the new life he at last is able to make with Mrs Eckstein.

The conflict between Soho and Felix is of mythical proportions because the two figures stand for different and opposed ambitions for the control and interpretation of the world. In this sense both figures, and not just Felix who is drawn in Kentridge's likeness, are used by the artist to negotiate his own relationship with reality.

(…)

The *Drawings for Projection*, as Kentridge calls the drawings for the animated films, are significant in their own right. In a sense, of course, the drawings are merely fragments of the completed films. But the process of their production, of drawing and erasure, has made these fragments into inverted story-boards that record the traces of action that has occurred in each scene, rather than signal the main points of the narrative. The drawings, therefore, are records of experience and they function in a way similar to Kentridge's landscape drawings, which document not topographical fact but the residue of human occupation of the landscape in the form of tyre-tracks, mine-dumps, billboards, and so on. In fact, the drawings of landscape for the animated films appear positively haunted by the scenes of human waste and destructiveness.

(*William Kentridge, Drawings for Projection*, Goodman Gallery, Johannesburg, 1992 {catalogue}, n.p. {partially reproduced in: *Revue Noire*, Paris, no.11, December 1993 - January 1994, p.20})

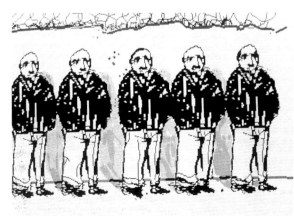

*William Kentridge, Vanessa Devereux Gallery*
*Charles Hall*

This exhibition brings together four recent animations by one of South Africa's most impressive political artists. The four films are broadly centred on the relationship between a wealthy South African industrialist, his wife and her lover.

The most striking quality of the work is the fluidity and freedom of Kentridge's handling of images. The day-dreaming lover's overflowing bath, whose waters flood his world, eventually bringing everything to destruction, and the small but nevertheless phallic fish that features in his fantasies, recur periodically throughout the series. This narrative ease is matched by inspired handling of visual imagery. The pillows propped up behind the industrialist periodically enfold him or, along with his bedspread, transmute into the landscape, which he then proceeds to transform into a bustling cityscape with a wave of his pudgy hand. In one dramatic sequence, he pushes down the plunger of his cafetiere, and the plunger continues down through his bed into the rock beneath, pushing through the mine he owns – amidst the showering and sleeping miners and, now in the guise of a lift descending its shaft, down through the subterranean galleries.

Kentridge draws on large sheets of paper, adding or editing the images for each successive shot. The effect is to leave, within each image, the shadowy echoes of past states. This proves particularly effective in recurrent scenes of great plains gradually populated by shuffling masses, or the dramatic implosion of Soho's business empire. The gallery is also showing these drawings, whose heavily worked surfaces have a distinctive, melancholy presence.

Apart from the strength of his draughtsmanship, Kentridge stands out from other political artists in the humanity of his vision. The capitalist is not an attractive figure, but he is a lonely one, whose pleas for his wife to come home eventually darken the skies. Kentridge is apparently planning to take a rest from overtly political art, as reform begins to pick up pace, and it is this humanity that will sustain his career once the urgency of dissent has dissipated.

(*Arts Review*, London, June 1992 p.9)

*Mixed Medium Marvel, 'Woyzeck on the Highveld'*
*Kathy Berman*

(…) The Handspring Puppet Company's production of *Woyzeck on the Highveld*, directed by artist, writer and filmmaker, William Kentridge, takes the classic *Woyzeck* tale by German playwright, George Büchner; adapts it to a local milieu; and then not only restructures (…) the text (…) but seemingly dispenses with live performances.

And at times it borders on brilliance.

A complex and dense mix of animated film, puppet performance, and human manipulation, the artful conjunction of two texts and two contexts merges into an intricate and compelling piece of work.

The startling sound, sights, music and happenings of urban Africa provide an evocative and heady *mise-en-scene* for the classic tale of class, sex, anger, frustration and revenge.

Handspring Company's Adrian Kohler and Basil Jones lead the team of actors and puppeteers (Lois Seboko, Busi Zokufa and Tale Motsepe). Their magnificently crafted shadow and rod puppets perform against, and within, the surrounds of an animated video landscape (a back-projected screen) created and executed by artist/director Kentridge.

The roughly-gouged features of the puppets, combined with the deeply etched shadows from the lights (lighting design is by Mannie Manim) lends the tragic tale a dark and sinister timbre.

The original *Woyzeck* was based on the true story of Johan Christian Woyzeck, who was beheaded for his crime of passion when he stabbed his lover, Widow Woost, to death with a knife. The epic tale was left incomplete by its creator, George Büchner who died of typhus in 1837.

Woyzeck, the Highveld model, bumps and grinds to the beat of the townships. Our local hero is a migratory labourer, and his rival, a muscular miner. His woman, Maria, *abbas* her baby on her back. From the upper classes (and still bearing the mannerisms of the original tale) come a Germanic Doctor and a Captain – haughty puppet people, complete with cigars, pipes, stethoscopes and other class accoutrements.

(…)

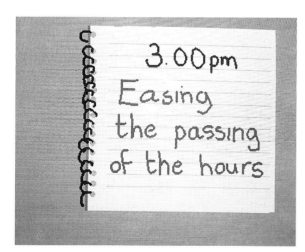

A particularly engaging moment comes early in the piece: Woyzeck, guided by puppeteer/performers Kohler and Seboko is laying (his master's) the Captain's table – with intense concentration. Above the puppet-Woyzeck, a video visually mimics, at times leads, and often mocks, the action – with drawn, charcoal, animated dinnerware darting across the filmed surface. A wry commentary on the interplay of realities.

More textual punning comes when the Doctor and Captain strike up a smoke: the two smoking puppets mime (with real sound effects from the puppeteers) blowing out non-real, animated, charcoal-drawn smoke rings – which sweep across the video screen in billowing black clouds.

A clever commentary on class iconography and stream-of-consciousness associations occurs during a medical examination: the Doctor holds a stethoscope/probing apparatus to Woyzeck's ear. To the beat of *mbaqanga* riffs emerges the images of an ear on-screen, which gives way to a barking, snarling dog. When held to his own ear, the apparatus exorcises classical chords and purring pussy cats.

(…)

(*Vrye Weekblad*, Johannesburg, 17 September 1992)

*Woyzeck on the Highveld*
*Margaret Heinlen*

In recent history, South Africa has most often appeared as a shrouded and distant country, a country with a face but no voice. With the recent political changes, South Africa is being welcomed back into the international community and must now find a voice for itself in politics, economics and the arts. It is somehow fitting that the Handspring Puppet Company chose to produce an adaptation of Büchner's *Woyzeck*, a play whose power lies in its universal and timeless representation of a common man capable of greatness of mind and feeling, driven to self-destruction by circumstances.

Director, designer, and animator of *Woyzeck on the Highveld*, William Kentridge initiated the collaboration with Handspring Puppet Company, 'to work in an area in which performance and drawing come together, to try and see if I could find an emotional depth and weight without recourse to the obvious technique of psychological transformations on an actor's face'.

(…)

Kentridge and Handspring share an interest in subject matter that explores South African realities and, 'the enormous pressures on people – economically, politically, socially and personally – which pushes people to the extreme. That means also to violence'.

(…)

Describing the process of their production, Kentridge noted its serendipitous consequences: 'We started with the animation and created a cast of puppets that could inhabit such a harsh space by leaving the puppets' raw wood roughly-hewn. So, like *Commedia dell'arte*, we then asked ourselves, "what are we going to play tonight?" We began writing and realised that we were doing Büchner and conceded that he did it much better than we. Likewise, in rehearsals we found no way to hide the puppeteers, and their presence has become one of the strongest parts of the production.'

The three levels of action, rear-projected animation, live actors and puppetry, shift the story into the metaphysical realm that Woyzeck inhabits. In his first experience of working with puppets, Kentridge has been most impressed by the 'strange condition where the manipulation of the puppet is completely transparent, where, in spite of seeing the palpable artificiality of the movement of the puppet, one cannot stop believing the puppet's own volition and autonomy.'

This phenomenon is one of the reasons founders Adrian Kohler and Basil Jones, who currently run the Handspring Company came to

puppet theatre. Kohler, trained as an actor, says of his characters: 'When a puppet performs simple everyday actions, the audience seems to observe the action for the first time and the puppet's movements become somehow epic. For example, it is difficult for an actor to suggest heroism in an act like drinking tea, but the puppet can make that leap and the audience can follow.'

(…)

The complex and tortured mind of Woyzeck is graphically illustrated in the juxtaposition of his explosive inner world animated on the backdrop/screen and his constraining external existence on the stage. We see Woyzeck through the eyes of madness. The animation not only conveys a sense of his environment from countryside, to shanties, to interiors but also gives us these visions interpreted by the main character. The distance between the actions on screen and stage is the thin line between reality and Woyzeck's twisted dream of it. The interplay of these very different realities are what most appeal to Kentridge who says of the text: 'It is a modern piece in which the first signs of absurd theatre are visible.' This is also what attracts the audiences that will experience *Woyzeck on the Highveld* at the International Festival of Puppet Theatre.

(*Puppetry International*, Premiere Issue, UNIMA-USA, 1994, p.20)

VISUAL ART

Group exhibition: 'Robert Hodgins, William Kentridge, Deborah Bell', Goodman Gallery, Johannesburg, 27 February - 13 March 1993, touring to Johannes Stegmann-Kunstgalery, University of the Orange Free State (UOFS) Art Gallery, Bloemfontein, South Africa 14 April - 7 May Exhibited works: *Easing the Passing (of the Hours)* 1992, (shown on monitor). 6 editions of 10 colour laser prints. *Act III*, tapestry woven by Marguerite Stevens Tapestry Studio, based on a computer mouse drawing. 2 banners: *Act I*, charcoal, pastel and gouache on paper; *Programme Notes*, charcoal, pastel and gouache on paper. 4 charcoal, pastel and gouache drawings and small collages

Solo exhibition: 'William Kentridge' Ruth Bloom Gallery, Los Angeles, organised by Vanessa Devereux, May Exhibited works: *Mine* 1991, (shown on monitor) with 7 untitled drawings from film, charcoal on paper

Group Exhibition: 'Incroci del Sud: Affinities - Contemporary South African Art', curated by South African Association of Art, Fondazione Levi Palazzo Giustinian Lolin, (part of 45° Venice Biennale, Venice), June - October, organised by the South African Association of Arts in collaboration with Sala 1, Rome, where the exhibition was held, 31 October - 2 December, touring Stedelijk Museum, Amsterdam, 1994 Exhibited works: 4 films on monitor: *Johannesburg, 2nd Greatest City after Paris* 1989; *Mine* 1991; *Monument* 1990; *Sobriety, Obesity & Growing Old* 1991. *Testa* 1991, gouache and charcoal on paper

FILM

Retrospective of films at 'Edinburgh International Film Festival', Edinburgh, August Projected films: *Salestalk* 1984; *Vetkoek/ Fête Galante* 1985; *Exhibition* 1987; *Johannesburg, 2nd Greatest City after Paris* 1989; *Mine* 1991; *Monument* 1990; *Sobriety, Obesity & Growing Old* 1991; *Easing the Passing (of the Hours)* 1993

Screening of *Sobriety, Obesity & Growing Old* 1991, 'Annecy International Festival of Animated Film', Annecy, 1993 (projected film)

Screening of *Sobriety, Obesity & Growing Old* 1991, 'Best of Annecy Festival', Museum of Modern Art, New York, touring to Centre Georges Pompidou, Paris, (projected film)

THEATRE

*Woyzeck on the Highveld* tours Europe, including Theatre der Welt, Munich and De Ark, 'Antwerp '93', Antwerp. Wins Quarterly Vita Award, Annual Vita Award for Fine Arts, Special Production Award, Vita Award for Best New South African Production of 1992-1993, Vita Award for Set Design of the Year

*Romancing the Plate*
*Rosemary Simmons*

Johannesburg formed William Kentridge and it remains his home base, yet his vision and work have a universality as well as a multi-media approach. He has just completed an intense short period of working with Jack Shirreff at Studio 107 in Wiltshire finalising plates and editions from two previous visits in the last year.

(...) there is the pleasure in collaboration, the sparking of ideas with like minds, but it is also the belief in letting the medium play its part in the final outcome. You may start with a charcoal drawing of an iris flower but at some stage the copper and acid or the acrylic sheet and the engraving tools impose their own scenario much as characters in a play or film. I think this is what William Kentridge welcomes and allows.

Two of the recent prints *The General* (1993) and *Head* (1993) seem to relate most directly to the animated films and to Kentridge's adaptation of *Woyzeck*. This play by George Büchner, first published in 1836, is now know for the opera by Alban Berg, completed in 1921. It tells the story of a simple soldier persecuted and put-upon: more tragically than in *The Good Soldier Schweik*, but equally harassed by superiors. Kentridge moves the story to a mining compound near Johannesburg and uses one actor to speak for each not-quite-life-size rod puppet (designed by Kentridge) and another to manipulate the arms and mouth mechanism. The print of *The General* evolved from *Woyzeck on the Highveld* via the computer animated film *Easing the Passing (of the Hours)*. It is basically drypoint on acrylic sheet printed on to pre-painted paper. Kentridge sees this as a monoprint because each background painting is different. This is one of the benefits of printmaking because variations can be made while still keeping the essential matrix unaltered.

(...)

(*Printmaking Today*, London, vol. 2 no.4, Winter 1993, p.7)

(…) This complex and sophisticated artist is, in may ways, closer in temperament to western artists of past centuries than to previous 20th-century social commentators. Indeed, Kentridge is not afraid to acknowledge his affinities with his more distant predecessors: he epitomises the postmodernist willingness to re-embrace historicity in art: to borrow, where appropriate, from the past, rather than to reject its legacy in a compulsive quest for innovatory form. In consequence, his works are rich in iconographical allusions and layered with subtleties of style and meaning.

### The Conservationists' Ball

This large triptych, which won a Merit Award at the 1985 Cape Town Triennial, displays many of the features that distinguish William Kentridge as an artist. It is not strictly a painting, though elements of gouache are incorporated. But neither is it decisively a drawing; and that ambiguity of technical procedure betokens a distinctive feature of Kentridge's artistic personality – maybe the vital link between his cinematic and his pictorial personae.

Characteristically, he establishes an evocative setting, a charged ambience in which the scenario unfolds. This atmospheric space is usually a deep, receding interior – frequently an opulent gallery, a stadium or hall. Even the exterior space defined here in Panel III, *Taming*, is presented as a claustrophobic chasm, confined by barricaded city walls. (Occasionally he sets the action in an open landscape, as in *The Embarkation*; and simply by eliminating those containing structures, extends the vista and allows the endless space to set the mood of loneliness and loss.)

The pictorial elements of the three scenes include recurrent Kentridge motifs and metaphors: men in evening dress, symbolic beasts, allusive artefacts and, typically, the partial self-image, reflected in the mirrors in Panels I and II and on the billboard in Panel III. The human participants are preoccupied and self-contained, connected to the world outside their private drama only by the mirrored presence of the artist, the unobserved eavesdropper. In contrast, the hyena in Panel III stares out accusingly and meets the viewer's gaze head on.

The satirical substance of the title and subtitles is communicated in various subtle details of the scenes enacted, in iconographical allusions and in visual puns.

Panel 1, *Culling*, in which repeated echoes of Velàzquez's *Las Meniñas* add overtones of secondary meaning, is set in an artist's studio. It arrests a moment in an enigmatic human drama, in which hypocrisy, infidelity and callousness each seem to play a role.

Panel II, *Gamewatching*, evokes the careless pleasures of café society, but puns on its complacent diversions – the nature of the game, the trophies of the hunt – and poses questions about the inevitable denouement.

Panel III, *Taming*, tenders a more brutal commentary on the consequences of human folly. Its *mise en scène* is a decaying city artery, clogged with the detritus of its reckless past. The sole conservator of this unnatural habitat is a scavenging hyena – survivor and temporary monarch of the urban wilderness, because he, too, has adapted to its mechanistic culture.

### A Cryptic Iconography

Kentridge communicates by means of metaphors; and, with repeated use, his pictorial motifs have tended to contract into a personal hieroglyphic code, a shorthand conveying multiple messages and performing varying functions in the narrative. The inconstancy of iconic meanings, the deliberate conceptual ambiguities and the wealth of artistic allusions all contribute to the density of his texts. They remain open to alternative interpretations, but they become more legible to viewers who are familiar with his oeuvre and with his sources.

Although he derives many of his images and forms from well-known masterpieces of western art, Kentridge also delights in the found image that lurks in press photographs, advertisements or books. He seldom draws from life. But he has a practice of warming up each day, in the manner of a ballet dancer limbering at the barre, by selecting two random images from his files. These he then juxtaposes in a single drawing, manipulating the relationship between them to achieve provocative pictorial situations. From such exploratory exercises, many of his major compositions have evolved.

Kentridge chooses not to work in paint because, in his view the medium itself is too assertive: he is more interested in the narrative than in the work's materiality. His working process itself is, nevertheless, essential to the outcome. The drawing fluctuates in form, developing organically and changing, while his eraser acts in concert – to accent, to edit and to modify the charcoal and pastel marks.

This artist rejects confining programmes, structures or ideologies. Flexibility, ambiguity and flux are central to his activist vision. And those properties, together with immateriality, are intrinsic features of the cinematic medium. Indeed, the two facets of his expression, works on paper/works on film, were brought into consummate harmony in the nine-minute animated video, *Sobriety, Obesity and Growing Old*, for which we won the Gold Medal in the 1991 Cape Town Triennial.

In that tour de force, the distinctive characteristics of his drawings – the gestural marks, the fluctuating image, the technical ambiguities, the conceptual density, the paradoxical relationships, even the essential process of erasure – all coalesced into a virtuoso realisation of his satirical perception of society and life.

(*Painting in South Africa*, Southern Book Publishers, Pretoria, 1993, pp.315-317)

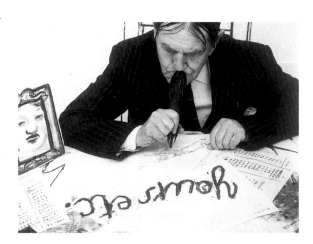

VISUAL ART

Makes *Felix in Exile*, fifth animated film in the series *Drawings for Projection*, 35mm, video transfer, 8 minutes, 43 seconds

Group exhibition: 'Trackings: History as Memory, Document & Object. New Work by Four South African Artists', Art First, London, 19 April - 19 May
With Malcolm Payne, Penny Siopis, Sue Williamson
Exhibited drawings and collages: *Reclining Woman* 1994; *Head* 1994. *Drive-In* 1994; 2 collages of charcoal and paper on canvas: *Head I* 1994; *Head II* 1994.
4 drawings from *Another Country* 1994, all charcoal and pastel on paper

Group exhibition: 'Goodman in Grahamstown', Victoria Primary School, Grahamstown, 30 June - 10 July
With Deborah Bell, Bongani, Norman Catherine, Alan Crump, Robert Hodgins, David Nthubu Koloane, Percy Ndithembile Konqobe, Mashego Johannes Segogela, Peter Shange, Cecil Skotnes, Martin Steyn, Andrew Verster
Exhibited works: Etching from *Felix in Exile* 1994, pastel, charcoal and gouache; *Memo* (1993), (screened on monitor), with set design

Group exhibition: 'Displacements', curated by Jane Taylor and David Bunn, Block Gallery, North Western University, Chicago, 22 September - 4 December
Exhibited works on paper: 3 drawings from *Felix in Exile* (1994): *Felix and Nandi Looking Through Mirror*, charcoal and pastel on paper; *Landscape with Billboard*, charcoal and pastel on paper; *Room,* charcoal and pastel on paper

Solo exhibition: 'Felix in Exile', Goodman Gallery, Johannesburg, 16 October - 5 November
Exhibited works: *Felix in Exile* 1994, (screened on monitor) with 32 drawings, 1994, charcoal and pastel on paper for *Felix in Exile*: *Felix in Bed; Felix in his Chair; Landscape with Pool; Billboard with Rocks; Felix

*Dreaming of Nandi; Felix with Seismograph; Landscape with Reservoir; Body Covered with Papers; Body with Covered Face; Felix in Pool; Little Landscape with Billboard; Small Landscape with Track; Small Landscape with Reservoir; Billboard – Small Pool; Landscape with Red Pole; Stormwater Drai; Nandi's Head; Lovers in a Pond; Tower; Head Frontal; Head Profile; Crow; Nandi Falling; Nandi's Cry; Nandi – for Angus; Nandi Profile; Nandi with Theodolite; Nandi Constellation; Felix in Exile; Felix with Suitcase; Felix in Exile*, etching

Group exhibition, Spacex Gallery, University of Exeter, November
Exhibited works: etchings published by David Krut Editions: *Head; Iris; Dutch Iris 1; Dutch Iris 2*

Makes *Another Country*, animated drawings on video for music by Mango Groove, screened on South African television

FILM

Completes *Memo* (1993-4) with Deborah Bell and Robert Hodgins, animated film 35mm, transferred to video, with drawings, actors and stage set, 3 minutes

THEATRE

*Woyzeck on the Highveld* tours Toronto, Brussels ('International Kunstfestival'), Stuttgart, Granada, Glasgow, Bochum, Braunschweig, Berlin, Goteborg, New York ('International Puppet Theatre'), Chicago

VISUAL ART

Group exhibition: 'Africus 1st Johannesburg Biennale', curated by Lorna Ferguson, organised by Africus Institute for Contemporary Art (Danish section, curated by Marianne Barbusse and Abrie Fourie), Johannesburg, 28 February - 30 April
With Doris Bloom
Exhibited works: *Memory and Geography*, multi-media project made in collaboration with Doris Bloom (Denmark) comprising a number of different elements: 6 drawings, 1994, white chalk on black gouache on paper. *M and G* 1994, animated film made from the drawings, existing in several versions: an 8-minute, projected video loop, visible through a peep-hole inside The Electric Workshop, and shown on monitors set into man-hole covers in the streets of Johannesburg, powered by a petrol generator; a 3-minute, 35mm film version, projected onto the walls of the city from the back of a truck at night; a commercial 3-minute film played before feature films in cinemas and drive-ins around the city. 2 outdoor works also based on the drawings: *Fire Gate*, a fire-piece created on the ground in front of Electric Workshop in Johannesburg; *Heart Drawing*, a white chalk drawing on the landscape 20 km south of Johannesburg in Walkerville. 3 large banners (photos printed onto 200 x 200 cm sheets of plastic) on the staircase in the Electric Workshop representing the *Heart Drawing*, a close-up of *Fire Gate* and a long shot of *Fire Gate.*

Two-person exhibition: 'Memory and Geography' Stefania Miscetti Gallery, Rome, 15 June - 28 July, with Doris Bloom
Exhibited collaborative works: 8 drawings from *M and G*; *Constellation*, etching printed at 2RC, Rome; slide projection of 12 drawings from *M and G* on walls of city at night, Piazza della Pilotta; *M and G* projected at San Giorgio al Velabro, Rome

Group exhibition: 'Panoramas of Passage: Changing Landscapes of South Africa', curated by Clive Van Den Berg, 'Standard Bank

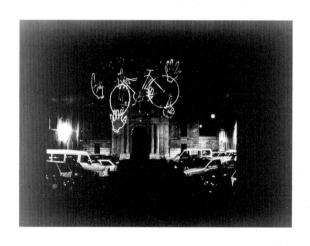

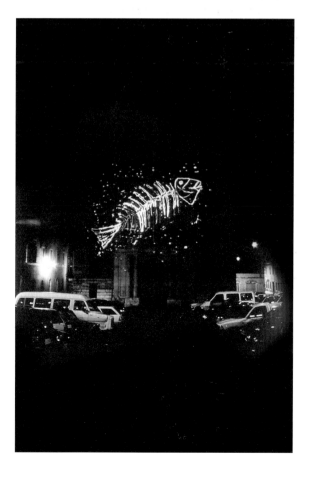

National Festival of the Arts', Albany Museum, Grahamstown, July, touring to Meridian International Centre, Washington, DC, October 18 - February 4 1996; Dallas, Atlanta, Los Angeles, West Hartford, Wilberforce, Little Rock, Flint, Lexington, Gertrude Posel Gallery, University of Witwatersrand, Johannesburg, July 1998
Exhibited works: c.6 fragments of drawings used to create animation for *Faustus in Africa!* 1995

Group exhibition, 'Mayibuye I Afrika: 8 South African Artists', Bernard Jacobson Gallery, London, 28 September - 28 October
With Wilie Bester, Norman Catherine, Kendell Geers, Robert Hodgins, Pat Mautloa, Zwelethu Mthethwa and Penelope Siopis
Exhibited works: 5 films (shown on monitors): *Johannesburg, 2nd Greatest City after Paris* 1989; *Mine* 1991; *Monument* 1990; *Sobriety, Obesity & Growing Old* 1991; *Felix in Exile* 1994; 4 drawings: *Death Register*, (drawing for *Faustus in Africa!* also titled *List of the Dead* or *List of Names*) 1995, charcoal on paper; *La Voce del Padrone*, (also titled *Gramophone*) 1995, charcoal on paper; *The Waterfall*, (also titled *Waterfall Drawing*) 1995, charcoal on paper; *Mbinda Cemetery*, (also titled *Tree with Objects*) 1995, charcoal on paper

Group exhibition: 'On the Road – Works by 10 Southern African Artists', The Delfina Studio Trust, London, curated by Linda Givon, (part of 'Africa 95', organised by Clementine Deliss), 5 October - 12 November
With Keston Beaton, Willie Bester, Berry Bickle, Norman Catherine, Kendell Geers, Kagiso Pat Mautloa, Antonio Ole, Renato Sadmiba Passema, Penny Siopis
Exhibited works: 4 films (shown on monitor): *Mine* 1991; *Monument* 1990, with drawing, charcoal on paper; *Sobriety, Obesity & Growing Old* 1991, with drawing, charcoal and pastel on paper; *Felix in Exile* 1994, with 2 drawings, charcoal

and pastel on paper: *Felix & Nandi*; *Felix in his Chair*

Solo exhibition: 'Eidophusikon', curated by Lorna Ferguson, (part of '4th International Biennale of Istanbul', curated by René Blok), The Istanbul Foundation for Culture and Arts, 10 November - 10 December
Exhibited works: c.60 drawings for *Faustus in Africa!* including: *List of the Dead* 1995 (also called *Death Register* or *List of Names*), charcoal on paper; *Sea Plane and Palm Tree* 1995, charcoal on paper; *Map of Lorenco Marque* 1995, charcoal on paper; *Africa Map with Cartouche* 1995, charcoal on paper; *The Waterfall* 1995 (also titled *Waterfall Drawing*), charcoal on paper; *La Voce del Padrone* 1995 (also titled *Gramophone*), charcoal on paper; *Impaled Body* 1995, charcoal on paper; *Impaled Body* 1995, charcoal on paper, collage

FILM
Retrospective of animated films at Annecy International Film Festival, June.
Projected films: *Vetkoek/ Fête Galante* 1985; *Exhibition* 1987; *Johannesburg, 2nd Greatest City after Paris* 1989; *Mine* 1991; *Monument* 1990; *Sobriety, Obesity & Growing Old* 1991; *Easing the Passing (of the Hours)* 1993; *Memo* 1993; *Felix in Exile* 1994

THEATRE
Conceives and directs *Faustus in Africa!*, 'Kunstfest', Weimar, 22 - 25 June (Premiere); Hebbel Theater, Berlin, 27 June - 1 July; 'Standard Bank National Arts Festival', Grahamstown, 4 - 8 July; The Market Theatre, Johannesburg, September - November; European tour: Zurich, Ludwigsburger, Munich, Prague, Stuttgart, Hannover, Basel, London, Remscheid, Gutersloh, Erlangen, Lisbon

*Meeting Place Johannesburg*
Poul Erik Tojner

(…) 'Beginning' or 'process' or, perhaps just 'movement', are key terms to describe the collaborative work of Doris Bloom and William Kentridge. And this reflected both the context and the individual backgrounds of the two artists. (…) Their collaboration has led to a two-stage project.

It was initiated by a land-art piece. The subsequent production of an animated film, intended to be shown in various contexts – all outside the classic, isolated space of the cinema – made up the project's second phase. The two phases are closely linked, like body and soul.

The land-art project consists of two parts. One is an enormous constellation in chalk, drawn out on the earth, a figure that creates an anatomical image of a heart. The production of this constellation took place in horizontal conditions, the image painstakingly measured to create the correct dimensions and sizes; actually experiencing it, however, demands a vertical, aerial view.

In this work, which is exclusively figurative, the heart unfolds like an allegory of the relationship between two very precise perspectives on a piece of land: that from above, and that amongst things; that which is at a distance, and that which is woven into the land's density and complexity.

The artistic process that created this image – whose experiential conditions are vertical, and whose production conditions are horizontal – highlights one of the questions we must ask in view of the specific situation that the Biennale explores in South Africa: the question of cultural identity. And its answer is ambiguous: it all depends on an association-filled mental map. Seen from another point of view, the running lines become a way of circumscribing a piece of land.

That the heart image has been made at the edge of the place in which Doris Bloom grew up only reinforces the ambiguous experience brought to the fore by land art: that only distance makes it legible as an image. That both Bloom and Kentridge have previously made pictures that illustrate landscape, and now make the landscape create the illusion of a picture, signifies the ambiguity that nourishes the entire work. That it is a heart that lies there, as fruit of their common efforts, is certainly not incidental. It refers to something primeval, something that transcends cultural differences. It is not, however, designed as an icon standing for anything in particular – love, faith, the rhythm of life – after all, it appears as an organ not a symbol.

Distorted in a parallel manner to this dry, dusty drawing on the earth's brown surface (…) is a work literally on fire – a fire-drawing executed on the actual site of the Biennale, in a former industrial zone at the edge of the Johannesburg skyline. The work is created from several miniature sand embankments, which were doused with gasoline and petroleum then set on fire, creating a flickering fiery drawing, which from a distance becomes a stable picture.

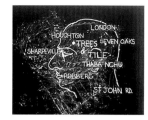

This time the image is not one of a timeless organ, the heart, but of something as profane as a gate from an entrance into a classic South African villa, from around the turn of the century we assume. On first sight, it is difficult to see anything else but the gate. But then one notices its ornament, which also contains a heart form. Re-viewed after having seen the animated film, however, the gate now falls into place in a mythology that is inherent in the collaboration of Bloom and Kentridge. In their animated film, the gate is used as a symbol of the way in which the increased brutalisation and violence during the 20th century can be expressed and discovered in such a simple, banal piece of everyday architecture.
(*Weekendavisen*, Copenhagen, December 1994) Reprinted in 'Bloom, Kentridge, Memory and Geography', *Africus 1st Johannesburg Biennale*, Africus Institute for Contemporary Art, 1995, {catalogue} n.p.)

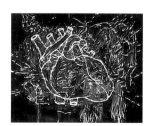

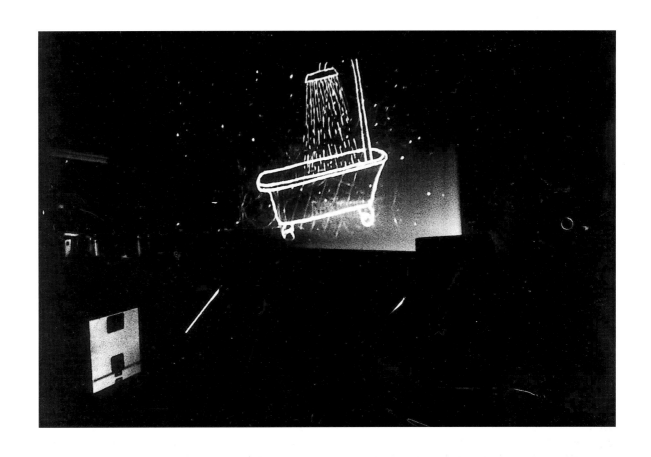

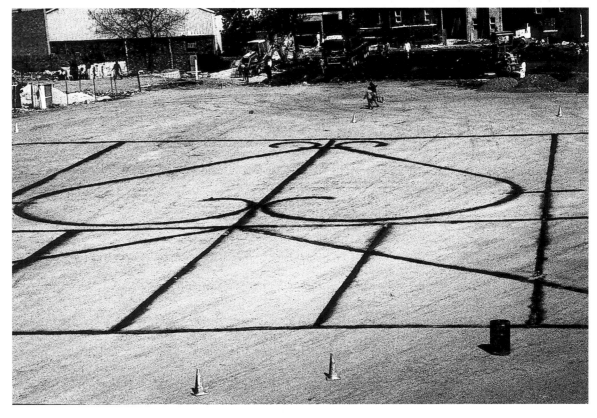

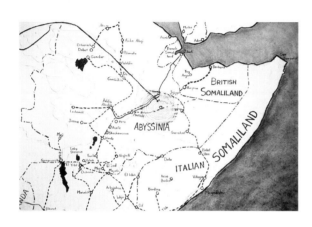

*Inside Out*
*Ruth Rosengarten*

The Johannesburg Biennale was the brainchild of Lorna Ferguson, who for 18 years ran the Tatham Art Gallery in Pietermartizburg and built it up from a minor regional museum to an important national collection. A feisty person with a famous temper, she made no few enemies as she carried out her unenviable task. The idea came to her after visiting Documenta in Kassel as a means of putting South Africa 'on the map', just as Documenta had been introduced in post-war Germany as a cultural corrective measure.

(…) two central themes were outlined: 'Decolonising our Minds' and 'Volatile Alliances'. The themes served as guidelines for submissions of exhibition proposals. The first theme attempts to show colonialism as above all, an *attitude* and, positing Africa as a focus of attention, aims to analyse the global repercussions of colonialism on representation. The second incorporates the concept of frontiers, both physical and mental, and how these might be expanded in allegiances that not so much dissolve as accommodate difference. Inherent to this agenda was the need to question the relationship between Eurocentric and Afrocentric interests, and to deal with broader issues of marginalisation (race, gender, religion, land rights and so forth). For all the organisers, the main question was how to avoid cultural re-colonisation, a re-appropriation by hegemonic powers. What sort of relationship might be established between Eurocentric and Afrocentric cultural discourses was thus a key note, struck more or less ubiquitously through the Biennale.

(…)

Questions of identity and memory were synthesised in the collaborative work of William Kentridge and Doris Bloom, representing Denmark. Both are South African, but Bloom has been resident in Copenhagen for the past 20 years. Entitled *Memory and Geography*, their collaboration resulted from a dialogue (conducted partly by fax) tracing the affinities and divergences of their early experiences and memories. The show was an assemblage of drawing (in white on black), along with a short animated film, seen through little peepholes in the main exhibition space but also screened in various places around the city. Two further drawings, one of a schematic heart and the other of an anatomical heart ('heart' defining both the centre of a space and the true seat of memory) were inscribed in the landscape itself. The first was a huge fire drawing, which took place on the ground, against the urban backdrop of Newtown, Johannesburg; the second, the anatomical heart (measuring 130 x 70 m) was drawn in whitewash on a fire-scarred veld in Walkerville, 25 km south of Johannesburg, and only yielded its *gestalt* as an image in aerial view. This work provided a stunning meditation on the interplay between inner and outer space, on the mutual inscription of the two terms described by the title of the show.

(…)
(*Frieze*, London, issue 23, Summer 1995, pp.46-48)

*Mayibuye, Bernard Jacobson Gallery and On the Road,*
*The Delfina Studio Trust*
*Robert Condon*

'Evidence is not Truth because the vision can change' wrote the poet and artist, Houria Niati about the search of Algerian women for an identity beyond the exoticising gaze of the West that would more adequately speak of the complexities of their realities. Re-envisioning the past in a search for the truth beyond the legacy that colonial domination has laid in its wake is an investigation often fraught with contradictions, misinterpretations, and hegemonic cultural

imperatives. For South Africans, their recent emergence from the apartheid era has called into question much of the evidence and strategies that have resulted in this myopic vision, which has defined South Africa's cultural past and still contends for its future.

While much of the fanfare that has accompanied the dismantling of apartheid on the international front has focused on the bridge-building efforts of the transitional government and other similar attempts at integrating South Africa's diverse populations, many of the more difficult questions are still to be addressed. One need only look at the disparaging under-representation of black South African artists at the 1995 Johannesburg Biennale to know that much work has yet to be done before the boundaries that apartheid established can be sufficiently labelled as the past.

During the recent 'Africa 95' festival in London, two shows, *Mayibuye e Africa* and *On The Road* focused on these disjunctures between Africa's past and the emerging perspectives on its future by interrogating the indeterminacy of both in articulating the shifting boundaries of African representation.

(…)

William Kentridge's video installation relying on the same sheet of paper to create and then rub out the images that comprise each scene of his narratives, depicts that past in a perpetual state of wilful erasure. They draw on the disintegration of the image – on the ability of memory to forget and grow vague – somehow allowing us to reinvent these memories by envisioning them anew. Each time, adding something new to the narrative that may have no relation to the original facts other than that it occurred in the mind of the same individual.

(…)

Developing new strategies for representation and an engaged inquiry into the processes that constitute art-making are key to these artists' search for a new way of envisioning experience. Reinvesting the subject with new tools better suited to challenging the conceits of the past and refiguring them to face the unravelling narrative of Africa's present.
(*NKA*, London, issue no.4, Spring 1996)

*Faust's Journey to Africa*
*Ruth Sack*

(…) in Goethe's play, what struck Kentridge as remarkably contemporary was 'the construction of the self; Faust's consciousness of himself in society and in the world – as compared, say, with the relatively simple moral battle being waged within the heart of Marlowe's Faustus. Surprising and modern, too, seems Goethe's vision of his society: brutal, as he saw it, shot through with disorder and insanity'.

*Faustus in Africa!* is, of course, no longer only Goethe's play. His recent collaborators are Lesego Rampolokeng and Kentridge himself, who have fairly extensively written, transposed, edited. Maintaining the form ('Both Goethe and rap use rhyming couplets'), they have managed to retain an integrity and unity in the writing, while creating new connections and new geographies within it.

And why is Faust in Africa? 'We are exploring the huge, overbearing weight of Europe on Africa', says Kentridge. (The burden of European culture is epitomised by a Bar Mitzvah present: 'I was given this great big two-volume set of Goethe's *Faust*, at the age of 13. Of course I didn't read it. But for years these two books sat on my bookshelves, in silent rebuke, gently oppressing me.')

The play has been set in a non-specific country but with very specific references to colonial Africa, in the period during which Europe brought its colonising bounty: slavery, disease, poverty, confusion. And then, says Kentridge, abandoned it.

Coincidentally, at the same time (…) Hegel – with his Age of Enlightenment perspective on things – was dismissing the continent

of Africa entirely: after the Pyramids, said Hegel, 'the World Spirit left Africa'.

Kentridge 'wanted to open up this albatross, see what was inside, re-stuff it, and send it back to Europe'.

The colonial period in Africa provided the designers with superb opportunities, stylistically. And Kentridge and Adrian Kohler (of Handspring) have used these opportunities to brilliant effect.

Finding their sources in old encyclopaedias, drawings and photographs by travellers and explorers, and colonial magazines, they based Mephistopheles' office on a 1930s photograph of a telegraphic office in Lourenco Marques; the puppet Gretchen on a picture of a laboratory nurse in the Congo; Helen of Troy on a model in a 1950s cigarette advertisement. Faust himself is based on the appearance of the 19th-century explorer, Count Leopold de Brazza; Mephisto's servant on Patrice Lemumba. The detail is extraordinarily rich.

Endlessly evocative, the layers of realism, magic and illusion blend and shift. As with their previous play *Woyzeck*, this production is conjured from a multiplicity of forms: human, puppet, animated charcoal drawing. Appropriately so, for the play's sweep is huge – Africa, the world, the other world.

(…)

The puppets are manipulated and performed by actors within our full view; and so gradually the character of each take on a double or even triple image, neither puppet nor operator taking precedence.

The effect of this multi-personed representation becomes almost one of witnessing the character's relationships with their selves – a very intense experience. (And sometimes volatile: at one point the witch-puppet, in her fury, turns and attacks her own manipulators)

(…)

(*Mail and Guardian*, Johannesburg, 15-22 June, 1995, p.31)

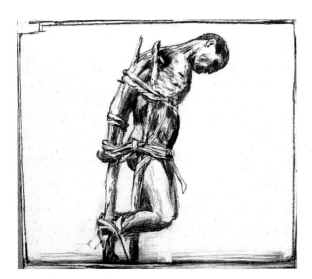

VISUAL ART

Makes *History of the Main Complaint*, sixth animated film in the series *Drawings for Projection*, 35mm transferred to video and laser disc, 5 minutes, 50 seconds

Solo exhibition: 'Eidophusikon', Annandale Gallery, Sydney, Australia, 27 March - 20 April
Exhibited works: 7 drawings entitled *Colonial Landscapes*, including *Falls of an Africa River* 1995, charcoal and pastel on paper, *Reed Bed* 1995, charcoal and pastel on paper. c.60 drawings from *Faustus in Africa!*, previously shown at Istanbul Biennale 1995

Group exhibition: 'Common and Uncommon Ground, South African Art to Atlanta', curated by Steven Sack, City Gallery East, Atlanta, 12 April - 7 June.
Exhibited work: *Casspirs Full of Love* 1989, etching

Summer residency at Civitella Ranieri Center, Umbertide

Group exhibition: 'Colours, Art from South Africa', Haus der Kulturen der Welt, Berlin, 14 May-18 August
Exhibited works: 4 films on monitor: *Johannesburg, 2nd Greatest City after Paris* 1989; *Mine* 1991; *Monument* 1990, with drawing, 1992, charcoal and pastel on paper; *Felix in Exile* 1994, with 3 drawings: *Felix in His Chair*; 2 untitled drawings, charcoal and pastel on paper

Group exhibition: 'Simunye: We are One. Ten South African Artists', Adelson Galleries, New York, organised in association with Goodman Gallery, 4 June - 1 July
With Willie Bester, Norman Catherine, Kendell Geers, Kasigo Patrick Mautloa, Zwelethu Mthethwa, Walter Oltman, Johannes Segogela, Penny Siopis, Sue Williamson
Exhibited works: 5 drawings from *History of the Main Complaint* 1996: *Ten Doctors*, charcoal and pastel on paper; *The Empty Room*, charcoal and pastel on paper; *Soho's Head in Bed*, charcoal and pastel on

paper; *X-Ray Typewriter*, charcoal and pastel on paper; *Head*, charcoal and pastel on paper

Group exhibition: 'Faultlines: Inquiries into Truth & Reconciliation', curated by Jane Taylor, The Castle, Cape Town, 16 June - 31 July
With Jane Alexander, Lien Botha, Kevin Brand, Randolph Hartzenberg, Moshekwa Langa, Billy Mandindi, Malcolm Payne, Colin Richards, Penny Siopis, Warwick Sony, Alfred Thoba, Clive van den Berg. (A seminar, radio events, a poetry reading and art workshops were also organised)
Exhibited works: *History of the Main Complaint* 1996, (Premiere) (projection onto small white board on a blackboard easel)

Group exhibition: 'Jurassic Technologies Revenant', 10th Sydney Biennial, curated by Lynne Cooke, Art Gallery of New South Wales, Artspace, Ivan Dougherty Gallery, 27 July - 22 September
Exhibited works: *History of the Main Complaint* 1996 (projected on wall), with 3 drawings: *Empty Ward* 1996, charcoal and pastel on paper; *X-Ray* 1996, gouache, charcoal and pastel on paper; *Sonar* 1996, gouache, charcoal and pastel on paper

Group exhibition: 'Inklusion-Exklusion: Versuch einer neuen Kartografie der Kunst im Zeitalter von Postkolonialismus und globaler Migration', curated by Peter Weibel ('Ici et Ailleures' film section curated by Catherine David), Steirischer Herbst, Reininghaus, Graz, Austria, 22 September - 26 October
Exhibited works: 4 films on monitor: *Johannesburg, 2nd Greatest City after Paris* 1989; *Mine* 1991; *Monument* 1990; *Felix in Exile* 1994, with 4 drawings

Group exhibition: 'Don't Mess with Mr In-between: 15 artistas da Africa do Sul', Culturgest, Lisbon, 25 September - 10 November
Exhibited works: 6 *Colonial*

*Landscapes*, charcoal and pastel on paper: *Hunting the Spur-winged Goose*; *My Camp in Siona*; *Its Course was towards the Rising Sun*; *Gaha Cataract near the Lui*; *Falls of an African River*; *View of the Zambezi*

Group exhibition: 'Campo 6, The Spiral Village', curated by Francesco Bonami, Galleria Civica d'Arte Moderna e Contemporanea, Turin, 28 September - 3 November; touring to Bonnefanten Museum, Maastricht, 19 January - 25 May 1997
With Doug Aitken, Maurizio Cattelan, Dinos & Jake Chapman, Sarah Ciraci, Thomas Demand, Mark Dion, Giuseppe Gabellone, Tracey Moffatt, Gabriel Orozco, Philippe Parreno, Steven Pippin, Tobias Rehberger, Sam Taylor Wood, Pascale Marthine Tayou and Rikrit Tiravanija
Exhibited works: *History of the Main Complaint* 1996, (triptych projection on wall alongside two slide projections of a skull X-ray and a chest X-ray)

FILM
Retrospective of animated films at 'Festival des Dessins Animés', directed by Doris Cleven, Le Botanique, Brussels, February
Projected films: *Vetkoek/ Fête Galante* 1985; *Johannesburg, 2nd Greatest City after Paris* 1989; *Mine* 1991; *Monument* 1990; *Sobriety, Obesity & Growing Old* 1991; *Easing the Passing (of the Hours)* 1993; *Memo* 1993; *Felix in Exile* 1994

Culturgest, Lisbon, July
Projected films: *Vetkoek/ Fête Galante* 1985; *Johannesburg, 2nd Greatest City after Paris* 1989; *Mine* 1991; *Monument* 1990; *Sobriety, Obesity & Growing Old* 1991; *Easing the Passing (of the Hours)* 1993; *Memo* 1993; *Felix in Exile* 1994

THEATRE
*Woyzeck on the Highveld* tours to Hong Kong, Adelaide ('Adelaide Festival'), Wellington, Bogota, Jerusalem, Avignon, Columbia, Scandinavia, France, Belgium, Italy, (Rome Teatro Vascello)

*Faustus in Africa!* tours to 'Adelaide Festival', Adelaide, 13 - 16 March 1996; Europe and Israel: 'KunstenFESTIVALdes-Arts', Brussels 8 - 12 May; Bochum, Hannover, Dijon, Jerusalem, Ellwangen, Hamburg, Copenhagen, St Polten, Polverigi, Avignon ('Festival D'Avignon'), May - July; Europe: Seville, Marseilles, Rome, Tarbes, Toulouse, Strasbourg, Paris, Sochaux, Bourg en Bresse, Chambery, October - December

## Of Becoming: the Arts of the Possible
*Jane Taylor*

On January 31 1996 a delegation of traditional healers, under the spiritual leadership of Chief Nicholas Tilana Gcaleka, will travel from the south-eastern region of South Africa to Scotland, in order to retrieve the head of the 19th-century Xhosa King, Hintsa. Gcaleka, informed by vision, has a message for the nation: that the violence and corruption that seem to be the post-colonial legacy will only abate once the head of Hintsa is returned to its ancestral place. Hintsa was shot in 1835 while attempting to escape after a period of humiliation as the hostage of Harry Smith, then Colonel of the British forces in the region. The historian JB Pieres gives an account of how, once Hintsa had been shot, his ears were cut off as trophies. According to historical account, the head was never severed; nor was it transported to Scotland. Thus this head, which now must be returned to South Africa in order that a millennium of peace might begin, is itself a fantastical emblem of dismemberment. It is, in legend, without ears, without body. It is a fragment that has been fragmented. What is of considerable interest, is that the retrieval and reintegration of Hintsa's head to the site of his national origins, will begin the process of healing. In Gcaleka's terms, the 'hurricane spirits' of the ancestors have revealed the Scottish resting place of the head, because the soul of Hintsa is 'blowing all over the world with no place to settle'.

(...)

The Hintsa story, which begins with a vision arising from great longing and distress, has forged an allegory of nationhood. The longing is expressed as a dream of integration, well-being, social order. Presumably, too, it is a longing for the reinvigoration of the role of traditional leadership whose stature has diminished under modernisation. The distress is that shared by many: a profound anxiety that the demise of apartheid law has come too late to save an already sundered society. It is an over-determined narrative of the complex relations of post-colonial South Africa. Perverse and brutal history is to be redressed through an imaginative act of recuperation. The shamanic authority of Chief Nicholas Tilana Gcaleka has aroused massive support in the Eastern Cape, and by popular account Mandela himself has reportedly given his blessing to the projected attempt to retrieve Hintsa's head. Thus, a constellation of meaning around visionary longing and historical redress brings about a negotiation of the roles given

to political leadership, both traditional and local (that of Gcaleka), as well as modernising and national (that of Mandela). The episode manifests the persistent commitment, in 'the New South Africa', to performances that display the viability of strategic alliance. The success of the national project is very clearly about acts of representation.

So the tale is not simply a manifestation of anti-colonial impulses. What is so striking, is that it provides an instance of how increasingly complex representations of subjectivity are becoming in a post-apartheid South Africa. Throughout the 1980s, South African representational forms were dominated by the Manichean logic that governed the country. Most typically, South African populist art became associated with monochrome linocuts in realist convention, which depicted township scenes of street warfare between the South African military and the proletariat. South African art became fixed, for the international community, as a system of signs that figured the dualisms of black versus white/oppressed versus oppressor/right versus wrong.

Through the process of pragmatic political engineering of the early 1990s, the historical antagonisms represented by such dualisms were suspended long enough to allow for the emergence of that singularly South African political invention, the 'government of national unity', an interim body consisting of all of the key parties, represented proportionally, as participants. This is a transitional moment. There is no way of knowing what will succeed it. What this instant seems to have generated, aesthetically, is a kind of wonder at the potential for diversity in visual forms and a period of remarkable diversity and experiment. Thus, while the processes of inventing a national identity will, in utopian terms, yoke us together despite our differences, our visual field by contrast seems to be increasingly dispersed, individual, private. Those artists whose work is still engaged with the legacies of racial discrimination and class inequities, are pursuing these inquiries in increasingly personal ways.

Moreover, the image that dominated previous decades itself had a history. During the 1960s analysts, historians, critics, produced interpretations that emphasised the absolute power of the state and the absolute humiliation of the masses. In 1968, Jack Simons and Ray Alexander's classic study *Class and Colour* depicted the desperate plight of the African working classes, for whom 'the constant raids and surveillance' reduced 'the inhabitants to a state of sullen submissiveness'. By the 1980s, this was replaced by the familiar images of

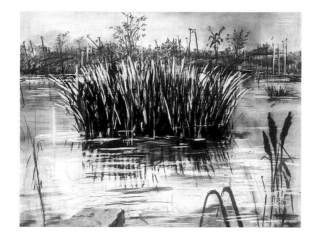

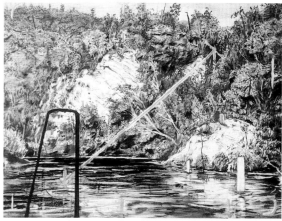

popular resistance, with a defiant group, against an urban landscape, battling apartheid forces. Menan du Plessis' novel *Longlive!* perhaps provides the most characteristic literary representations of this era: '… in other parts of the city that day the police had acted with less restraint: by midnight there were eight dead, and hundreds more wounded; and a day later the toll of the dead had risen to seventeen. Within a week, thousands of teenagers had abandoned school and taken to the streets of their neighbourhoods. There might be a lull of two or three days, but then the barriers of oil-drums, old bicycle frames, branches and burning tyres would rise up again. The Casspirs (armoured vehicles) would come cruising back down the streets; and the stones and bottles of petrol would once again start flying'.

By the mid-1990s these scenes, ubiquitous half a decade earlier, have been replaced in large measure by small inquiries: images of individual loss, the textures of private grief, or memory, little places of intimate longing.

(…)

Increasingly, too, the body has become more diverse in its meanings. Once almost wholly used as a field upon which to inscribe the history of pain, it is now also a site of pleasure, or of nurture, or of expression or of style. This is not to deny that pain persists: South Africa is still marked by racial inequality, unemployment, gang-violence, industrial exploitation, sexual terror. But other meanings have gained a measure of legitimacy.

(…)

The interwoven webs of history and subjectivity, memory and longing, are evident in the work of William Kentridge. As the French film-maker Alain Resnais, in *Hiroshima Mon Amour*, had used the consolations of a love story to lead his audience through the horrors of nuclear Holocaust, so Kentridge explores apartheid histories through the evolving erotic landscape of his protagonist, Felix Teitlebaum. The personal and political are mutually entailed; their metaphors constantly slip across the horizon that separates the two spheres, but they should not, he seems to suggest, be mistaken for each other.

Bodies, in South Africa, are marked spatially. The dream of the apartheid map was to fix identities within designated geographical spaces: 'Separate Development'. The apartheid regime propped itself up on the fiction that identity could be spatially bound, in 'homelands', 'locations', 'group areas'. The necessary transaction of identity across and between such spaces, as people moved daily back and forth from place of residence or work or, more infrequently, from township to homeland, was managed by an enormous bureaucracy and police-force which brutally administered the pass-law system, whereby people's passage was tolerated under rigid rules of concession. Ultimately, much of the ideological work of apartheid was to misrepresent the movement of persons back and forth, and to create the phantom that 'peoples' had been fixed into given places, that somehow they belonged there for reasons of ethnic affiliation.
(*Colours: Kunst aus Sudafrika*, Haus de Kulturen der Welt, Berlin, 1996, {catalogue} pp.30-35)

*Momento Mori*
*Roger Taylor*

Kentridge believes that he had a typical white South African childhood 'in the sense of a comfortable suburban life', describing his family as 'part of a privileged white elite that has seen and been aware of what was happening but never borne the brunt of the might of the state'. But he notes that his childhood was 'a lot less blind than a lot of other white suburban childhoods would have been'. Kentridge's father, after all, was involved not only in the Sharpeville inquest but also in the 1964 Treason Trial (in which 120 political leaders, including Nelson Mandela, were tried and, in some cases, jailed, for sabotage and subversion) and the 1978 Steve Biko inquest.

The issue of apartheid was very evident at home 'because the personalities involved came to consult with my father', says Kentridge. 'I was vocal in my opposition to apartheid, as white students were in the 1970s. But I was not someone who was detained or imprisoned. I fitted in with a corps of white, left-wing students and young professionals, which had always been an important part of the South African political scene. Then, in the late 1970s, I had to make a choice between becoming a full-time activist, working with something like the UDF, or becoming a full-time artist. I decided that I worked much better in my studio, and although I wouldn't say that I was particularly effective there, I was spectacularly ineffective as a politician. It wasn't even a choice. It became very clear that the studio was the right place to be working, for even if you were simply doing your drawings as a diary in a most personal way, you couldn't avoid the way in which the political world intruded upon your daily life.'

Taking his lead from Honoré Daumier and George Grosz, Kentridge invokes the tradition of political illustration – a tradition of satire, realism and social protest – to populate his animations. Kentridge's recurring characters include the impeccably dressed mine-owner, Soho Eckstein, avatar of capitalism, greed and corruption; Felix Teitlebaum, an opposing character who always appears naked in the animations, and Harry, leader of the poor oppressed.

Unlike Daumier and Grosz, Kentridge is not a caricaturist, yet his drawings contain the same authority of line, the same contour and weight, and his characters occupy a similar capsule of gloom. In Daumier's case, it was the gas-lit city, the dim, grey battlefield of 19th-century Paris; in Grosz's, it was the disabled, mutilated, crumbling capitalist society of Germany between the two world wars. In

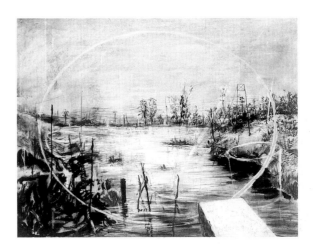

Kentridge's case, it is the dark, wind-swept landscape of contemporary South Africa, recovering from the excesses of apartheid. Soho Eckstein carries the heavy burden of the historical memory of all that has transpired in South Africa through this landscape. He is the only character to appear in Kentridge's most recent animation, *The History of the Main Complaint*.

(…)

'In the film, the question was – here's a person who's in a coma because of the weight of what he's seen, of what he's been through', Kentridge explains. 'The question is – is that going to kill him? It becomes clear. No, people don't die from the guilt of their feelings or the weight of their memories – even though they ought to, perhaps. But they contain them. These memories may suddenly resurface in a crisis, but they get put away. So in the end, all the things that Eckstein has experienced get resolved or get reduced to mementoes on his desk, and he continues through the world. He's busy, but the sobering thing is – well, if he's just back and busy in the world, then what was the point of the whole journey?'

'Here we are in the new society that's busy and bubbling. But what of all the pain that went into its making? Does that simply disappear? Do we forget about it or do we desperately hang onto it forever? It's a South African problem, but also a problem for all countries that have gone through major change. What do they do in East Germany with the Stasi, for example? What exactly is the balance between historical memory and forgetting in order to make a sane society?'

Emphasised by the unsurpassed starkness of his charcoal drawings, it is notions of disease, power and violence that make up the work of Kentridge's animations. In *Main Complaint*, we sense that the life of this especially powerful man, Soho Eckstein, is being threatened by particularly strong memories of the violence that he has personally witnessed. 'In the scene where he's driving along and someone dashes into the middle of the road and is killed there is a sense in which it's not his fault', says Kentridge. 'He didn't deliberately set out to do it. But at the end of the day, through his presence and through the presence of the other person, there is one dead body. He can't say "Well it wasn't my fault. I didn't do it deliberately, therefore I have no feelings of guilt or responsibility for it." It's that sort of indeterminate position. He is the driver, and is somehow tied into and responsible for events that he is part of, even if he is not, as it were, forensically guilty of it.'

(…)

(*World Art*, Melbourne, May 1997, pp.49-50)

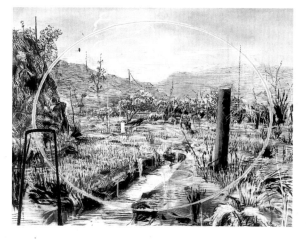

*William Kentridge's 'History of the Main Complaint' – Narrative, Memory, Truth*
*Michael Godby*

William Kentridge was commissioned to make the animated film, *History of the Main Complaint*, for the 'Faultlines' exhibition that was held at the Castle in Cape Town in the Winter of 1996. This context suggests that the film, like the exhibition as a whole, was intended to address the issues of memory, truth and reconciliation that engage South Africa at this time. Until now, Kentridge has used the genre of landscape, in both drawings and installation, as the medium of memory in which the past is made present: images of civil engineering and other traces of human activity in his landscape drawings, for example, render geography as the product of nature and history. In *History of the Main Complaint*, the vehicle of memory is a metaphorical car journey into the past that is designed to revisit the violence of this history and question its impact on the experience of the present.

(…) the basic structural form of *History of the Main Complaint* is narrative and this narrative has been substantially elaborated. Since the film is clearly concerned with history, it may be useful to begin by comparing its use of narrative with recent developments in the use of narrative as a means of explanation in the discipline of history.

Reviewing recent trends in the discipline, Peter Burke notes the re-emergence of narrative after years of neglect by historians practising the structural analysis of the Annales school. But instead of the traditional narrative of 19th-century historians that appeared to encompass all events from a single authoritative point of view, the trend now, according to Burke, is for historians to present a narrative fragment (usually termed a 'micronarrative') and to situate it in the historical structures (or 'grand narrative') of the institutions, social or economic frameworks, modes of thought (mentalities), etc, in which it takes place.

(…)

These developments in the discipline of history have occurred because of changes in the conception of truth. Postmodern borrowings from literature and film serve to deconstruct and disperse the notions of objectivity and truth. But history, needless to say, cannot become the fiction it appears to emulate. History is committed to the past and all the new rhetorical devices are focused on it. In an art work, on the other hand, these strategies are turned on the spectator. Thus in *History of the Main Complaint*, whose subject is the past, the project is not to understand history for its own sake but, rather, the relationship of the individual to the past. The truth and reconciliation process itself is concerned as much with the present as with the past. And, in his film, Kentridge constantly renews and extends this present by engaging the individual spectator in the process on each occasion of viewing. The spectator, therefore, effectively becomes part of the film in a way that is simply not possible with an historical text. Put another way, the idea of truth which, in history, no matter how deconstructed, inevitably remains attached to the object of study, becomes, in *History of the Main Complaint*, the medium of memory that connects the spectator to the past.

The conception of time, upon which narrative of any sort is dependent, is thoroughly problematised in *History of the Main Complaint*. Indeed, if narrative is understood as the development in time from the first scene to the last, the narrative of the film is the single event of Soho Eckstein recovering from coma. In fact, for the greater part of the film, time is actually reversed in order to explain the opening scene of Soho in hospital. And the film uses discrete experiences of time, both in cuts from scene to scene and, in a different way, when the acceleration of the sound of the heartbeat signals a heightened sense of drama.

(...)

The fracturing of time in *History of the Main Complaint* is one of the features of the film that separates it from conventional historical description. The different presentations of time relate not to a shared sense of reality but to subjective experience and the uneven process of memory. Similarly, Kentridge's use of animation appears to dissolve the fixity of the objective world. His extensive use of fantasy, most conspicuously in the ceaseless mutation and metamorphosis of object, gives space to the viewer's imagination.

(...)

The structures that encourage the spectator's participation in the film assist also in the conversion of the narrative from a simple sequence of events into an allegory of recent South African history. Because of these devices, the representation of the car journey through a landscape of violence is readily understood as a metaphor of the recent past; and the assault in which the trauma of the victim is transferred to the witness can be taken as an allegory of the indivisibility of South African society. The overloading of the fragmentary narrative by an extensive rhetorical vocabulary demands metaphorical interpretation of every significant image. Thus Soho Eckstein's body becomes the sick body politic of an unreconciled state; and this metaphor is extended in the group of physicians who attempt to heal the patient without being able to diagnose the cause of this sickness. The business paraphernalia of telephones, punches, blotting pad, etc., seems to stand for continuity in the exercise of economic power, but simultaneously, for the tendency of that power to absorb or deny the violence on which it is based. And the climax of the film, in Soho's recognition of his complicity in this violence, and the liberation that flows from this epiphany, appears to relate to the function of the truth and reconciliation process in South Africa today.

Perhaps the image that most forcefully includes the spectator within the dramatic structure of the film is the repeated view of eyes in Soho Eckstein's rear-view mirror. As Michel Foucault has demonstrated, the person reflected in a mirror is simultaneously present and absent. Kentridge's mirror, of course, seems to reflect the eyes of not only the driver of the car, but also the spectator of the film. The image thus slips through both time and reality, from the time of the fictive event represented, to the time each spectator confronts their own participation in history. Through this device, the spectator is made to share the experience of the driver as he witnesses the assault and becomes involved in the accident: the spectator shares the experience and the responsibility. The climax of the film in Soho's recovery at the very moment of his recall to memory of the accident, suggests that liberation from the burden of responsibility comes on with each individual's acknowledgement of their complicity in the violent history of this country.

The artist does not exclude himself from this statement of the need for a general anamnesis – that is, the process of remembering and mourning that leads to healing. The eyes in the rear-view mirror, as well as being Soho's and the spectator's, are at least for the moment of making the drawing, the eyes of the artist: in fact, these eyes look very much like Kentridge's own. Moreover, the artist includes himself more substantially in the narrative in the role of Soho's physician, who appears eventually in no less than ten manifestations.

(...)

The idea that art (and any other practice of social diagnosis) is inseparable from the society it seems to observe is one indication amongst several in the film of the indivisibility of South African society. We have seen that the injuries of the victim are transferred to Soho as witness; and the fact that Soho and the physician(s) who attend him wear the identical suit and tie renders the idea of moral responsibility utterly circular: the physician is hardly distinguishable from his patient who, though only a witness, bears the injuries of the victim. Moreover, this collapsing of identities within the narrative is extended beyond the boundaries of the film. The artist's self portrait connects the film with the real world; and the spectator participates by responding to the drama of the film.

(eds Sarah Nuttal and Carli Coetzee, *Negotiating the Past: the Making of Memory in South Africa*, Oxford Uuniversity Press, Cape Town, 1998, pp.100-111)

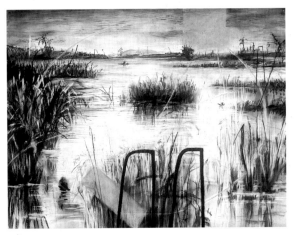

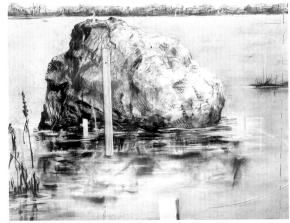

*William Kentridge*
*Vivienne Bobka*

'I am interested in a political art, that is to say an art of ambiguity, contradiction, uncompleted gestures and uncertain ending. An art (and a politics) in which optimism is kept in check and nihilism at bay.' These are the words of South African painter and animator William Kentridge, whose films draw on a tradition of satirical illustration that stretches from Honoré Daumier to George Grosz and Art Spiegelman. Rife with caricature and metaphor and marked by sudden, surreal shifts in tone and perspective, Kentridge's widely acclaimed animated films provide trenchant commentary on the lingering effects of colonialism, racial and labour relations in contemporary South Africa, and the gulf between rich and poor. Recurring characters in such films as *Johannesburg, 2nd Greatest City after Paris* (1989), *Monument* (1990), *Mine* (1991) and *Sobriety, Obesity & Growing Old* (1991) include mine-owner Soho Eckstein, avatar of capitalism, greed and corruption; Felix Teitlebaum, an opposing figure modelled on the artist; and Harry, leader of the oppressed and hopeless poor.

Kentridge's films, which never run beyond ten minutes, are distinguished by an unusual approach to animation. Rather than drawing hundreds of individual pictures as traditional cel animators do, he starts with a handful of charcoal drawings, which he painstakingly films one frame at a time. Movement is suggested by carefully erasing and redrawing portions of each sketch between takes – a method that imparts a rough, choppy quality to the motion. A drawing might be altered and re-photographed as many as five hundred times in this manner. Each scene thus becomes not only a sequence in the completed film but also a record of old marks, erasures and pentimenti. The drawings are characterised by an open, gestural technique, expressive energy and a disdain for detail and finish. Lacking any definite, fixed identity, each form is open to a multitude of transformative possibilities vividly realised: for example, Eckstein's bed turns into a desk (*Mine*) and his cat into a telephone, a gas mask and a bull horn in quick succession (*Growing Old*).

Kentridge has recently expanded his activities into theatre, where he has worked as actor, set designer and director in Handspring Puppet Company productions. In *Faustus in Africa!*(1995-96), there was interaction between live actors, extraordinary satirical puppets and Kentridge's trademark projected animation. This inter-media approach is also characteristic of his latest film, *The History of the Main Complaint* (1996), presented here at the Biennale. The film is projected alongside, and exactly the same size as, three of the drawings used in its creation and becomes, in a sense, a fourth drawing. Seeing the drawings and the film grouped together in this way we are aware of how Kentridge's artwork carries within it the record of its own making and how his incessantly altered cartoon world mirrors the ambiguous dialectics of the political process.
(*Jurassic Technologies Revenant*, 10th Biennale of Sydney, Art Gallery of New South Wales, 1996, p.85)

*William Kentridge – Colonial Landscapes*
*Ruth Rosengarten*

William Kentridge's work in animated film and theatre has, among other things, highlighted an analogy between the anatomical body and the body politic. The analogy is played out against a landscape that describes a boundary: the Johannesburg city limits with their mine dumps, drive-in screens and scrap yards – the waste products that exist at the body's limits. The six *Colonial Landscapes* exhibited here are unusual in his oeuvre: no longer the city's edges, they are uninhabited landscapes, prospects where the human narrative is implicit rather than determining. Deriving from some of the drawn landscapes in the artist's production of *Faustus in Africa!*(seen here at Culturgest in November last year), these drawings allude to a particular style and a particular period: to the images of Africa prevalent in 19th- and early 20th-century typographic landscapes in books such as Boys' Own: English children's books of what the colonies looked like (c.f. the books in Gavin Younge's *Sit Down Benny*). These are generalised views of 'Africa' seen from the point of view of white 'discoverers'.

If the initial images upon which these drawings are based were already steeped in ideology – the distance of viewing point suggesting the notion of prospection and surveillance while maintaining intact European conventions of landscape representation – Kentridge's images are several times filtered and mediated. Their discreet irony resides in this mediation. We see the shadow of the limits of the source-image in the hint of vignettes, which add a nostalgic suggestion of re-presentation. And if the sensual, sooty, velvety markings of charcoal on paper are analogies for the graphic marks of the source-etchings, the red crosses on the surface suggest an outside space, the space from which the survey is taken and implicitly too, the artist's own space of observation. This suggestion of measuring and taking stock creates not only a distance, but also a sense of unease: the landscape as targeted. (In Kentridge's latest animated film, *The History of the Main Complaint*, similar red crosses appear on bodies as sites of impact, where someone has been assaulted.) As the artist succinctly put it: 'it's bruising in the landscape'.
(*Don't Mess With Mister In-between*, 15 South African Artists, Culturgest, Lisbon, 1996, {catalogue} pp.26-27)

*Art in South Africa: The Future Present*
*Sue Williamson and Ashraf Jamal*

In the introductory note to *Felix in Exile*, Kentridge writes: 'In the same way that there is a human act of dismembering the past, both immediate and further back, which has to be fought through writing, education, museums, songs and all the other processes we use to try to force us to retain the importance of events, there is a natural process in the terrain through erosion, growth, dilapidation that also seeks to blot out events. In South Africa this process has other dimensions. The very term "new South Africa" has within it the idea of a painting over the old, the natural process of dismembering the naturalisation of things new'. In evidence here is Kentridge's preoccupation with layers, erasures, shifts – his historical and geological sense of change. In the interface values are vulnerable, asserted all the more. For humankind asserts and nature 'blots out'. Therein lies the crux of Kentridge's art, that of the palimpsest, the pentimento.

Kentridge's works are archaeological tracings, at the root of which lies 'an anxiety about relinquishing meaning'. His animated videos he calls 'small polemics'. He is wary of the threat of arbitrariness and guards against an underground series of chance images in which 'anything changes into anything else too easily, in which anything is possible without any pressure'. Speed in the making and arrangement of mutating images is vital and fulfilling. 'There's an edge that comes to the animated drawings that the other drawings don't have', says Kentridge. The 'edge' lies in the swiftness of construction and the shifting 'provisional' worldview that underpins it. For Kentridge this insistent link has everything to do with living in South Africa – 'that pressure to make meaning in a work, which is very different from the United States and Europe'. He speaks of the 'literalness of the clarity that the country threw up'.

Kentridge's *Faustus in Africa!* tackles this 'literalness' on a grander scale. 'The broad themes of *Faustus* are negotiation and transformation.' As in Goethe's *Faustus*, the realpolitik of South Africa 'is not about good vanquishing evil, the new system replacing the old… but this ongoing negotiation in which old devils of the past keep their places'. For Kentridge there has been no 'clearing of the deck'. 'Revolutionary triumph and getting rid of the old order and making a new order was just never a possibility here… The best possible outcome was this ongoing accommodation of devils and angels… The idea that evil people should pay for their deeds, that they get taken down to hell… my experience is that they don't. They stay on their farms and they get their pensions'. This is 'the whole irony of South Africa's central problem that has to be negotiated every day'.
(David Philip, Cape Town and Johannesburg, 1996, pp.50-51)

VISUAL ART
Makes *Ubu Tells the Truth*, animated film, 8 minutes

Makes series of etchings entitled *Sleeper*, each in edition of 50, published by David Krut: *Sleeper and Ubu*, aquatint and drypoint; *Sleeper – Red*, aquatint and drypoint from 2 plates; *Sleeper – Black*, aquatint and drypoint from 2 plates; *Sleeper I*, single plate drypoint etching/aquatint

Group exhibition: 'Contemporary Art from South Africa', curated by Marith Hope, organised by Riksutstillinger, Oslo, January, touring to venues in Norway including Stenersenmuseet, from 23 January - 26 November
Exhibited works: *Ubu Tells the Truth* 1996-7, portfolio of 8 etchings hardground, softground, aquatint, drypoint and engraving: *Act I Scene 2*; *Act II Scene 1*; *Act II Scene 5*; *Act III Scene 4*; *Act III Scene 9*; *Act IV Scene 1*; *Act IV Scene 7*; *Act V Scene 4*. 2 large *Ubu* drawings: *Ubu on a Bicycle* 1997, gouache, charcoal, pastel, raw pigment on paper; *The Flagellant* 1997, gouache, charcoal, pastel, raw pigment on paper

Solo exhibition: 'Applied Drawings', Goodman Gallery, Johannesburg, 2 - 22 March
Exhibited works: *History of the Main Complaint* 1996, (screened on monitor), with 18 drawings, charcoal and pastel on paper: *Sonar*; *X-Ray with Elective Affinities*; *Consultation*; *Private Ward*;

*Scanners*; *Coma*; *Soho Redux*; *Second Opinion*; *History of the Main Complaint*; *Soho Awake*; *X-Ray… Skull*; *X-Ray… Telephone*; *Sonar… Victim*; *Side Window*; *Casualty*; *X-Ray… Typewriter*; *Sonar… Hand Generator*; *CAT Scan… Adding Machine*. 22 drawings from *Faustus in Africa* 1995, charcoal and pastel on paper: *Mbinda Cemetery*; *Corot's Landscape*; *The Jewel Song*; *Faustus' Notebook*; *Menagerie*; *Lot 121*; *Tropical Landscape with Palms*; *Lot IPIIIII*; *Strange Fruit*; *Cameroon Gate Post*; *Lot 78500*; *Stony Landscape*; *Death Register*; *La Voce del Padrone*; *Lucifer Clock*; *Flag*; *Ernemann Tropikameras*; *La Machine des Coloniaux*; *Philips*; *Indispensable*; *Robutesse*; *Aitchison's Prism Binoculars*. 9 *Colonial Landscapes*. 1996, charcoal and pastel on paper: *Hunting the Spurwinged Goose*; *Cataract*; *Falls Looking Upstream*; *Reservoir 1*; *Water Feature*; *Reservoir 2*; *Falls of an African River*; *Falls Looking Upstream*; *Cataract*. 7 Project Drawings (also titled *A Project for Havana and Santa Fé*) 1997: *Cartographer*; *The Sleeper*; *Flagellant*; *Project Drawing*; *Figure 1 (Man with Microphone)*; *Project Drawing Figure 2 (Listener)*; *Project Drawing Figure 3*. 3 drawings of *Cyclist* 1997, charcoal, gouache, pastel on paper

Group exhibition: 'Città/Natura: mostra internazionale di Arte Contemporanea', curated by Carolyn Christov-Bakargiev, (with Ludovico Pratesi and Maria

Grazia Tolomeo) organised by Palazzo delle Esposizioni, Villa Mazzanti, Rome, 21 April - 23 June,
With Carla Accardi, Giovanni Anselmo, Stefano Arienti, Mark Dion, Willie Doherty, Jimmie Durham, Bruna Esposito, Salvatore Falci, Dan Graham, Rodney Graham, Gary Hill, Jannis Kounellis, Wolfgang Laib, Fabio Mauri, Mario Merz, Marisa Merz, Ettore Spalletti, Haim Steinbach, Luca Vitone, Lawrence Weiner, Gilian Wearing (and works by Fontana, Lo Savio, Manzoni, Klein, Pascali, Beuys, Smithson)
Exhibited works: 4 untitled drawings from *Colonial Landscapes*, charcoal and pastel on paper; *Mine* 1991 (projected as installation with drawings)

Group exhibition: 'Sexta Bienal de La Habana: el individuo y su memoria', curated by Llilian Llanes, Centro Wifredo Lam, Havana, May - June 1997
Exhibited work: *Ubu Tells the Truth* 1997, animated film (Premiere), with wall drawings and drawings on paper of large Ubu figures

Group exhibition: 'documenta X', curated by Catherine David, Museum Fridericianum, Kassel, 21 June - 28 September
Exhibited works (video projections on wall): *Felix in Exile* 1994; *History of the Main Complaint* 1996

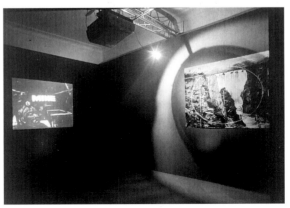

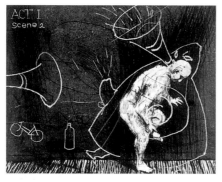

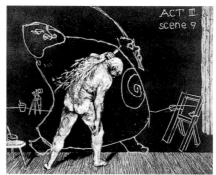

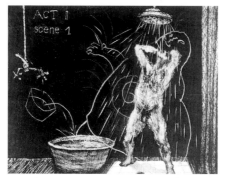

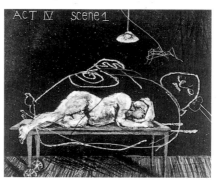

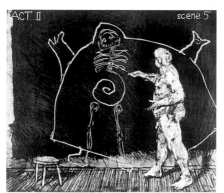

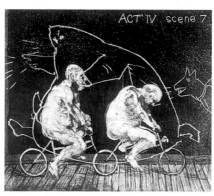

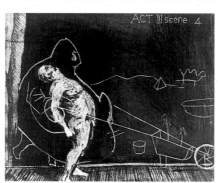

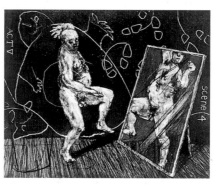

Group exhibition: 'Ubu: ± 101', collaboration with Robert Hodgins, Deborah Bell, curated by Fiona Rankin-Smith, Observatory Museum, Standard Bank National Festival of the Arts, Grahamstown, 3 July - 13 July 1997, touring to Gertrude Posel Gallery, Senate House, University of the Witwatersrand, Johannesburg, August 1 - 15
Exhibited works: collaborative series of prints entitled *Ubu: ± 101* published by Caversham Press, of which Kentridge's contribution is *Ubu Tells the Truth* 1996-7, portfolio of 8 etchings

Group exhibition: 'Truce: Echoes of Art in an Age of Endless Conclusions', Site Santa Fé, New Mexico, curated by Francesco Bonami, 15 July - 15 October
Exhibited works: *Ubu Tells the Truth* 1997, animated film, with drawings on paper, plus wall drawings specifically designed for Santa Fé

Group Exhibition: 'New Art from South Africa', curated by Fiona-Rankin Smith and Duncan Macmillan, Talbot-Rice Gallery at University of Edinburgh, Edinburgh, 10 October - 8 November
With Deborah Bell, Willie Bester, Robert Hodgins, David Nthubu Koloane, Trevor Makhoba, Kagiso Patrick Mautloa, Durant Sihlali, Alfred Thoba, Sandile Zulu
Exhibited works: *Ubu Tells the Truth*, portfolio of 8 etchings

Group exhibition: 'Transversions', curated by Yu Yeon Kim at AICA, Africus Institute for Contemporary Art, Newtown, Johannesburg, (as part of '2nd Johannesburg Biennial 1997. Trade Routes: History and Geography', curated by Okwui Enwezor), 12 October 1997 - 18 January 1998
Exhibited works: *Ubu tells the Truth* 1997, (animated film projected on wall as installation)

Group exhibition, 'Les arts de la résistance' (as part of the festival 'Fin de Siècle, Johannesburg', Nantes), Galerie Michèle Luneau, 17 October - 22 November
With Deborah Bell & Robert

1   2
3   4
5   6
7   8

Hodgins, Norman Catherine, Helen Sebidi, Sue Williamson
Exhibited works: 5 drawings from *Felix in Exile* 1994: *Man covered with Newspapers*, charcoal and pastel on paper; *Landscape*, charcoal and pastel on paper; *Man covered with Newspapers*, charcoal and pastel on paper; *Circular Landscape*, charcoal and pastel on paper; *Small Landscape*, charcoal and pastel on paper. *Large Head* 1997, charcoal, gouache, collage on paper. *Casspirs Full of Love* 1989, etching. *Sleeper* 1997, portfolio of 4 etchings: *Sleeper and Ubu*, aquatint and drypoint; *Sleeper – Red*, aquatint and drypoint from 2 plates; *Sleeper – Black*, aquatint and drypoint from 2 plates; *Sleeper I*, single plate drypoint etching/aquatint

Group exhibition: 'Lifetimes: Art from Southern Africa', curated by Ruth Sack, Aktionsforum, Praterinsel, Munich, 21 November - 3 December
Exhibited works: drawing from *Faustus in Africa!* 1995: *Death Register* 1995, charcoal on paper

Group exhibition: 'Not Quite a Christmas Exhibition', Linda Goodman Gallery, Johannesburg, 29 November - 20 December
With Deborah Bell, Willie Bester, Tracey Derrick, Philippa Hobbs, Robert Hodgins, Senzeni Marasela, Sfiso ka Nkame, Anne Sassoon, Johannes Mashego Segogelo
Exhibited works: *Ubu Tells the Truth* 1996, portfolio of 8 etchings; *Sleeper* 1997, portfolio of 4 etchings

Group exhibition, 'Delta', curated by Francesco Bonami, ARC Musée d'Art Moderne de la Ville de Paris, Paris, 4 December 1997 - 18 January 1998
With Darren Almond, Maurizio Cattelan, Giuseppe Gabellone, Kevin Hanley, Lothar Hempel, Thomas Hirschhorn, Mats Hjelm, Lukas Jasansky & Martin Polak, Suchan Kinoshita, Marie-Claire Mitout, Patrice-Félix Tchicaya
Exhibited works: *Ubu Tells the Truth* 1997, animated film, (projected on wall)

THEATRE
*Faustus in Africa!* tours USA: Washington DC, Chicago, Springfield Massachusetts, Northampton Massachusetts

Conceives and directs, with Handspring Puppet Company, *Ubu and the Truth Commission*, theatre production with actors, puppets, animation, written by Jane Taylor, Mannie Manim Productions, 'Kunstfest' Weimar, 17 - 22 June (Premiere), touring to 'Standard Bank National Arts Festival' Grahamstown, 11 - 13 July; 'Avignon Festival' Avignon, 19 - 23 July; The Market Theatre, Johannesburg, 31 July - 30 August; European tour: Zurich, Geneva, Basel, Romainmotier, Hannover, Rungis, Ludwigsberg, Nantes, Kristiansand, Neuchatel, Dijon, Erlangen, Munich, September - November

*Kentridge Bridges the Gap*
Kendell Geers

(…) *History of the Main Complaint* is Kentridge's sixth film and, together with the exhibition 'Applied Drawings', signals a major shift in his career. Already a household name in South Africa, Kentridge is currently focusing on his international career both as an artist and theatre director. He has become the second South African ever, after Marlene Dumas, to be selected for the prestigious 'documenta' exhibition. It is interesting that both have chosen to work with charcoal on paper as their primary medium.

Kentridge is the most important artist living in South Africa today, not for what he makes, but for what he represents. *History of the Main Complaint* opens with the character Soho Eckstein lying in a hospital bed. Through the course of the six films, he has now finally merged with his alter ego Felix Teitlebaum and become more of a self-portrait than ever before. A number of Eckstein clones then perform the task of self-examination. The film later cuts to Kentridge/Eckstein driving along an endless road, his eyes focusing on the past as he peers out of the rearview mirror. Meanwhile, on the edge of his vision, the past injustices return to haunt him as people are beaten up, run over or tortured, leaving behind little red crosses marking their pain, scars left behind on the front window. Finally the hero blinks and the wipers clean the windscreen before the film cuts back to the Eckstein/Kentridge character at a large desk with countless telephones ringing and it is back to 'business as usual'.

The film functions within the rarefied art gallery context in precisely the same terms as the Truth and Reconciliation Commission does in politics. More than any other social class or group, the white middle class feels the guilt of apartheid most strongly for they benefited most from it. The guilt is different from that being discussed at the TRC for there is nothing to confess, for no actual crimes were committed. The guilt grows out of simply having been born into a system where privilege was granted at the cost of another's.
(*The Star*, Johannesburg, 14, March 1997 pp.23-24)

*Citynature*
Iwona Blazwick

Most city dwellers take their nature in small doses: a pet cat; a sapling growing out of the pavement with the branches snapped off; billboards awash with colour photos of all that meadow/jungle/turquoise sea/wilderness that represents the city's other, an opposition made all the more fantastical by the lateral spread of the city into endless suburbia.

We mourn the fact that whales perish and that children believe milk is produced by cardboard cartons. We are anxious about our scientific rationalisations of the natural world. Yet as we rush to Body Shop, we shudder to see the cockroach scuttle or the pigeon multiply. Despite the apparently supreme organisation of nature in the city – by park or corporate atrium, by supermarket barcode or antibiotic – its sheer randomness persists. From urban foxes to killer viruses, nature is both more powerful and more anarchic than our science or our myths can account for.

Nature is at once alien and omnipresent. Despite the dominance of science, technology and material culture at the end of the 20th century, this tension continues to emerge through modern and contemporary art.

'Città/Natura' (…) evokes in its title an implied opposition between the city and nature, which in turn stands for other binaries. A Western view of nature has evolved from nature as the syncretic, all-encompassing expression of the glory of God, to a threatening and chaotic wilderness, which it is our task to master, to an endlessly

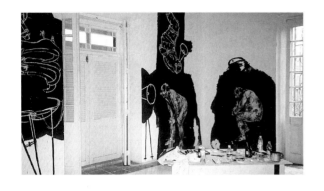

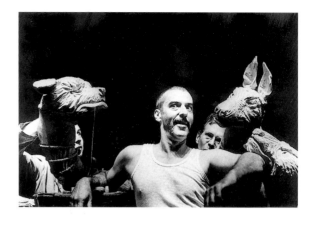

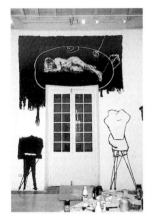

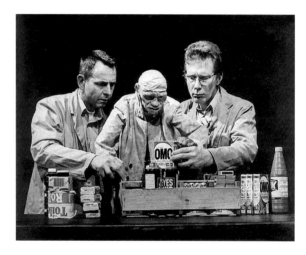

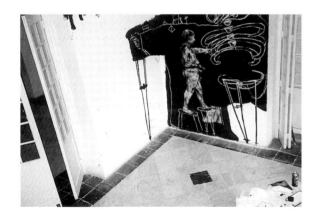

exploitable resource, to a vanishing paradise. Today nature is regarded as, on the one hand, a kind of biotechnology that can be refined and reproduced, and on the other, as a fragile, endangered entity. In the immediate post-war period its manifestation in art has tended towards oppositions – it has symbolised archetypes, origins, utopias, essential and immutable truths, which, by inference, our urban culture lacks; it has represented a loss, not only of an Edenic environment, but also of our true selves. By contrast, the so-called posthuman 1980s saw the emergence of nature purely as cultural construct. Cultural theorist Kate Soper characterises contemporary attitudes: '…while the ecologists tend to invoke nature as an independent domain of intrinsic value, truth or authenticity, postmodernist cultural theory and criticism emphasises its discursive status, inviting us to view the order of "nature" as existing only in the chain of the signifier.'

(…)

This inscription of nature within social and economic systems is given an overwhelmingly poignant expression in William Kentridge's *Mine* (1991). His charcoal drawings of the South African landscape are a kind of dystopic picturesque. Bearing all the marks of total resource exploitation – through mining, agriculture or the construction of dams – his highly wrought landscapes are overlaid with diagrammatic schema. Kentridge also creates single, yet evolving, drawings, where an image is drawn, erased and drawn again to provide a series of stills that are animated on film. With all the shaky but mesmerising vibrancy of early animation, *Mine* shows the metamorphosis of a businessman's bedspread into the Savannah, of a breakfast tray into a mining platform, of people into workers, into African statuettes, into souvenir trinkets, swept away to make room for a tiny white rhinoceros, reduced to an executive's plaything. The images recount a perhaps overly familiar and even problematic narration of oppression. Yet the tentative graphics, the silence of the figures, give this work its moving effect.

(*Art Monthly*, London, June 1997, pp.7-9)

*Preface*
*Rory Doepel*

Kentridge, Hodgins and Bell have engaged the theme of Ubu from a very different kind of perspective from that which would have been possible for Jarry's contemporaries. Ubu in the context of contemporary South Africa, particularly relevant for Bell and Kentridge, evokes our past and the present as represented by the events, images and information we have been exposed to in televised programmes of the Truth and Reconciliation Commission hearings.

The three artists, who celebrate ten years of collaboration at an exhibition to be held at the Johannesburg Art Gallery in 1997 (this will provide a much broader overview of their work, which is thus not attempted here), have each confronted the task in a different way, bringing discrete perceptions and approaches to their realisation of the theme.

(…)

Despite multi-valency, ambiguity, and internal inconsistencies, which are bound to be manifest in both the works and the texts presented, the unifying factor that can be extracted is based on having to come to grips with the reality of Ubu, not only as manifest in society, but in 'self'. The differences in the three artists' work may be seen as being dependent on the extent to which Ubu is internalised, and the extent to which his presence is observed externally, sometimes as historical fact, sometimes as invented scenario. The value of the exercise may ultimately lie in the recognition that the conquering of Ubu requires that we all grapple with the shadow-side: it cannot exist in society if it does not exist in itself. Perhaps it cannot be contained in society if it is not internalised and integrated in self? The question of

'who might I be if I were born in Rwanda, in Bosnia, in Afghanistan or Germany?' is ever-present. The even more difficult questions in a local context – 'Who *was* I, and who am I now?' – are equally pertinent. (…)

*William Kentridge: Ubu Tells the Truth*

Kentridge's approach to the subject of Ubu was not – as one might expect given that he is currently directing the theatrical production of *Ubu and the Truth Commission* – an approach in which he systematically researched the Ubu texts, deciphering and decoding symbolism and narrative. (…) he is not an artist who at the outset formulates a programme verbally and conceptually. It is the tension between the analytical and intellectual, and the creative and intuitive, that he finds intriguing. He maintains a 'space' enabling a state of consciousness that allows for spontaneous recognition of possibilities, which seem 'right' and almost appear to pre-exist – waiting to be discovered. His thinking, during the act of creation, is primarily visual, and motifs that are introduced take their place in scenarios that stem as much from life as from a text.

He has described his conception of Ubu as 'the emblematic 20th-century man of power, cruelty, self-pity and social blindness'. Ubu is taken 'through the world of evidence emerging from the Truth and Reconciliation Commission' in the etchings, drawings and the collaborative theatrical production, which stem from his engagement with the theme. For Kentridge, the project in its entirety arises out of a 'personal response to a political event and a literary tradition', leading to the creation of a 'schematic world of interrogations, explosions, ablutions through which Ubu journeys'.

(…)

(*Ubu: ± William Kentridge, Robert Hodgins, Deborah Bell*, The French Institute of South Africa and the Art Galleries of the University of Witwatersrand, Johannesburg, {catalogue} pp.2-3, 9)

*William Kentridge*
*Francesco Bonami*

*Ubu and the Truth Commission* presents the double-side of language. The surrealist story, intersected by hyper-realistic description, deals with the Truth Commission in South Africa. Neither way of handling language succeeds in clarifying our relationship to the world, but together create a land of assumption, a suspension in which the viewer also suspends his or her judgement. The artist produces a 'nowhere' of morals. In his animation, Kentridge superimposes Ubu's character with some graphic details of the confession, performed by a pitiful parade of contemporary Ubus wearing suits, moustaches and fixed expressions. As Jarry's work explodes the spatio-temporal convention of naturalistic theatre, the oddly dispassionate voices of the Truth Commission's translators, conveying testimony of vicious brutality often given in local languages such as Xhosa, Sotho or Zulu, create another kind of absurd naturalism that pushes the concept of 'truth' into a scary and surreal dimension. Kentridge avoids indulging in any of these two ideas of 'veritas' and lands on a third level of healing perceptions that save truth from being a dangerously mystified expression.

(*Delta*, ARC, Museé d'Art Moderne de la Ville de Paris, 1997, {catalogue} n.p.)

*Pulling Strings*
*Andrew Worsdale*

(…) Originally Kentridge wanted to do Samuel Beckett's *Waiting for Godot* with Handspring, but the author's literary estate would not allow one word or line to be changed – which would have been impossible considering the group uses puppetry, original music, animation and live film footage. Instead they devised an ambitious project involving researchers going to Angola and Mozambique to find evidence of the ravages of war. But then the Truth and Reconciliation Commission (TRC) proceedings began in earnest, and Kentridge realised they had the ideal subject matter for a play.

*Ubu and the Truth Commission* is an adaptation of Alfred Jarry's play, *Ubu Roi*, about the political, military and criminal exploits of the avaricious Ubu, a satirical version of *Macbeth*, who with his wife, attempts to seize all forms of power. When the work was first performed in 1896, it sparked a riot.

In this production, writer Jane Taylor and Kentridge skilfully weave Jarry's themes of ultra-violence, conceit, cowardice and self-pity with TRC revelations.

(…)

This time, he has employed crudely joined paper cut-outs and white chalk drawings, sometimes on a piece of paper the size of a cigarette box. Several startling images linger in the mind – the devastating transformation of a Jayne Mansfield-like blonde into a skeleton; and the sequence featuring an incessant battery of assaults, hangings and people falling from the tenth floor of what could be John Vorster Square, with each of the previous frames being a window in the building.

But Kentridge doesn't limit himself to animation. Several of the screen sequences consist of archival footage from June '76 and the various states of emergency during the 1980s. In addition he uses live footage, like the scene where Ma Ubu speaks to her husband as he kneels suppliantly before the screen. Another scene has a close-up of Kentridge's own mouth passing sentence, but the words he utters are out of sync with his lips; the effect is brilliantly unnerving.

Most of the film work was integrated into the live performance with the help of a non-linear off-line computer, which enabled film editor Catherine Meyburgh to set up her equipment in the rehearsal room and try out sequences directly with the performers.

Then there are the puppets, eighteen in all. Handspring Puppet Company, which is headed by Basil Jones and Adrian Kohler started out creating puppet plays for children. Their first adult play was *Episodes of an Easter Rising* about two white women who give refuge

to a wounded activist. In 1989 they collaborated with Malcolm Purkey on Junction Avenue's *Tooth and Nail*, an apocalyptic look at the chaos of pre-election South Africa, where they met Kentridge.

He believes that many people only regard marionettes as things for kids. 'In all the work I've done with Handspring we've been trying to explore a certain gravitas with the puppets.'

'A lot of directors of "normal" theatre are nervous of puppets', says Kohler. 'They invariably become the neighbourhood or the fairies. William is one of the first to give puppets centre stage.'

Handspring's puppets are all built with the equivalent of human joints and a central controlling mechanism. 'It's important', Kohler continues, 'that the audience believe the movement … Because they're made of wood they have to be wished into life so the viewer can become actively involved. It goes back to playing with toy cars or dolls as a kid.'

The theatrical interplay of the puppets and live actors is completely beguiling. Their characters are metaphors for something greater.

With all the special effects, stirring performances, a musical score by Warwick Sony and Urban Creep's Brendan Jury that combines thunderous percussion and geographically ambiguous ethnic sounds, there is one moment of puppet and performance artistry that is the highlight of the play.

Ubu is delivering his testimony to the commission bathed in a solitary light on a lectern with two microphones. As he continues his litany of excuses, the microphones go crazy, lurching at him, virtually hitting him in the face. Minnaar, a consummate actor, handles the scene with exquisite comic timing.

(…)

(*The Sunday Times*, Johannesburg, August 17, 1997, pp.14-16)

VISUAL ART
Solo exhibition, 'William Kentridge', The Drawing Center, New York, 8 January - 14 February 1998
Exhibited works: 2 animated films (projected on wall): *Felix in Exile* 1994; *History of the Main Complaint* 1996

Group exhibition: 'Vertical Time', curated by Francesco Bonami, Barbara Gladstone Gallery, New York, 10 January - 21 February
With Giuseppe Gabellone, Pierre Huyghe, Koo Jeong-a, Mark Manders
Exhibited works: *WEIGHING… and WANTING* 1997, (projected on wall)

Solo exhibition: 'William Kentridge', curated by Hugh M. Davies, The Museum of Contemporary Art, San Diego, January - April
Exhibited works in Museum of Contemporary Art downtown: *WEIGHING… and WANTING* 1997, (projected onto paper of same dimensions as two drawings from film, hung alongside).
17 drawings for *WEIGHING… and WANTING* 1998, all charcoal and pastel on paper: *House*; *Title Empty Room*; *Rock*; *Soho & Rock*; *Head*; *Scanner*; *Cracked Rock n.8*; *Pylon Landscape*; *Scales*; *In Whose Lap do I Lie?*; *Brain Scan*; *Brain Scan Blue*; *Brain Scan, Red Cross*; *Soho Listening*; *Soho Listening Scan*; *Soho Full Face Listening to Cup*;

*Brain Scan with Landscape.* Fragments of other drawings. Exhibited works in La Jolla section of Museum: *Sleeper* 1997, portfolio of 4 etchings

Solo exhibition: 'William Kentridge', Stephen Friedman Gallery and A22 Gallery, London, 6 March - 18 April
Exhibited works at Stephen Friedman Gallery: 2 animated films, (screened on monitor): *History of the Main Complaint* 1996; *Felix in Exile* 1994. Drawings for *History of the Main Complaint* 1996: *Sonar*, gouache, charcoal and pastel on paper; *X-Ray with Elective Affinities*, gouache, charcoal and pastel on paper; *Consultation 10 Doctors*, charcoal on paper; *Scanners*, charcoal on paper; *Soho Redux*, charcoal on paper; *Second Opinion*, charcoal on paper; *History of the Main Complaint*, charcoal on paper; *Soho Awake*, charcoal on paper; *X-ray Skull*, charcoal on paper; *Sonar… Victim*, charcoal on paper; *X-ray… Typewriter*, charcoal on paper; *Sonar… Hand Generator*, charcoal on paper; *Cat Scan… Adding Machine*, charcoal on paper; *The Road*, charcoal and pastel on paper. *Project drawings*: *Man with Microphone*, charcoal, gouache and pastel on paper; *Sleeper*, charcoal, gouache and pastel on paper; *Crouched Man*, charcoal, gouache and pastel on paper; *Cyclist – Ubu*, charcoal, gouache and pastel on paper.
Exhibited works at A22 Gallery: *Ubu Tells the Truth* 1997, (projected on wall), with drawings and fragments

Solo exhibition, William Kentridge, Palais des Beaux-Arts/ Paleis voor Schone Kunsten, Brussels, 15 May - 23 August 1998, touring Kunstverein, Munich 28 August - 11 October 1998, Neue Galerie Graz am Landesmuseum Joanneum, , 15 November 1998 - 15 January 1999
Exhibited works: 8 animated films with drawings and fragments: *Johannesburg, 2nd Greatest City after Paris* 1989 (shown on monitor); *Mine* 1991 (shown on monitor); *Monument* 1990 (shown on monitor); *Sobriety,*

*Obesity & Growing Old* 1991 (shown on monitor); *Felix in Exile* 1994 (shown on monitor); *History of the Main Complaint* 1996 (triptych projection from laser disc onto wall alongside two slide projections of a skull X-ray and chest X-ray); *WEIGHING… and WANTING* 1997; *Ubu Tells the Truth* 1996, (projected on wall). Drawings for animation of *Il Ritorno d'Ulisse* 1998, with projections.

THEATRE
*Ubu and the Truth Commission*, tours to Spier, Stellenboch (South Africa)

Creates animation for, and directs production of, *Il Ritorno di Ulisse*, based on the opera by Claudio Monteverdi, with Handspring Puppet Company, musical direction Philippe Pierlot, organised by KunstenFESTIVALdesArts, La Monnaie and Vienna Festwochen, Luna Theatre, Brussels, 9 May (Premiere), touring to Sofiensäle, Vienna; Hebbel Teater, Berlin; Civic Theatre, Amsterdam during 'Holland Festival'; Werthalle, Zurich for 'Theatre Spektakel'

*A Laconic Film Far From Silent*
Leah Ollman

'The story of the film is very simple', William Kentridge says of his newest work, *WEIGHING… and WANTING*, now on view in an installation at the downtown branch of the Museum of Contemporary Art, San Diego.

'It's a man on his own, who looks at a rock. In the rock he sees a relationship with a woman under stress, shattering, then reconstituting itself.'
(…)
In the exhibition, Kentridge's first solo museum show, *WEIGHING… and WANTING* is accompanied by a series of predominantly black-and-white charcoal drawings that comprise the visual fabric of the film. Lushly drawn and steeped in the emotional weight of private associations, the images of the male character's changing psychic landscape transmute as Kentridge alters, adds and erases elements in the course of filming. In one sequence evoking the collapse of the relationship, the man appears first with his head in the security of the woman's lap. Her figure dissolves and is replaced by a clunky, ringing telephone, which then metamorphoses into a smug black cat…
(…)
One of the origins of the new film, he says, was a dream he'd had of being comforted by writing, by an image of the wall. The film's title comes from an episode in the Book of Daniel, in which a disembodied hand writing a cryptic message on the wall appears to the Babylonian king Belshazzar. Daniel, summoned for his wisdom in interpreting dreams and visions, tells the King what the message means: he has been weighed in the balance and found wanting, for he has not humbled his heart before God; his kingdom has come to an end.

Kentridge, who calls this the most personal of his films, embodies several of its key personae. He is, at once, the dreamer who gives rise to the image, the one who writes on the wall, as well as the decoder who interprets the sign. Though Kentridge's films never approach the subject of apartheid directly, the title's reference to Belshazzar's moral bankruptcy and abuse of power resonates with the downfall of South Africa's oppressive system of rule.

'The series of films as a whole works a bit like a diary, where things of vastly different importance come together', Kentridge remarks. 'If you were keeping a diary, you might say, "protesters marching down the street outside my window today", or other things that struck you very forcibly in the day; but equally forcible would be, "I had a fight with my brother that I must resolve – feeling depressed about it, anxious".

'There's a polemic within the process, an implicit one, saying that these subjective interventions are one of the ways that we have to understand the broader social questions'.
(*Los Angeles Times*, Los Angeles, February 8 1998, pp.58-59)

*Swords Drawn*
Okwui Enwezor

(…) While Kentridge works without any predetermined narrative or storyboard the films are not products of chance: they usually begin with a central image and then, like a montage, fragments are drawn, cut-outs are attached, until the narrative builds to a coherent picture. Traces of indecisions, hesitations, erasures, reversals, corrections and alterations are often left for us to see. The films take as their primary subject the beleaguered landscape of apartheid South Africa; its history, memory, industry, ideology, nativism, politics, fraught racial relations, and the mindset forged by its corrupting and debasing influences.

Of course, they could be read as ordinary stories of human circumstance, with its complications and contradictions, were apartheid just an ordinary story. But apartheid *is* no ordinary story. Both visitors and residents of South Africa are ensnared by it, entangled in its now almost dysfunctional legacy. Though it has ceased as an ideological and legal form of government and discrimination, its foundations, from monuments to the current orgy of confession, are inscribed everywhere and are much more difficult to eradicate.

(…)

Rather than seeking merely to illustrate or describe that world, Kentridge searches for ways to analyse it: to probe it, jab it and scratch at it as if it were a sebaceous node, tumescent flesh bubbling with an abscess about to burst. With his detached dispassionate consciousness of both the historical and the more recent past, his subtext is a humanist one, suggesting that it is not so much history that fails us, as human memory. This is the reason his work has always been grounded in exploring the immediacy of his country's political history as it stutters towards emancipation as a democratic state. *Sobriety, Obesity and Growing Old* (1991), for example, made just after Nelson Mandela's release, explored the frailty of faith in the emerging new state. In the film, Soho Eckstein decides instead that politics are too complex for his sensibility. Rather than confronting the new context, he sets a scorched-earth policy, demolishing his assets so as to free himself from the demands of the future.

(…)

However, these varied influences are less emphatically stated than subtly suggested and distilled. The artist offers a vision of a world that is far from representative: a world in which the true measure of the answers we solicit from it are brought down to scale and concentrated in the workings of the psyche of both victim and perpetrator, demagogue and conscientious objector. However, it is important to add that bringing these often irreconcilable opposites together is in no way in empathy with the pervasive and reactionary relativism that exists today in South Africa, where victim and perpetrator are joined in the same galley. Nor does it place Kentridge in that milieu that a dismissive South African colleague of mine called 'white guilt and middle-class sentimentality', although this accusation does raise some interesting questions.

(…)

Ever since I first visited South Africa two years ago, I have been fascinated by the ways in which the white population has sought to avert its gaze from the anxiety and horror of blackness that surrounds it by building make-believe words that attempt to mask and eradicate the harsh reality that lurks everywhere: especially in the patterns of the country's landscape. Throughout its history and in post-apartheid South Africa, landscape and memory represent more than spatial and temporal dynamics. They symbolise the very essence of identity and its construction: what the land does not retain, memory seeks to efface. The threat imposed by a landscape that bears gloomy signs of past horrors awaiting future discovery is a major source of anxiety in this country.

Throughout his films, landscape serves as an emblem both for remembering and unremembering. It is always drawn schematically, fluid and changing; and always contingent and under what critic Robert Condon has described as a perpetual state of erasure. The most pervasive of its features are the flat-topped, soft-edged mounds of the mine dumps, which to a visitor first appear to be hills. Deploring the picturesque as a colonial agent, Kentridge positions his films as critiques of our tendency to behold landscape as a phenomenon of 'pure undisturbed nature' by drawing it as if it were a naked body, ploughed, eroded, bruised and battered. It is portrayed with such vigour that the very act of marking space becomes almost tantamount to surveying it in an archaeological dig; loosening and making it reveal itself. Land in his work is under perpetual exploitation, whether it is being mined or used by other industries. According to Kentridge, he

inveighs against the picturesque because of the inherent lie of the horizonless, open, unoccupied veld – a trope very much part of the colonial representation of the country as empty and unoccupied prior to European arrival, best exemplified for Kentridge in the work of JH Pierneet, the darling of the apartheid state and Afrikaaner nationalists.

Despite the dazzling technical mastery of the films, it is the drawings – whether the delicate etchings, aquatints, mural-sized drawings rendered directly on the wall or those that comprise the final products of the films – that reveal the full measure of his art. It is their old master-style authority and their modern character that make his films sing. The fluidity of his line and precision of his gestures enable him to convey very intense emotions – violence, tenderness, ambiguity, melancholy – with just a few lines. Faces, in particular, are drawn so expressionistically, using a hatching technique of criss-crossed lines, that they often resemble masks.

(…)

Nowhere is line used more successfully to render movement and ghoulishness than in his latest film *Ubu Tells the Truth* (1997) (…) Here Kentridge engages directly with what he calls 'memory, truth and responsibility' as a way of coming to terms with the apartheid years. The film borrows from Alfred Jarry's original *Ubu Roi* to deal with the question of truth in post-apartheid South Africa. It is the story of one of apartheid's killers and his wife, who has no idea of her husband's dreadful job. She attributes his absences at night and his lack of marital responsibility to infidelity, but later discovers the truth, much to her relief. Ubu himself is relieved that his marriage is going to remain intact, ascribing the responsibility of his crimes to higher powers. At the end of the play no one is convicted and, like Jarry's original character, the contemporary South African Ubu is able to flush his conscience down the toilet. Totally cleansed, the re-made man sails into the sunset with no qualms.

The story mimics the farcical and lengthy process of testimonies to the Truth and Reconciliation Commission charged to investigate apartheid crimes and to bring the chief perpetrators to book. A toothless dog that cannot legally convict anybody, the Commission can only recommend, and has so far only been able to deliver small fry. (…) For the first time, [in *Ubu Tells the Truth*], Kentridge worked with secondary images, such as archival photographs and footage, spliced together with his own schematic drawings to create a surreal montage of forms that is as tense as it is menacing. Spare and taut, there is a total absence of colour. Instead, against a dense black background, the fast moving actions of the chalk drawn figures reach a crescendo of shocking violence – drowning, asphyxiation, electrical shocks, strangulation, window death plunges – the full repertoire of apartheid thuggery.

(*Frieze*, London, issue 38, March/April 1998 pp.66-69)

# ILLUSTRATIONS IN CHRONOLOGY

p. 155
*Panelbeaters* 1986, charcoal, pastel and gouache on paper;
*Flood at the Opera House* 1986, charcoal and pastel on paper;
*Alice with Hyena* 1986, charcoal on paper

p. 156 - 157
*Industry and Idleness* 1986-87, 8 etchings after Hogarth printed by the Caversham Press:
*Double Shift on Weekends Too*, sugar-lift aquatint, dry point and engraving; *Responsible Hedonism*, aquatint, drypoint and engraving; *Forswearing Bad Company*, aquatint, engraving and drypoint; *Waiting Out the Recession*, aquatint, engraving and drypoint; *Promises of Fortune*, hard ground, engraving, aquatint and drypoint; *Buying London with the Trust Money*, hard ground, aquatint, engraving and drypoint; *Lord Mayor of Derby Road*, drypoint and engraving; *Coda*, aquatint and drypoint

p. 158
Study for *The Embarkation* 1986-1987, charcoal and pastel on paper

p. 160
*Swimming Pool Dreaming* 1989, charcoal and pastel on paper

p. 161
*Casspirs Full of Love* 1989, banner outside Vanessa Devereux Gallery, London, for 'Responsible Hedonism', 14 May - 20 June 1989

p. 162
1. *Responsible Hedonism* 1988, charcoal and pastel on paper; 2. Drawing from *Johannesburg, 2nd Greatest City after Paris* 1989, charcoal and pastel on paper; 3. *Casspirs Full of Love* 1988, preliminary drawing for *Johannesburg, 2nd Greatest City after Paris*, charcoal and pastel on paper; 4. *Comrade Mauser* 1989, charcoal and pastel on paper; 5. *Untitled* 1989, charcoal and pastel on paper; 6. *Untitled* 1989, bitumen, Indian ink and pastel on paper

p. 163 (bottom)
*Develop, Catch-Up, Even Surpass* 1990, charcoal and pastel on paper; Installation view: 'William Kentridge: drawings', Gallery International, Cape Town, 29 October – 10 November 1990

p. 164 (right)
Drawing from *Sobriety, Obesity & Growing Old* 1991, charcoal on paper

p. 165 (right)
© Brigitte Enguerand (Courtesy the artist)

p. 166
From left to right: Reinhold Cassirer, Robert Hodgins, Deborah Bell and William Kentridge at Cassirer Fine Art, 1992;
Computer drawing used in *Easing the Passing (of the Hours)* 1992, animated film made in collaboration with Deborah Bell and Robert Hodgins

p. 167 - 168
Computer drawings used in *Easing the Passing (of the Hours)* 1992, animated film made in collaboration with Deborah Bell and Robert Hodgins

p. 170
Still from *Memo* 1993-1994, animated film made in collaboration with Deborah Bell and Robert Hodgins

p. 171
Outdoor projections in *Memory and Geography*, multi-media project made in collaboration with Doris Bloom, Rome 1995 (Courtesy Studio Stefania Miscetti, Rome)

p. 172
Drawings for animated film in *Memory and Geography* 1995, multi-media project made in collaboration with Doris Bloom, white chalk on black gouache on paper

p. 173
Outdoor projection and *Fire Gate* in *Memory and Geography* 1995, multi-media project made in collaboration with Doris Bloom, Johannesburg

p. 174
1 - 6: Studies and drawings used in the animation for *Faustus in Africa!* 1995;
7 - 8: Scenes from theatre production *Faustus in Africa!* 1995, Johannesburg: Antoinette Kellermann with Helen of Troy puppet; From left to right: Dawid Minnaar and Louis Seboko with Faustus puppet; photos: Ruphin Coudyzer (Courtesy Handspring Puppet Company)

p. 175 - 176
Drawings used in the animation for *Faustus in Africa!* 1995

p. 177
*Colonial Landscapes* 1995-1996:
*Reed Bed*, charcoal and pastel on paper; *Gleaming Pool*, charcoal and pastel on paper

pp. 178 - 180
*Colonial Landscapes* 1995-1996:
*Its Course was Towards the Rising Sun*, charcoal and pastel on paper; *Hunting the Spurwinged Goose*, charcoal and pastel on paper; *Reservoir*, charcoal and pastel on paper; *Water Feature*, charcoal and pastel on paper

p. 182
Installation views: 'Città/Natura: mostra internazionale di Arte Contemporanea', Rome, 21 April - 23 June, 1997

p. 183
Etchings from the portfolio *Ubu Tells the Truth* 1996-1997, hardground, softground, aquatint, drypoint and engraving:
*Act I Scene 2*; *Act II Scene 1*; *Act II Scene 5*; *Act III Scene 4*; *Act III Scene 9*; *Act IV Scene 1*; *Act IV Scene 7*; *Act V Scene 4*

p. 185
1 - 4: William Kentridge executing wall drawings for *Ubu Tells the Truth* at the 'Sexta Bienal de La Habana: el individuo y su memoria', Havana, May - June 1997;
5 - 6: Scenes from *Ubu and the Truth Commission*, The Market Theatre, Johannesburg, 1997; Dawid Minnaar with Brutus puppet;
Adrian Kohler and Basil Jones with Woyzeck puppet
photos: Ruphin Coudyzer (Courtesy Handspring Puppet Company)

p. 187
Installation views: 'William Kentridge', Museum of Contemporary Art, San Diego, January - April 1998, photo: Pablo Mason (Courtesy Museum of Contemporary Art, San Diego)

# SELECT BIBLIOGRAPHY (BOOKS AND CATALOGUES)

Alan Crump, Elza Miles, *William Kentridge*, 'Standard Bank Arts Festival', Grahamstown, The Broederstroom Press, 1987, (catalogue)

Sue Williamson, *Resistance Art in South Africa*, David Philip, Cape Town & Johannesburg, 1989

Michael Godby, *Robert Hodgins, William Kentridge and Deborah Bell. Hogarth in Johannesburg*, Witwatersrand University Press, Johannesburg, 1990

*Art From South Africa*, Museum of Modern Art, Oxford, 1991, (catalogue)

Michael Godby, 'William Kentridge: Four Animated Films' in *William Kentridge: Drawings for Projection*, Goodman Gallery, Johannesburg, 1992, (catalogue)

Esmé Berman, *Painting in South Africa*, Southern Book Publishers, Pretoria, 1993

*Incroci del Sud: Affinities – Contemporary South African Art*, Fondazione Levi Palazzo Giustinian Lolin, 45° Venice Biennale, Venice, organised by the South African Association of Arts in collaboration with Sala 1, Rome, 1993, (catalogue)

*4th International Biennale of Istanbul*, The Istanbul Foundation for Culture and Arts, 1995, (catalogue)

*Africus 1st Johannesburg Biennale*, Africus Institute for Contemporary Art, 1995, (catalogue)

*On the Road – Works by 10 Southern African Artists*, The Delfina Studio Trust, London, 1995, (catalogue)

Jane Taylor, *Colours: Kunst aus Sudafrika*, Haus der Kulturen der Welt, Berlin, 1996, (catalogue)

Geoffrey V Davis, Anne Fuchs, *Theatre and Change in South Africa*, Harwood Academic Publishers, Amsterdam, 1996

Sue Williamson, Ashraf Jamal, *Art in South Africa: The Future Present*, David Philip, Cape Town and Johannesburg, 1996

*2nd Johannesburg Biennial 1997. Trade Routes: History and Geography*, AICA, Africus Institute for Contemporary Art, 1997, (catalogue)

*Campo 6, The Spiral Village*, Galleria Civica d'Arte Moderna e Contemporanea, Turin and Bonnefanten Museum, Maastricht, 1997, (catalogue)

*Città/Natura: mostra internazionale di Arte Contemporanea*, organised by Palazzo delle Esposizioni, Villa Mazzanti, Rome, 1997, (catalogue)

Contemporary Art from South Africa, Riksutstillinger, Oslo, 1997, (catalogue)

*Delta*, ARC, Musée d'Art Moderne de la Ville de Paris, Paris, 1997, (catalogue)

Catherine David and Jean-François Chevrier, *Politics – Poetics documenta X the book*, Museum Fridericianum, Kassel, Cantz Verlag, Ostfildern-Ruit, 1997 (catalogue)

Rory Doepel, *Ubu:± 101, William Kentridge, Robert Hodgins, Deborah Bell*, Observatory Museum, 'Standard Bank National Festival of the Arts', Grahamstown, 1997, (catalogue)

Kendell Geers, *Contemporary South African Art, The Gencor Collection*, Jonathan Ball Publishers, Johannesburg, 1997

*Jurassic Technologies Revenant*, 10th Sydney Biennale, 1997, Art Gallery of New South Wales, Artspace, Ivan Dougherty Gallery, 1997, (catalogue)

*New Art from South Africa*, Talbot-Rice Gallery at University of Edinburgh, Edinburgh, 1997, (catalogue)

*Sexta Bienal de La Habana: el individuo y su memoria*, Centro Wifredo Lam, Havana, 1997, (catalogue)

*Truce: Echoes of Art in an Age of Endless Conclusions*, Site Santa Fé, New Mexico 1997, (catalogue)

Michael Godby, 'Wiliam Kentridge's *History of the Main Complaint*: Narrative, Memory, Truth', in Sarah Nuttal and Carli Coetzee, *Negotiating the Past: the Making of Memory in South Africa*, Oxford University Press, Cape Town, 1998

Carolyn Christov-Bakargiev, *William Kentridge*, Palais des Beaux Arts, Brussels, 1998 (catalogue)

# William Kentridge

## Werken 1989-1998

Vereniging voor Tentoonstellingen van het Paleis voor Schone Kunsten Brussel

Deze brochure verschijnt als bijlage bij de catalogus
*William Kentridge*, ter gelegenheid van de tentoonstelling
in het Paleis voor Schone Kunsten, Brussel,
van 15 mei tot en met 23 augustus 1998.

Teksten: Carolyn Christov-Bakargiev (CCB) en William Kentridge
Vertalingen uit het Engels: Alfabet
Ontwerp: Gracia Lebbink
Zetwerk: Holger Schoorl

De tentoonstelling werd georganiseerd in het kader van het
KunstenFESTIVALdesArts en het Samenwerkingsprogramma
Vlaamse Gemeenschap – Zuid-Afrika.
Met dank aan Linda Givon en de Goodman Gallery, Johannesburg.

Het Antichambres-programma wordt gesteund door de Vlaamse
Gemeenschapscommissie van het Brussels Hoofdstedelijk Gewest.

# JOHANNESBURG, 2ND GREATEST CITY AFTER PARIS, 1989

Animatiefilm:
16 mm-film; overgezet op
video en laser disk
8 minuten, 2 seconden
Tekeningen, fotografie en
regie: William Kentridge
Montage: Angus Gibson
Geluid: Warwick Sony met
muziek van Duke Ellington
en koormuziek
Een productie van
Free Filmmakers Co-operative,
Johannesburg
Serie van ca. 25 tekeningen;
houtskool op papier of
houtskool en pastel op papier;
variabele afmetingen

Dit is de eerste van een reeks korte animatie-films getiteld *Drawings for Projection*, opgebouwd rond de hoofdpersonages Soho Eckstein en Felix Teitlebaum. De animatie-techniek is eenvoudig: Kentridge maakte – en wijzigde vervolgens door stukken uit te vlakken en opnieuw te tekenen – zo'n 25 tekeningen in houtskool en pastelstift op papier en legde deze tekeningen in elk van hun vele ontwikkelingsstadia vast op 16 mm-film. In deze techniek van onvolledige uitvlakking, waarbij vlekken en sporen van het productie-proces zichtbaar blijven, komt het verstrijken van de tijd en de gelaagdheid van gebeurtenissen in het geheugen tot uitdrukking. Binnen een van tevoren vastgelegd schema is ruimte gelaten voor het toeval. Aan het eind van het proces hield Kentridge een reeks tekeningen over die alle talloze malen zijn gefilmd en die elk het laatste shot van een van de scènes van de film voorstellen.

De film laat ons kennismaken met Soho Eckstein, projectontwikkelaar in Johannesburg, diens verwaarloosde vrouw Mrs. Eckstein, en de naakte dromer Felix Teitlebaum. Als sym-bool van kapitalistische hebzucht en corruptie wordt Soho altijd frontaal geportretteerd, achter zijn bureau, gekleed in een krijtstreep-pak; Felix, die veel wegheeft van de kunstenaar zelf, is vaak op de rug te zien, uitkijkend over het landschap. De titel is ironisch: de film speelt in het stedelijke 'wasteland', de indus-trieel uitgeleefde woestenij van Johannesburg en omgeving. Hij verhaalt over de stichting en de bouw van een mijnstadje dankzij de voort-schrijdende groei van Soho's macht, en de traumatische effecten hiervan op het landschap – voorgesteld als een 'getekende', kunstmatige omgeving, bezaaid met de sporen van opge-geven bouwprojecten – en zijn inwoners. Parallel aan dit verhaal loopt de geschiedenis van verlangen en liefde tussen Felix en Mrs. Eckstein. In Felix' gedachten en erotische fantasieën wordt zij steeds geassocieerd met beelden van water en baden. Op zeker ogenblik schenkt hij haar een kleine vis, een blijk van zijn liefde dat in latere films terugkomt. Deze vochtige voorstellingswereld van liefde en seks wordt geplaatst tegenover het droge mijnland-

schap, in een van de vele binaire tegenstellin-gen tussen Soho en Felix. Papier hoort bij beide werelden: het papier van Soho is dat van geld en zaken, Felix schrijft liefdes-brieven en maakt tekeningen van of voor zijn geliefde. In de verhaallijn worden beelden en geluiden van het groeiende Eckstein-imperium afgewisseld met scènes uit Felix' affaire met Mrs. Eckstein en korte flitsen van een ano-nieme, eenzame zwerver die zich op krukken voortbeweegt in een obscure, met prikkeldraad afgezette omgeving of zich bij een vuur zit te warmen.

Voor de geluidsband tekende de Zuid-Afrikaanse componist Warwick Sony, die later in talrijke andere projecten met Kentridge zal samenwerken. Soho vervolgt zijn weg naar het succes op de tonen van Duke Ellingtons vroeg 20ste-eeuwse muziek. Bij de beelden van berooide mijnwerkers, die in een stoet vanaf de horizon door de stedelijke woestenij op-komen, bijna alsof zij deel uitmaken van dit gehavende landschap, klinkt Zuid-Afrikaanse koormuziek (door Kentridge fictief aangeduid als The South Kaserne Choir).

Net als de tekstborden in een stille film verschijnen er woorden op het scherm die de kijkers informatie geven over de gevoelens van de personages of over gebeurtenissen die aan het verhaal ten grondslag liggen. Felix wordt voorgesteld als 'Captive of the City' (gevangene van de stad), Mrs. Eckstein als 'Waiting' (wachtend) en wanneer Eckstein de behoef-tigen doet verdwijnen door voedsel naar ze te gooien, lees je: 'Soho Feeds the Poor' (Soho geeft de armen te eten).

De film eindigt na een symbolische strijd tussen de twee mannelijke personages, die bijna lijken te verworden tot complementaire delen van een en dezelfde persoonlijkheid. Felix zegeviert. De stoet mijnwerkers verandert nu van richting en beweegt zich weer naar de horizon toe. Dit symmetrisch formeel raam-werk wekt de indruk dat het oog van de camera de dubbele – zowel sociale als innerlijke – strijd aan de oppervlakte laat komen. Het tweede optreden van de mijnwerkers herinnert ons er ook aan dat er uiteindelijk helemaal geen eindoverwinning is: het voortdurende, ruimere

conflict blijkt te zijn ingebed in het verminkte
landschap zelf. (CCB)

*In deze film vechten Soho Eckstein (vastgoed-
makelaar extraordinaire) en Felix Teitlebaum
(wiens angst het halve huis deed onderlopen)
om de harten en mijnen van Johannesburg en
om de liefde van Mrs. Eckstein. Er is een stoet van
berooiden, Soho geeft de armen te eten. Felix
geeft Mrs. Eckstein een liefdesgeschenk. Soho en
Felix worstelen in de slijkputten van de stad.*
(WK, 1994)

# MONUMENT, 1990

Animatiefilm:
16 mm-film; overgezet op
video en laser disk
3 minuten, 11 seconden
Tekeningen, fotografie en
regie: William Kentridge
Montage: Angus Gibson
Geluid: Catherine Meyburgh
met muziek van
Edward Jordan
Een productie van Free
Filmmakers Co-operative,
Johannesburg
Serie van ca. 11 tekeningen,
houtskool op papier of
houtskool en pastel op papier;
variabele afmetingen

*Monument* is Kentridge's tweede animatiefilm in de kroniek over Soho Eckstein, een onderzoek naar de ontwikkeling van de mijnbouw en arbeid in Zuid-Afrika en de effecten hiervan op het landschap en de werkomstandigheden van de mijnwerkers. De film gaat ook over de overtuigingskracht van massacommunicatie in de moderne tijd, waarbij indirect wordt gezinspeeld op de invloed van de media bij het vormen en beheersen van het bewustzijn. De film is geïnspireerd door Samuel Becketts stuk *Catastrophe* en vertelt aan de hand van twee sequenties het eenvoudige verhaal van de plechtige onthulling door Soho van een monument voor de arbeid. Kentridge hanteert opnieuw een binaire structuur van tegenstellingen tussen personages, dit keer evenwel zonder Felix. In de eerste scène verschijnt een anonieme Afrikaanse mijnwerker met gebogen hoofd en een zware last op de schouders. De tekening toont vooral zijn gezicht, terwijl de vracht aan werktuigen slechts gedeeltelijk zichtbaar is. De film vervolgt met een close-up van zijn blote voeten. Hun beweging wordt gesuggereerd door de sporen van opeenvolgende tekeningen en overtekeningen, een procédé dat herinnert aan vroege chronofotografische experimenten of aan de weergave van gelijktijdigheid in de futuristische schilderkunst. Vervolgens zien we hem, gekleed in een lange, donkere jas, links het beeld in lopen, door de grijze woestenij aan de rand van de stad. Halverwege draait hij zich om naar de horizon en trekt van de kijker weg het landschap in. De tweede sequentie, getiteld 'Soho Eckstein Civic Benefactor', vormt een contrast met deze eerste scène vol last en eenzaamheid. Er duiken microfoons op in het titelbeeld en rechts verschijnt Soho. In zijn hand houdt hij vellen papier met de tekst van zijn toespraak. De bladen veranderen in megafoons of luidsprekers in het landschap. Ze zenden donkere vlekjes uit die een zwart, monochroom vierkant vormen in het midden van het beeld. Het landschap is veranderd en staat nu vol met lege reclameborden en hoge lantaarnpalen. Van achter het zwarte vierkant, dat langzaam wordt uitgewist, verschijnt een grote, verpakte vorm die in de steigers staat. Deze tekening verwijst

enerzijds naar Henry Moore's schetsen van ingepakte sculpturen, anderzijds naar Christo's verpakte structuren en vormen. Zo ontstaat een subtekst over de morele en ethische problemen waarmee de kunstenaar bij zijn keuze van onderwerpen en materialen te maken krijgt. Aan de horizon verschijnt een mensenmassa die zich naar de voorgrond beweegt en een menigte vormt rond het verhulde monument. Volgt een close-up van Soho; hij spreekt de menigte toe, gesticulerend, met een vriendelijke uitdrukking op het gelaat, maar misschien niet helemaal oprecht. Een long-shot van het tafereel toont de onthulling van het monument. Verrassend genoeg blijkt het een beeld van de eenzame figuur die zijn gereedschap draagt. Wanneer de camera omhoogbeweegt van de geketende voeten van het beeld om op het gezicht scherp te stellen, valt het geroezemoes van het publiek stil. Het beeld richt zijn hoofd op en knippert met de ogen. Het begint zwaar te ademen – de figuur leeft. (CCB)

*In deze film zien wij Soho Eckstein als openbaar weldoener die een monument opricht ter ere van zichzelf en de stad. Een man uit de stoet der berooiden wordt onsterfelijk gemaakt, met zijn last nog op de rug.* (WK, 1994)

5

# MINE, 1991

Animatiefilm:
16 mm-film; overgezet
op video en laser disk
5 minuten, 50 seconden
Tekeningen, fotografie en
regie: William Kentridge
Montage: Angus Gibson
Muziek: Antonin Dvořák,
*Cello Concerto in B Minor*,
Opus 104
Een productie van
Free Filmmakers Co-operative,
Johannesburg
Serie van ca. 18 tekeningen,
houtskool en pastel op papier;
variabele afmetingen

Hoewel *Mine* Kentridge's derde animatiefilm is over de Johannesburgse magnaat, industrieel en projectontwikkelaar Soho Eckstein, wordt deze film door de kunstenaar vaak als de tweede in deze serie getoond, vóór *Monument*. De film schetst een dag uit het leven in en rond de mijnen en is opgebouwd volgens een tegenstelling tussen onder en boven – mijnschacht en begane grond. Soho's wereld van het Kapitaal en de luie pleziertjes ligt boven de grond, in zijn bed en in zijn kantoor, terwijl het verborgen, teruggetrokken en claustrofobische bestaan van de mijnwerkers zich onder de grond afspeelt. Soho's uitbuiting van zowel het 'lichaam' van het land (het gouderts) als dat van de mijnwerkers wordt hier visueel voorgesteld, waarbij zijn ongevoeligheid voor 'white guilt' aan het licht komt, alsook zijn besef van de slavernij, de pijn, het lijden, de kou, het gevaar en de dood die de mijnwerkers dagelijks beleven.

De film begint in het donker met een oorverdovend geluid dat doet denken aan ondergronds voortdenderende wagons. Deze atmosfeer van nachtelijk onderbewustzijn wordt onderbroken door de muziek van Dvořák en het stilstaande beeld van een hoofd dat zowel een mijnwerkershoofd met -lamp zou kunnen zijn als een gekroond Nigeriaans *Ife*-hoofd, een allusie op de kolonialistische of toeristisch exotiserende kijk op Afrika. Vanuit het diepe, horizontale perspectief in de eerste scène nadert de titel van de film op expressionistische wijze, als een ijzeren wagon vanaf de achtergrond. Het beeld maakt dan plaats voor een verticale doorsnede van een mijn. Een lift vervoert mijnwerkers uit de schacht omhoog, terug naar het aardoppervlak, dat de gedaante aanneemt van Soho's bed. Onder het bed/de grond, parallel aan Soho's ontwaken, zien we een slaapzaal met stapelbedden en gemeenschappelijke douches die herinneren aan de verschrikkingen in nazi concentratiekampen: het decor van een ander ontwaken, dat van de verkleumde mijnwerkers. Een van hen warmt zijn handen aan de rode vlam van een grote stoof. Door voortdurend over te schakelen van boven naar onder en terug, brengt de film parallelle, doch contrasterende acties met elkaar in verband.

De zuiger van Soho's koffiepot daalt als een omgekeerde periscoop af en boort zich door zijn ontbijtblad heen, door zijn bed, in lagen aarde, afval, werktuigen en hoofden. Hij voert de blik van de kijker mee op de weg naar herinnering en bewustwording. De diepste laag is de mijngang waarin mijnwerkers aan het boren zijn en leemten van licht openen. De tunnels nemen de vorm aan van een oud slavenschip waar mensen in alle hoeken en gaten zijn samengepakt. Boven de grond begint Soho aan zijn werkdag; nu verandert zijn koffiepot in een kasregister of rekenmachine die rollen papier uitspuugt en massa's mijnwerkers, wier lichamen verharden tot goudstaven of blokken uit een modernistische architectuur. Een eenzame figuur in de slaapzaal beneden – op de rug gezien – herinnert aan het silhouet van Felix in andere films. Er wordt iets door de mijnen omhoog gedragen en op Soho's bureau neergezet. Het is een piepkleine, levende neushoorn. Dit tot snuisterij verworden symbool van Afrika is een pendant van het Nigeriaanse hoofd aan het begin van de film en richt de aandacht op de door de industrie veroorzaakte schade aan het milieu. Soho maakt zijn bureau leeg, dat weer verandert in een bed om ruimte te maken voor zijn nieuwe speeltje. (CCB)

*In deze film zien wij Soho Eckstein als mijneigenaar die uit de aarde een hele sociale en ecologische geschiedenis opgraaft. Atlantische slavenschepen, koninklijke Ife-hoofden en ten slotte een miniatuurrhinoceros worden door de in de rotsen ingebedde mijnwerkers omhooggebracht naar Soho, die net aan zijn eerste kop koffie zit.* (WK, 1994)

# SOBRIETY, OBESITY & GROWING OLD, 1991

Animatiefilm:
16 mm-film; overgezet op
video en laser disk
8 minuten, 22 seconden
Tekeningen, fotografie en
regie: William Kentridge
Montage: Angus Gibson
Muziek: Antonin Dvořák,
*String Quartet in F*, Opus 96;
koormuziek uit Zuid-Afrika;
*M'appari*, aria uit *Martha*,
Friedrich van Flotow,
vertolkt door Enrico Caruso
Serie van ca. 25 tekeningen,
houtskool op papier of
houtskool en pastel op papier;
variabele afmetingen

Deze vierde animatiefilm in de reeks Eckstein/ Teitlebaum toont de ineenstorting van Soho's imperium (of liever: hoe Soho dat imperium laat instorten). Het wordt voorgesteld als een moderne stad vol wolkenkrabbers die herinnert aan het Johannesburg van de jaren '50. De film neemt de draad van Felix' verhouding met Mrs. Eckstein weer op, met de hieruit voortvloeiende competitie en het conflict tussen de twee mannelijke personages die we leerden kennen in *Johannesburg, 2nd Greatest City after Paris* (1989).

In *Sobriety, Obesity & Growing Old* komt het verhaal echter duidelijker tot ontwikkeling dan in de voorgaande films, die eerder waren opgebouwd als een reeks van nagenoeg op zichzelf staande episoden. De film vertelt hoe Soho zijn vrouw verliest: ze ruilt zijn wereld van architectuur en rationaliteit in voor Felix' open landschap met megafoons, luidsprekers en hartstocht.

De film opent met een betoging. Wanneer deze in het verlaten landschap verschijnt, absorberen luidsprekers en megafoons het blauw van de lucht. Felix, die zich naakt in deze setting bevindt, 'luistert naar de wereld', zoals het bijschrift ons vertelt. Over naar Soho's kantoor. Ofschoon nog steeds achter zijn bureau is hij – tegen de gewoonte in – van achteren te zien. Een ingelijste foto van Mrs. Eckstein op het bureau staat in contrast met het uitzicht vanuit het raam over de stad. Een zwarte kat op het bureau ontwaakt en verandert in een telefoon. Na deze proloog komt Felix binnen; hij geeft Mrs. Eckstein een visje. Terwijl Soho alleen in zijn bed ligt, luisteren Felix en Mrs. Eckstein samen door hoofdtelefoons naar de wereld en ze kijken naar de betogers. Soho's personage schijnt te verschuiven: blauwe stralen omgeven zijn kantoorgebouw, een teken dat hij het ontstaan ervaart van gevoelens van liefde en verlangen.

Het water van Felix' liefde overspoelt Soho's kantoor terwijl deze zit te kijken naar het stel dat de liefde bedrijft op het scherm van het fotolijstje. Onder de druk van Felix' en Mrs. Ecksteins hartstocht, die als water wordt voorgesteld, beginnen de gebouwen van Johannesburg letterlijk te smelten en te verkruimelen, verpletterd onder het gewicht van verlies en eenzaamheid.

Na deze catastrofe blijft Soho alleen met zijn kat achter in het landschap, terwijl zijn eenzaamheid wordt onderstreept door de bijschriften 'HER ABSENCE FILLED THE WORLD' en 'COME HOME'.

Het oog van de camera sluit zich, waardoor er in het verhaal een ellips wordt gecreëerd, en gaat vervolgens weer open met een middellang shot van Soho en Mrs. Eckstein, herenigd in het hart van het barre landschap. Zij worden begeleid door het honingzoete, nostalgische geluid van een oude opname van de aria *M'appari*, vertolkt door Caruso. Felix zit alleen, net als aan het begin van de film. Water vult de ruimte rond het languit liggende paar, terwijl vanaf de gebogen horizon achter in het beeld de betogers naderbij komen.

Stonden in eerdere films sociaal onrecht en menselijk lijden voorop, in *Sobriety, Obesity & Growing Old* wordt de politiek op de achtergrond gehouden van wat overwegend een psychologisch drama van liefde, verlangen, verlies en eenzaamheid lijkt te zijn. Dit is echter ook de eerste film waarin de stedelijke bevolking niet wordt afgeschilderd als passief onderdanig ten opzichte van de macht, maar een aaneengesloten menigte vormt. Met rode vlaggen trekt zij actief door de stad: ze neemt het lot in eigen handen. Dit is een directe verwijzing naar gebeurtenissen in Zuid-Afrika in die tijd: oppositie tegen het Apartheidsregime, demonstraties en betogingen die leidden tot het opheffen van het verbod op politieke organisaties (1990) en de versoepeling van de meeste regels en beperkingen die in het kader van de noodtoestand golden (1991).

In deze film wordt, nog sterker dan in de voorgaande, duidelijk dat Felix en Soho twee kanten zijn van een enkele, complexe persoonlijkheid. Soho blijkt in staat tot bewustwording en verlangen, misschien zelfs tot schuldgevoel en berouw, en wordt daarom een slachtoffer van zijn eigen verleden, minder machtig maar ook menselijker. Niet alleen wordt hij af en toe op de rug getoond, zoals eerder ook Felix, zijn kale hoofd geeft ook aan dat hij ouder is geworden. Zowel Soho als Felix worden geassocieerd met

luidsprekers en megafoons, middelen die de zintuigen projecteren, instrumenten waarmee je vanuit een machtspositie boodschappen uitzendt (de megafoon bovenop het Eckstein Building), of waarnaar je aandachtig en bewust luistert (als in de scènes waarin Felix in het voorstedelijke landschap zit, omringd door luidsprekers). Als Soho de blanke macht in Zuid-Afrika vertegenwoordigt tijdens de Apartheid, dan wijst deze transformatie van de oppervlakkige, stereotiepe karakterisering van de eerste paar films tot een meer genuanceerde figuur met emoties, op metaforische wijze naar de voortschrijdende bewustwording in de blanke gemeenschap, parallel aan de opkomst van activisme en georganiseerd protest vanuit de zwarte gemeenschap. Impliciet onderstreept de film hoe deze parallelle vormen van bewust-wording konden bijdragen aan het ten val brengen van het systeem van rassenscheiding. (CCB)

*Een volgend stadium in de krachtmeting tussen Soho en Felix. Soho's imperium stort ineen. De wereld is te hard voor hem. Hij laat de stad imploderen. Alleen in de woestenij roept hij om zijn vrouw: 'Come home'. Felix blijft alleen achter in de woestenij. (WK, 1994)*

# FELIX IN EXILE, 1994

Animatiefilm:
35 mm-film; overgezet op
video en laser disk
8 minuten, 43 seconden
Tekeningen, fotografie en
regie: William Kentridge
Montage: Angus Gibson
Geluidsmontage:
Wilbert Schübel
Muziek: compositie voor
strijkerstrio van Philip Miller
(uitgevoerd door Peta-Ann
Holdcroft, Marjan Vonk-
Stirling, Jan Pustejovsky);
'Go Tlapsha Didiba' door
Motsumi Makhene (uitgevoerd
door Sibongile Khumalo)
Serie van 40 tekeningen in
houtskool, pastel en gouache
op papier;
variabele afmetingen

In *Felix in Exile*, de vijfde film in de reeks Soho Eckstein/Felix Teitlebaum, is Felix de hoofdfiguur, terwijl Soho tijdelijk uit het verhaal is geschrapt.

De film begint met een niet nader geïdentificeerd landschap dat veel wegheeft van het mijn- en industriegebied van Witwatersrand rond Johannesburg. Het volgende beeld is een close-up van een hand die landmeetkundige tekens en maten uitzet op papier, meteen gevolgd door een portret van de Afrikaanse vrouw Nandi, die de tekening maakt. Achter haar staat een theodoliet, een instrument dat landmeters gebruiken voor het meten van hoeken.

Evenals in eerdere films worden twee gezichtspunten naast elkaar geplaatst, maar zij worden niet als elkaars tegenpolen gepresenteerd zoals dat het geval was bij Felix en Soho. Felix wordt naakt geportretteerd en eenzaam in een sombere hotelkamer met enkel een bed, een stoel, een spiegel, wastafel en bidet. Hij kijkt naar een koffer vol met Nandi's tekeningen. Nandi observeert het land met behulp van het gereedschap en de instrumenten van de landmeter en tekent wat ze ziet. Zij verzamelt en registreert op papier het bewijsmateriaal van geweld en woeste moordpartijen, zodat dit niet in de grond verdwijnt. Ook kijkt zij 's nachts naar de hemel waar zij in de sterren symbolen en beelden ontwaart. Wanneer zij tekent wordt haar visie gematerialiseerd tot oranjerode omtreklijnen rond lichamen met bloedende wonden, liggend in het landschap. Geïsoleerd als hij is in zijn kamer, kan Felix het landschap niet direct 'zien', noch de marsen van betogers, noch de stervende, bloedende, met kranten bedekte lichamen die door het landschap worden opgeslokt. Hij ziet alleen maar Nandi's tekeningen en door haar ogen, door wat zij ziet in haar ronde lens, wordt hem een schuine en indirecte blik gegund op het geweld dat het lichaam/land van Afrika is aangedaan. Nandi's tekeningen lijken veel op die van Kentridge, zodat de kijker geneigd is werkelijkheid en voorstelling, kunst en leven binnen de film door elkaar te halen – de film die nochtans zelf een representatie is. Op vergelijkbare wijze vliegen blaadjes papier van Nandi's tekenbord of uit Felix' koffer weg. Ze worden de lucht in geblazen of tegen de wanden van de hotelkamer waar zij binnenskamers een landschap vormen. De stukken papier bedekken de lichamen als verband en worden dan weer tekeningen. Bij het scheren wist Felix zijn eigen spiegelbeeld uit, maar Nandi, als bevond zij zich aan gene zijde van het membraan tussen kunst en realiteit (de spiegel), zet zijn kamer onder water en komt hem tegemoet via een telescoop met twee uiteinden, waar zij beiden in kijken. Felix en Nandi omarmen elkaar in het water. Nandi begint te tekenen; bakens of markeringen verrijzen uit de grond. Dit tekenproces kan worden gezien als een metafoor voor de poging om een post-koloniale en post-Apartheid identiteit te reconstrueren door de herinnering aan en het bewustzijn van kolonialisme, geweld en racisme levendig te houden in plaats van ze uit te wissen. Door het landschap op te meten eigent Nandi zich de instrumenten toe die ooit werden gebruikt om het land te onderwerpen, in een actieve poging een nieuwe geschiedenis en geografie, een 'nieuw' Zuid-Afrika in kaart te brengen.

Felix blijft intussen eenzaam en verlangend, een opgesloten en machteloze toeschouwer. Als Nandi in het water gaat baden, wordt zij neergeschoten en valt ze op de grond net als de lichamen die zij eerder in de film heeft getekend. De hotelkamer loopt onder water, het papier komt van de muren en Felix blijft alleen achter in de poel van haar verloren lichaam, met zijn rug naar de toeschouwers, uitkijkend over het barre land. (CCB)

*Felix is alleen in een kamer (naar ik aanneem in Parijs, afgaand op de titel van de eerste film). Het landschap van de East Rand vult zijn koffer en de wanden. Het land is bezaaid met lichamen. Deze lijken worden in de bodem opgenomen. Een nieuwe vrouw, Nandi, landmeter van dit landschap, ontmoet hem van achter zijn spiegel. Zij verdwijnt in de grond. Felix keert terug naar haar poel.* (WK, 1994)

Felix in Exile *werd gemaakt in de tijd vlak voor de eerste algemene verkiezingen in Zuid-Afrika en stelde de vraag hoe de herinnering aan de*

*mensen die zijn gestorven op weg naar dit*
*nieuwe systeem levendig zou worden gehouden*
*– waarbij het landschap wordt gebruikt als*
*metafoor voor het proces van herinneren of*
*vergeten.* (WK, 1997)

# HISTORY OF THE MAIN COMPLAINT, 1996

Animatiefilm:
35 mm-film; overgezet op
video en laser disk
5 minuten, 50 seconden
Tekeningen, opnamen en
regie: William Kentridge
Montage: Angus Gibson
Geluid: Wilbert Schübel
Muziek: madrigaal van
Monteverdi
Serie van ca. 21 tekeningen in
houtskool en pastel op papier;
variabele afmetingen

Dit is de zesde film in de saga van Soho Eckstein en Felix Teitlebaum. De film werd gemaakt vlak na de installatie van de Truth and Reconciliation Commission in april 1996, een reeks publieke hoorzittingen inzake misdaden tegen de mensheid, begaan onder het Apartheidsregime. Deze hoorzittingen, waarbij mensen hun persoonlijke verhaal kunnen doen, moeten vergeten geschiedenissen in herinnering brengen, diegenen die hebben geleden, schadeloos stellen, amnestie verlenen en een algemene context scheppen voor een nieuw post-koloniaal en post-Apartheid tijdperk van nationale verzoening. Het onderliggende thema van *History of the Main Complaint* is Soho's persoonlijke erkenning van zijn verantwoordelijkheid.

De film begint met het beeld van een verlaten straat in de stad; een stuk krantenpapier waait in de wind, in de verte loeit een sirene. Er heerst het gevoel dat wij getuige zijn van de nasleep van gedenkwaardige gebeurtenissen. Over naar een ziekenzaal. Soho ligt alleen in een bed achter een wit gordijn. Op de geluidsband een madrigaal van Monteverdi. Soho ligt in coma, draagt een zuurstofmasker; zijn ogen zijn gesloten, zijn mond staat wijd open. Hoewel hi-tech machines zoals röntgenapparatuur, MRI, CAT-scans, echo-apparatuur, enz. zijn hartslag en andere lichaamsfuncties registreren, doet de locatie denken aan een 19de-eeuwse ziekenzaal – het ziekenhuis van een land waar cosmetische ingrepen een luxe zijn. Een arts in een krijtstreeppak, bijna een kloon van Soho, of een zelfprojectie, verschijnt aan zijn bed met een stethoscoop, die hij op ongebruikelijke delen van Soho's lichaam aanbrengt. Een tekening van een röntgenfoto toont de sensor als hij het lichaam binnendringt en langs zijn ruggegraat naar beneden beweegt, hetgeen opnieuw herinnert aan de zuiger van Soho's koffiepot in *Mine*. De röntgenfoto lijkt te ademen.

Steeds meer artsen verschijnen aan Soho's bed, terwijl bellen en telefoons rinkelen – de geluiden en de sporen van zijn vorige leven als oprichter van een imperium. Deze artsen zijn niet zozeer genezers als wel verkenners van het lichaam. Zij herinneren ons eraan dat in de late Middeleeuwen de studie van de anatomie het aanbreken van de moderniteit markeerde met het ontstaan van de experimentele wetenschap. Een beeld van het inwendige van het lichaam op het scherm van een echo-apparaat verandert in een beeld van de buitenwereld gezien door de voorruit van een rijdende auto. Uit de bijna abstracte, grijze nevel van de medische screening ontstaan beelden van schrijfmachines en telefoons. Het is alsof sporen van Soho's begraven verleden worden opgedolven. Hoe meer Soho deze instrumenten voor intern onderzoek herkent en erkent, des te groter wordt zijn gevoeligheid voor gebeurtenissen buiten zijn eigen ego.

De film toont afwisselend de onderzoekende blik van de artsen in het lichaam via de machines en Soho's blik door de autoruit. Ofschoon het Soho is die – op de rug gezien – aan het stuur zit, zijn het Felix' ogen die ons via de achteruitkijkspiegel aanstaren in een eindeloze weerspiegeling. Was in eerdere films de versmelting van deze twee personages enkel impliciet aangegeven, nu vindt ze daadwerkelijk plaats.

De tests waaraan Soho's lichaam wordt onderworpen, lopen parallel met zijn herinneringen aan ruwe gewelddaden tegen zwarte Afrikanen, wier lichamen hij aan de kant van de weg zag liggen. Rode kruisen geven de exacte plaats van hun verwondingen aan. Deze externe verminkingen worden afgezet tegen Soho's inwendige wonden en er wordt een analogie gesuggereerd tussen de pijn toegebracht aan anderen en de zelfverwonding van Soho's ziel.

Soho droomt van of herinnert zich een ongeluk waarbij zijn auto een man op de weg raakt. Zijn verantwoordelijkheidsgevoel manifesteert zich en hij is niet langer in staat zo maar buiten bewustzijn te blijven liggen als een bevrijd getuige van gebeurtenissen. Hij richt zich in zijn ziekenhuisbed op en spert zijn ogen wijd open. Maar als de witte gordijnen rond het bed ook open gaan, komt de figuur van Soho, in zijn oude luister – strak in het pak – achter zijn met papieren overladen bureau, te voorschijn. De vraag of Soho morele vooruitgang heeft geboekt, blijft dus onbeantwoord. Wij zijn

getuige geweest van zijn proces van bewust-
wording, maar nu hij is teruggekeerd in zijn
bekende wereldje zetten wij vraagtekens bij de
effecten ervan en vragen wij ons zelfs af of het
allemaal wel is gebeurd. (CCB)

*De eerste aanzet tot de film was een schets*
*voor een operaproject dat volgend jaar wordt*
*gepland. Ik wilde zien of het mogelijk was de*
*techniek van houtskoolanimatie die ik beoefen,*
*te combineren met de muziek van Monteverdi.*
*En ik wilde zien of er een verband is tussen de*
*17de-eeuwse muziek en de zeer 20ste-eeuwse*
*systemen om het lichaam te verkennen*
*– CAT-scans, echo- en röntgenapparatuur,*
*MRI, enz.* (WK, 1996)

# UBU TELLS THE TRUTH, DE 'UBU PROJECTEN', 1996-97

Animatiefilm:
35 mm-film; overgezet op
video en laser disk
8 minuten
Tekeningen, fotografie en
regie: William Kentridge
Montage: Catherine Meyburgh
Muziek: Warwick Sony en
Brendan Jury
Serie van ca. 30 tekeningen,
houtskool op papier;
variabele afmetingen

De andere Ubu-projecten:

*Ubu Tells the Truth*
Portfolio van 8 etsen

*Ubu and the Truth Commission*
Theaterproductie met acteurs,
poppen, animatie

*Project Drawings*
Reeks van 7 grote figuratieve
tekeningen

*Sleeper*
Reeks van 4 grote etsen

In 1888 schreef de Franse dramaturg Alfred Jarry het stuk *Ubu Roi*, een satirische en groteske fabel over hoe arbitraire macht krankzinnigheid voortbrengt.

Hij portretteerde een potsierlijk maar verschrikkelijk despoot, tevens losbandig libertijn, als symbool voor de domme en hardvochtige daden die worden gesteld in dienst van een gewetenloze staat. Jarry beantwoordt deze arbitraire macht met zijn zogenoemde 'patafysica' – de wetenschap der imaginaire oplossingen – en onthult de absurditeit ervan in een klucht, liever dan de macht van de tiran te bevestigen door hem ernstig te nemen.

*Ubu Roi* heeft talloze kunstenaars en schrijvers geïnspireerd en Jarry's benadering gaf aanleiding tot een nieuw genre: het absurdistische theater.

In de Zuid-Afrikaanse context is Ubu een bijzonder krachtige metafoor voor het krankzinnige Apartheidsbeleid, dat door de staat werd voorgesteld als een rationeel systeem.

In 1975 speelde Kentridge de rol van kapitein McNure in *Ubu Rex*, een productie van Junction Avenue Theatre Company, gebaseerd op het stuk van Jarry. Precies 20 jaar later, in 1996, stelde de kunstenaar Robert Hodgins, met wie Kentridge vaak heeft samengewerkt, voor om een groepstentoonstelling samen te stellen met prenten rond het thema *Ubu*.

Met het oog hierop schiep Kentridge een reeks etsen. Twee zeer verschillende types van tekeningen werden over elkaar heen gelegd: krijttekeningen naar Jarry's cartoon-achtige, schetsmatige voorstellingen van Ubu en Kentridge's eigen, in toon en textuur rijk geschakeerde tekeningen van een naakte man, geïnspireerd door foto's van hemzelf in de studio. Het resultaat was een serie buitensporige beelden getiteld *Ubu Tells the Truth*, die werden geëxposeerd in de tentoonstelling 'Ubu: ± 101' in Grahamstown, 1997, samen met werk van Hodgins en Deborah Bell. Het ineenschuiven van beide soorten beelden is niet alleen een verdere verkenning van Kentridge's bekende thema van de coëxistentie van tegengestelde wezens in eenzelfde persoon, maar impliceert ook dat er een Ubu schuilt in ieder van ons. Door deze Ubu in onszelf meester te worden

– zoals Soho Eckstein in *History of the Main Complaint* – kan hij wellicht in het individu en bijgevolg ook in de maatschappij worden bedwongen.

Na de reeks etsen vatte Kentridge het idee op om met de schoolbord- en cartoon-achtige Ubu-tekeningen een nieuwe animatiefilm te maken: *Ubu Tells the Truth* (1997). Deze film werd op zichzelf en in combinatie met wandtekeningen getoond. Hij werd tevens gebruikt, zij het anders gemonteerd, in de theatervoorstelling *Ubu and the Truth Commission* (1997). Het stuk vloeide niet rechtstreeks voort uit de wens het Ubu-thema opnieuw aan de orde te stellen. Omdat hij zijn samenwerking met Handspring Puppet Company na *Woyzeck on the Highveld* (1992) en *Faustus in Africa!* (1995) graag wilde voortzetten, had Kentridge een nieuw stuk gepland over de ervaring van het wachten. Zij hadden een bewerking voor poppen overwogen van Samuel Becketts *Waiting for Godot* , maar hadden geen toestemming kunnen krijgen. Rond dezelfde tijd stelde de schrijfster en conservator Jane Taylor de vraag naar de betekenis en de consequenties van de afschuwelijke verhalen die werden verteld tijdens de hoorzittingen van de recentelijk geïnstalleerde Truth and Reconciliation Commission. Deze denkpistes kwamen uiteindelijk samen in een groepsproject dat een onderzoek wilde zijn naar zowel de persoonlijke gruwelverhalen die de getuigen voor de commissie deden, als de bekentenissen van geweldplegers, beide elementen in het ruimere discours van nationale verzoening.

In het stuk dat hieruit voortkwam, waarvoor Taylor het script schreef en dat door Handspring werd vertolkt, werd Adrian Kohlers poppenspel gecombineerd met Kentridge's animatie en regie. De gruwel van de getuigenissen zou een tegengewicht vinden in de extravagante wildheid van Ubu.

De vulgaire en demonische Pa Ubu met zijn groteske spiraalbuik, berijdt het fallische driehoofdige beest van Apartheid (een diabolische Cerberus die teruggaat op Jarry's personage Palcontents). Zijn absurde aanwezigheid laat zien dat zelfs de historische en tragische gebeurtenissen in Zuid-Afrika een kluchtige

dimensie kunnen krijgen. Pa Ubu – een moordenaar en folteraar voor de Apartheidsstaat, wordt uiteindelijk gratie verleend en geherintegreerd in een geïdealiseerde nieuwe wereld. Net als Mephisto in *Faustus in Africa!* wordt zijn rol tijdens de voorstelling meestal enkel door een acteur vertolkt. De getuigen worden gespeeld door poppen én acteurs. Hun woorden zijn ontleend aan de feitelijke getuigenissen die zijn voorgelegd aan de Waarheidscommissie en worden gesproken in de oorspronkelijke talen. De grove, ruw gesneden poppen roepen tijd op, ervaring, sporen van misbruik. Een andere pop, in de vorm van een krokodil, is een denkbeeldige, geanimeerde versie van een papierversnipperaar, een symbool van heimelijke schuld.

Net zoals Kentridge in zijn etsen radicaal verschillende tekenstijlen over elkaar heeft gelegd, zo worden in zijn animatiefilms de parodie en de klucht voortdurend afgewisseld met contrasterend documentatiemateriaal. Deze film verschilt van de voorgaande, niet alleen door de cartoon-achtige, karikaturale figuur van Ubu, maar ook door de productiemethode en de directere betrokkenheid op het geweld en de gruwel in Zuid-Afrika, die tot het einde van het Apartheidsregime hebben geleid en tot de verkiezingen in 1994. Het procédé van steeds opnieuw aangepaste houtskool- en pasteltekeningen op papier wordt nog steeds toegepast, maar Kentridge maakt ook collages met tekeningen in wit krijt op zwart papier, papierknipsels en documentaire foto's en filmbeelden. Dit archiefmateriaal omvat beelden van politiemensen die met zwepen op een rennende menigte inslaan in Cato Manor in 1960 of die een groep studenten bestormen aan de Wits University ten tijde van de noodtoestand in 1985, alsook filmfragmenten van de Soweto-opstand in 1976.

Terwijl aan het stuk *Ubu and the Truth Commission*, waarvoor Taylor het script schreef, duidelijk de idee ten grondslag ligt dat theater een rol dient te spelen in de nationale catharsis en verzoening, draagt Kentridge's animatiefilm *Ubu Tells the Truth* een minder duidelijke boodschap uit, een benadering met een open einde. Het is een ontwrichte, schokkerige, vaak ruwe montage van geluid en beeld, vol met sprongsgewijze overgangen, slecht getekende cartoons en visueel storende nevenschikkingen. De gruwelijke afgrond van misdaad en lijden wordt gestaafd met een scatologische beeldtaal die herinnert aan een scène uit Jarry's stuk waarin Ubu tijdens een banket 'pschitt' serveert aan zijn gasten. Ofschoon – uiteraard – moreel geweld wordt gesuggereerd, lijkt de film de kijker geen enkele ondubbelzinnige ideologische positie aan te reiken.

In een van de scènes in de animatie trekt Pa Ubu zijn kleren uit. Zijn lichaam wordt een drievoet en zijn hoofd verandert in een radio, een kat, een camera. De camera kan een instrument zijn voor autoritaire bewaking en beheersing, maar is ook datgene waarmee de kunstenaar vloeiend beelden kan opnemen en wissen. Kentridge lijkt te suggereren dat kunst een rol moet spelen in de maatschappij, maar niet door middel van definitieve oordelen en voorschriften. Volgens Kentridge nodigt kunst de toeschouwer uit een proces van zelf-anamnese aan te vatten, waarbij hij zich bewust wordt van de complexiteit van de menselijke ervaring en van het constante potentieel aan onmenselijke handelingen.

Kentridge zette zijn onderzoek naar de Ubu-figuur voort in een reeks grote *Ubu*-tekeningen en een reeks prenten getiteld *Sleeper*. De *Ubu*-reeks werd al eens gepresenteerd naast andere tekeningen, gemaakt in wit krijt op een zwarte wand om een theaterruimte te suggereren. Ernaast stond een drievoet met een monitor waarop de animatiefilm *Ubu Tells the Truth* speelde. De drievoet is een echo van diegene die Ubu's skelet vervangt in de animatiefilm zelf. De complexe identificatie van de kunstenaar met de figuur van Ubu wordt hiermee eens te meer onderstreept. (CCB)

*Hoe ga je om met het gewicht van het aan de Truth and Reconciliation Commission voorgelegde bewijsmateriaal? Hoe verwerk je de gruwelverhalen zelf, en de gevolgen van wat je wist, half wist en niet wist van de misstanden tijdens de Apartheidsjaren? (De ruime context, enkele van de specifieke geweldsvormen waren*

*bekend. De details, de huiselijke kanten van het*
*geweld – wat mensen deden als zij slachtoffer*
*werden, hoe mensen vanuit een huiselijke*
*achtergrond tot geweldplegers werden –*
*de specifieke syntaxis bij het toebrengen en*
*verwerken van lijden – was niet bekend.)*
*De noodzaak om met dit materiaal te werken*
*kwam voort uit de prangende vragen die rezen*
*naar aanleiding van deze analyse. Ik verwacht*
*niet dat een theaterstuk specifieke antwoorden*
*kan leveren op de vraag hoe je omgaat met je*
*eigen en met historische herinneringen, maar*
*wel dat het werk (bij het maken van het stuk, of*
*misschien het kijken ernaar) deel gaat uitmaken*
*van het proces van verwerking van deze erfenis.*
(WK, 1996)

# WEIGHING… and WANTING, 1998

Animatiefilm:
35 mm-film; overgezet op
video en laser disk
Tekeningen, fotografie en
regie: William Kentridge
Montage: Angus Gibson en
Catherine Meyburgh
Geluid: Wilbert Schübel
Muziek: Philip Miller
Serie van ca. 40 tekeningen,
houtskool en pastel op papier;
variabele afmetingen

Dit is de zevende animatiefilm in de reeks over opkomst en ondergang van Soho Eckstein. Verschillende jaren scheiden het maken van deze film van de rellen, opstanden, onderdrukking en gruwelen onder de noodtoestand in de jaren '80. Meer dan tien jaar zijn verstreken sinds de opstand in Soweto en vier jaar sinds de nationale verkiezingen van 1994, waarbij het ANC aan de macht kwam. Het is het begin van een periode van verzoening, waarin een nieuwe nationale identiteit op basis van herinneringen wordt geconstrueerd. Dit thema van verzoening vormt de kern van de film.

In deze periode werkte Kentridge ook aan zijn eerste opera, *Il Ritorno d'Ulisse*, en er zijn heel wat verbanden aan te wijzen tussen deze film en het verhaal van Odysseus' terugkeer naar Ithaca. De geschiedenis van Odysseus is het verhaal van een thuiskomst, het einde van een epische reeks gebeurtenissen, een verzoening met de Goden na jaren van rondzwerven als straf, een ontwaking en een vorm van psychische integratie. De belangrijkste verhaallijn in *WEIGHING… and WANTING* suggereert ook een thuiskomst, maar hier wordt op meer dubbelzinnige wijze met het thema omgesprongen. Aan de hand van het personage Soho Eckstein presenteert Kentridge wat het einde van een reis zou kunnen zijn, of misschien alleen maar een begin, een verzoening, of mogelijk slechts het verlangen naar verzoening, een gebeurtenis die werkelijk kan zijn of alleen maar fictief, een droom, een overgangsmoment.

De film gaat over het nauwe verband tussen vergeten en herinneren. Gebeurtenissen verdwijnen geleidelijk naar de verre achtergrond van ons geheugen en het ons omringende landschap, terwijl onze identiteit juist door dit vergeten, en door ons schuldgevoel erover, wordt geconstitueerd. Dit proces van geheugenverlies komt in Kentridge's tekeningen tot uiting in de techniek van onvolledige uitwissing en in de manifeste sporen van het verleden – in de vorm van de mijnbouwconstructies en openbare bouwwerken – in het landschap rond Johannesburg.

Centraal in de film staat het beeld van een rots, die functioneert als een allegorie, een condensatie van verschillende metaforen. De rots maakt deel uit van het landschap en is het landschap zelf. Hij staat voor de geest, de zetel van het geheugen. De rots vertegenwoordigt de gelaagdheid van gebeurtenissen en is de tijd zelf. Hij is ook een gewicht dat op het landschap drukt.

Op het eerste gezicht is de film eenvoudig gestructureerd: een onzekere evenwichtstoestand wordt doorbroken en na een crisis volgt de terugkeer naar de rusttoestand. Maar bij nader inzien ontdekken we een voortdurende verwarring in tijd en ruimte, een slingerbeweging tussen verleden, heden en ingebeelde toekomst, tussen binnen en buiten, de geest en de wereld, microkosmos en macrokosmos, droom en werkelijkheid. Een dergelijke verwarring herinnert aan geestestoestanden tussen slapen en waken.

De film begint met de tekening van een witte, blauwgerande kop-en-schotel. Dit beeld van breekbare huiselijkheid wordt gevolgd door een beeld van een woonkamer, met een haard, bloemen in een vaas. De kamer is leeg, maar op een tafel liggen papierknipsels uitgespreid. Op de wand verschijnt een woord: 'WEIGHING…', gevolgd door de woorden 'and WANTING' – waarbij het laatste woord zowel verlangen als tekortschieten kan betekenen. Dit motief van het schrift op de wand is ontleend aan het Boek Daniël, waarin Koning Balthasar een hand zonder lichaam ontwaart die een tekst schrijft op de wand van de zaal waar hij feestviert. Balthasar is de zoon van Nebukadnezar, Koning van Babylon, die de joden heeft overwonnen en de jongsten en briljantsten, onder wie ook Daniël, als astrologen, zieners en droomuitleggers naar zijn hof brengt. Terwijl Nebukadnezar de nederigheid leert via de inzichten van Daniël, aanbidt Balthasar gouden, zilveren en ijzeren afgoden en hij drinkt wijn uit vaten die zijn gestolen uit de Tempel in Jeruzalem. Hij biedt Daniël goud aan in ruil voor het uitleggen van de inscriptie: 'God heeft uw koninkrijk geteld en Hij heeft het voleind. Gij zijt in weegschalen gewogen en gij zijt te licht bevonden.' Die nacht wordt Balthasar vermoord.

In Kentridge's laatste film wordt meermaals naar dit bijbelverhaal verwezen. Een hersen-

scanner die lijkt op een crematoriumoven suggereert het einde van een leven en is wellicht een toespeling op de holocaust. De twee schalen van een oude weegschaal bewegen gedurende de film bij tussenpozen op en neer. Een verlaten landschap met een poel van blauw water herinnert ook aan de wereld van *Felix in Exile*. Het is onduidelijk of dit een schildering is van een pre-koloniale en pre-moderne omgeving dan wel een verlaten en waardeloze woestenij. Een grote rots verschijnt in het landschap; de rots lijkt op een stel hersenen.

Het lichaam van Soho Eckstein/Felix Teitlebaum (de twee figuren zijn inmiddels samengesmolten) wordt de CAT-scan-machine/oven ingereden. Een hoofd, in zijaanzicht, dat gelijkt op dat van Felix en Soho maar ook op dat van de kunstenaar zelf, wordt gepenetreerd door medische scanners. Verschillende hersenlagen worden doorgelicht. Op zeker ogenblik wordt een laag bereikt die in een flits het beeld van een mijn onthult: een stoet mijnwerkers, flarden van ver weg klinkende stemmen. De film schakelt abrupt over op een ander landschap. In de verte, beschermd door hoge bomen, staat een huis, geïnspireerd op een gebouw in Sergei Eisensteins *The General Line* (1928). Of dit een origineel modernistisch huis is dan wel een voorbeeld van laat-modernistische, kleinsteedse architectuur wordt in het midden gelaten. Het water van de hartstocht in Kentridge's vroege films is veranderd in een beschermd zwembad van afgewogen verlangen.

Een long-shot toont ons een man, Soho, die over een pad naar het huis loopt. Misschien komt hij thuis na een reis. Hij staat stil, raapt een steen op. Na een tijdsellips zien wij Soho in het huis, hij zit aan tafel en inspecteert de rots. De schalen staan op de tafel, samen met de stukken papier. De film schakelt over naar beelden van de wereld, fragmenten van het verleden in de rots. Wij zien Soho, geheel gekleed, die liefdevol een dunne, naakte vrouw met bril omarmt (de bril als teken van ouderdom, maar ook van wijsheid – staat zij misschien voor Daniël?). We krijgen weer beelden van de rots in het landschap.

Beelden van de wereld buiten en het leven in Zuid-Afrika markeren in Kentridge's films vaak momenten van bewustwording, en de film zoemt in op Soho's persoonlijke verhaal en op de herinneringen aan zijn voorbije leven, zowel persoonlijk als publiek. Met het kopje aan zijn oor – als was het een grote schelp – graaft hij in zijn geest en in de rots en vindt hij een verhaal van groei en macht. Zwarte houtskoolvegen op papier veranderen in tekeningen van openbare bouwwerken. Het beeld van de vrouw wordt uitgewist door een ijzeren raamwerk dat uit het landschap omhoog rijst (en herinnert aan Soho's ontwikkeling van Johannesburg in *Johannesburg, 2nd Greatest City after Paris*). Soho legt zijn hoofd in haar schoot, maar zij verdwijnt en hij blijft achter, leunend op een telefoon. In latere beelden wordt hij op zijn beurt uit het tafereel weggevlakt. Markeringen in het landschap worden littekens op zijn blote rug. De tekening van het ijzerwerk verschijnt, net als bij de verschijning aan Balthasar, op de wand van de woonkamer; de zwarte houtskoolvegen op de tekening kantelen en worden letters. Ze vormen de volgende tekst: 'In whose lap do I lie?' (In wiens schoot lig ik?), die herinnert aan Odysseus' monoloog tijdens het ontwaken op het strand in Monteverdi's opera *Il ritorno d'Ulisse in patria* (eerste bedrijf, scène VII): 'Slaap ik of ben ik wakker?/Welk landschap zie ik nu weer?/Welke lucht adem ik in?/Welke bodem betreed ik?'

Er volgen conflictscènes tussen Soho en de vrouw. Zij slaat hem, waarbij het theekopje aan scherven valt; chaos wordt uitgedrukt in zwarte en rode markeringen op het papier en in losgescheurde snippers. Soho is terug in het huis. Alleen. Uit de rots wordt de vrouw opnieuw geboren. Hij luistert, zij ontmoeten elkaar weer, de fragmenten worden samengevoegd. De camera wijkt tot de rots weer als geheel te zien is. Wij zien de woonkamer met een bak water op de tafel, de stukken papier zijn verdwenen. Soho's hoofd rust op de rots buiten. Het is nacht en hij ademt. Slaapt hij? Was het een droom? Heeft hij het huis nooit echt bereikt? (CCB)

*Hoe breng je de hele voorstelling van de wereld in je hoofd?* (WK, 1998)

(oorspronkelijke versie in *Stet*, Johannesburg, november 1988, jaargang 5, nr. 3, blz. 15-18)

Ongeveer een jaar houd ik mij nu bezig met het tekenen van landschappen. Mijn landschappen begonnen als incidentele details in andere tekeningen. Een raam achter een dansend stel, een open ruimte achter een portret. Het landschap nam geleidelijk de overhand en overspoelde het interieur. Slechts weinigen van de mensen in de afbeeldingen wisten hun plaats in de tekeningen te handhaven. Ik maak mijn tekeningen met houtskool op ruw papier, zodat beelden die vast en donker lijken met een doek in één beweging kunnen worden verwijderd. Er blijven sporen achter. Zelfs nadat het papier is schoongeboend blijft het bewijs dat er iets is geweest. Maar dit wordt gemakkelijk bedekt en opgenomen in de tekening. Een paar tekeningen tonen specifieke plaatsen, maar de meeste zijn samengesteld uit elementen van het platteland rond Johannesburg.

## Enkel voor uitwendig gebruik

Woorden of gedachten van kunstenaars over hun werk moeten met de nodige behoedzaamheid worden aangenomen. Niet omdat wij dom zijn of niet goed uit onze woorden komen, maar omdat deze verklaringen van ons werk volgen op de gebeurtenis zelf. Het zijn eerder rechtvaardigingen of, in het beste geval, reconstructies van een proces dat heeft plaatsgevonden, dan omschrijvingen van een programma waartoe was besloten voordat het werk werd aangevat. De betekenissen zijn illusoir. Niet dat de tekeningen geen betekenis hebben, maar de betekenis kan van tevoren niet met zekerheid worden vastgesteld. Wat mensen ook denken dat zij doen, uiteindelijk komen hun verwachtingen en angsten en verlangens naar boven. Kwade trouw – politiek of moreel of in welke zin dan ook – voel je op je klompen aan en zal zich wreken. Vandaar de waarschuwing op het etiket.

## Lief Dagboek

Dinsdag- en donderdagmiddagen op King Edward VII Preparatory School. Kijkend naar ellenlange etnografische films over het dorsen van maïskolven en herdersjongens die de kudde terugdrijven naar de lemen hutten, op de tonen van een krakende Marimba uit de luidspreker achter in de aula van de school. Zelfs op vijf- of zesjarige leeftijd leek dit beeld van Afrika een complete fictie, veel minder overtuigend dan de Tarzan-films die wij aan het eind van elk semester te zien kregen. De zwarten die ik kende en leerde kennen woonden niet in lemen hutten en hielden zich niet bezig met vee of met het spelen op de trom; zij namen de bus, droegen modieuze hoeden, woonden in kleine kamers aan de achterkant van grote huizen, luisterden naar de radio.

## Alexis Preller voorwaardelijk vrij

De discussie en de achterdocht rond transitionele kunst op dit moment hebben naar mijn gevoel iets met deze dichotomie te maken. En buiten de academische arena worden duidelijk verschillende visies uitgedragen door – zeg maar – de foto's van inheemse dansen op ANC platenhoezen en de post-revolutionaire, Russisch constructivistische beelden in de COSATU*-reclame.

Ik heb altijd de mensen benijd die rond de eeuwwisseling in Frankrijk werkten en de Afrikaanse iconografie, de maskers en sculpturen in de vormentaal van hun werk konden opnemen, zonder zich te hoeven bekommeren om de beladen vragen die hier onvermijdelijk bij een dergelijke toespeling horen.

Aan het Afrika van de inheemse stammen heeft altijd een reactionair luchtje gezeten, vooral door toedoen van diegenen die het gewapenderhand hebben getemd, enkel om de totems als decoratiemateriaal te vieren. Maar zelfs bevrijd van deze directe associaties is het idee van een onschuldig, klasseloos Afrika uitermate problematisch. Er schuilt nostalgie in, of het nu om een schilderij van Preller gaat of om de aanroeping ervan door Black Consciousness-groeperingen, een verwijzing naar een toestand van genade, zuiver en onbekend met de beperkingen en wantoestanden in

* Congress of South African Trade Unions

Afrika tijdens de overheersing. Dit idee van een onschuldig pre-Europees Afrika is op de eerste plaats verkeerd en, wat belangrijker is, het verdoezelt de vreemde, tegenstrijdige verhouding tussen de westerse verovering en de tribale cultuur, die nu nog steeds bestaat.

Dit utopische Afrika vol mystiek, spirituele heling en ongerepte natuur verschilt niet zo veel van het Afrika als Hof van Eden in de werken van de beroemde Zuid-Afrikaanse landschapsschilders. Op de Volschenks en Pierneefs is geen stambewoner te zien, maar toch heerst er dezelfde sfeer. Het landschap wordt gearrangeerd tot een beeld van puur natuurlijke, majestueuze oerkrachten, van rotsen en luchten. Een 'kloof' met steile wand, een boom worden geïdealiseerd. Een bepaald feit wordt geïsoleerd en elk idee van proces of historie blijft achterwege. Deze schilderijen – van het landschap in een toestand van genade – zijn documenten van vergetelheid.

Het is niet meteen zo gegaan. De vroege Zuid-Afrikaanse landschapsschilderijen waren wetenschappelijke, cartografische studies. Of direct historisch. Een aantal van de vroegkoloniale schilderijen toonde veroveringstaferelen, er werd in het landschap een strijd uitgevochten. De rook van geweren en ter aarde stortende Xhosa: ze werden bij honderden geproduceerd. Later voltrekt zich een verandering: de geweren worden vaker op andere fauna gericht: kudden olifanten, leeuwen. En pas aan het eind van een lang proces, dat gelijke tred houdt met de stapsgewijze onderwerping van Afrika, komt het pure landschap te voorschijn.

*Een reis door Afrika*
Voor de bewoner van een blanke voorstad begon de reis door Afrika aan de overkant van de binnenplaats, in de kamer van de bediende. Een Singer naaimachine met pedaal, ZCC*-kalenders en foto's aan de wand. Daarna herinner ik mij tochtjes naar de markt in Mbabane met een geurencocktail van overrijp fruit en vers mandenwerk en pas later, veel later, enige kennis van de sculptuur die wordt gemaakt in Venda en het besef dat in Afrika bepaalde mensen wel degelijk in lemen hutten

wonen en vee hoeden, zij het dan niet op de manier zoals dat werd getoond in de schoolfilms. Maar in het hart, in het centrum van Afrika, in het Houghton-huis, was er Michelangelo's *Laatste Oordeel* en Hobbema's *Laan met populieren*, dit laatste op de cover van *The Great Landscape Paintings of the World*, een boek dat ik van mijn grootvader had gekregen.

*Londen is een voorstad van Johannesburg*
Privé-landkaarten van vertrouwde plaatsen stemmen met geen enkele geografische projectie overeen. Pretoria is altijd buitenaards geweest, de vreemde plaats waar mijn vader tijdens mijn jeugd jarenlang naar toe ging; om te werken aan de 'Trees and Tile'**. De plek werd geassocieerd met frustratie en woede en is niet vertrouwder geworden. En met een Zuid-Afrikaans paspoort is al het land in noordelijke richting natuurlijk één grote leemte, iets wat je voor waar aanneemt op basis van de foto's in *National Geographic* (evenals Oost-Europa en het grootste gedeelte van Azië); delen van Londen, New York zijn vertrouwder: verlengstukken van Johannesburg, absoluut dichterbij dan Kaapstad.

Hobbema's laan met bomen was een vaste halte. Iets tussen de geconstrueerde natuur – de ontluikende eikenbomen en de sappige weiden uit koloniale kinderboeken – en het onbestaande landschap dat ik kende van rond Johannesburg. Op dit vreemde schilderij was in elk geval niet veel te zien: een paar bomen, een weg, een sloot, een haag. Niet de paarsgetopte bergen en voorbijstromende rivieren van de Volschenks en De Jonghs en Pierneefs, die op hun eigen wijze even buitenaards waren als die etnografische films. (Er is mij sindsdien door mensen die een tijd op een boerderij of op het platteland hebben doorgebracht, verteld dat er wel degelijk plaatsen bestaan die eruit zien als die schilderijen, maar inmiddels is de schade al aangericht.)

Je kon uiteraard ook gemakkelijk van de Hobbema houden. Het schilderij is afkomstig uit een vreemd land en is honderden jaren geleden geschilderd; er is niets waar het aan kan worden gestaafd, geen context dat het werk in twijfel trekt. Maar de Volschenks beantwoord-

den in niets aan mijn ervaring. Ik had nog nooit, en heb in zekere zin het gevoel dat ik nog steeds geen schilderij heb gezien dat overeenstemt met hoe het Zuid-Afrikaanse landschap aanvoelt. Ik veronderstel dat mijn begrip van het platteland een overwegend urbaan begrip is. Het heeft te maken met het uitzicht vanaf de weg, met een landschap dat vorm en betekenis krijgt door de incidenten die er plaatsvinden, stukjes weg- en waterbouw, pijpleidingen, duikers, hekken. Dit is in wezen een naturalistische benadering van de landschapskunst. Een van mijn werkwijzen bestaat erin dat ik een van tevoren bepaalde, maar willekeurige afstand rijd, laten we zeggen, 6,3 of 19,8 kilometer en op dat punt aan de slag ga met wat zich daar voordoet. Ik doe dit overwegend om te ontsnappen aan de plaag van het schilderachtige (ofschoon dit bijna onmogelijk is). Over het algemeen is het resultaat een catalogus van weg- en waterbouwkundige details. Het is mij duidelijk geworden dat de waaier aan menselijke ingrepen in het landschap veel breder is dan alles wat het land zelf te bieden heeft. De verscheidenheid aan hoge lichtmasten, vangrails, duikers, de overgangen van een uitgraving naar een hek, naar de weg, naar de horizon, naar het veld, zijn even groot als elke geologische verschuiving (althans in het 'highveld' – de schoonheden van de Kaap zijn anders, je kunt er plezier aan beleven, maar ze doen me niet naar mijn schetsboek grijpen).

Er zijn daar ook andere sporen te zien. Een oneindige kroniek van rampen of bijna-rampen in de remsporen die de weg steeds onderbreken. (Zelfs op de vlakke, rechte stukken van de N1 door de Karroo is het aantal van dergelijke sporen zelden minder dan vijf of zes per kilometer.) En het gevoel van een ruimte waarop druk is uitgeoefend, die niet zo onschuldig is of badend in genade als men graag zou willen.

*Magoeba's Kloof en de Land Act van 1913*
Natuurlijk zijn er, zelfs als je op willekeurige plaatsen langs de weg stopt, opmerkelijk mooie uitzichten. Blind te zijn voor die schoonheid getuigt van lompheid, maar je erdoor te laten opslokken lijkt even absurd. Ik denk dat je nooit eenvoudig kan reageren op een plaats waarvan het uitzicht zo weinig in overeenstemming is met de geschiedenis.

In een tv-documentaire zag ik beelden van bossen ergens in Polen. Diep grijsgroene pijnbomen en golvende heuvels in het zachte Europese licht. Wat moet je met zo'n landschap? Enerzijds zie je dat idyllische platteland, aderzijds weet je dat het de plaats is waar in de jaren '40 honderdduizenden mensen achterin vrachtauto's werden vergast. De sporen in het landschap zijn miniem. Een open plek in het bos, een gedeelte waar nieuw aangeplante bomen in strak gelid nog niet zo hoog reiken als de bomen eromheen. In dezelfde documentaire is een terrein te zien dat niet erg afwijkt van het land rond Wadeville of Vereeniging, vlak en kleurloos, een paar horizontale strepen in de grond die laten zien waar zich een fundering bevond, een nietszeggende vlakte: een van de crematoria van Auschwitz.

*Urbaniteit als ziekte*
Ik teken geen locaties van plaatselijke bloedbaden (hoewel ik denk dat het op zichzelf een interessant project zou zijn), maar ik teken ruimten die niet natuurlijk of neutraal zijn. Ik geloof dat het Adorno was die schreef: 'Na Auschwitz is er geen lyrische poëzie meer' – dat de gebeurtenissen van de oorlog zo traumatisch zijn geweest dat zij de psyche van alle mensen hebben getransformeerd, dat zij het vermogen hebben weggenomen om in bepaalde vormen zoals lyrische poëzie iets zinnigs te ontdekken. Natuurlijk had hij het bij het verkeerde eind. Het geheugen van de mens en het collectieve geheugen van de mensheid is extreem kort of wordt gesust om plaats te maken voor het leven van alledag. Er zijn bepaalde gebeurtenissen voor nodig, films, boeken, om dat geheugen weer op te frissen. En dat is de reden waarom dat landschap van Poolse bossen iets betekent. Er schuilt een gebeurtenis in die een plaats heeft gekregen, die is opgenomen in de gang van het dagelijks leven.

In Bertrams, de voorstad waar ik woon, zijn het afgelopen jaar vier bommen ontploft (in de Standard Bank Arena en Ellis Park – de meest

recente was vandaag, een uur geleden; er werden drie mensen gedood) en twee of drie moorden gepleegd. Maar dat alles kan worden verwerkt. Het doet je steeds minder. Deze afstomping is ook een vorm van geheugen-verlies. Urbaniteit, waarmee ik het vermogen bedoel om alles te absorberen, om van tegen-stelling en compromis de basis te maken van het dagelijks leven, lijkt karakteristiek voor hoe mensen in Zuid-Afrika te werk gaan. Het is in zijn meest overdreven vorm aanwezig in blan-ke voorsteden, maar naar mijn idee blijft het daar niet toe beperkt. Activisten wier taak het is om de afwijkende gebeurtenissen rondom ons aan het licht te brengen en niet te laten ontglip-pen, hebben het opgegeven.

Ondanks alles voel je je de volgende och-tend weer beter.

De landschappen die ik de laatste tijd teken, komen voort uit deze arena van urbaniteit. Wat niet wil zeggen dat het er illustraties van zijn. Het tekenproces verloopt meestal nogal blind, met slechts af en toe een pauze voor reflectie of waardering. Elementen van een landschap blij-ken geschikt te zijn en worden de structuur van een tekening. Stukken van een tekening verlie-zen hun houvast en moeten worden verwij-derd. Er zijn geen punten, geografisch noch moreel, die ik probeer te illustreren. De teke-ningen zijn empirisch, naturalistisch. Maar zij zijn doordrongen van een gevoel dat het land-schap, het 'veld' zelf, andere dingen in zich bergt dan alleen maar natuur.

(uittreksels van een lezing door
William Kentridge ter gelegenheid van het
'Standard Bank National Festival of the Arts',
Winter School, Grahamstown, juli 1986)

(…)

*De schilderijen waar ik van hou zijn niet
voor mij weggelegd*

De grote impressionistische en postimpressio-
nistische schilderijen als de grote Seurat in de
National Gallery in Londen en die luchten van
Tiepolo zijn de schilderijen waar ik het meeste
plezier aan beleef. Direct plezier, in de zin van
een gevoel van harmonie met de wereld.
Het zijn beelden van een toestand van genade,
van een paradijs op aarde.

*Kunst en de toestand van Genade*

Deze genadetoestand is voor mij onaanvaard-
baar. Ik weet dat dit tegenstrijdig klinkt. De
toestand in de wereld is in termen van mense-
lijke ellende niet zo sterk veranderd sinds het
eind van de 19de eeuw. Er stonden fabrieken
langs de Seine die Seurat schilderde en in de
slechte jaren kwamen de boeren op het platte-
land van de honger om niet ver van Tiepolo's
plafonds. Toch wekken die schilderijen niet de
indruk van een vertekende geschiedenis, maar
van een welwillende wereld.

Dankbaar zijn voor die leugens is één ding,
ermee doorgaan is wat anders.

Er zijn bepaalde kunstenaars, van Matisse
tot de abstracte 'colour field'-schilders, die erin
geslaagd zijn een onschuld of blindheid te
handhaven en zijn kunnen blijven werken tot
op de dag van vandaag, zonder dat een slecht
geweten aan hun werk knaagt. Ik zou het fan-
tastisch vinden als ik zo zou kunnen werken.
Maar het is niet mogelijk.

Deze onmogelijkheid is complex. Wanneer
ik het probeer, zien de plaatjes er verschrikke-
lijk uit. Lyriek ontaardt in kitsch of sentimenta-
liteit. Of anders verandert de aard van het
beeld. Lyriek lijkt een zeker zelfvertrouwen en
een duidelijk bewustzijn te vereisen, wat bij
mij ontbreekt. Natuurlijk is de redenering
nagenoeg omkeerbaar. Als ik op een lyrische
wijze zou kunnen werken met kleur of beelden,
zou dat vertrouwen er misschien zijn. Zeker

ben ik mij zeer bewust van mijn sofisme als ik
een tekortkoming in mijn schilderen toeschrijf
aan morele schaarste.

Misschien als ik ver weg van hier zou wer-
ken in een of ander Europees of landelijk oord,
misschien zou ik dan appels en kleuren kunnen
schilderen, maar ik betwijfel het. Hier word je
meer dan waar ook elke dag geconfronteerd
met compromissen en deze zijn met zekerheid
grotesker dan de meeste, maar in wezen denk
ik dat zij niet sterk verschillen.

Het zijn altijd de boeren die het gelag
betalen en zuiverheid is een illusie.

*Kunst en de toestand van Hoop*

Tatlins *Monument voor de Derde Internationale*
is een van de grote beelden van hoop. Ik zeg
'beeld', want hoewel het monument bestond
als model, ken ik het alleen van foto's. Dat is
ook voldoende. Het is het project, veeleer dan
het feitelijke object, dat iets teweegbrengt. Ik
stel mij voor dat de grijze betonnen peilers van
het echte monument, ruim driehonderd meter
hoog, monsterlijk zouden zijn. Maar uit het
beeld van Tatlin en zijn assistenten die rond
het model – op zichzelf al enorm – klauteren,
spreekt een hoop en een zekerheid die ik alleen
maar kan benijden. Zo'n hoop, met name hier
en nu, lijkt onmogelijk. Het falen van deze
hoop en van idealen, en het verraad, zijn te
machtig en te veelvuldig. Ik kan geen afbeel-
dingen schilderen van zo'n toekomst en geloof
toch nog steeds in de afbeeldingen.

Wat wellicht niet eens nodig is. Goede
propaganda kan komen van vakmanschap en
plichtsbesef, veeleer dan van conventie.
Ofschoon dat moeilijk is. Op de weinige
posters die ik op verzoek heb ontworpen,
sijpelt de ironie (het laatste toevluchtsoord van
de bourgeoisie) door en wordt hartstocht
gereduceerd tot een bittere grap. Uiteindelijk is
mijn geloof in de democratische socialistische
revolutie bezoedeld. Niet doordat ik twijfel aan
de noodzaak of de wenselijkheid ervan, maar
omdat het ongerechtvaardigd optimistisch lijkt
te denken dat de revolutie zal plaatsvinden en
omdat, zelfs als dat zo zou zijn, ik niet weet hoe
ik daarin zou passen.

* Deze titel gaf William
Kentridge later ook aan een
van zijn werken: een triptiek
in zeefdruk uit 1988
(catalogus p. 15).
Daarom blijft hij hier
onvertaald.

Waar brengt mij dat, zonder geloof in een verworven (ook maar gedeeltelijke) toestand van genade, noch in een immanente verlossing hier?

### Kunst onder de staat van beleg

Max Beckmanns schilderij *Death* is een baken voor bedreigde zielen. Het aanvaardt het bestaan van een gecompromitteerde maatschappij en sluit toch niet alle betekenis of waarde uit en pretendeert ook niet dat deze compromissen moeten worden genegeerd. Het markeert een plaats waar optimisme in bedwang wordt gehouden en nihilisme tot staan wordt gebracht. Het is in deze nauwe opening die hij in kaart brengt dat ik mijzelf aan het werk zie. Bewust van en gesteund door de anomalie van mijn positie. Aan de rand van enorme sociale beroeringen, maar er ook ver van verwijderd. Niet in staat deel te hebben aan die opstanden, maar evenmin in staat om te werken alsof zij er niet zijn.

Deze positie, waarin ik geen actief deelnemer ben, noch een belangeloos waarnemer, is het beginpunt en de voedingsbodem van mijn werk. Het is niet noodzakelijkerwijs het onderwerp ervan. Het werk zelf bestaat in even zovele excursies aan de rand van deze positie.

### Na Auschwitz is er, helaas, nog steeds lyrische poëzie

Deze positie, de arena waarin ik werk (dit schuttersputje, zoals het vaak aanvoelt) is geen unieke positie. Het is de toestand van veel mensen, zo niet van ons allen. Ik benadruk hem alleen maar, omdat hij voor mij centraal lijkt te staan. Er gaat geen dag of geen uur voorbij zonder dat dat zich aan mij presenteert (niet als leed, dat komt te weinig voor, maar ten minste als por in de zij). En het staat centraal in mijn activiteiten. Ik weet zeker dat andere mensen zich ervan bewust zijn, maar kunnen werken zonder dat het van invloed is op wat zij doen.

Het centrale kenmerk ervan is ontwrichting. Het feit dat het dagelijks leven is samengesteld uit een onafgebroken stroom van onvolledige, tegenstrijdige elementen, impulsen en sensaties.

Het boeiende voor mij is echter niet deze ontwrichting zelf, maar het gemak waarmee wij ze het een plaatsje geven. Er is een enorme persoonlijke schok voor nodig, willen wij langer dan vluchtig onder de indruk zijn. De overgang van gruwelijk nieuws in de krant naar het sportkatern of de kunstpagina is snel gemaakt en een slecht geweten, als het er al is, duurt maar even.

### Urbaniteit als ziekte

Urbaniteit, de weigering ons te laten raken door de gruwelen die ons omgeven en waarbij wij zijn betrokken, hangt boven ons aller hoofd. De vraag waarom hartstocht zo vergankelijk kan zijn en het geheugen zo kort, knaagt voortdurend aan mij. Het is een diepgewortelde vraag.

Ik herinner mij de schok die ik als kind (ik ben tweede kind en dus vredestichter; het bijleggen van tegenstellingen was voor mij een levenstaak) te verwerken kreeg toen ik mij realiseerde dat een woedeuitbarsting die een paar minuten eerder niet te stillen was en op niets minder gericht kon zijn dan de verminking van het doelwit, nu was weggeëbd en dat de woede jegens diegene die het probleem had veroorzaakt, ofschoon niet minder verdiend, nu onecht was. Wat was er met die kwaadheid gebeurd, hoe kon die zo maar in het niets oplossen?

De vragen van nu lijken niet zo veel te verschillen. Wat is die sfeer waarin wij leven, die ervoor zorgt dat we zo kalm blijven onder de schokken en conflicten van het dagelijks leven? En de mate van kalmte is verbazingwekkend.

### White Guilt Come Home

Over het blanke schuldgevoel worden vaak verkeerde dingen gezegd. Zijn meest overheersende eigenschap is zijn zeldzaamheid. Het verschijnsel bestaat uit kleine druppels die met onregelmatige tussenpozen worden ingenomen en waarvan de effecten niet lang merkbaar zijn. Maar de stelling gaat verder dan dit. Mensen die zich veel dichter bij het geweld en alle ellende bevinden keren nog steeds terug uit de traangasrook en staan een uur later alweer hun eten te koken of kijken naar 'The A-Team' op de televisie.